The World of Mathew Brady

PORTRAITS OF THE
CIVIL WAR PERIOD

The World of Mathew Brady

PORTRAITS OF THE CIVIL WAR PERIOD

by Roy Meredith

BONANZA BOOKS
New York

This 1988 edition is published by Bonanza Books,
distributed by Crown Publishers, Inc., 225 Park Avenue
South, New York, New York 10003, by arrangement with
Brooke House Publishers, Inc.

Printed and Bound in the United States of America

LIBRARY OF CONGRESS CATALOGING-IN-PUBLICATION DATA
Meredith, Roy, 1908–
The world of Mathew Brady : portraits of the Civil War
period / by Roy Meredith.
p. cm.
Reprint. Originally published: Los Angeles, Calif. :
Brooke House,
1976.
ISBN 0-517-21640-X
1. United States—History—Civil War, 1861–1868—
Biography.
2. United States—Biography—Portraits.
3. United States—History-
Civil War, 1861–1865—Pictorial works.
4. Brady, Mathew B., 1823
(ca.)–1896. I. Title.
[E467.M47 1988]
973.7′092′2—dc 19
[B] 88-26298
CIP

h g f e d c b

Acknowledgments

I would like to express my grateful appreciation:

To my friend, Joan Wilcoxon (Mrs. Ray Mitchell), writer and dramatist, who urged me to develop the *People You Will Never Meet* essays. One of the most talented people I have ever met, Joan introduced them, and me, to the late Garland Griffin, distinguished managing editor of the Riverside *Press Enterprise*. Joan's exuberant encouragement and "Griff's" editorial advice and warm friendship preordained their success.

To the staff of the Palm Springs Public Library, particularly Mrs. Berenice Doak, Ruth Lewis, Lillian Rising, and Betty Rosine for their invaluable assistance; and to Mrs. Pat Service, librarian of the Palm Desert Public Library, for her kindness and assistance in locating reference books long out of print.

I am especially indebted to Milton Caniff, a friend of long standing, creator of the famous adventure strip, "Steve Canyon" and one of the truly great cartoonists and artists of our time, for his thoughtful advice and friendly efforts in my behalf.

Contents

The World of Mathew Brady

PORTRAITS OF THE CIVIL WAR PERIOD

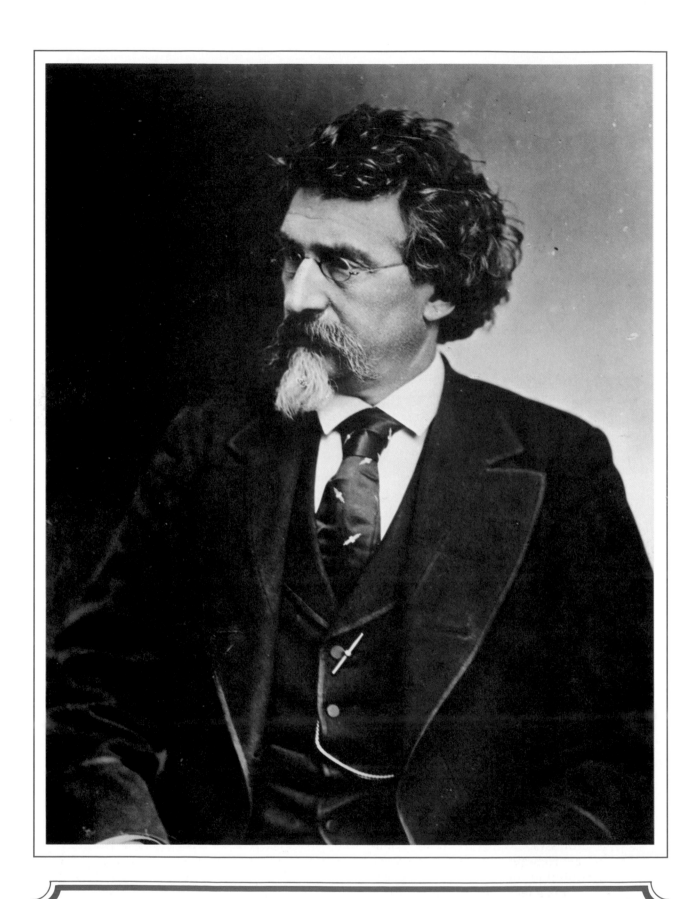

Mathew B. Brady at the age of sixty

Introduction: Brady of Broadway

"Brady of Broadway" died on January 16, 1896, destitute and alone except for a devoted friend, William Riley, who stayed with him to the end, at the New York Presbyterian Hospital.

To Brady's nephew, L.C. Handy, Riley wrote of Brady's last moments: "Brady was conscious, but for two or three days he was unable to speak on account of the swelling in his throat. I don't think he realized he was dying . . ."

Earlier, another devoted friend William Slocum had written the nephew: ". . . I wish you could be here with him as he is evidently suffering great pain from his injuries, *but he is showing his usual pluck and perserverence.*"

Despite his age, 76, and injuries, in this writer's opinion Brady died as a much a victim to his devotion to his profession as to physical causes. His profession was filled with mountebanks and get-rich-quick artists, who were already capitalizing on Brady's early endeavors, as witness a letter from William Riley to the nephew: "I enclose you an ad from which you will see they are already banking on Brady photos. I called them this morning as I came down and found the work was written by Rossiter Johnson, and the whole thing is a cheap affair. The illustrations are badly printed some of them being indistinct—but they are genuine copies." And this is only one example. There are other examples, too numerous to mention.

But there were also more scrupulous photographers, honest in their work, like Brady, who sought to better the profession.

One of the most gifted photographers of all time (and this is not the hyperbole of a devoted admirer), Mathew Brady, a foremost pioneer in the art of portrait photography, was renowned and respected for his ability, like the artist he was, to capture on his plates the authentic character traits of his distinguished sitters.

To three generations, Mathew Brady represented integrity in his work; and his signature, "Brady N.Y.," on a plate, was the hallmark of social acceptance as well as the trademark of an excellent photographer.

Brady's gold medals for portraiture, both abroad and at home, brought him early recognition and affluence. These, in turn, became an investment in himself, which assumed the form of two elaborate galleries in New York City and one in Washington, D.C., rewards for diligence and professional ability.

Rightly honored as his fame grew, Mathew Brady moved in the company of presidents, princes, distinguished American and foreign statesmen, musicians, artists, soldiers, beautiful women of consequence, poets, editors, and diplomats, men and women whose careers were integral in the tapestry of American history.

I discovered Mathew B. Brady in 1937, while looking through some of my maternal grandfather's effects, which included, among his honorable discharge and other papers and medals from his four-year service in the Union cavalry, a regimental history and a collection os about twundred of Brady's card photographs of incidents of the Civil War, along with some stereo photos, all marked with the Brady imprint.

They were wonderful photographs, and I determined to find out just who this photographer was, because there was, to me, something far above average in work signed with the name. The result was my first book, *Mr. Lincoln's Camera Man: Mathew B. Brady*.

During my work on the present book, which grew out of a series of articles published in the *Press-Enterprise* of Riverside, California, I came to the conclusion that Mathew Brady was an artist, with an artist's temperament, a man whose enthusiasm for his work completely overshadowed everything else, so engrossed was he in his work.

Seemingly totally oblivious to, or disinterested in, the paper-shuffling, bookkeeping, and the (to him) banal necessities of "business management," Brady seems to resemble the type of man Winston Churchill describes in his book of the Sudan War, *Amid These Storms*.

"Broadly speaking," writes Churchill, "human beings may be divided into three classes: those who are toiled to death; those who are worried to death; and those who are bored to death . . . but Fortune's favored children . . . are those whose work and pleasure are one. For them the working hours are never long enough." I believe Brady belonged to this group, and there is no end of documentary proof to support this assumption.

During Brady's lifetime of professional work, he encountered the "prestige stealers," those who, for one reason or another, set their names to authorships of works not their own, who would rather steal than work for prestige.

Brady had many competent people working for him, both photographers and artists, and boasted of it. It is ridiculous to imply, as do some of Brady's detractors, that he ran from studio to studio exposing every shot. Brady did, however, supervise or arrange the sittings of the VIPs. To put this nonsense to rest, especially the implication that Brady didn't know much about his profession, that his reputation was more or less a "fluke" and the product of a friendly press, one has only to read C. Edwards Lester's account, which many have overlooked (the italics are mine):

"[Brady] has merited the eminence he has acquired; from the time he first began to devote himself to it, he has adhered to his early purpose, with the firmest resolution and the most unyielding tenacity . . . while he offered inducements *to the best operators*, and chemists to enter his studio, *he* [Brady] *superintended every process himself* and made himself master of every department, sparing no pains or expense by which new effects could be introduced to increase the facilities or embellishments of the art. . . .

"Mr. Brady has never, after upwards of twenty thousand experiments, grown so familiar with the process of Daguerreotypy as not to feel a new and tremulous interest in every repeated result, when, after preparing his plate, he stepped aside to wait for Nature to do her work."

Mathew B. Brady's early beginnings are somewhat hazy. Nothing new in research since I wrote *Mr. Lincoln's Camera Man* has disproved the information as to his birth given there, and nothing since has come to light concerning his youthful years in upper New York State.

Born in Warren County, near Lake George, New York, in 1826, the son of Irish immigrant parents, Mathew Brady in his youth moved to Saratoga Springs, where he learned the trade of

making cases for watches and instruments. As a boy he made the acquaintance of William Page, the American portrait painter and pupil of Samuel Finley Breese Morse. Morse, while on a trip to Europe, met Louis-Etienne Daguerre, inventor of the daguerreotype, and so far as is known learned the process from him, and brought home some equipment to practice it.

In 1840, William Page, "who had given Brady some crayons" and art instruction, brought young Brady to New York City, where he apparently became acquainted with Morse and probably studied the process with him, since Morse was earning a living teaching the subject. During that time, Brady worked as a clerk in A. T. Stewart's department store to earn at least food and lodging.

With the probable financial help of A. T. Stewart, a millionaire merchant, Brady opened his first gallery on the corner of Broadway and Fulton Street, the present site of the New York Telephone Company Building, diagonally opposite P.T. Barnum's Museum.

The gallery became an immediate success, and soon thereafter was referred to in the press as "Brady's Broadway Valhalla."

Celebrities of government, theater, and New York society flocked to his door to have their images impressed on the polished plate of the daguerreotype. According to one reporter, "the wise Gothamites of the Press were glad that Mr. Brady, the prince of photographers, was on our side of the water." Newspapermen realized that nowhere else in New York could they find such a selection of glamorous subjects for stories and anecdotes for their columns and articles.

Among Brady's first sitters were Daniel Webster and Henry Clay, and their portraits were among the first pictures to be mounted in a magnificent portfolio entitled *Gallery of Illustrious Americans*.

Throughout the course of Brady's long career in photography, many famous faces looked down from the walls of his galleries, "all taken from life, with the subtle look of life." Among them were the likenesses of Zachary Taylor, Andrew Jackson, Peter Cooper, Edgar Allan Poe, James Knox Polk, John Tyler, Winfield Scott, James Audubon, and, later, Abraham Lincoln: celebrities in all walks of life, far too numerous to list. Never in the history of photography has one man's studio enjoyed such a distinguished clientele.

According to all accounts in existence, to the people who sat for his camera Brady's personality and manners were captivating. The nature of his profession gave him the opportunity of studying great men and women at firsthand; but his observations of, and comments on, their behavior were always discreet, never derogatory. Brady kept his own counsel, and this trait made him many personal friends among the great and near-great. His gift and artistry, his intellect and gracious traits of character, were admired by all who met him; and he was, despite his little formal education, a fine conversationalist and a genial companion.

He was seen by his close contemporaries "as a man of artistic appearance and of very slight physique—about five feet six inches tall, who generally wore a broad-brimmed hat, similar to those worn by the art students of Paris."

The Fulton Street Gallery prospered and, in 1850, in response to the demands of his growing business, Brady opened a huge establishment at 359 Broadway, in New York City, the finest gallery of its kind probably in the nation. His fame assured, with two galleries in operation, he could look forward to a life of ease on his income.

Brady could eventually lay claim to having photographed, or daguerreotyped, every president of the United States, from John Quincy Adams to Grant, Hayes, and Garfield, Arthur and Cleveland, with the single exception of William Henry Harrison, who died a month after his inauguration three years before Brady went into business in 1844.

Photographic awards gave Brady even greater distinction, and in 1854 he was invited to display his work at the London World's Fair.

While in London, Brady saw for the first time Scott Archer's collodion "wet plate" process, that of photographing an image in negative form, from which any number of prints could be made. Brady was quick to see the advantages in this process, that it would, before long, make the daguerreotype obsolete.

Returning to America with Alexander Gardner, a Scottish chemist and photographer, and an expert in Archer's process, Brady introduced the new process into his galleries, which increased his output enormously. Before long his

galleries would be turning out more than thirty thousand portraits yearly, ranging in price from about $5 to $150, the latter for an "imperial" photograph, or one finished in watercolor, pastel, or oil.

Brady was by now a comparatively wealthy man; he had become a fad. Other incidents of note were the visit of Edward, England's Prince of Wales, who contributed vastly to Brady's success by informing the press in an interview that he and his entourage had crossed the Atlantic to visit Brady's Gallery. On the morning of October 13, 1860, at 12:00 noon, the royal visitor arrived at Brady's Gallery. The gallery was closed to the public that day, arrangements having been made the day before when Edward had summoned Brady to his hotel suite. As the Prince's carriage drove up to the gallery entrance, a fashionably dressed Brady was on hand to meet them.

When the sittings, which were eminently successful, were over, Brady inquired of the Duke of Newcastle why he had been selected over other, equally prominent New York photographers. "Are you not *THE* Mr. Brady, who earned the prize nine years ago in London? You owe it to yourself. We had your place of business down in our notebooks before we started!"

And the press remarked, "Brady ... succeeded admirably with His Royal Highness—took some pictures of the Prince and Suite, and came off with flying colors. We suppose that his fortune is made now. Of course, Upper Tendom will have to visit Brady's. Of course, the Codfish Aristocracy will go nowhere else to get photographs of the little Tom Cods. Nothing but a veritable 'Brady' will hereinafter answer for the parvenu set who could not make the floor strong enough to hold up the Royal Party when engaged in Terpsichorean exercises."

The Washington Gallery, which Brady had opened in 1858, had done fairly well, and there was mention of Brady's arrival in Washington City in the *National Intelligencer*. The newspaper writer tells of his visit to the gallery, and his "astonishment ... at the perfection of the counterfeits of many friends which met our view ... faithful and natural expression ... beautiful coloring. Those who have not yet seen this charming gallery would do well to while away an hour in scanning this array of beauty,

diplomacy, living senatorial and clerical celebrity, besides the speaking, almost startling likenesses of the great ones who have passed from this earth."

The Washington Gallery, located at the corner of 3rd Street and Pennsylvania Avenue, "over Gilman's Drugstore" at No. 352, was a three-story affair, with fully equipped studios. The gallery was fairly prosperous, but its income fell far short of the New York galleries. By this time Brady had engaged two well-known artists, Henry F. Darby and John F. Neagle, to paint portraits from the daguerreotypes of Webster, Clay, and Calhoun, which he already had on collodion wet plates. Artist Darby painted Clay and Calhoun, and Neagle executed the portrait of Webster. Some years later, when Brady found himself in financial straits, he sold the paintings to the Congressional Joint Committee on the Library for a total of $4000 for the decoration of the Capitol.

The coming of the Civil War in some respects spelled bad times for the Washington Gallery, but it opened a wide field of photography in another direction. Brady conceived the idea of becoming a "pictorial war correspondent"—what today would be called a photo-journalist. It was through Colonel Schuyler Hamilton, aide to General Winfield Scott, that he gained permission to follow the Union Army.

Some time after the war, the noted war correspondent George Alfred Townsend, one of the more reliable of the newspapermen of that day, who wrote under the name of "Gath," interviewed Brady.

"Did you have any trouble getting to the war to take views?" asked Townsend.

"A good deal," Brady answered. "I had long known General Scott, and in the days before the war it was the considerate thing to buy wild ducks at the steamboat crossing of the Susquehanna and take them to your choice friends, and I often took Scott his favorite ducks. I made to him my suggestion in 1861. He told me to my astonishment, that he was not to remain in command: 'Mr. Brady, no person but my aide Schuyler Hamilton knows what I am to say to you. General McDowell will succeed me tomorrow. You will have difficulty, but he and Colonel Whipple are the persons for you to see.' I did have trouble; many objections were raised. However, I went to the battle of Bull

Run with two wagons from Washington. My personal companions were Dick McCormack, a newspaper writer, Ned House [another writer], and Al. Waud, the sketch artist. We stayed all night in Centerville; we got as far as Blackburn's Ford; we made pictures and expected to be in Richmond the next day, but it was not to be . . ."

In the hysteria that followed the defeat of the Union Army at Bull Run, Brady, in a facetious story, was partially blamed for causing the rout. "Some pretend, indeed, that it was this mysterious and formidable instrument [Brady's big camera] that produced the panic! The runaways mistook it for the great steam gun discharging five hundred balls a minute, and took to their heels when they got within focus."

Another reporter said, "Brady has shown more pluck than many officers and soldiers that were in the fight. He went, not exactly like the Sixty-Ninth, stripped to the pants . . . but with his sleeves rolled up and his big camera directed upon every point of interest on the field. It is certain they [the Union soldiers] did not get away from Brady as easily as they did from the enemy. He has fixed the cowards beyond the possibility of a doubt."

Following his experience at Bull Run, against the advice of his wife and close friends Brady outfitted and trained twenty photographers, and embarked upon a project that, four years later, would reduce him, financially, to ruin. "My wife and my most conservative friends had looked unfavorably upon this departure from commercial business to pictorial war correspondence with much misgiving," he said to George Alfred Townsend, who was interviewing him after the war, "but, like Euphoria, a spirit in my feet said 'GO' and I went."

Brady, obviously, could not take *all* the pictures made in the camps and on the battlefields during "that gloomy war." At the same time, it is ridiculous to assume that Brady "never saw a battlefield," when there are numerous battlefield pictures of the Eastern theater of the war, in which he is plainly seen in the forefront of front-line activity, especially throughout Grant's campaigns in Virginia. These pictures show him at the battlefronts in Virginia, Maryland, and Pennsylvania with the Army of the Potomac. He took pictures at Gettysburg, Fredericksburg, Antietam, and he was with Grant in the final campaigns of the Wilderness, Spotsylvania Court House, Cold Harbor, and the siege of Petersburg, under fire on several occasions.

Oddly enough, Brady was not present at the most dramatic event of the war, Lee's surrender at Appomattox Court House. The records show that there was not a photographer within forty miles of where the surrender was signed. The only possible reason for this photographic oversight is that it happened so fast and so unexpectedly that the photographers didn't hear about it until it was all over. (Not a single photograph of the surrender has come to light in a century to refute this.)

Part I: Decade of Foreboding

But among the people there were the hidden causes of war —
the causes which have ever brought down ruin upon imperial
races.

—*Marcus Annaeus Lucanus, A.D. 62*

The year was 1849. New York City, the teeming metropolis, where everything assumed a grandiose scale, boasted the largest office buildings, stores, restaurants, hotels, theaters, and churches in the nation.

Horse-drawn and pedestrian traffic moved up and down the main thoroughfares in almost unbelievable numbers. On Broadway, the widest, most fashionable main stem in the city, the traffic was so dense that it "was worth one's life to try and cross it."

Soon after the opening of his gallery at Tenth and Fulton streets, Brady made his residence the Astor House, New York's most fashionable hotel, directly opposite his gallery. Besides its convenience, it afforded him opportunities to meet the many celebrities who made the hotel their residence when in New York.

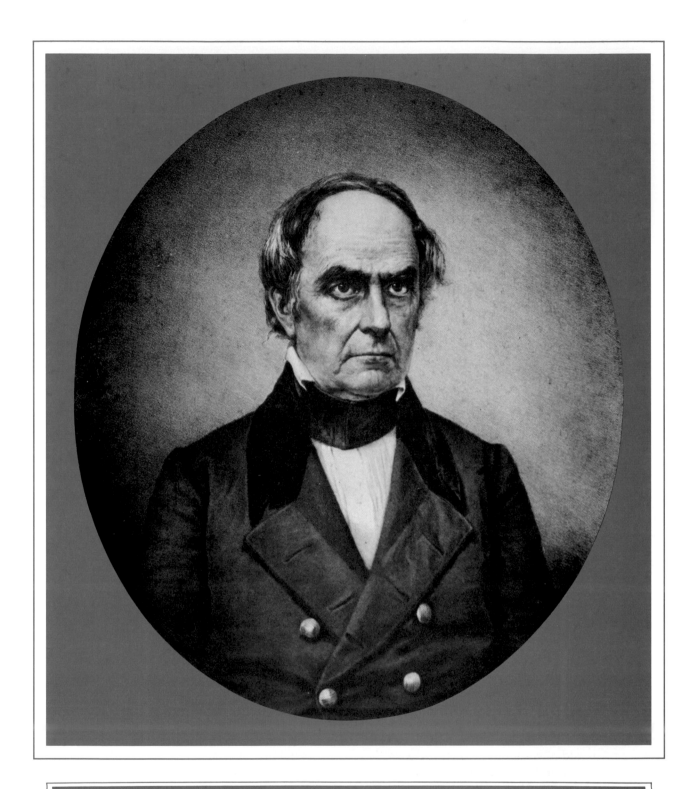

Daniel Webster, the great orator and jurist, sat for this daguerreotype portrait in 1849. Brady published it that year in his "Gallery of Illustrious Americans."

From a daguerreotype by Mathew Brady. Author's collection.

Daniel Webster— Brady's famous subject

In the fall of 1849, five years after the opening of his Daguerrian Gallery, the New York society photographer, Mathew B. Brady, had the good fortune to meet and photograph one of the most celebrated lawyers and statesmen in American politics, the eminent Daniel Webster of New Hampshire.

The sitting, which helped make Brady famous, was made possible through the assistance of Charles Augustus Stetson, proprietor of the Astor House, New York's most fashionable hostelry. Stetson, a former bellboy who lived up to his adage "that a hotel-keeper was a gentleman who stands on a level with his guests," was a personal friend of both Brady and Webster. Indeed, Webster had once said facetiously that if he "were shut out of the Astor" he "would never go to New York again."

Brady, a permanent resident of the hotel, was advised by Stetson of Webster's arrival. Knowing how much it would mean to the photographer to have Daniel Webster's picture for his "Gallery of Illustrious Americans," Stetson promised to signal him by "waving a handkerchief from the Vesey Street side of the Astor" when he was ready to bring the famous jurist to the studio.

Webster's fight on the Senate floor against the Southern Whigs "who would never give a single vote for the tariff until the slavery business was settled" had made him a national figure.

Brady waited patiently for two days before Stetson's signal was seen, and a few moments later the hotel man and the senator were on their way to the gallery. Webster's entrance into the gallery was somewhat melodramatic. Out of breath from climbing three flights of stairs, he announced his presence in a booming voice: "Mr. Brady, I am here, sir. I am clay in the hands of the potter. Do with me as you please, sir. I am at your service."

Webster took his place in front of the camera, "submitting with the greatest good nature," sitting quietly, mild amusement showing on his swarthy face at all the activity going on about him.

Brady pointed the camera and, studying Webster's upside-down image on the ground glass, noted that "Webster's dark eyes, set in

deeply cavernous sockets, seemed to hide mysteries in their depths." Three plates were made, and the sitting ended "with formal departing amenities."

The legal acumen of Daniel Webster had made legend in New England. In his classic story, "The Devil and Daniel Webster," Stephen Vincent Benét places Daniel Webster before a kangaroo court, defending a young farmer who has sold his soul to the Devil for the favor of riches. The judge and jury comprise twelve of the worst murderers and rogues in American history. The Devil is his own prosecutor.

"If two New Hampshiremen aren't a match for the Devil," says Webster to his client, "we might as well give the country back to the Indians." Webster wins the case, the Devil finally conceding "that even the damned may salute the eloquence of Mr. Webster."

Perhaps the nation's greatest legal mind of his time, Daniel Webster was also the most eloquent. Born in Salisbury, New Hampshire, on January 18, 1782, Daniel was next to the youngest of five children born to Captain Ebenezer Webster and Abigail Eastman, his second wife.

Captain Webster, an uneducated man "but an intrepid colonial," had fought with General Jeffrey Amherst's army against the French in the invasion of Canada in 1759, a campaign that ended with the decisive battle on the Plains of Abraham, overlooking Quebec, and that gave Canada to Great Britain. Montcalm and Wolfe, the opposing French and English generals, were both killed in the action.

For his part in the war, Captain Webster was awarded 225 acres of land in the upper Merrimack Valley, where he became a local judge of the common pleas court, later serving in the state legislature.

As a youngster, "in delicate health" and physically unable to take part in the heavy labor of the frontier farm, Daniel attended Salisbury's "random schools," where he "generally could perform better than the teachers." His teachers, nevertheless, were convinced that "his fingers were destined for the plough tail" rather than the pen.

However, his father, bent on "saving his son

from a life of arduous toil" and determined that Daniel would have the advantage of knowledge that he himself had been denied, enrolled his fourteen-year-old son in the famed Phillips Exeter Academy at Andover. The mentally precocious Daniel, though extremely proficient in his studies, failed in declamation because he "could never command sufficient resolution" and was terrified at having to speak before his class.

In 1796, Daniel returned home and taught school for a while. The Reverend Samuel Wood of Boscawen offered to tutor him for Dartmouth College, and the following year he arrived at the college on horseback, "with baggage and some bedding," to start the fall term. Four years later, he graduated at the top of his class, with the added distinction of being the leader of Dartmouth's debating society.

Shortly thereafter, young Daniel began the study of law in the offices of Thomas W. Thompson "with little enthusiasm," doubting that he had the "brilliancy and penetration of judgement enough for a great law character." But after studying the works of "Vattel, Robertson and three volumes of Blackstone," he "began to feel more at ease" in his chosen profession. Believing the law could help "invigorate and unfold the powers of the mind," young Webster tried to enliven the mannered style of legal briefs by embellishing them with quotations from the classics and insertions in verse and rhyme.

He longed to practice in Boston, "the capital of New England," but believed that "only a miracle" could bring it about. However, his brother, Ezekiel, who taught school there, found him a position as clerk in the law office of Christopher Gore, who had just returned from a diplomatic mission abroad. Gore's "stimulating scholarship" and his distinguished associates had great influence upon the young attorney, and he passed his examination for the Massachusetts bar in March 1805.

His plans had been to open his own law office in Portsmouth one day, but when his father became ill, Daniel felt that it was his duty "to drop from the firmament of Boston gayety and pleasure, to the level of a rustic village of silence and obscurity." After the death of his father in September 1807, Daniel opened his law office in Portsmouth. In May 1808, he

married Grace Fletcher, the daughter of a New Hampshire clergyman.

For the next "nine very happy years," his law practice flourished. Most of his cases were tried before the superior court. His income was scarcely more than $2,000 a year, but he was brought into professional rivalry with Jeremiah Mason, in Webster's opinion "the greatest lawyer in the country." Their court-room clashes became renowned legal contests that Webster enjoyed for their mental stimulation. From these courtroom battles Webster learned that careful preparation and "effective diction" usually won cases.

Imbued with the Federalist convictions of his late father, the brilliant young attorney, now "reinforced by the bigwigs of Boston," became convinced that "wealth and intelligence" went hand in hand with "playing a dominant role in political life." He joined the Federalist Party because its ranks held "more than two-thirds of the talent, character, and the property of the nation."

Ominous shadows of revolution were casting their presentiments "along French revolutionary lines," ideas which Webster visualized as signs "threatening civil war." He warned that if the Northern and Southern factions did not come to an agreement, a time would come "when American blood shall be made to flow in rivers by American swords."

Fearing a break "in the bonds of our Federal Union," Webster, in orations and political pamphlets, directed his strenuous efforts toward nullifying the effect of Jefferson's election of 1800, rousing the Federalists to awaken those in their ranks "who were disposed to sit still and sigh at the depravity of the times" while "the contagion of Jeffersonian democracy" threatened to "pervade every place and corrupt every manly and generous sentiment."

Napoleon's decision to take on the British empire in a contest for Europe, the indiscriminate seizure of American merchant vessels on the high seas by British men-of-war, and Jefferson's ignore-them-and-they-will-go-away policy against these acts of piracy infuriated Webster. He became the champion of New England shipping interests "against the retaliatory measures of Great Britain," and when Jefferson instituted the ruinous policy of economic coercion against the New England states, Webster led the Federalist opposition in a highly effective fight. Great Britain, believing she could regain her former colonies by engaging in a war she was sure she could win, had used the device of impressing of American seamen to start it.

With the coming of "Mr. Madison's War" of 1812, Webster put all his political strength and oratory into denouncing the war as unjustifiable. He took on both Madison's war Administration and the old die-hard Federalists of New England, who still toyed with the idea of separating New England from the Union. Webster denounced them all and took a firm stand for "the peaceful remedy of election," winning out in the end. In August 1812, Webster, standing "on the right of full freedom of criticism," delivered his famous Rockland Memorial speech, which launched him into Congress. There, as a member of the Foreign Relations Committee, he presented a series of resolutions that compelled the Government to explain the war's causes; opposed the bounties for enlistments in the army and navy; refused to vote taxes to support the war; and denounced the Government's draft bill "as an infamous expedient, unconstitutional and illegal."

Two years after the war, in August 1816, Webster moved back to Boston, where he sidetracked politics for his more lucrative law practice, which now earned for him $15,000 a year. Through the early decades of the nineteenth century, the incidents of Webster's lively political career were in some measure overshadowed by the brilliance of his legal career. There was no "conflict of interest" for politician-lawyers then. Later, Webster would be trapped by the charge of such a conflict, which was almost to ruin him. During his last winter in the Senate, in 1819, Webster was retained by the Supreme Court in cases involving the payment of prize money to crewmen of American privateers, and the famous Dartmouth College case, in which he defended his alma mater. A Republican legislature that year had tried to enact a law which would place the college and its governing body under the jurisdiction of the general court of the state. Webster led the fight against this political domination in the New Hampshire Superior Court, and lost the case, which was then

appealed to the United States Supreme Court. Using a carefully prepared brief and presentation, Webster won the case, along with a reputation "as the most brilliant lawyer of his time."

During the decade of the 1820s, in the midst of a busy law practice, Webster managed to keep in the public eye. There was always the vision of his becoming President one day, a haunting vision which never left him. His powerful orations, among them the oration on the two-hundredth anniversary of the landing of the Pilgrims, and his Bunker Hill Monument oration, again put him in the public press. He was chosen as a Presidential candidate in the election of 1824, but did not receive the nomination. John Adams won the election, with Webster's backing.

In June 1827 Webster was again elected to the U.S. Senate, but the death of his wife so depressed him that he completely lost interest in his work. A year later, however, he was back in the political fray, this time leading the fight in favor of the Tariff Act for the protection of New England products. Passage of the act again thrust him into public prominence.

The following months were gloomy ones for Webster. President John Adams was defeated by General Andrew Jackson of Tennessee for the presidency, and, in his own family, Ezekiel, his favorite brother, died. But after a time, the shock of his brother's death wore off. Life gained new meaning for Webster with his marriage to Caroline Le Roy, a New York socialite. Politically, there followed, successively, his battle against John C. Calhoun's Doctrine of Nullification; and his famous series of debates with Robert Y. Hayne, "Calhoun's Mouthpiece," which were hailed as the greatest of American orations, and which headed off the impending Civil War for another thirty years. Webster's "Liberty and Union, now and forever, one and inseparable" was the ringing phrase that attacked the theory that the states were sovereign under the Constitution. The greatest constitutional lawyer of his time, Daniel Webster foresaw the Civil War and did all that he could to prevent it.

Although Webster was a wizard in public finance, he was more than careless with his own personal financial affairs and was heavily in debt to the Bank of the United States, "a profitable client." President Jackson's "war" on the bank and his veto of the bank's rechartering, which Webster strongly advocated, led to Webster's censure by the Senate on a charge of conflict of interests.

Defeated in the election of 1836, Webster seriously considered retiring from politics. He had invested large sums of borrowed money in land holdings in Ohio, Indiana, Illinois, Michigan, and Wisconsin. Unable to realize a return on his unfortunate investments, he retired to Marshfield, New Hampshire, "his seaside home near the sea." But he was bedeviled by his creditors—financial embarrassments which dogged him to the end. Had it not been for his wealthy friends, who saved him from actual disgrace, Webster would have lost everything. His Massachusetts friends returned him to a special session of Congress following the panic of 1837. There, Webster led the inspired Whig fight against Martin Van Buren's subtreasury plan; he battled with John C. Calhoun on the extension of slavery into the Western Territories; and he helped settle the boundary dispute between Maine and Canada.

The election of 1840 gave William Henry Harrison the Presidency. He appointed Webster as his Secretary of State, but died a month after taking office. His successor, John Tyler, a Southern Whig, retained Harrison's Cabinet, but a split in the party brought the resignations of all but Webster, "who deplored the violence and injustice" of the Southern leaders.

In the war with Mexico, Webster opposed the acquisition of Texas and the proposed extension of slavery in that territory, at the same time condemning the war as a "war of aggrandizement," and the South's "peculiar institution of slavery" as "a great moral and political evil."

The deaths of his son, Major Edward Webster, in Mexico with the army, and of his daughter Julia depressed him so greatly that his friends began to wonder whether, at the age of sixty-six, he was the man he once was. The years were moving on, and no one knew that fact better than he.

With the death of President Zachary Taylor, Webster was appointed Secretary of State in President Millard Fillmore's Cabinet, handling

"the more than ordinary diplomatic difficulties" concerning Spain, Mexico, and Great Britain with more than ordinary skill.

With his position, which demanded of him and his wife more than the usual social obligations, Webster indulged himself in the "lavish hospitalities, and good drink" afforded by Washington society; but the inroads of his "annual hayfever" and his large, pressing financial problems made him wish "he had been born a miser." These and other problems wore him down, and he was overcome by an attack of cirrhosis of the liver, from which he never recovered. He died on October 24, 1852.

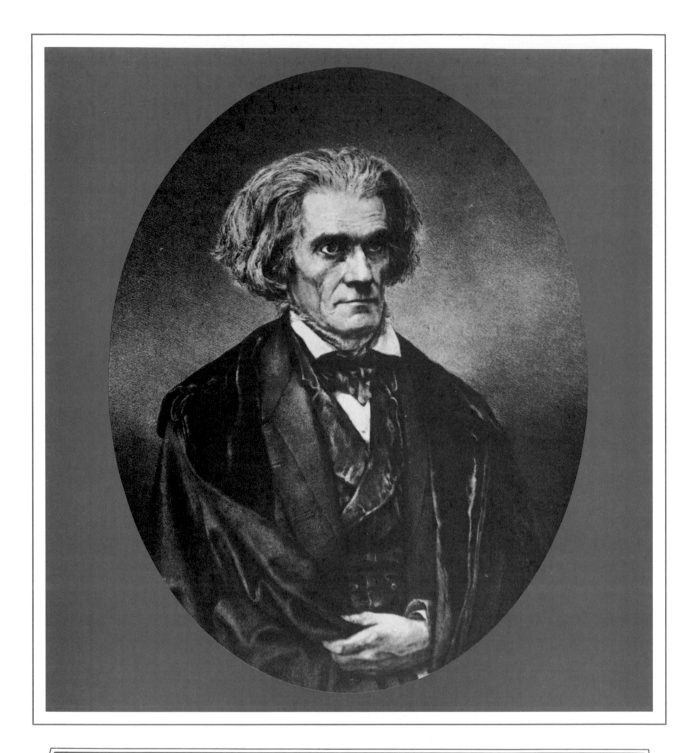

"The most elegant speaker that sits in the House," John Calhoun of South Carolina was daguerreotyped by Brady in the winter of 1850—the year of Calhoun's death. Brady first published this picture in his "Gallery of Illustrious Americans" the following year.

From a daguerrotype by Mathew Brady. Author's collection.

John Caldwell Calhoun— a lively "ghost of the republic"

Justice Oliver Wendell Holmes, one of our greatest jurists, each year selected a deserving Harvard Law School student as a temporary secretary. To be successful, he told each of them, mere legal knowledge wasn't enough; a lawyer had to have "fire in your belly, sonny. Fire in your belly!"

John Caldwell Calhoun, the senator from South Carolina, probably fitted Holmes's description of a man with fire in his belly better than any other man in public office of his era, except perhaps Stephen Arnold Douglas, the Senate's "steam engine in britches." The sound of Calhoun's voice, and his advocacy, lingered on long after great age removed him from the political scene. A product of South Carolina, "oldest, proudest, the most aristocratic" of the cotton states, John Caldwell Calhoun was a political philosopher dedicated to the Federal Constitution insofar as it supported states' rights.

The next youngest son of Patrick Calhoun and Martha Caldwell, his second wife, John Caldwell Calhoun was born on March 18, 1782,

in the "Calhoun Settlement" of the South Carolina uplands bordering the Savannah River.

His ancestors, of Scotch-Irish descent, had migrated to Pennsylvania in 1733 but were driven southward by Indian raids and by the defeat and massacre of General James Braddock and his army in the Pennsylvania woods. His grandmother, Catherine Calhoun, was massacred by a Cherokee war party on the Virginia frontier in 1760. Her youngest son, Patrick, John Calhoun's father, "marked her burial place with a slab."

Catherine's and James's four sons, Patrick among them, built substantial homes, supported the American cause against Great Britain during the Revolution, and became distinguished citizens. Patrick Calhoun's family prospered, "owned a score or two of slaves," and lived the life of Southern planters. Patrick, for many years a member of the South Carolina legislature, and "a pronounced individualist," opposed the ratification of the Federal Constitution. Some of his father's political indi-

vidualism seemed to have rubbed off on young John.

In 1796, when John was fourteen, he became a pupil of his brother-in-law, Moses Waddel, master of an academy in Columbus County, Georgia; but the sudden death of Mrs. Waddel closed the academy, and young John returned home. With the death of his father that same year, John carried the burden of running the plantation for the next four years; but in 1800 his elder brother, a prosperous Charleston merchant, prevailed on him to move to Charleston and prepare for a profession.

John entered the junior class of Yale College, graduated in 1804, and studied law at Tapping Reeve's law school at Litchfield, Connecticut. He completed his legal studies in the law office of Henry W. De Saussure in Charleston. He passed his bar examination in 1807, and opened his own law office in Abbeville, near his family home.

Although his practice was profitable, he found the law "uncongenial" and decided to abandon it as soon as the opportunity presented itself. The opportunity arrived sooner than he expected. Floride Bouneau Calhoun, the wife of his father's cousin, John Ewing Calhoun, had inherited a plantation from her Huguenot family. After her husband's death in 1802, Floride, in the custom of the grandees of the rice coast, began to spend her summers in Newport and her winters in Charleston. Her visit to Charleston was fortuitous for young John.

Having given up his law practice, John, at twenty, became Floride's protégé and a privileged member of her household. His political career began with an inflammatory speech at Abbeville. In the speech, he denounced British impressment of American seamen, and got himself elected to the South Carolina legislature, where he helped to revise the state representational system. With his own family prestige and the influence of the Bouneaus, young John was elected to Congress in 1810, at the age of twenty-eight. The following year he married Floride's daughter, who was named after her mother.

His eighteen-year-old bride brought him a modest fortune, but young John objected to the "lowland custom" of marriage settlements, and his wife's money and holdings were placed under his control. His marriage was a happy one, their family numbering nine children.

His wife's property and his own personal financial resources made Calhoun an independently wealthy man, and in 1825 he extended his land holdings by building a large plantation homestead in his "native locality" which he named "Fort Hill," the region once having been fortified during the Indian uprisings.

Calhoun's appearance on the national political scene began in the Twelfth Congress, which had its "War Hawks," young legislators who were pressing for a shooting war with Great Britain. Henry Clay, Speaker of the House, gave young Calhoun his head, and John became acting chairman for foreign affairs, working for almost a year toward creating a majority in the House willing to vote favorably for a declaration of war.

On June 3, 1812, Calhoun got his chance when President James Monroe presented a report which recommended a declaration of war. Monroe, unwilling to be classed as a "War Hawk," permitted the report to be read to the Congress by Calhoun, who delivered it in "ringing tones." Monroe's authorship was kept secret, and Calhoun received credit for its contents and became famous. War was declared, but the vote was by no means unanimous. For the two years of the conflict, "the young Hercules carried the war on his shoulders," raising troops and funds, speeding the service of supply, regulating war commerce. The early military and naval disasters only spurred him on to greater effort to effect a complete victory over Great Britain, bringing him in direct conflict with Daniel Webster and William Randolph, the "doves" and "obstructionists," whom he fought to a standstill on the House floor.

As a supporter of the Monroe administration, Calhoun gave his reluctant consent to the Treaty of Ghent, which brought the war to a close; but he regarded it as "inconclusive," believing it a fragile peace at best.

The war did not teach the Jeffersonian pacifists a lesson in preparedness, even though British troops got close enough to the White House to burn it down; but Calhoun fervently promoted American military and naval preparedness. He addressed Congress on January 31, 1816, calling for a navy second to none, and

a standing army big enough to cope with any emergency. In that same session, Calhoun proposed a national bank, internal improvements, and a protective tariff, deploring the differences in "sectional spirit" that were undermining the nation, his own "preference" being "that erectness of mind which in all cases is disposed to embrace what is itself just and wise."

Described as "the most elegant speaker that sits in the House," Calhoun promoted nationalism, Republicanism, and national unity between the Northern and Southern sections of the country, "insofar as it connoted allegiance to states rights." And he made his beliefs known in the House, "his gestures . . . easy and graceful, his manner forcible, and language elegant; above all [he] confines himself closely to the subject, which he always understands, and enlightens everyone within hearing. . . ."

Near the close of his third term in Congress, Calhoun accepted the appointment as Secretary of War in President Monroe's Cabinet, serving with distinction for seven and a half years.

The demise of the Federalist Party and the re-election of James Monroe were the signals for the free-for-all race between the nationalists and radicals, who began to choose up sides, and Henry Clay, John Quincy Adams, William Lowndes (also of South Carolina), and Calhoun, who now became rivals in the race for nationalist leadership.

Andrew Jackson "campaigned as a civilian" for the candidates interested in popular power rather than in details of policy; and at the early death of Lowndes, Calhoun became the favorite son candidate of South Carolina. The Pennsylvania delegation had promised Calhoun its support, but ended by endorsing Jackson for President. Clay's antipathy toward Jackson manifested itself in the House; although Jackson showed a plurality in the electoral college, Clay's influence gave John Quincy Adams the Presidency in the House of Representatives' vote, and Calhoun, with the second highest vote, became Vice-President.

Adams appointed Clay Secretary of State and "brought on a mighty grudge" which spurred William Randolph to "new epithets" and caused Calhoun to warn that Clay's appointment "created a most dangerous precedent which the people would reprove at the new election." As Vice-President presiding over the Senate, Calhoun handled himself well. He let William Randolph rave and rail against President Adams, "and only interrupted Randolph when another senator requested a 'point of order.'"

Calhoun himself came in for some vilification when a newspaperman carelessly charged that he, while Secretary of War, "had participated in the profits" of a fortification contract. Calhoun, at his angry best, demanded that the House investigate the charge "as a grand inquest of the nation." He walked out of the Senate—and stayed out until the investigating committee cleared him categorically and apologized. With his eye on the White House, Calhoun had no intention of allowing anyone to trifle with his personal integrity.

But a larger problem faced Calhoun's Presidential ambitions, and that was the personal battle between Andrew Jackson and John Quincy Adams, which narrowed Calhoun's Presidential chances. Calhoun made a shrewd political guess, joined Jackson's camp, and, in 1828, was elected for a second term as Vice-President under a new President. This victory presumed the possibility of succeeding Jackson after a single term.

In the long run, Calhoun was not destined for the Presidency. Events of the next four years clouded Calhoun's career and changed the nation's course of history. Among these unhappy events were the exclusion of his wife from Washington society, and the irreparable breach in his relations with Andrew Jackson.

Calhoun now found it "a great defect of our system when the separate geographical interests are not sufficiently guarded," and threatened "to make two of one nation." The first signs of conflict came with the South's early battle with Northern industrial interests, and Calhoun's famous "South Carolina Exposition," which "embodied the doctrine of nullification." In a confidential letter to Governor Paul Hamilton of South Carolina, in "a superb piece of rigorous reasoning," Calhoun wrote: "The purpose of any constitution is at once to empower and to restrain the government; and if the general government should exceed its powers against the will of the people of a state,

it is within their legitimate power, by means of convention, though not by act of legislature, to declare the congressional act null and void, and to require the state government to prohibit enforcement within the limits of the state. It is the constitution that annuls an unconstitutional act. Such an act is itself void and of no effect. Any court may proclaim such nullity, but the people of a state retain a similar power which no federal agency may override."

South Carolina, in a special session of the state convention, adopted the ordinance and nullified the tariff acts of 1828 and 1832, effective the first day of February 1833.

Calhoun resigned the Vice-Presidency and returned to the Senate the following year, when President Jackson sent a message to Congress requesting authority to use military power if necessary "to enforce federal laws." The result was the "Force Bill," which brought Calhoun into a fiery debate with the formidable Daniel Webster. The upshot of these political maneuverings was the founding of the Whig Party to oppose the Democratic Party, a coalition which brought Calhoun's own political career to a close.

Although the slavery question was dividing the nation, the actual war clouds would not gather for another thirty years, but the groundwork to fratricidal war was already being laid. In view of the serious political differences between the North and the South—and this in 1832—Calhoun suggested that "to oppose the concentration of despotic force . . . and to secure the domestic tranquility of the South, and to perpetuate the Union . . . an amendment to the constitution be made . . . to replace the single President with a dual executive . . . each of the two Chief Magistrates to be chosen by one of the great sections of the country, and the assent of both to be requisite for the validation of acts of Congress."

By 1838, Calhoun was advocating separation of the Union, taking an aggressive stand for Southern rights. The years that followed saw a gathering of sectional forces and political clashes, punctuated by the Mexican War and the annexation of Texas, which gave the United States a vast Western and Southwestern territory of empire proportions.

Calhoun now resorted to his pen and wrote a series of documents that embodied his philosophy of constitutional government, in which he stated that "society is essential to mankind, and government is necessary to preserve and perfect society by curbing individual selfishness. But government itself must be held in check by constitution in order that public agents may be prevented from abusing their powers, whether by self-aggrandizement or by promoting majority interests through spoliation of minorities."

Some time in the early months of 1850, John Caldwell Calhoun was in New York City, and it was the request of his granddaughter, who wanted his picture for her locket, that brought him and his daughter, Mrs. Florence Clemson, to Mathew Brady's gallery on Broadway.

The day was stormy and none too favorable for picture-taking. According to Brady, "Calhoun seemed conscious of this fact, continually remarking about the bad weather and its effect on the outcome of this picture." The sole light source was the skylight of the gallery, but Brady "put Calhoun at his ease" by explaining that the apparently poor lighting conditions "could be easily overcome by a longer exposure in the camera."

After Calhoun had taken his seat before the camera, Brady, focusing Calhoun's image on the ground glass, was struck by his apparent great age. "His hair, which in his younger days had been dark, and had stood frowningly over his broad, square forehead, was now long and thin and combed back, falling behind his ears. His most outstanding feature," Brady recalled, "was his eye which startled and almost hypnotized me!"

Owing to the murky atmosphere and poor light, the first exposure took a full minute, without result. To the elderly statesman, this appeared a long time to be seated in front of a camera.

Brady made another plate, and this time the exposure took ten seconds. During the "intervals of posing," Brady noted that Calhoun's daughter "delicately arranged her father's hair and the folds of his coat, and expressed surprise at the length of time the first plate had taken."

"How is it that your first picture consumed so much more time than your second?" she asked her father. And while the third plate was being prepared, Calhoun "proceeded to give an

amazing explanation of the Daguerreotype process that both fascinated and astonished the technicians in the gallery."

A third picture was made, and after "expressing extreme pleasure" at Brady's announcement of success, he called "his daughter's attention to some of the pictures that looked down from the walls of the gallery."

Calhoun was almost eighty at this time, and before he left Washington, his last formal speech was read to the Senate by Senator Mason, while the elder statesman sat with head bowed. The date was March 4, 1850. Before the end of the month, John Caldwell Calhoun would be dead. A few days before his death, Calhoun praised Daniel Webster's conciliation speech, but he said he thought it was "difficult to see how two people, so different and hostile, can exist together in one common Union."

In a last letter he wrote: "Kiss the children for me, their grandfather." His last spoken words were, "The South, the poor South!"

The *Metropolitan Record* of New York City referred to him as the last of "the ghosts of the Republic," along with "Jefferson, Jackson, Clay and Hamilton."

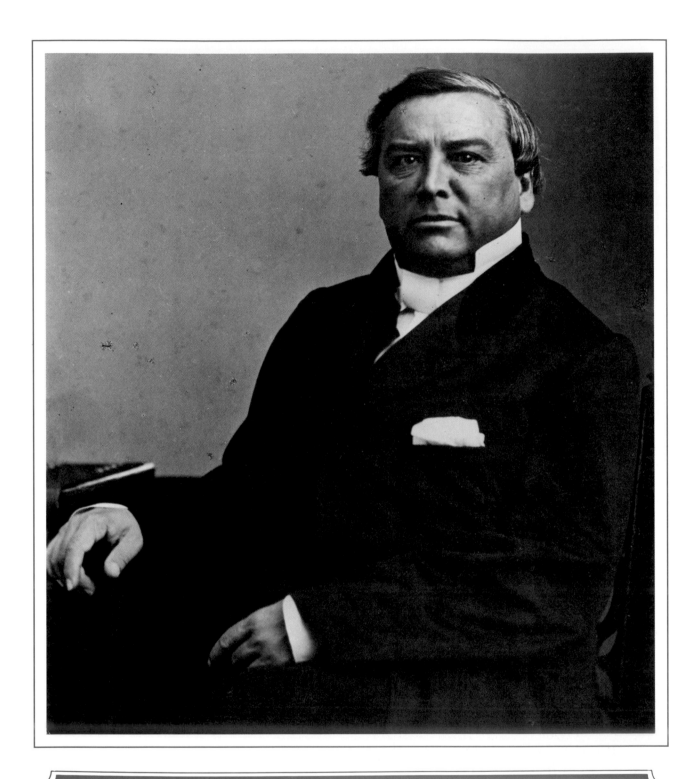

Sometime dynamic attorney, and a man of many and diversified talents, Bishop Francis Lister Hawkes was the rector of New York's Episcopal Church of the Mediator, a cleric who possessed "remarkable gifts."

From a photograph by Mathew Brady. Author's collection.

Bishop Hawkes— more like an itinerant preacher

By 1847, New York City, Washington Irving's "old town of the Knickerbocker's," as it had been known to the early Dutch settlers, had become a metropolis.

Almost overnight, amid rampant commercialism, runaway crime, and massive overcrowding, New York's citizens tripped the light fantastic down the garden path, hand-in-hand with the cultists, mesmerists, phrenologists, spiritualists, and other "oracles" of the lunacy fringe.

Among these purveyors of the mystic, whose exotic machinations kept things lively in New York's melting pot, were "The Poughkeepsie Seer," "The Cobbler's Apprentice," and Andrew Jackson Davis, "The Harmonial," whose drab, woolly predilections enabled New Yorkers of that era to pull aside the transparent curtain on uninhibited eroticism.

And for those New Yorkers who weren't gullible enough to hold clammy hands with the spiritualists who sought the timeless dimension of departed relatives who had "gone beyond"; or to have their doubtful futures read according to the bumps on their heads; or to be "mesmerized" into a trance to think things over, there was always the "water cure" to fall back on.

And if all that wasn't enough for New Yorkers who really wanted to "be turned on," there was "Passional Hygiene," a fascinating bit of eroticism conceived by Charles Fourier, an imaginative Frenchman who worked as a clerk for a New York business firm.

Fourier had really gotten down to fundamentals. His concepts of "attractional harmony" and "passional hygiene" had apparently captured the imagination of the heads of his firm, for they financed his school for "Fourierists," where he gave regular lessons to old and new members of the cult.

While many New Yorkers were undergoing these forms of psychological castration, into their midst came Francis Lister Hawkes, the new rector of the Episcopal Church of the Mediator, and probably one of the most versatile American churchmen of the nineteenth century. Bishop Hawkes had a job on his hands.

Lawyer, college professor, magazine editor, historian, and author of numerous children's books, Bishop Hawkes's greatest contribution to American letters was his editorial work on the official papers of Major General Alexander Hamilton.

Francis Lister Hawkes began his amazing career in 1815, when he graduated with honors from the University of North Carolina. Upon graduating, he began an intensive study of the law with a prominent attorney, William Gaston, who prepared him for his bar examinations.

Three years later, he moved to Litchfield, Connecticut, where he entered the famous law school of Tapping Reeve and James Gould. Upon passing his bar examinations, first in his class, he returned to North Carolina in 1820, and became a court reporter for the North Carolina Supreme Court.

A most eloquent man, Bishop Hawkes as a lawyer proved himself a trial attorney to be reckoned with in court. His arguments, which were based upon well-prepared briefs, and the force, logic, wit, and charm of his summations made him a powerful adversary before a jury or an appellate court.

A man of great ability, his conversational charm made him widely popular, and in 1821 he was asked to represent the borough of New Bern in the North Carolina House of Commons.

Although his legal career showed great early promise, as an intellectual he apparently saw greater fulfillment as a churchman. Being a devoted member of the Episcopal Church, it was only natural that he decided to enter the ministry.

For the next six years he studied theology with the Reverend William M. Green, bishop of Mississippi, and in 1827, Hawkes was ordained a deacon and priest in the Episcopal Church.

His early life in the ministry seems to have been one of frequent change, for after completing his theological studies he became assistant deacon of Trinity Church in New Haven, Connecticut, also acting as assistant deacon in the parish of St. James in Philadelphia.

The 1830s seem to have been his most active years. He became rector of St. Stephen's Church, and a short while afterward he moved to St. Thomas', where he was rector until 1843. As assistant secretary-general of the general convention, and later secretary of the New York Diocesan Convention, he spent a good deal of his time editing the *New York Review*, in which he criticized severely the policies of Thomas Jefferson and Aaron Burr.

During this period, Bishop Hawkes established a church school, St. Thomas Hall, in Flushing, Long Island; but this venture resulted in heavy financial loss, and personal criticism compelled him to resign. However, he retained his post as professor of ecclesiastical history at the General Theological Seminary.

Upon his resignation, he moved to Mississippi, where he was one of the original trustees of the University of Mississippi. As a natural consequence, he was elected bishop, but he declined the office in favor of becoming the rector of Christ's Church in New Orleans.

Also in 1844, he was elected first president of the University of Louisiana, where he guided the destiny of the college until 1846, when he volunteered to become a professor of history at the University of North Carolina. However, the chair had not yet been established, and nothing came of it.

Throughout his entire career, Bishop Hawkes was apparently motivated by restlessness, moving from one clerical post to another, and from one college to another—for three years later, he resigned both his clerical charge and the university presidency to return to New York as rector of the Church of the Mediator.

With the outbreak of the Civil War in 1861, his strong Southern sympathies became paramount, and again he was compelled to resign. He spent the war years as bishop of Christ's Church in Baltimore.

At the end of the war in 1865, Bishop Hawkes returned to New York City, where he founded the Parishes of Our Saviour and Iglesia de Santiago, preaching and conducting services in Spanish.

A remarkably gifted man, Francis Lister Hawkes was noted as a churchman for his forcefulness and sincerity, and his sermons were widely popular.

But despite his felicity, he was known for his "quick temper" and inclination towards "unrestrained and angry speech," which perhaps accounts for his seeming restlessness, and which probably had more than a little to do with his frequent changes of clerical posts.

At one period in his life, at the General Convention of the Episcopal Church, he was elected to write the colonial history of the Church. The great mass of manuscript material he brought back from England was partly utilized in his *Ecclesiastical History of the United States.*

During the course of his colorful career, he declined elections to two church posts in Rhode Island and the Southwest, wrote poetry, edited Appleton's *Cyclopedia of Biography,* authored books on the *Monuments of Egypt* and *Peruvian Antiquities,* and wrote the narrative of *Commodore Perry's Naval Expedition to the China Seas and Japan.*

As an historian, he supervised the reorganization of the New York Historical Society, and was one of its most active members. He devoted his last years to writing. His literary work was sound, and—in view of the material then available—remarkably accurate.

The second son of Francis and Julia Stephens Hawkes, Francis Lister Hawkes was born at New Bern, North Carolina on June 10, 1798. In 1823, he married Emily Kirby of New Haven, Connecticut, by whom he had two children. His first marriage ended abruptly with the death of his wife in 1827.

Two years later, he married Olivia Trowbridge Hunt of Danbury, Connecticut, who gave him six children, and who survived him. On September 27, 1867, Bishop Francis Lister Hawkes died in his Danbury home, leaving a fragmentary, confused record of his activities which cover over a half century.

As a footnote, it is the opinion of this writer that the photograph of Bishop Hawkes accompanying this chapter, which was taken by Mathew B. Brady, the New York society photographer, is a "wet plate" copy of an original daguerreotype which was made in 1854, when the wet plate process superseded the daguerrean process in Brady's New York gallery.

Brady opened his gallery in 1844, on the corner of Broadway and Fulton streets, and the daguerreotype process was the only photographic process known at the time that actually produced a faithful picture.

A copper plate of high polish was sensitized by placing it in a fuming cabinet, where fumes from iodized salts, heated by a spirit lamp, coated the face of the plate. The plate was then exposed in the camera for as much as a minute, and then removed, developed, and "fixed."

The fine-quality image, fixed on the mirror-like surface of the copper, was then placed in a fancy frame. No other duplicates were possible, unless photographed in the camera each time.

Brady adopted the wet plate process. He coated a glass plate with silver nitrate solution, and exposed it in the camera while wet. Then it was processed as film is processed today. The wet plate then became a negative from which any number of prints could be made on sensitized paper.

In the middle 1840s, Brady began to make a series of the prominent people of that era, to preserve their images in daguerreotype before they died, as a historical record.

He hired the best engraver known at the time, the Frenchman, D'Avignon, and the result was an enormous book entitled, *Brady's Gallery of Illustrious Americans,* which contained fifty beautiful copies of original daguerreotypes "taken from life." Only one hundred copies of this book were published.

To preserve these early daguerreotypes for all time, Brady had them copied in wet plate in 1854. Therefore, judging from the age of Bishop Hawkes, this photograph is, in all probability, a wet plate copy made in that year.

Born into a distinguished Southern family of French descent, Senator Lucius Quintus Cincinnatus Lamar of Mississippi served in the Confederate Army. Yet he believed in the Union and after the war worked diligently to repair the breach between North and South.

From a photograph by Mathew Brady. Author's collection.

Lucius Quintus Cincinnatus Lamar— Justice of the United States Supreme Court

Twenty years following the close of the Civil War, in 1885, Grover Cleveland, "the invented President," appointed a new Secretary of the Interior, the former senator from Mississippi, who answered to the high-sounding name of Lucius Quintus Cincinnatus Lamar.

Senator Lamar accepted the Cabinet post with "misgivings," not the least of them being the simple fact that, with the election of President Lincoln in 1860, he had resigned his seat in the United States Senate to go home and write the state of Mississippi's Ordinance of Secession.

As a member of the very stormy Charleston Democratic Convention of that year, unprecedented in its sectional hates and internal party disputes, Lucius Quintus Cincinnatus Lamar had strongly opposed the withdrawal of the Southern delegates from the convention, but had been overruled; and though he believed in the Union, he qualified his conviction, firm in the belief that the "rights and liberties" of the slave-holding states could only be perpetuated by the dissolution of the Union.

Now, two decades after the close of "that sad strange war," his appointment to the Cabinet post raised a few eyebrows in Government circles, since it obviously was one of President Cleveland's election pay-offs, designed to mollify former secessionist Democrats "who had seen little public office" throughout the postwar years.

Probably in the belief that he owed his friend, Jefferson Davis, an explanation for his acceptance of the post, Lamar wrote the former President of the Confederacy, saying that his "aim was to impress the country with a desire of the South to serve the interests of the common country."

Just how this letter assuaged the bitter feelings of the Confederacy's deposed Chief Executive is unknown, but it was no secret that Davis largely felt contempt for his former critics in the Federal government.

With the fall of Richmond, Davis had attempted to flee to parts unknown, unwilling to face a trial for treason; but he was picked up by an alert Federal cavalry patrol at Irwinville,

Georgia on May 10, 1865, and arrested. Parenthetically, when Lee surrendered, Lincoln was asked how he intended to treat the Confederacy's political leaders. If they managed to elude arrest, "let 'em go" was his comment.

But the Northern radicals in Congress had other ideas, and Davis was imprisoned at Fortress Monroe for two years, "in irons" for part of the time.

Davis was never brought to trial, and upon his release, he retired to "Beauvoir," his home on the Gulf Coast, with his wife, Varina. The home was bequeathed to him by his wife's friend, Mrs. Sarah A. Dorsey. Davis remained a bitter, disappointed man, reduced to "a mere mass of throbbing nerves"—to the end, an "unreconstructed" rebel.

Sectional feelings notwithstanding, Lamar's administration of his office's affairs so impressed President Cleveland that he nominated Lamar to the Supreme Court on December 6, 1887, to fill the seat vacated by the death of Justice Woods.

On the grounds of his advancing age (Lamar was sixty-two) and other contentious political considerations, including factious and sectional opposition, Lamar's appointment to the High Court was confirmed on January 16, 1888.

Apparently, Lamar's term on the bench was little more than routine. According to Chief Justice Melville W. Fuller, Lamar "rendered few decisions," but was "invaluable in consultation." Justice Fuller further declared that "his was the most suggestive mind that I ever knew, and not one of us but has drawn from its inexhaustible store."

Indeed, Lucius Quintus Cincinnatus Lamar represented "the best of the Old and New South"—and he had the family ancestry and name to support it.

An "eccentric" uncle, John Lamar, a man with a sense of antique humor, "a thrifty farmer who gave his children a sound common-school education," was responsible for Lucius Lamar's unusual name.

Lucius Quintus Cincinnatus Lamar, the fourth of eight children, was born in Putnam County, Georgia on September 17, 1825. He was named after his father, a distinguished lawyer who also served as a judge of the Ocmulgee circuit court. His mother, Sarah Williamson, carried the also distinguished names of Bird, Clarke, and Campbell on her family roster.

The Lamars, of French Huguenot ancestry, "according to southern tradition," had first settled in Maryland in 1663, later emigrating to Georgia in 1755.

The Lamars were a colorful, if not gregarious, family. Mirabeau Buonaparte Lamar was Lucius' uncle (his father's brother), and first cousin to Gazzaway Bugg Lamar, first president of the Bank of America. Mirabeau was the second president of the Republic of Texas, having been elected to that office in 1836 as the result of a strange campaign in which two of the opposing candidates committed suicide.

And when the United States Government rejected Texas' petition for statehood, the sagacious Mirabeau, displaying all the proper political instincts, made immediate plans to "create a great independent republic," found a national bank, and institute a comprehensive school system. An excellent horseman, witty orator, and writer, when the spirit of the Muse moved him he wrote Verse Memorials "after the spirit of Byron," and published them in a book of the same title.

Young Lucius received his elementary education in the "common-schools" of Baldwin and Newton counties, and in 1841 he entered Emory College at Oxford, Georgia. Following his graduation in 1845, he read law in Macon, under the tutorage of Judge Absalom Chappell, a distant kinsman.

Two years later, he was admitted to the bar in Vienna, Dooly County, and entered into a law partnership with Judge Chappell. For indeterminate reasons, the association terminated that same year.

Most Southern families of that era traditionally tried to marry well, and Lamar's marriage to Virginia Longstreet on July 15, 1847 was no exception. Their wedding united two illustrious Georgia families.

His father-in-law, Augustus Baldwin Longstreet, a college president and newspaper publisher, was the widely read author of "Georgia Scenes." These humorous literary pieces dealing with life in Georgia, as he knew it, were published in his town newspaper, the *Augusta State Rights Sentinel*. Interestingly enough, these amusing little stories were the forerunners of the later "Uncle Remus," "Ten-

nessee's Partner," and "Huckleberry Finn" stories.

Earlier that year, his father-in-law had been appointed to the presidency of the University of Mississippi at Oxford. The young couple followed not long afterward. At Oxford, Lucius opened his own law office, and joined the faculty of the university as an adjunct professor of mathematics. At the same time, he entered politics.

After a short stay of three years, Lucius Lamar returned to Newton County, Georgia in 1852, and for a year represented the county in the state legislature. Another move in 1854 brought him to Macon. Not finding matters in Macon to his liking, he returned to Oxford and became "permanently identified" with Mississippi by getting himself elected to Congress from the First District, on the Democratic ticket.

Lamar, re-elected to the Thirty-Sixth Congress in 1859, voted during the next two turbulent years with the secessionist Southern Democrats on the vital issues of slavery and states' rights—sectional contentions which, for thirty years, had fanned smoldering, unreasonable political differences that now threatened to burst into a shooting revolution.

With the firing on Fort Sumter, Lamar resigned his Congressional seat, returned home, and recruited the Nineteenth Mississippi Regiment of Infantry. As its lieutenant-colonel, he was involved in the early actions in Virginia until he was compelled by ill health to resign his commission in 1862.

That same year, Jefferson Davis appointed him "special commissioner" to Russia, to work for foreign intervention on the side of the Confederacy; but as foreign involvement needed unqualified military success as inducement, the serious military reverses of the Confederate armies at Vicksburg and Gettysburg in 1863 emphasized the futility of his mission. After several months in London and Paris, his recall came through just as he was about to set out for St. Petersburg.

Returning to Richmond in January 1864, the grimmest winter of the war for the Confederacy, Lamar spent the final year of the conflict trying to assuage the very vociferous critics of the Davis Administration and its conduct of the war. He tried hard to explain away Davis'

political and military mistakes; but apparently he was unable to convince Davis' dissatisfied constituency, who were on the point of starvation.

So from December 1864 to Lee's surrender in April 1865, Lamar put on his uniform and served as judge-advocate to the Third Corps of the Army of Northern Virginia. When the end of the Confederate dream came and his military and political life appeared at an end, Lamar returned to Oxford, Mississippi and re-opened his law office. He also resumed teaching at the University of Mississippi as a full professor, holding classes in law and metaphysics during the first seven years of the Reconstruction and military occupation.

At a time when he thought his political career had run its course, unexpected liberal Republican support elected him to Congress, giving him the first Democratic victory in Mississippi since the start of Congressional reconstruction in that state.

In April 1874, with the death of Charles Sumner, senator from Massachusetts, and a "Boston Brahmin," Lamar's eulogy of the Senate's erstwhile indomitable foe of sedition in all its forms brought him into the national spotlight, and went far toward healing sectional wounds.

As the Reconstruction and military occupation of Mississippi ran its inevitable course under the control of Northern radicals in Congress, conditions in the state reached intolerable proportions.

Lamar, taking the lead in a headlong floor fight that shook the House of Representatives to its foundations, won his battle to rid the Government, and especially his state, of corrupt, radical rule; a victory which made him one of the leading Mississippi political figures of the time. His national patriotism and personal integrity had won him the admiration of Congress and the nation, and when he pleaded for an end to sectional differences and a return to reconciliation, his plea did not fall on deaf ears.

In the critical Hayes-Tilden election of 1876, Lamar cooled hot tempers by supporting the electoral compromise settlement, which made Rutherford Burchard Hayes President.

Re-elected to the Senate in January of that year, Lamar took his seat on March 6, 1877 and

proceeded to represent a "New South"—productive, and free of petty differences; but this wholesome, constructive approach to the solution of post-war economic problems subjected him to the infantile badgering of Roscoe Conkling, the very questionable James G. Blaine, and others of like mentality, who reminded Lamar of his former Confederate affiliations. Most of these verbal assaults on Lamar led to "spirited" floor fights, in which the senatorial obstructionists always came out second best. They were no match for Lamar's education, sharp wit, and background. These floor fights became renowned, and only increased his personal popularity.

In 1878, Lamar took it upon himself to disregard his state's legislature's explicit instructions about the stand he was to take on the free silver movement. The stand he did take, that the free coinage of silver was an unsound policy under existing conditions, "attracted much attention" and "adverse criticism." He also stated unequivocally that he opposed the redemption of Federal bonds payable in silver, since it constituted a complete breach of faith on the part of the Government.

Lamar had a son and three daughters by his first wife, who died on December 30, 1884. Three years later, he married Henrietta Holt of Macon, the widow of William Holt. There were no children from this marriage.

On January 23, 1893, at the age of sixty-eight, Lucius Quintus Cincinnatus Lamar died. His professional and political life combined the attributes of education, intelligence, and leadership, all of which set him apart as the gentleman "permanently identified with Mississippi."

Part II:
The Golden Age

Each year the sun saw Rome move forward toward either pole, a small part of the East excepted, night and day from beginning to end; and all the sky revolved for Rome, and the stars in their courses saw nothing that was not hers.

—Marcus Annaeus Lucanus, A.D. 62

The 1850s, America's "Golden Age," was a decade in which art, literature, religion, and music competed with commercialism and the acquisition of money.

Literature occupied "center stage" in the persons of Nathaniel Hawthorne, Herman Melville, Walt Whitman, Ralph Waldo Emerson, and Henry David Thoreau.

The concert stage, theater, and pulpit provided the divertissement.

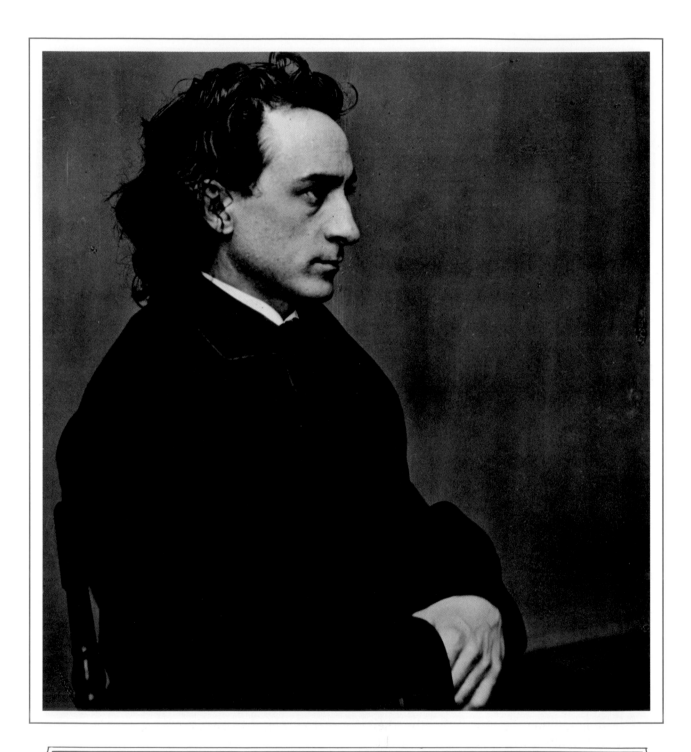

Edwin Booth, the son of the great tragedian, Junius Brutus Booth, who was one of the most celebrated American actors, lived to surpass the theatrical fame of his father. His older brother, John Wilkes Booth, gave the family an infamous name, but Edwin was able to outlive that stigma.

From a photograph by Mathew Brady, circa 1857. Author's collection.

Edwin Booth—
at eighteen a drunkard,
at twenty a libertine

"All those goddamned Booths are crazy!" growled the veteran actor Edwin Forrest when he was informed that John Wilkes Booth had assassinated President Abraham Lincoln. Forrest's expletive, delivered in rage, had been meant more for Junius Brutus Booth, father of both Edwin and John Wilkes Booth, and it struck to the heart of a sensitive matter.

It was well known among the Booth family that the elder Booth was indeed given to "temporary fits of madness" or "spells of singular phase." But the Booth family, their father's mental aberrations understood, looked upon them "with awe and reverence!"

A far different man and actor than was his father or, for that matter, either of his two brothers, Edwin Thomas Booth was born on his father's farm in Bel Air, Maryland, on November 13, 1833. His formal education, if it could be called that, consisted mainly of private tutoring in private schools; but his employable education was gathered in the school of experience.

His father, Junius, was an incurable alcoholic, and his drunken bouts, both in and out of the theater, were notorious. As an adolescent, Edwin accompanied Junius on his theatrical engagements, acting as his valet, but mainly to keep his father away from the bottle.

It was a grave responsibility for so young a man, for it was his job to see to it that his father kept his engagements, didn't commit suicide, and generally to restrain him during his periods of drunkenness and "partial insanity."

Edwin was his father's favorite and cared for him deeply, even though the old man would go into fits of raving, which Edwin learned to ignore.

"Go away, young man, go away!" the old actor would roar in his cups. "By God, sir! I'll

put you aboard a man-of-war, sir!" But the gentle young man had his own way with his father most of the time.

Young Edwin made his stage debut in 1849 at the Boston Museum, playing a small part in Shakespeare's *Richard III*. For the next two years he filled minor roles in plays such as *The Iron Chest* and *Brutus*, written by John Howard Payne.

One night in 1851, at the National Theater in New York, without warning his father forced him to appear in his place as *Richard III*. Edwin played well, but he was sensitive about his smallness of stature, and "awkward and ill-at-ease" in these early stage appearances. In fact, there was nothing in his portrayal of those roles that would indicate he was destined for greatness in the American theater.

In July 1852, Edwin went to California with his father where, under the management of the youngest of the brothers, Junius, Jr., father and son enjoyed a profitable engagement at the Jenny Lind Theatre in San Francisco; but the follow-up engagements in Sacramento would have been rated, in today's parlance, "total flops."

Some months later, Edwin, together with D.W. Waller, another actor, made a tour of the California mining camps. The aging Junius Brutus, unable to stand the rigors of Western life, returned home, but he died during the long voyage.

Edwin stayed on in California, leading the life of a vagabond, moving from one mining camp to another, living in huts, doing his own housework, trying to scratch out a meager living. In later years, he admitted that those days of hardship were the happiest of his life.

Edwin returned East with a well-earned reputation for the roles he had played in the gold-rush country and its principal cities. During this Western trouping, he managed to overcome most of his sensitiveness about his histrionic faults. Back in New York City in 1853, he found himself acknowledged the country's leading tragedian.

In San Francisco, he had been penniless and near starvation, and it had been his brother Junius who had come to his aid by giving him employment as a stagehand and utility man. Occasionally, he made appearances as a star,

playing such roles as Petruchio, Macbeth, Hamlet, Giles Overreach, and Edmund Mortimer.

But it was Mrs. Catherine Forrest Sinclair who gave him a real chance to prove himself, when she opened New York's Metropolitan Theatre and engaged him to play a supporting role to Laura Keene, one of the theater's better actresses, and a star in her own right.

Ten years later, Laura Keene would be a witness to the shooting of Abraham Lincoln in Ford's Theatre in Washington, D.C., a murder committed by the brother of the man who played opposite her. Apparently, Laura Keene didn't think much of Edwin's acting, for she blamed her own failure in the play on "Edwin Booth's bad acting."

In 1854, Booth was offered an engagement to tour Australia with a road company, with Laura Keene as its leading lady. In Sydney, young Booth appeared in the leading role of Shylock. The play was a failure, and the company moved on to Melbourne, where it met with financial disaster.

So, young Booth and D.C. Anderson, an actor of the troupe, returned to America by way of Honolulu, where Booth gave several performances, among them *Richard III*, played before the Hawaiian king, Kamehameha IV. When he got to San Francisco, he was again offered a part by Mrs. Sinclair at her Metropolitan Theatre, playing Benedict to her Beatrice in *Much Ado About Nothing*.

In August 1854, Booth returned to Sacramento, where he appeared at the Sacramento Theatre in juvenile roles in comedies and melodramas with great success. In the fall, he joined up with another road company, under an impresario named Moulton, and again toured the mining camps in and around Nevada City, California. At one point during this tour the troupe was snowed in and almost perished.

This mining camp circuit had its humorous side, however. By some chance, it was noticed that after each of Booth's stage appearances a fire started when the actors had left town. Alarmed, the mining community "rose against the dangerous intruders, who ... ignominiously dispersed and sought safety in the valley." Booth came away from this tour bearing the epithet of the "Fiery Star."

Back again in Sacramento, Booth played a brief engagement at the Forrest Theatre, but was fired in November of that year "because of economic reasons." Again, it was Mrs. Sinclair who came to his aid, saving him from starvation by organizing a stock company and making him its leading man.

Booth and his benefactor produced, for the first time in America, *The Marble Heart, or The Sculptor's Dream*, Booth playing the leading role of Raphael.

Two months later, in February 1855, Mrs. Sinclair's company took over the Forrest Theatre for a two-month run, after which Mrs. Sinclair left the cast to fulfill an engagement in the East. It was the chance Booth needed, for his popularity had now risen to the point where he received a Grand Complimentary Testimonial, for his acting, by members of the California legislature and the citizens of Sacramento.

Booth's final appearance in California was in San Francisco, where he played in a Nahum Tate adaptation of *King Lear*.

After triumphant engagements in Boston, Baltimore, and New York, repeating his successes in the South and West, Booth was established as a man "who reached the very pinnacle of success" in his profession.

On July 7, 1860, amid the rumbling of war clouds in the South, Edwin met and married Mary Devlin, a young actress who had once played Juliet to Charlotte Cushman's Romeo. Booth's wife left the stage after their marriage, and the couple took up residence in Dorchester, Massachusetts.

Julia Ward Howe, the celebrated author of the "Battle Hymn of the Republic" and a friend of the couple, called Mary "this exquisite little woman." But on the Booth family side, Edwin's sister, Asia, upset at her brother's marriage, accused Mary of taking advantage of her brother, that she "had enticed Booth into marrying her when he was drunk."

There is no supporting evidence that this was true, but Booth did "confess" to his young wife that "before he was 18 he was a drunkard, at 20 a libertine . . . allowed to roam at large, and at an early age had lived in a wild and almost barbarous country where boys became old men in vice."

Their life together, nevertheless, was happy; but it was destined to be short-lived. Mary understood her actor husband and was anxious for him to succeed. "If my love is selfish," she wrote, "you will never be great; part of you belongs to the world. I must remember this."

Success now followed on success for Edwin Booth. In September, he played Shylock at the Haymarket Theatre in London, and followed it with other equally important roles, including that of Richelieu. The Civil War was in its third year when Booth returned to the New York Winter Garden, where, on February 20, 1863, his engagement was interrupted by news that his wife, in Dorchester, had been taken seriously ill.

Depressed at being away from his wife for such long periods, he had taken to drinking. Her illness had been worrying him, and it showed in his performances. He had appeared on the stage drunk and depressed, and the performance wasn't missed by the press.

The critic of the New York *Herald* commented: "Seldom have we seen Shakespeare so murdered as at the Winter Garden during the last two weeks. It would have been better to have closed the theater and disappoint the public, than to place Mr. Booth upon the stage when he was really unfit to act."

That night, when the curtain came down, Edwin Booth returned to his dressing room to find a telegram, one of three, on his table. The play had been *Richard III*, and Booth had staggered on and off the stage in a drunken stupor. The manager of the theater had to read to him the telegram from the family physician, Dr. Miller, that Mrs. Booth had only a few more hours to live. Mary Devlin Booth had fallen victim to pneumonia. Booth got himself together and took the train to Boston, but he arrived too late. His wife was dead.

Services were held at the Mount Auburn Cemetery in Cambridge, and Julia Ward Howe recalled: "As Edwin Booth followed the casket, his eyes were heavy with grief. I could not but remember how often I had seen him act the part of Hamlet at the stage burial of Ophelia. Beside or behind him walked a man of remarkable beauty." The man was Edwin's brother, John Wilkes Booth.

After his wife's death, Booth went into retirement. A year later, he returned to New York

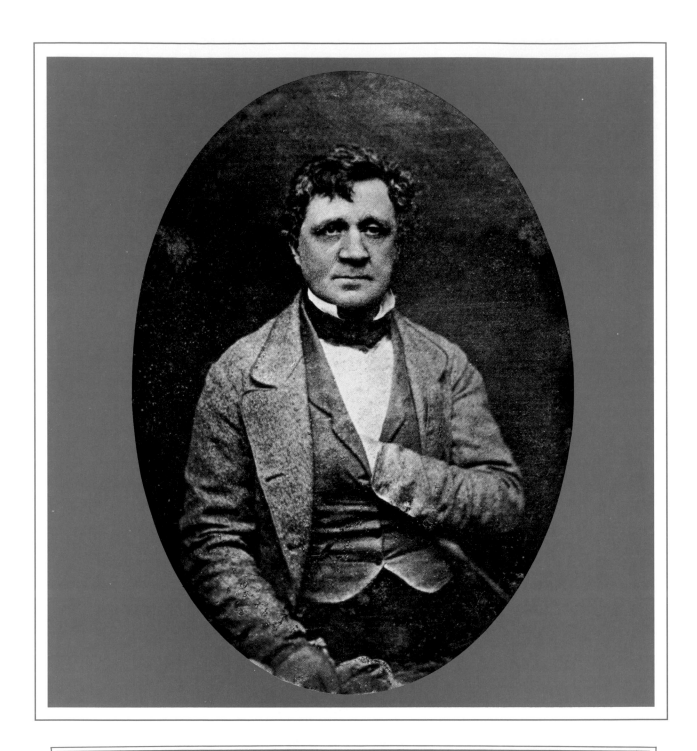

Junius Brutus Booth, father of Edwin and John Wilkes Booth and himself a noted actor.

From a daguerreotype by Brady, about 1850. Author's collection.

as manager of the Winter Garden Theatre, where he again played his now famous role of Hamlet, which enjoyed the remarkable run of "a hundred days," unprecedented in the theater of the time.

A few more months of remarkable success, then tragedy struck again. This time the scars would remain with him for life. During the Civil War, Edwin Booth had remained loyal to the Union, but his brother John Wilkes Booth's disloyalty was well known. It reached its mad climax at Ford's Theatre, in Washington, D.C., on April 14, 1865, when the younger brother fired a bullet into the head of President Lincoln.

When the assassination occurred, Edwin Booth was playing at the Boston Theatre. That night John McCullough, an actor who worked with Booth, burst into Edwin Forrest's room at the Metropolitan Hotel, shouting excitedly that John Wilkes Booth had shot and killed President Lincoln. "But I don't believe it," said McCullough.

"Well, I do," rasped Forrest. "All those goddamned Booths are crazy!"

Edwin Booth, learning of his brother's crime, was shaken to the depths, and he went into retirement knowing his brother's act would forever shadow the family.

Edwin returned to New York's Winter Garden on January 3, 1886. He had received many threats on his life, but his audiences remained loyal. Throughout the remainder of this awful period, Booth produced and staged lavish productions at the Winter Garden, until a disastrous fire, on March 23, 1867, completely destroyed the theater, along with Booth's priceless library and picture collection, his clothes and his costumes.

Undiscouraged by the loss, he started to make plans for a new theater, which was to be the most beautiful in New York and which would bear his name. The Booth Theatre opened on February 3, 1869, and the plays he produced and acted in brought him to the peak of his career, perhaps the most notable in American theatrical history.

The rest of Edwin Booth's life and career is marked by misfortune. On June 7, 1869, he married his leading lady, Mary McVicker, an actress of mediocre ability; but this marriage too was short-lived. Having left the stage after her marriage to Booth, she lapsed into a long period of despondency because of her inactivity. At last, on November 13, 1881, she died, insane at the end.

Although the following years were marked by some success artistically, Booth's financial problems caught up with him at the peak of his popularity. The financial panic of 1873-74 brought about the loss of his theater and put an end to his hopes.

He took up residence at the Players Club in New York, an organization he had founded. On Tuesday, April 17, 1893, in his room on the third floor, he awoke with a headache. A brain hemorrhage ensued and left his right arm paralyzed. On June 7, 1893, Edwin Booth died at the age of 60, his passing "like the passing of a shadow." He was buried in Auburn Cemetery, in Cambridge, alongside his first wife, Mary Devlin. During his funeral, Ford's Theater in Washington, D.C., hundreds of miles away, collapsed and some twenty people died.

Another real life tragedy had occurred, even after the curtain had fallen on the life of this tragedy-prone tragedian.

Concert violinist, musical genius, and political agitator, Ole Borneman Bull of Norway played the world's concert stage and tried to establish a socialist Norwegian colony in Pennsylvania, only to be foiled by American swindlers.

From a photograph by Mathew Brady. Author's collection.

A Norwegian Violinist— and America's golden age

In 1843, during America's era of "manifest destiny," the leading cities of the nation, especially New York, Philadelphia, and Boston, enjoyed a phenomenal growth and expansion, commercially, culturally and—sometimes—spiritually.

New York, most lawless and most expansive of the three cities, was a maelstrom of activity and daily "happenings."

On several occasions during that period, the poet and writer of mystery stories, Edgar Allan Poe, attended "literary evenings" at the home of Miss Anna Lynch, former personal secretary of the eminent statesman Henry Clay, where Poe read his, "The Raven," and other works.

In the top floor "rookery" of New York University, the eminent painter, Samuel Finley Breese Morse, having just returned from Paris and a meeting with Etienne Daguerre, inventor of the daguerreotype, experimented with his magnetic telegraphic instrument and tried to take pictures with his daguerreotype camera.

To newspaperman George William Curtis, New York, "Washington Irving's Town," was in the midst of "the golden age . . . not yesterday or tomorrow, but TODAY."

Although New York was "the commercial metropolis" and a literary and musical center, where the theater held sway, and Castle Garden and the Academy of Music played host to the musical greats of the day, the city was also host to a crime wave of unprecedented proportions, without police protection. Everybody was on his "honor" which, for the most part, was conspicuous by its absence.

On the national scene, President John Tyler and his Secretary of State, Daniel Webster were having a few problems with Great Britain concerning the northeastern boundary between Canada and Oregon.

And Congress loosened its purse strings and appropriated $30,000 (a large sum then) for an experimental telegraph line between Washington and Baltimore.

America and its cities were on the march, and the "Great Migration" of 1843 was heading westward, menaced by, according to Horace Greeley, "snowy precipices, and gnawings of famine;" and to Greeley, this "migration," on the whole "wore an aspect of insanity."

In New York, Walt Whitman, "an expansionist," attended meetings of "The Swedenborgians," and ignored the agitation in the Willamette Valley and the ominous rumblings in Texas. Into the once "bland and simple city" strode the Norwegian violin virtuoso, Ole Borneman Bull, to begin a concert and recital tour that would be repeated five times and make him the idol of the American concert stage.

Born in Bergen, Norway on February 5, 1810, Ole Borneman Bull was the son of an apothecary of some means. Of his boyhood and the rest of his family, little is known in America.

It is known, however, that he took up the study of music against his family's wishes. They wanted him to study for the ministry. Nevertheless, his first music teacher was a Dane named Paulsen, and sometime later Bull received some musical instruction from a pupil of Baillot, and from a Swede named Lundholm who had settled in Bergen; but throughout his musical career, Ole Bull, amazingly enough, was largely self-taught.

At the age of nine, he was precocious enough to play in the orchestra of Bergen's musical society, The Harmonien, which set aside its rules to admit the young virtuoso.

At Osteroy, the family summer home, Ole learned to play Norwegian folk tunes of the region's peasant fiddlers. This music greatly influenced Bull's musical development and his subsequent career.

Because his father disapproved of a musical career, young Ole was sent, upon completion of grammar school, to the University of Christiana to study theology, a course he agreed to take just to please his father. However, his theological studies didn't preclude his interest in music, and he became the director of Christiana's musical and dramatic society.

Had he given his undivided attention to music and theology, matters would have gone well for him in Norway; but during his early collegiate days, he took part in campus agitations for Norwegian independence, being a devout nationalist. He became so involved in the movement that he was compelled to flee the country in 1829 to avoid arrest and imprisonment.

"To satisfy an intense desire to see and hear the great violinist, Spohr," whom he admired greatly both for the master's virtuosity on the violin and for his compositions, Ole Bull made his way to Cassel to meet the master.

But the meeting with Spohr disillusioned him, for the great Spohr treated him with indifference. Disappointed, he crossed the border to Göttingen in the Prussian province of Hannover, where his "boisterous manner" promptly got him involved in a duel, which ended, happily, in his favor.

Returning to Norway, a wiser young man of twenty, Ole Bull spent the next few years playing concerts in Trondhjem, and in his home city of Bergen.

With a gnawing desire to master the violin, in 1831, at the age of twenty-one, Ole Bull went to Paris to study at the Paris Conservatoire. Again, he was faced with disappointment; for although his technical proficiency and facility were more than adequate to gain him admittance to the musical institution, his application was refused.

But despite this crushing blow to his ambition, Paris, to Ole Bull, "was the turning point in his life and musical career"; for it was in Paris that he met the great Italian violin virtuoso, Paganini, whose technical facility was world renowned.

Paganini's playing was an inspiration to young Ole Bull, and it fired him with an ambition to equal, if not better, the violin virtuosity of the Italian master.

"In pursuit of technical studies" to master the musical feats performed with such ease by the Italian virtuoso, Ole Bull practiced for hours on end. The intensity of his musical studies brought on a severe illness, which kept him bedridden for more than a month.

The motherly care of a Parisian lady nursed him back to health, and, following his recovery, he made his debut on the concert stage of Paris, accompanied by none other than the great concert pianist and composer, Frederic Chopin. At another concert, he was accompanied by Ernst.

The success of his recitals in Paris and his marriage to the daughter of the Parisian lady who had nursed him brought him to Italy for

more concerts, "where he created a perfect furore with his music;" and from this time until the end of his career, his concerts and recitals took him all over Europe, with occasional periods of rest at his home in his beloved Norway.

On May 21, 1836, at the age of twenty-six, Ole Bull made his first appearance on the London concert stage as soloist with the Philharmonic Society's Orchestra. He was greatly acclaimed.

During the next sixteen months, Ole Bull played a phenomenal two hundred and seventy-four recitals in England, Scotland, and Ireland. Back in London in 1840, he again played another Philharmonic concert engagement, in which he played Beethoven's "Kreutzer" Sonata. This time, his accompanist was the great concert pianist, Franz Liszt.

His European successes eventually brought him to the United States for the first time in 1843. His tour began in New York's Castle Garden, where he played to enthusiastic audiences.

His American recitals for the next two years earned him a considerable fortune, and in 1845 he returned to Norway a wealthy man and a celebrated artist.

In the United States, the war with Mexico got first billing on center stage while Ole Bull sojourned in Norway for the next five years. During the time he spent at home, he founded the Norwegian National Theater (Den Nationale Scene), appointing the twenty-three-year-old Henrik Ibsen as playwright and stage manager.

When Ibsen left the theater, Ole Bull engaged another youthful playwright, Bjornsterne Bjornson, who later became one of Norway's great literary talents.

A warm-hearted man, "much loved by his fellow artists" because of his intense interest in inspiring a Norwegian cultural renaissance, Ole Bull was the first to recognize and encourage the enormous, original talent of Edvard Grieg.

Returning to America in 1852, Ole Bull began the second of his five concert tours, endearing himself to American audiences as never before. His popularity was greater than ever.

It was during this concert tour that Bull, first and foremost a Norwegian "with a passionate interest in the welfare of his own people," conceived the idea of founding a colony for poverty-stricken Norwegians in America. It was to be founded on the French socialist principle and named "Oleana."

As big-hearted as he was trusting, Ole Bull purchased one hundred twenty-five thousand acres of land in north-central Pennsylvania "for distribution among . . . indigent Norwegians."

And it was here that he ran head-on into the American swindler of the era—the type that sold the Brooklyn Bridge to gullible and trusting foreigners.

The property did not have a clear title; in reality, the land belonged to a third party. And although Ole Bull "was not without native shrewdness," he was no match for the swindlers. The unfortunate transaction involved him in a lengthy and troublesome lawsuit, which not only depleted his personal fortune but cost him the land as well.

Without wasting time decrying his losses, Ole Bull set out to regain his fortune by another concert tour, and in this effort he was largely successful.

In 1855, he leased the Academy of Music in New York to encourage young composers to write American music, offering a prize of $1,000 to any youngster, who could write "a grand opera . . . on an American subject." But the prize was never awarded simply because there were no American composers around at the time with the talent and ability to undertake such an ambitious project.

In 1870, at the age of sixty, Ole Bull married an American girl of twenty named Sara Chapman Thorp some time after the death of his first wife. For the next two years, the couple led a happy married life.

In 1879, accompanied by Emma Thursby, he played his last American concert tour, completing forty years of brilliant showmanship and musical artistry.

As an artist, Ole Bull was undoubtedly a musical genius who liked to say that he "was largely self-taught."

His technical facility on the violin rivaled Paganini's, and was distinguished by his use of an instrument with an almost flat bridge. With this violin he produced effects in "double-stops" (two note chords in harmony in rapid succession) and "staccato harmonics," some-

Joe Coburn, New York prize fighter. He fought the leading men of the ring from 1856 to 1872, but Jem Mace refused to meet him.

Author's collection.

times playing passages with four-part harmonies.

Ole Bull was a large man, tall and broad-shouldered. He had enormous hands, and the "bow of his violin was of unusual length and weight . . . such as no man of smaller stature and strength could effectively or comfortably handle."

His recitals rarely included "serious music." He restricted his program selections to his own compositions "and extemporaneous renderings," with an occasional choice of selections by the great Paganini, his idol.

His accuracy of technique, showmanship, personal charm, and numerous renderings of the native music of Norway endeared him to music lovers the world over.

His compositions include two violin concertos, many sets of variations, "Pieces d'Occasion," "The Niagara," "Solitude of the Prairies," and "To the Memory of Washington"—all inspired by his American tours.

Today his music is rarely, if at all, performed. Many of his compositions died with him, never having been committed to paper.

Ole Bull breathed his last at Lyso, his country home near Bergen, Norway, on August 17, 1880, at the age of seventy, shortly after his return from his last American tour. His passing was mourned in Norway as a national loss.

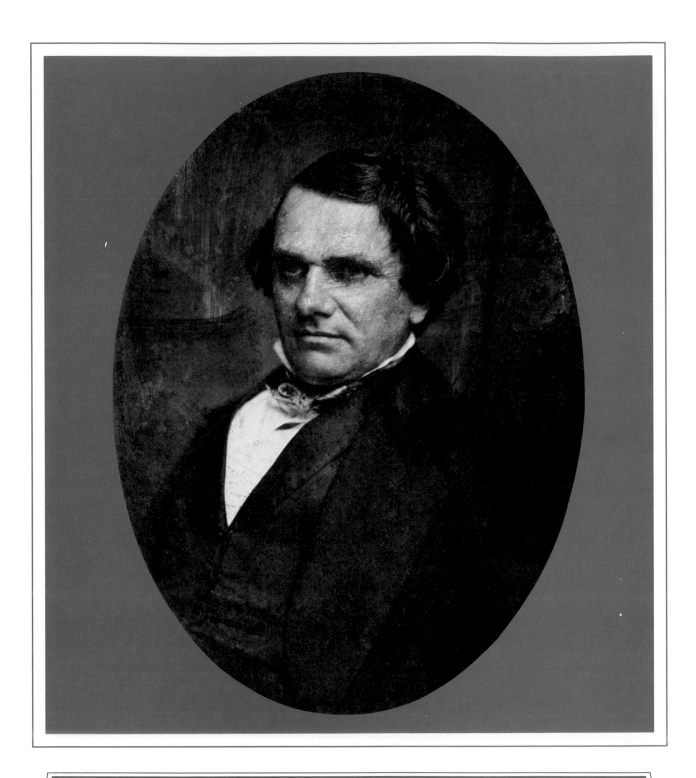

Named the "steam engine in britches" because of his enormous energy, Stephen Arnold Douglas, Democratic Senator from Illinois, a supporter of the Union, found it difficult to reconcile his views on slavery with the views of the Southern Democrats.

From a daguerreotype by Mathew Brady, circa 1850. Author's collection.

Stephen Arnold Douglas— the "steam engine in britches"

In 1856, he was called "the steam engine in britches" and "the little giant," and his personality, energy, and physical height fitted both descriptions.

Star performer of the greatest magnitude in the Democratic galaxy, Stephen Arnold Douglas was a master of practical politics by the time he reached the age of thirty and a brilliant United States senator from Illinois at thirty-six.

A one-time cabinet-maker's apprentice from Vermont, Douglas entered politics and became the voice of the Mississippi Valley and the spokesman for the Andrew Jackson-style Democratic Party, with an army of followers in Missouri, Ohio, Kentucky, Iowa, and his home state of Illinois.

As chairman of the Senate Committee on Territories, he had come face-to-face with the greatest question of the hour: the extension of Negro slavery into the Western and Midwestern territories, a vital question which carried ominous overtones in the election of 1860. To Stephen Douglas, the slavery issue was a very troublesome, practical problem which had to yield to an equally practical solution. He maintained the position taken in his ill-fated Kansas-Nebraska Bill until the fiery signs of war over the issue manifested themselves on the political horizon; indeed, until the first gunshots of the Civil War were heard.

Though of small stature, he was an attractive man who fascinated youthful Americans. Young himself, he was generous, impulsive, and audacious; unafraid to state his opinions, he was ready to stand or fall on them.

His qualities of personal charm and magnetism had brought his name up for the Presidency as early as 1852; but the old fogies and mossbacks of the Democratic Party were too blatant and vociferous, and stilled the murmuring voices of "Young America." Douglas was sidetracked before he could get a foothold on the nomination.

President Abraham Lincoln. Portrait by Brady made in 1863. Author's collection.

In addition to the loss of the nomination, the death of his wife temporarily dulled the brilliance of the senator from Illinois. Sadly, he took to excessive drinking, grew slovenly and careless, and was even more turbulent in debate. His series of debates on the slavery question with the formidable Abraham Lincoln, which for the most part ended in a draw, created headlines across the country.

The fight over his Kansas-Nebraska Bill, and his marriage to the beautiful Adele Cutts, a Washington belle, restored him to his former dynamic self. The second Mrs. Douglas came from a distinguished Maryland family; her father was a nephew of the famous Dolly Madison; and her mother was one of the Maryland O'Neales, and a sister of the spy for the Confederacy, Rose O'Neale Greenhow. Adele's charm opened many doors for Senator Douglas which previously had been closed to him. Her devoted interest in her husband encouraged him to greatness.

Even with all these things in his favor, however, Douglas was again sidetracked for the Democratic Presidential nomination of 1856. With his fortune from lucky real estate ventures behind him, he threw himself wholeheartedly into the fight to preserve the Union. The United States had few more noble and disinterested citizens in those fateful years than he.

While politicians and Government officials intrigued and talked, and men of action stood helpless, Stephen Douglas strove desperately to keep the Democratic Party intact—the sole individual who, if seen in terms of the integrity of his effort, might have kept the Union from dissolution. But all of his efforts were to no avail.

The Douglas magnetism attracted generous, idealistic youth, as well as his beautiful, charming wife. It also drew such dwellers of the shadows as the ruffianly George Law, who supported him in 1852; and the more than slippery mayor of New York City, the Honorable Fernando Wood, whose political machinations included the secession of New York City from New York State, as well as from the Federal Union.

Practical politics spawned strange bedfellows more than a century ago. History has a strange way, indeed, of repeating itself.

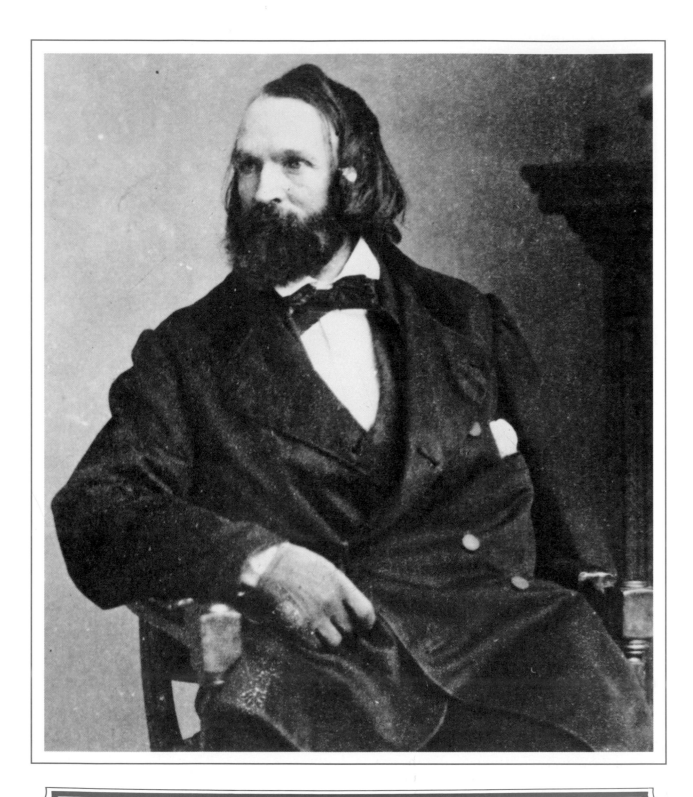

All facets of Long Island's unique rustic life of the nineteenth century became subjects for "America's Barnyard Artist," William Sidney Mount.

From a photograph by Mathew Brady. Author's collection.

Long Island's Past as the "Barnyard Artist" saw it

"Originality is not confined to one place or country, which is very consoling to us Yankees, by God!" So spoke William Sidney Mount, "father of Genre painting," which, in the pretentious jargon of art critics, simply means scenes painted from everyday life.

When Mount stepped into his own rustic barnyard with his easel and paints and began to immortalize on canvas rural life as he lived it, he exemplified the artist as described by Washington Irving, one of America's immortal writers. "An artist is an artist," he said, "only by dint of his exquisite sense of beauty; a sense affording him rapturous enjoyment. . . ."

Mount fitted Irving's definition, but the writer might have added, "with a sense of humor," which Irving himself had in abundance.

Mount indeed had a sense of humor, and never failed to use it when the occasion demanded. One art critic of the period wrote that Mount's paintings " . . . banished sentimentality."

Almost a century later, in the 1930s, another art critic moribundly mourned the fact that ". . . none of Mount's characters is unhappy or sickly or underfed," and went on to bewail that Mount's paintings misrepresented American life as it really was—that they "presented a too idyllic view of American life."

This of course implied that unless, for example, a painting depicted a grim scene like the body of Caesar sprawled out on the floor of the Roman Senate, looking as if it had been run over by a road-grader, bleeding from every pore, it wasn't *art*.

Mount was an American artist who painted in the captivating manner of the "Little Dutch Masters," and his subjects were the hardworking, fun-loving people of his own region of Setauket and Stony Brook, Long Island, localities steeped in the history of Colonial America.

Mount's Long Island had early become a farming province in which agriculture was the

mainstay of commerce. Whaling and fishing had their beginnings in the seventeenth century, at East Hampton and South Hampton, today the summering places of New York's "Four Hundred."

Sag Harbor had early become a major whaling port, and it held its leadership for many years; but with the decline of the whaling industry, many fisheries flourished along the western shore, and in Peconic Bay.

William Sidney Mount was born at Setauket, Long Island, on November 26, 1807, one of five children born to Thomas Shepard and Julia Hawkins Mount.

When William reached the age of seven, his father died, and the family moved to Stony Brook, where they took up permanent residence at the Hawkins' homestead belonging to William's mother.

William's early schooling was sketchy. He and his brothers, Henry and Shepard, attended the country school the region afforded. To help support the family, the boys helped run the farm. "To the age of seventeen," he told William Dunlap, the art historian, "I was a hard-working farmer's boy."

Sometime in 1820, the elder Mount, Henry, opened a sign-painting shop in New York City, which prospered; and in 1824, both William and Shepard became sign-painting apprentices in their elder brother's shop.

William and his brothers "were ambitious to qualify" as painters, and apparently all three were self-taught. Artistic talent ran in the family.

While working as a sign-painter, William studied the works of Benjamin West, an American artist who had gone to England to study with Sir Thomas Gainsborough, and whose painting, "Madness of Lear" Mount "had studied attentively."

William "eagerly sought and examined pictures," and in 1826 he entered the National Academy of Design as a student painter. A year of hard work, however, took its toll, and his health, seriously affected by intense study and overwork, compelled him to return home.

He remained at home for two years, regaining his health and roaming the Long Island countryside. During this time, he painted three important canvases, one a self-portrait. The two larger compositions were allegorical pieces based on biblical themes, "Christ Raising the Daughter of Jairus," and "Saul and the Witches of Endor."

The first painting was inspired by the biblical lines of St. Mark, "The Legion of the Devils Cast Out."

And, behold, there cometh one of the rulers of the synagogue, Jairus by name, and when he saw him, he fell at his feet, and besought him greatly, saying my little daughter lieth at the point of death. . . .
And when he come in, he saith unto them, why maketh this ado, and wee? the damsel is not dead, but sleepeth.
And they laughed him to scorn.
And he took the damsel by the hand and saith unto her. . . . Damsel I say unto thee, arise!
And straightway the damsel arose and walked. . . .

The biblical lines from XXVIII Samuel inspired the canvas for "Saul and the Witches of Endor," an unusual theme for a painting, and probably the last allegorical painting to come from his brush.

And Saul disguised himself, and put on other raiment, and he went, and two men with him, and they came to the woman by the night; and he said, I pray thee, devise unto me by the familiar spirit, and bring me him up, whom I shall name unto thee.
And the woman said unto him, behold, thou knowest what Saul has done, how he hath cut off those that have familiar spirits, and the wizards, out of the land; wherefore then thou layest thou a snare for my life to cause me to die.

Recovering from his illness, Mount returned in 1829 to New York City to set himself up as a portrait painter. He opened a studio and began to work.

Legend has it that a wealthy New York art collector named Luman Reed bought Mount's first exhibited work for $1,000.

The story goes that Mount, never having seen that much money in his entire life, told Reed "that he intended to live on that money for the rest of his life at Stony Brook."

A member of the National Academy discredited the story, saying that Mount "was by no means so ridiculous a person as these statements would make him appear to be."

In 1832, at the age of twenty-five, Mount was elected an associate member of the National Academy. His brothers Shepard and Henry also became members, but a year later William was advanced to full membership.

Four years later, in 1833, Mount exhibited his full-length portrait of Bishop Onderdonk, "a painting," wrote William Dunlap, "[which] elicited a universal burst of applause."

New York City grew mightily, and in 1844 two matters of relative importance took place. The Long Island Railroad began regular train service to Greenport, which was later extended to Montauk Point, the farthest point on the island; and a young photographer, Mathew B. Brady, opened his "Brady's Daguerrian Gallery" on the corner of Broadway and Fulton streets, in the center of New York's thriving metropolis.

Almost overnight, Brady's gallery became the "fashionable" meeting place.

It is unlikely, although not impossible, that Mount sat for the Brady portrait accompanying this chapter at that time. The date of this portrait would be nearer the latter part of the 1850s, when printing on platinum-sepia paper became a studio practice.

Mount became a popular artist, both at the academy and with his patrons. Although he painted many portraits, his first love were the subjects of his canvases of his native Long Island, which earned him the sobriquet of "America's Barnyard Artist" and brought him his greatest successes.

Sometime in 1859, Mount returned home to paint the scenes that would later make him famous. Interestingly enough, he constructed a portable studio on wheels, "which greatly interested his fellow artists", probably the forerunner of the kind of portable, traveling studio and darkroom that Brady constructed to take his camera to the Civil War battlefields.

Mount never seemed to aspire to cover the Civil War as a combat artist, as did his colleagues Eastman Johnson, Winslow Homer, and a host of other artists like Alfred and William Waud, who made big reputations as military artists for *Harper's Weekly*. It is possible that his declining health had a lot to do with his not joining the armies.

More than likely, however, Mount preferred to paint familiar scenes of his beloved Long Island countryside rather than depict the doings of soldiers in camp and in battle, which would not have been in character with his personality.

The last years of his life in Setauket and Stony Brook were fairly productive, although his health suddenly began a steady decline. Nevertheless, his rustic characters appeared in "The Fortune Teller," "Raffling the Goose," "The Long Story," "Coming to the Point," "The Truant Gamblers," and "Bargaining for a Horse," paintings now in the New York Historical Society.

Although Mount never attained the distinction he desired as an artist, his portraits and paintings "have a sturdy honesty and constructive solidity which entitle them to respect," to quote a critic of the day.

But there is a bit more to it than that. Mount's paintings have preserved the scenes of Long Island, many of which have all but disappeared, and a life lived in rural America that is also a thing of the past. "It is a delightful locality," Mount once wrote of his native countryside. "No wonder Adam and Eve, having visions of the future, was [sic] glad to get out of the Garden of Eden."

His brothers never attained fame as painters, and their work is almost completely unknown. One of his brothers became a dancing master.

Throughout his life, Mount probably believed that he was following in the footsteps of Teniers, in his paintings of rustic dancers, banjo players, cider-makers, hog-killers, horse-traders, and the like.

Every aspect of rural seaside life was depicted on his canvases, all with the faithful realism "and authentic charm" that seemed to be an American characteristic. Many of these paintings were made before the Civil War, when he painted his best pictures.

During the last few years of his life, William Sidney Mount's health took a turn for the worse, and on November 19, 1868, he died in his home amid the surroundings that had inspired him.

On November 30, 1868, the National Academy of Design, in council, honored him in their minutes, saying that he was "endeared" to all who knew him "by his frank, cheerful and manly character, by the wit and humor that brightened his social hours."

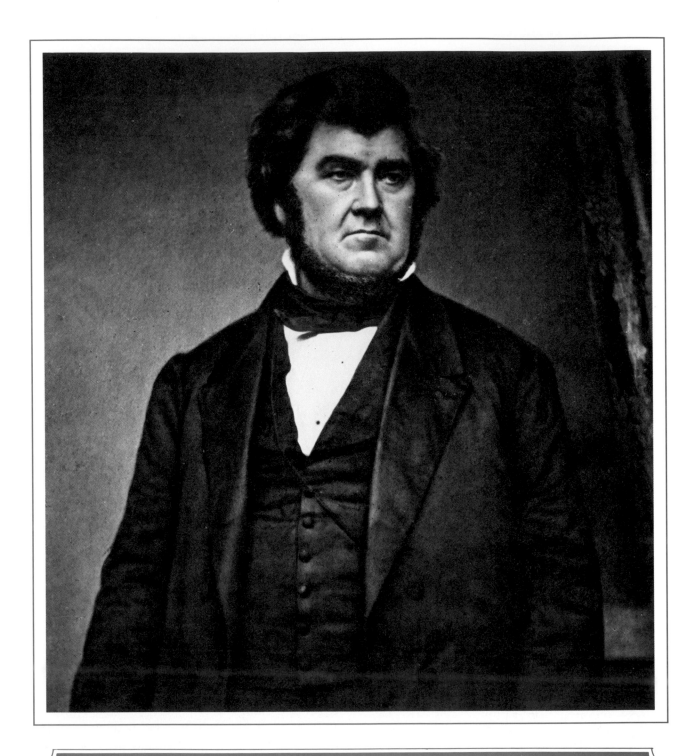

At the age of eighteen, George Law went to work as a hod-carrier on the then-building Erie Canal. His subsequent career as contractor, banker, railroad financier, and steamship executive followed a pattern that would seem fictional anywhere but in nineteenth-century America.

From a photograph by Mathew Brady, 1858. Author's collection.

George Law—
the hod-carrier who became a millionaire

The year was 1824. A young man of eighteen, answering to the name of George Law, took a last look at the home of his birth, his father's dairy farm in Jackson, New York, and set out along the dusty road to try to find work on the Erie Canal, which was then nearing completion.

As a youth, he had few leisure hours, farm work precluding daytime schooling, so he attended winter night school and became an "omnivorous reader."

Since the mania for building canals was part of the pattern of things at that moment in American history, George Law got himself a job as hod-carrier, and later as a stone-cutter, on the Erie Canal. Before long, his talent for engineering manifested itself in jobs on the Dismal Swamp, Morris, Harlem, and Delaware and Hudson canals.

Two years later, with the business acumen and mental outlook of a man twice his age, George Law, at twenty, formed his own con-

tracting company. His first job was to build a small lock and aqueduct. His later construction projects were marvels: an inclined plane for the Lehigh Canal, a rail portage system for hauling canal boats over the mountains; the Croton Water Works; and High Bridge, the largest single-span bridge of its time, over the Harlem River in New York City, his greatest piece of construction and one which is still in use.

By 1830, he had saved $2,800, and five years later he "phased out" his construction business, from which he had amassed a million dollars in railroad and canal construction in eastern Pennsylvania, and went into the business of banking. In 1842, he was elected president of the Dry Dock Bank of New York, which was then tottering on the brink of bankruptcy. Law saved it and made it prosper.

Realizing that the railroad would become the nation's most important means of transportation, Law bought into many of the newly organizing railroads, sensing their potential

with the same canniness and acumen that had served him in calculating to the penny the profit on fill and sand.

In 1848, with the advent of the Gold Rush, Law went into partnership with another canny transportation promoter, Marshall Owen Roberts; the two made an unbeatable pair.

Roberts had been, in turn, a ship's chandler, a trader, and a general promoter who dabbled in railroads and anything else that would make money.

As a stock market trader, Wall Street held Roberts in high esteem, despite the fact that "many cynical observers detected subtle overtones of larceny in his every activity."

Be that as it may, Law and Roberts established the U.S. Steamship Company, purchased four ships, and, in return for a bi-weekly delivery of the mails to New Orleans, Havana, and Chagres, received an annual government subsidy of $290,000.

Unwilling to let matters rest there, Law and Roberts opened a branch line from the Isthmus of Panama, and a pack-team land haul, whereby the mails were placed aboard Pacific mail steamers at Panama City and ultimately delivered to San Francisco.

Fortunately for the partners, they had begun their ambitious enterprise at the start of the Gold Rush. Many thousands of gold-seekers, who refused to haggle about price, became eager to board the very first boat for San Francisco—and the money rolled in.

When the rush to the California gold fields fell away, the stockholders of the line filed suit for a full accounting of the profits that went into Law's and Roberts' capacious pockets.

On top of this crisis, the partners were greeted with more trouble in the person of an even more rapacious collector of money, Cornelius Vanderbilt, who opened a rival steamship line.

As the losses piled up, Law's partner, Roberts, "with consummate impudence," instituted suit against the Federal Government for additional subsidies, on the grounds that the added service to the Isthmus of Panama had not been provided for in the original contract. Forceful lobbying in Washington in the grand style put the claim across, and the partners got more than a million dollars of Federal money.

Eventually, more competition for the steam-

ship business developed when Henry H. Aspinwall opened his Pacific Mail Steamship Company, starting a line from New York to Chagres.

In 1850, Law purchased four ships to compete with Aspinwall's line between Panama and San Francisco; but a year later the rival lines divided their routes, Law taking the Atlantic, and Aspinwall the Pacific.

During the Cuban trouble of 1850, several of Law's ships became involved when a Mr. Smith, the purser of the *Crescent City*, furnished the *New York Herald* with a story that angered Cuba's captain-general, who issued orders that any ship with Smith aboard would not be allowed into Havana's harbor.

Ignoring President Millard Fillmore's warnings to avoid trouble with Cuban authorities, and risking the loss of Government mail contracts, Law sent his ships, with the purser aboard, into Havana Harbor many times; and Law's daring started a Presidential "boom" for him for the coming election.

Strangely enough, Law, a Roman Catholic Irishman, attached himself to the anti-Catholic "know-nothing" party, and received the political support of the Pennsylvania legislature when he supported John C. Fremont against President Fillmore.

Now a millionaire several times over, Law, and his partner Roberts, were eventually forced out of the steamship business by the competitive fury of Cornelius Vanderbilt. Vanderbilt opened a rival line to the West Coast by way of Nicaragua, which cut traveling time by two days and reduced the fares between New York and San Francisco.

When the Government's contract ran out in 1858, Law broke with Roberts and dissolved the partnership, and Law went on to rise high in the counsels of the Mohawk and Hudson, and Harlem River railroads.

After a run of tilting with the shipping companies and meddling in Cuban politics, Law sold out his shipping interests just before the big slump in American shipping of 1858, and invested his money in streetcar lines and ferries.

During his later years, Law's son took over the management of his streetcar lines and the Brooklyn-Staten Island ferries, which Law senior had acquired.

After a long period of illness, George Law, the

hod-carrier who had amassed a fortune, died at his home on Fifth Avenue, New York, at the age of seventy-five.

Such was the career of an Irish immigrant from County Down, Ireland. His wife was the former Miss Adele Anderson of Philadelphia, whom he had married in 1834, near the start of his amazing career. The couple had one son.

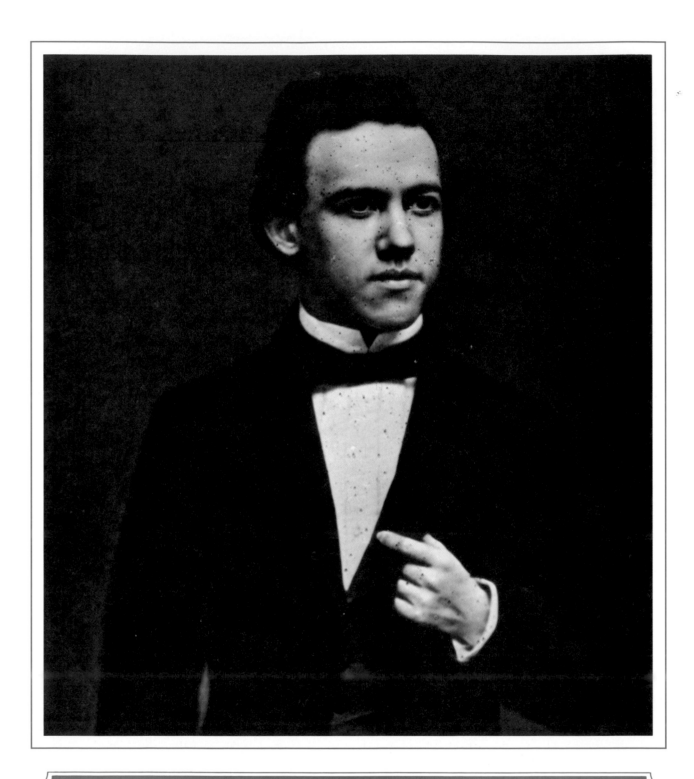

An American chess player who even today is regarded as "the greatest chess genius ever to play the royal game," Paul Morphy of New Orleans was also regarded as a "martyr to his own skill."

From a photograph by Mathew Brady. Author's collection.

Paul Morphy— a most fascinating player

Picturesque New Orleans provides the nineteenth-century background for Paul Morphy, even to this day recognized by many as the world's greatest chess player.

Morphy, of French, Spanish, and Irish lineage, as were many of the Creole City's residents, seems to have lived within the guidelines of Old World traditional mores and codes.

New Orleans, in those antebellum days the heart and focal point at the base of the fertile Mississippi Valley, with its varied population, held a remarkable position in cultural and commercial activity. Cotton and sugar, the principal crops of the Plantation South, were the chief sources of wealth for its 18,000 residents.

Paul Charles Morphy, only son of Alonzo Morphy, a distinguished member of the Louisiana bar and a judge in its High Court, was born in New Orleans on June 22, 1837. His mother, of equally patrician French family ties, had come to the city from Santo Domingo.

His paternal grandfather, Diego Morphy, who probably was of Irish ancestry, and whose father was probably one Michael Murphy, claimed to be "a native of Spain." The father had a "passion" for chess, and New Orleans' gentry let it go at that.

It was Grandfather Morphy who taught his precocious descendant to play "the game of kings" while attending Jefferson Academy. Young Morphy was then ten years old, and by the time he had reached twelve he was regarded as "the strongest player in New Orleans."

Young Paul must have led an exciting life as a schoolboy. New Orleans underwent, during those years, the ravages of the elements and disease.

On a Friday night, May 4, 1849, the Mississippi River, at flood stage brought on by seeming endless heavy rains, tore out a 130-foot gap in the levee at Sauvé's Plantation, nine miles outside the city. The levee caved in, covering the flatlands under six feet of water,

which reached the city three days later, inundating 220 city blocks and 2,200 dwellings and buildings.

The havoc caused by the flood was almost beyond description. There were drownings at street corners and, to save the gas works that provided the fuel that illuminated the city, four-foot levees were erected hastily around the buildings, while a steam engine pumped out the seepage. The Charity Hospital caught fire, and the entire fire department of the city struggled hip-deep in the dirty water to bring the fire under control. The flooding by the "Father of Waters," following closely as it did on the heels of a cholera epidemic that raged in December 1848 and took 3,000 lives, was the worst disaster in the city's history. According to the records of the Louisiana Historical Society: "As the waters finally subsided, a vast, intolerable stench arose and hovered over the city. Dead animals, garbage and other offensive matter floated through the canals and collected around the edges of the inundation." Mark Twain's river was like his weather: "nobody did anything about it."

Just how young Morphy fared in all this period of disaster is not recorded; but the following year, to the month, in May 1850, the thirteen-year-old lad contested and defeated the great Hungarian chess expert J.J. Löwenthal, who was visiting New Orleans, winning one game and playing a second to a dramatic draw.

But, though chess was "his passion" too, young Paul had other interests in mind. Far more important to him was the study and practice of law; his overriding ambition was to become a lawyer and follow in the footsteps of his father.

Soon after his historic games with Löwenthal, Paul entered Spring Hill College in Alabama, four years later graduating with honors.

The profession of law involved him deeply, and he remained at Spring Hill College for a second year, addressing himself to mathematics, at which he was also a master, and studies for his bar examination. It may be added here, that he was fluent in French, German, and Spanish.

Morphy completed his education at the University of Louisiana, graduating with honors;

but he had to wait until August 1857 before he could take his bar examination and go into practice—he just wasn't old enough to practice law!

When the American Chess Congress occurred in New York in 1857, he accepted an invitation to participate in their tournament, "made at the urgent solicitation of the Committee of Management." Also playing at the Congress were some well-known masters: James Thompson, C.H. Stanley, Theodor Lichtenhein, Dr. Raphael of Kentucky, and the soon-to-be famous Louis Paulsen.

Morphy's phenomenal success in these games—he won 14 games, drew 3, and lost only one—brought him recognition as "the foremost American player." Wrote the correspondent for *Frank Leslie's Illustrated Newspaper* on October 31, 1857:

"Mr. Morphy is a most fascinating player for those looking on . . . His attention is not by any means riveted on the game; and he makes his moves with a speed approaching rapidity. Knights are thrown away and bishops left carelessly *en prise;* but the young general has certain victory in his eye; and when his antagonist perchance thinks he can at least win one game . . . Morphy quickly suggests that MATE may be given in five, six or seven moves."

Morphy was then aged twenty, and it was noted that he was "slight of build" and short in stature, with dark eyes and hair, and carried himself as a man of culture in both speech and manner. He was also becoming recognized as one of the greatest chess geniuses in history.

News of his smashing victories in New York reached New Orleans, and upon his return there was "an enthusiastic reception awaiting him."

In June 1858, he sailed for London, his object to challenge the European experts, and to test his mettle against Howard Staunton particularly, one of the foremost writers and players of chess in England and claimant of the world's championship.

Staunton formally refused Morphy's challenge, as did other European players, for reasons best known to themselves. So a tournament was arranged between Morphy and his old friend and former opponent, J.J. Löwenthal, whom he had defeated ten years before.

Löwenthal had defeated Staunton in a recent tournament, and the inference was that, should Morphy defeat Löwenthal again, in effect he would be defeating Staunton.

In this second encounter with the Hungarian master, Morphy won nine games to three, two drawn.

Probably to add to the entertainment value of his game, Morphy had begun to practice playing blindfolded before he embarked on his European tour, and while in England on this same visit Morphy was invited to play at the Chess Congress in Birmingham.

At this tournament, Morphy played eight games—blindfolded—against a battery of first-line players, awesomely winning six games, losing one, and drawing one. He repeated this performance with success in Paris, and later again in a return appearance in England.

In Paris, Morphy found himself facing the best chess players Europe—and the world—had to offer, namely, Daniel Harrwitz, Augustus Mongredien, and Adolf Anderssen, the latter the most astonishing of them all.

Adolph Anderssen had played a celebrated game at Simpson's Divan in London in 1851, against Lionel Kieseritzky which by common consent earned the sobriquet "The Immortal Game"; it remains the "classical example of a classical game." The play helped make Anderssen "the first universally credited world's champion," though it was rather Anderssen's winning the 1851 London Tournament that gave him the reputation of being the world's best player.

Morphy, now twenty-one, decisively defeated all of his opponents, including Anderssen, returning to New York acclaimed as the "recognized champion of the world" and an "unparalelled genius."

Once again, the receptions accorded him in New York were extravagant, and his admirers lavished numerous gifts on the young man who had represented his country as its own renowned chess master. But while his faltering speeches of acceptance and thanks revealed his love for the game he played so brilliantly, they also exposed his ambition to become a distinguished lawyer and thereby emulate his father. This would not only satisfy his own thwarted ambition, but would at the same time placate, and satisfy, his mother's expectations of him.

It was an intense personal mental conflict that would eventually lead to his undoing, both physically and mentally.

It is a matter of record that young Morphy received no financial remuneration from his chess tournaments, and he paid his own traveling and living expenses from money advanced by his family. To his own way of thinking, his personal financial problems seemed to him insurmountable, since his only means of earning a living was in the law, which had so far been denied him.

He received some small compensation from an editorial position he had been given on *Chess Monthly*, a magazine in which he annotated "hundreds of games of chess" for its readers, most of which "were generally adopted." At this same time, he conducted a chess column for the *New York Ledger*. But neither of these positions brought financial relief substantial enough to support him, and a year later he resigned both positions.

Despite his family background and the established position in legal and social circles of his father in New Orleans, it appears to be paradox indeed that no opening in the practice of law could be found for him in his native city. It is stranger still that his own father could find no place for him in his own law office.

The simple fact that his son was a man of international reputation and prominence, let alone that the young man was an honor student in the law, makes it almost incredible that the father could not use his talents. Young Morphy's educational accomplishments, his linguistic abilities, his world-wide reputation as a master of chess, would have been valued as first-rank assets by any law firm today.

At this period in his life, it seemed that all his formidable academic labors and accomplishments were to go for naught; and though it became increasingly clear to Morphy that there was no place for him in New Orleans, for a while longer he continued to strive for a legal career, but without encouragement or success.

The outbreak of the Civil War in 1861 was a personal disaster for Morphy, and he sailed for Havana, Cuba. He stayed there for almost a year, afterward sailing for Paris, scene of his earlier chess triumphs. Although he played a few games in private, for some unknown reason

he had become adamant about not playing in public matches or tournaments.

Upon his return to New Orleans at the close of the war, he became seriously involved in a dispute with the executor of his late father's will and estate, not to mention his quarrels with his personal friend, Charles Amedée Maurian. He played little chess at this time, seeming to have lost interest, though he returned once again to Paris in 1867. But this was no more than a token visit, more to relieve his boredom than anything else, and he played no chess.

A year later he returned home and took up residence with his mother. He was now thirty-eight years of age and, from all indications, had given up all hope of opening a law office in his home city or anywhere else, "there being no place for him!"

In 1885, at the age of forty-five, continuing to refuse all invitations to play chess, he began to suffer noticeably from a sort of mental despondency. That same year he was approached by a publisher who was contemplating a series of biographies of Louisiana's great men. Morphy responded in a letter to the editor of the *New Orleans Bee* in which he pointed out that the editor would do well to consider the achievements of his father and grandfather, rather than his own; that his own modest reputation in chess was trivial when compared to the dazzling accomplishments of his father and grandfather. The letter was, of course, a revelation of his own disappointment, which undoubtedly preyed on his mind.

Just why Paul Morphy held his own amazing talent in such low esteem is a matter of conjecture for psychiatry. The more romantic of the existing records of this amazing man claim that his despondency was caused by an unrequited love affair; that may have been, but whatever the cause Paul Morphy died on July 10, 1884, a brooding recluse of forty-seven years of age. Thus there passed from the scene the man "universally recognized as the greatest chess genius in history." To this day, that reputation has never been surpassed.

WHITE (Morphy)	BLACK (Freeman)	WHITE (Morphy)	BLACK (Freeman)
1 - P-K4	P-K4	20 - P-Kt3	Kt-B3
2 - B-B4	B-B4	21 - P x Q	Kt x Q
3 - P-QKt4	B-Kt3	22 - B x B	Kt x P
4 - Kt-KB3	P-Q3	23 - R-Kt sq. ch	Kt-Kt3
5 - P-Q4	P x P	24 - QR x Kt ch	P x R
6 - Kt x P	Kt-KB3	25 - R x P ch	K-R2
7 - Kt-QB3	Castles	26 - R-Kt7 ch	K-R3
8 - Castles	Kt x P	27 - B-K4	P-KB4
9 - Kt x Kt	P-Q4	28 - B-Q3	P-Kt3
10 - B-KKt5	Q-K sq.	29 - R-Kt3	R-B2
11 - B x P	P-QB3	30 - B-K5	R-K sq.
12 - R-K sq.	Q-Q2	31 - B-B4 ch	K-R2
13 - Kt-B6 ch	P x Kt	32 - R-Kt5	R-K8 ch
14 - QB x P	Q-Q3	33 - K-Kt2	R-KKt2
15 - Kt-K6	B x Kt	34 - B x P ch	K-R sq.
16 - Q-R5	B x P ch	35 - P-KR4	R x R ch
17 - K-R sq.	Q-B5	36 - B x R	R-K sq.
18 - R x B	Kt-Q2	37 - K-B3	Resigns
19 - B-Kt2	B-Q5		

For the reader who wishes to savor Morphy's brilliant style as a blindfold player, here is the score of his game against James Freeman, secretary of the Birmingham Chess Club, one of the six games Morphy won, playing without sight of the board in eight games simultaneously at Birmingham, England, on August 27, 1858.

New York's Mayor Daniel Fawcett Tiemann sat for this picture the year of his election, in Brady's gallery on Broadway at Fulton Street. The mayor who originated the custom of placing street names on street lamps, Tiemann was the only city mayor to own his own city hall.

From a photograph by Mathew Brady. Author's collection.

Daniel Fawcett Tiemann—
the pre-Civil War "Andrew Volstead"

New York City, "the Empire City," in the decades of the 1850s and 1860s was without question the nation's metropolis: a city of sharp contrasts and extremes in most everything.

During that era, New York traffic consisted of horse-drawn, white-topped omnibuses; carriages; carts; beer wagons; and hackney-coaches, which ran up and down Broadway in a never-ceasing rumble. And it was worth one's life to cross New York's main thoroughfare from the "shilling" side to the "dollar" side at any time of day or night.

It was a city of fancy, gas-lighted saloons, elite restaurants, theaters, and stores. It was the city of the millionaire. In fact, New York coined the word that was applied to the Astors, Aspinwalls, Hones, Vanderbilts, and Cookes, those celebrated businessmen and merchants who had made undreamed-of fortunes by using questionable methods that today would be the subject for a Senate sub-committee investigating shady business practices. Nevertheless, they were the chosen few upon whom the ubiquitous "Lady Luck" had smiled and bestowed her favors.

The living pace of New York was fast; an incredible, pulsating tempo found in no other city in the nation. "Change" was the byword, and New York's face, like the stage of a theater, saw a scenery change with every act.

Philip Hone, a former mayor of New York, millionaire, fashion plate, and well-known after-dinner speaker, once remarked on New York's chameleon-like ability to change, particularly Broadway's. At the beginning of the 1850s era, Hone said: "There is scarcely a block in the whole extent of this fine street, of which some part is not in a state of transmutation."

James Fenimore Cooper, the celebrated novelist of life on the American frontier, pointed out to his wife that "the improvements here are wonderful. They build chiefly in brownstone, and noble edifices, of five and six stories, spring up with a good deal of ornamental pretension."

In this pre-Civil War era, New York was living its lotus years. Famous New York restaurants like Delmonico's on South William Street only accepted the wealthy, the socialite, and the famous. Gosling's Restaurant catered

to the less affluent, and enjoyed a thousand hungry patrons a day. The Astor House, on Broadway and Barclay Street, founded by the millionaire John Jacob Astor, was now owned by newspapermen and politicians. For those interested in the bizarre, there was always Barnum's Museum of Oddities, a large building bedecked with flags, owned by Phineas T. Barnum, the great impressario and showman.

During the day, fashionable ladies promenaded up and down Broadway, dressed in the latest Paris creations, most of them headed for Alexander T. Stewart's "marble department store," where paying $1,000 for a Paisley shawl was considered a paltry purchase. Stewart's "take" each day was more than $10,000. It was A. T. Stewart who first financed Mathew B. Brady in his own photographic studio.

New York also had its seamier side. While New York's fancy hotels surpassed anything any other city had to offer and New York's Fifth Avenue mansions were world-renowned, a stone's throw from Broadway lay the most dangerous, most despicable area of the city. The streets carried the filth of weeks; a policeman walking through "Murderer's Alley," "Cow Bay," or "Paradise Square" took a chance on coming out alive. Gangs of the toughest hoodlums, thieves, murderers, prostitutes, and "fences" for stolen property infested the area. The "Dead Rabbit" led the lot, the worst gang New York ever experienced.

The king of the confidence men and politicians and ruler of the "Five Points" district was "Captain" Isaiah Rynders, a political hack and former United States marshal, who owned a saloon on Park Row. Rynders, along with Mark Maguire, John Morrissey, a minor Tammany Hall politician, and Fernando Wood, was probably the greatest political thief and manipulator and "boss" of Tammany Hall.

Into this human maelstrom of activity strode Daniel Fawcett Tiemann, a paint and color manufacturer with a penchant for politics. And if nothing else, Daniel Tiemann had lots of nerve and spunk, even if he lacked judgment.

Born in New York City on January 9, 1805, Daniel was privately educated in the city of his birth. The son of Anthony and Mary (Newell) Tiemann learned fast and well, and at the age of thirteen he took a job after school hours as a clerk in the wholesale drug house of Henry Schieffelin, today a famous drug firm in New York.

He held his position with the drug firm for six years. Then he quit his job and went to work for his father in the paint business. Daniel made a study of the business, "learning every detail of the manufacture of paints and colors." In 1827, at the age of twenty-five, he became a partner in the firm. With his father's retirement in 1848, young Daniel reorganized the firm into D. Tiemann and Company, which, over the years, grew into a very prosperous firm. The firm is still in existence.

Daniel Tiemann's political persuasion was Democratic, and in 1839 he entered the political arena when he was elected to alderman on New York's Board of Aldermen. As a businessman, he was a complete novice when it came to the "art" of local politics. Moreover, he permitted his personal zeal for temperance to overrule his judgment when it came to being aware of the spirituous needs of his fellow men.

In a move that apparently shocked his fellow aldermen, in 1839, Daniel Tiemann gave the order to stop the sale of liquor at New York's City Hall, and went so far as to advocate every known method of suppressing all sales of spirituous liquors. In New York's City Hall, this act was like trying to hold New York's Niagara Falls back with bare hands.

Just how successful Daniel Tiemann was in banning liquor from City Hall was never recorded. He lived to a ripe old age, but prohibition had to wait another eighty-one years before a misguided gentleman named Andrew Volstead successfully implemented the same idea.

This drastic act of prohibiting liquor apparently was popular in some political circles, however, for Daniel Tiemann was re-elected in 1850 to the same office, which he held for the next five years.

With his paint business a success, Daniel Tiemann could afford to continue in politics, and in 1856 he found himself elected mayor of New York City, an office he held for one term. His administration was studded with unusual events, including the legal sale of "New York's City Hall" from under him to satisfy a court judgment.

When the Atlantic Cable was laid, Tiemann was the first to send a congratulatory message to the lord mayor of London, and he originated the custom of "placing the names of streets on street lamps."

But the most startling, to say the least, and

disconcerting thing to embarrass his administration took place in 1858, following the state quarantine of a yellow fever epidemic hospital at Tompkinsville, Staten Island, across New York Harbor. Yellow fever appeared in 1858, and people blamed it on the proximity of the hospital. When ten years of petitions to the New York legislature availed them nothing, the citizens of Tompkinsville decided to burn it down themselves. The night they chose to do it was September 1, 1858, while the metropolitan police force and civic leaders were celebrating the completion of the Atlantic Cable.

Burned down by thirty "men of wealth and social prominence," they were quickly joined by a "1000-man mob," who fell to and completed the job on the main buildings, the small-pox patients, and yellow fever patients. The patients were "dragged out by heroic nurses," who saved them from being burned alive.

The incident embarrassed Tiemann's administration; and there were arrests and trials, but no convictions, since it was difficult to convict a mob.

The most ridiculous aspect of Tiemann's administration followed immediately on the heels of the Staten Island hospital fire.

A month following the fire and quarantine riot, a very affluent gentleman named Robert W. Lowber, a Wall Street broker with an apparently grim sense of humor, decided to add a few more thousands to his already filled pockets. He had made a fortune selling land to New York City at exorbitant prices, sharing his graft with one of the wiliest politicians of them all, Fernando Wood, a member of the city council. The grafter, Wood, and city officials agreed to pay Lowber $196,000 for some land valued at about $60,000.

But things have a way of changing, and before the estimable Mr. Lowber could collect his money, Daniel Tiemann was elected to the office of mayor of New York. Tiemann, not as naive in business as he was in temperance, caught on to the swindle, and refused to pay the money Wood had promised. But Tiemann's reform administration was in for a shock, having underestimated the power of Wood's grafting prowess.

Lowber instituted suit against New York City for the sum, along with damages, interest, and legal fees. All this brought the sum in question to $228,000, which probably included a small fee for wounds to his grafting soul. Lowber won the suit, and instituted collection.

At City Hall, the comptroller blandly informed Mayor Tiemann that the city had "no funds applicable" to meet the "transaction"; and to make matters worse, Lowber, probably with tongue in cheek, called upon the sheriff to collect the money. Embarrassed though he was, the sheriff was compelled by law to carry out the court's decision; he had to seize city property and put it up for auction to satisfy the judgment.

It was said that "bullets of sweat" ran down the face of the very worried Mayor Tiemann when the sheriff announced that "one day in October 1858," he was going to auction off City Hall "and all its contents," including the mayor's chair.

Rumors flew around the city that former councilman Fernando Wood, a very wealthy man, would appear at the auction and bid for the building, buy it, and "then make the grand gesture of allowing city officials to use the building."

Daniel Tiemann was indeed a rich man, but Fernando Wood was far richer. Tiemann placed his bids at the auction through a clerk. Although desperately worried that Wood would bid against him and outbid him, Tiemann went on with the bidding, and New York's City Hall was knocked down to him for $50,000—a nominal amount of money, considering the value of the property the old building rested on. Wood never did appear at the auction. And so Mayor Daniel Tiemann became the only mayor in the nation who purchased his own City Hall at an auction, and held it for a short time. Some time later, the city made good its obligations to the broker and bought back its City Hall from its own mayor, Daniel Tiemann. And there the ridiculous matter ended.

At the end of his term as mayor of New York City, Daniel Tiemann returned to his own business. In 1872, he was elected to the New York State Senate, where he served for many years.

He had married Martha W. Clowes, a niece of Peter Cooper, the eminent industrialist, and in the course of their happy marriage they had ten children.

Daniel Tiemann retired from the management of his paint business at the age of ninety. He died in his beloved New York City on June 29, 1899.

Rare photograph, taken by Mathew B. Brady, shows Mark Twain seated between George Alfred Townsend on his right and Edward (Ned) House, on his left. Townsend was a top war correspondent for the Washington Post; *House, a Boston music and drama critic turned war correspondent, was one of Brady's companions at the Battle of Bull Run in 1861.*

From a photograph by Mathew Brady. Author's collection.

Mark Twain— American journalist and frontier writer

The date was 1861. The place, the stagecoach station at St. Joseph, Missouri. Two young men, Sam Clemens and his older brother, Orion, having paid their individual fares of $150 each, boarded the Overland Stage for Carson City, Nevada.

Each carried a pistol. Stage holdups were a way of life on the frontier. Orion packed a heavy revolver, and Sam carried a tiny Smith and Wesson, "which carried a ball like a homeopathic pill. . . ." To knock down a desperado "would take a whole dose of seven. . . ."

Their trip was necessary. Both boys were out of jobs. The Civil War had closed the Mississippi River to Sam as a river pilot, and Orion had been offered a position as secretary to the territorial governor of Nevada at Carson City. So he brought Sam along as his own personal secretary.

The trip from St. Joseph had been uneventful: the stagecoach moved "along at a fast clip," and the horses were changed every ten miles. Somewhere along the route, a hilarious incident took place, which found its way into *Roughing It*, Sam's book on his western adventures.

A woman got on, who lived fifty miles away, and we had to take turns sitting outside with the driver and conductor. Apparently she was not a talkative woman. She would sit there in the gathering dusk, and fasten her steadfast eyes on a mosquito rooting into her arm, and slowly she would raise her hand until she got the range, and then she would launch a slap at him that would have jolted a cow; and after that she would sit and contemplate the corpse with tranquil satisfaction. She was a dead shot at short range, for she never missed her mosquito. She never removed the carcasses but left them there as bait.

I sat by this grim Sphinx and watched her kill 30 or 40 mosquitos—watched her and waited for her to say something, but she never did. So, I finally opened the conversation myself. I said:

"The mosquitos are pretty bad about here, madam."

"You bet."

"What did I understand you to say, madam?"

"You bet!"

Then, she cheered up, and faced around and said:

"Danged if I didn't think you fellers was deef and dumb. I did, by gosh! Here I've sot, and sot, and sot, a-bustin' mosquitos and wonderin' whut wuz ailin' ye'!"

At the time, Sam Clemens was twenty-six years old. When the Clemens boys reached Carson City, they found their jobs, all right, but discovered to their dismay that their secretarial positions carried neither duties nor salaries. The territorial governor apparently had little to do, himself.

And so for a year, they worked as ardent prospectors without any appreciable evidence of reaching financial independence "and the good life." Then in 1862, Sam Clemens became a reporter for the *Territorial Enterprise*, Virginia City's leading newspaper, and began writing under the pseudonym of "Mark Twain," occasionally taking literary sideswipes at the "sacred cows" of the day. "Mark Twain" was a riverboat term meaning "two fathoms deep," and before three more years would pass, the name would be representative of the best in Western literature. Inadvertently, Sam Clemens had found his career.

The man most responsible for bringing Mark Twain and his writings to the nation's notice was Charles Farrar Browne, a famous humorist of the Civil War era, who wrote under the pen-name of "Artemus Ward." Browne came to Virginia City to gather material in 1863, and there he met Mark Twain. The two writers became close friends and "lived it up" in Virginia City style. Their binges were the talk of a town where binges of legendary proportions were commonplace.

Browne recognized his friend's genius, and encouraged him to try and build a wider audience than existed in the narrow confines of the mining community.

In 1864, an unfortunate incident involved Twain in a duel, making it necessary for him to leave Nevada on rather short notice. He made his way to California and found work as a reporter in Calaveras County, where many of the gold mines were located. There he met Bret Harte, "a conscious man of letters."

The Civil War was at its height; the casualty lists were staggering; and the nation's outlook was one of despair. Mark Twain provided a temporary, if not welcome, diversion from the cares and sadness that came with the end of the war and the death of Abraham Lincoln.

While roaming the mining camps of Calaveras County, in a flash of genius Mark Twain struck his literary bonanza in a short sketch he called "The Celebrated Jumping Frog of Calaveras County." Inspirational in its native humor, perfect in construction, it hilariously told the story of a prospecting character named Jim Smiley, who kept all sorts of pets, including an "educated" bullfrog named "Dan'l Webster." Smiley had a habit of betting on everything, and you could fetch nothing for him to bet on but he'd match you.

He ketched a frog one day, and took him home, and said he cal'lated to educate him; so he never done nothing for three months but set in his back yard and learn that frog to jump.... He'd give him a little punch behind, and the next minute you'd see thet frog whirlin' in the air like a doughnut ... and come down flat-footed and all right, like a cat....

Why, I've seen him set Dan'l Webster down here on this floor ... and sing out, "Flies, Dan'l, flies!" and quicker'n you could wink, he'd spring straight up and snake a fly off'n the counter there, and flop down on the floor ag'in as solid as a gob of mud ... You never see a frog so modest and straightfor'ard as he was, for all he was so gifted.... Smiley was monstrous proud of his frog....

Well, Smiley kep' the beast in a little lattice box, and he used to fetch him down-town sometimes and lay for a bet. One day a feller—a stranger in the camp, he was—come acrost him with his box, and says:

"What might it be that you've got in the box?"

And Smiley says, sorter indifferent-like ... "it's only just a frog."

And the feller took it, and looked at it careful, and turned it round this way and that, and says, "H'm—so 'tis. Well, what's *he* good for?" ...

Smiley says, "Maybe you understand frogs and maybe you don't understand 'em ... Anyways, I've got *my* opinion, and I'll resk forty dollars that he can outjump any frog in Calaveras County."

And the feller studied a minute, and then says, kinder sad-like, "Well, I'm only a stranger here, and I ain't got no frog; but if I had a frog, I'd bet you."

And then Smiley says, "That's all right—that's all right—if you'll hold my box a minute, I'll go and get you a frog!" And so the feller took the box, and put up his forty dollars along with Smiley's, and set down to wait.

So he set there a good while thinking and thinking to himself, and then he got the frog out and prized his mouth open and took a teaspoon and filled him full of quail-shot—filled him pretty near up to his chin—and set him on the floor. Smiley went to the swamp and slopped around in the mud for a long time, and finally he ketched a frog, and fetched him in, and give him to this feller, and says:

"Now, if you're ready, set him alongside of Dan'l, with his fore paws just even with Dan'l's, and I'll give the word." Then he says, "One—two—three—git!" and him and the feller touched up the frogs from behind, and the new frog hopped off lively, but Dan'l give a heave, and hysted up his shoulders—so—like a Frenchman, but it warn't no use—he couldn't budge; he was planted solid as a church, and he couldn't no more stir than if he was anchored out. Smiley was a good deal surprised, and he was disgusted too, but he didn't have no idea what the matter was, of course.

The feller took the money and started away; and when he was going to the door, he sorter jerked his thumb over his shoulder—so—at Dan'l, and says again, very deliberate, "Well," he says, "I don't see no p'ints about thet frog that's any better'n any other frog."

In 1865, Charles Farrar Browne sent the story to New York, where it was published in the *Saturday Press* on November 18. Its success was immediate, and the story was reprinted in newspapers all over the country. The enormous success of the jumping frog story was the real beginning of Mark Twain's writing career. Yet only three weeks before, he had resigned himself to go back to piloting on the Mississippi. He said to his brother that, as he saw matters, he had two choices: being a preacher or a pilot. Being a preacher was out of the question because he "lacked the necessary stock in trade; RELIGION." And so it was either become a writer or a pilot. The success of the jumping frog story settled the matter.

Mark Twain had an almost perfect background of personal experiences, especially as a newspaperman, for the writings that eventually made him famous.

His boyhood on the Mississippi; his personal experiences in the mining regions of Nevada and California; his inborn optimistic nature; and frontier life in general provided the settings and characters. And the casual, humorous approach written in literary style that is found in all his stories is the hallmark of his work. The innate ability to observe and record for further

use at the right time was a talent that few Western writers had in those days.

Mark Twain was born Samuel Langhorne Clemens on November 30, 1835, in the village of Florida, Missouri. He was the son of John Marshall Clemens and Jane Lampton, who boasted a background of English royalty.

His father, of Virginian ancestry, had married Jane in Kentucky. After a short stay in Tennessee, the couple had finally settled in Hannibal, Missouri, a small town on the banks of the Mississippi River. John Marshall Clemens, an impractical dreamer, owned eight thousand acres of Tennessee land and hoped to make his fortune out of it, but the hoped-for rise in land values never took place.

In 1847, the sudden death of John Clemens left the family all but penniless; but thanks to the practicality of Jane, and the land tract in Tennessee, the family was able to manage. Young Sam left school to help support the family, and became apprenticed to a printer. At twelve years of age, his aptitude was astonishing, and in no time at all he mastered the setting and composition of type.

And, in storybook fashion, it was only a question of time before young Sam was writing pieces for the newspaper owned and edited by his brother, Orion. On occasion, he also wrote pieces for other newspapers.

A curious, restless man, Sam Clemens liked "roving commissions," and from 1853 until the outbreak of the Civil War he traveled as a journeyman printer, working in Philadelphia, New York, St. Louis, and Keokuk, Iowa, where his brother, Orion had started another newspaper.

In 1856, his restlessness manifested itself in wild plans for a trip to South America to gather cocoa along the banks of the Amazon River, his expenses to be defrayed by working as a correspondent for a Keokuk weekly. Sam got as far as Cincinnati, and wrote three installments of a little number entitled, "The Adventures of Thomas Jefferson Snodgrass," an epic sample of frontier journalism at its worst.

On his way to New Orleans by Mississippi riverboat, he managed to get himself apprenticed to a river pilot, and it was thus that the "Father of Waters" became the proving ground and school that taught him the meaning of responsibility. Guiding a large riverboat

through the channels of a changeable, treacherous river called for precise knowledge, and he learned his lessons well. He spent four years on the Mississippi, two and a half of them as a top licensed pilot. Eventually, his book, *Life on the Mississippi*, recounted these years.

In all, his experience as a river pilot introduced him to a diverse, ever-changing segment of humanity, a macrocosm of life and times in the United States, when life was simple and values—less "circular" and superficial—had substance.

Life in Hannibal had been everything a boy could have ever wished for, and it is fairly certain that the writer's "cast of characters" was drawn from real life. Chances are that the "judge" was in reality his father and that "Aunt Polly" was his mother. "Sid Sawyer" was his brother Henry, and the Negro, "Jim," was modeled after a slave named Uncle Dan'l. "Huckleberry Finn" was Tom Blankenship, and, to quote the author, "Tom Sawyer" "was a combination of three boys whom I knew," one of them unquestionably being the author himself. Such was the background for his two masterpieces, *Tom Sawyer* and *Huckleberry Finn*.

Mark Twain was totally unlike the average Western journalist. Born prematurely, he was lightly built, small-boned, five feet eight inches in height—in general, small in comparison with the burly characters of the mining regions. His head was almost too small for his body, and "his delicate hands quivered when he was moved." Kipling once said that "his mouth was as delicate as a woman's."

William Dean Howells, the Boston writer, didn't think that Mark Twain represented the typical American Westerner because "he didn't paw anyone, was no back-slapper, or arm squeezer, and he avoided touching people."

As for temperament, Mark Twain was "excitable and easily hurt, desperately hungry for affection, often depressed, capable of great rage, and greater remorse."

1867 was a banner year for Mark Twain. He published his first book, *The Jumping Frog and Other Sketches*, an immediate success. That same year he met Olivia Langdon, whom he "saw . . . for the first time in the form of an ivory miniature . . . in the summer of 1867, when she was in her twenty-second year."

After the success of *The Jumping Frog*, California claimed Mark Twain for her own, and he received a "roving commission" to cover the Sandwich Islands "and write about whatever interested him." He was so proficient at this assignment that his personal reputation skyrocketed, rivaling even the success of Charles Farrar Browne's lectures in Colorado and the Far West.

In 1868, Mark Twain accepted another journalistic assignment for another world tour, this time sponsored by a California newspaper. Following a highly successful lecture at New York's Cooper Union, he sailed aboard the *Quaker City* with a party of excursionists bound for the Mediterranean and the Holy Land. The stories he wrote on that trip provided the groundwork for a book entitled *The Innocents Abroad*, a hilarious, if not irreverent, account of the behavior of American tourists abroad.

Prior to his sailing, he sojourned in San Francisco as a newspaperman. Naturally, he had covered the police courts, saloons, morgue, and theaters, moving within an arena of reporters, chorus girls, actors, bartenders, and other denizens of San Francisco's so-called substratum society. He was a newspaperman, and he came and went as he pleased.

One San Francisco editor, however, who deplored and perhaps was jealous of his successes as well as of his "pub-crawling" with "Artemus Ward," wrote a piece about him which today would undoubtedly bring a million dollars in libel and slander damages.

This editor wrote: "The Bohemian from Sagebrush, who was a jailbird, bail-jumper, deadbeat . . . was rolled in a whorehouse . . . and since he was departing San Francisco, he would never be missed in the City of the Golden Gate."

By 1869, Mark Twain was a national literary figure, and *The Innocents Abroad* made him a fortune. The following year, he married Olivia Langdon, whose picture he had fallen in love with three years before. They had their wedding in 1870, but not before Mark passed muster with his bride's mother, who apparently frowned on his loose ways. By way of explanation he told her that "he was a man of convivial ways," and that he "was not adverse to social drinking," an understatement considering the fantastic benders he and his friend

"Artemus Ward" indulged themselves in while in Virginia City and elsewhere.

Jervis Langdon, the bride's father, presented the couple with a house at 472 Delaware Avenue, in Buffalo, New York, where they lived for two years. His marriage brought an end to his "Bohemian ways" for ever, although it didn't have any effect on his "lone wolf" inclinations. Nevertheless, he adapted himself to the conservative ways of his own family circle and their bourgeois New York society.

In the course of his colorful career, Mark Twain wrote and published twenty-two books, not to mention newspaper stories and articles. In addition, lectures brought him equal fame as a public speaker. He moved his family to Hartford, Connecticut from Buffalo, where he had written articles for the *Buffalo Express*, a newspaper he partly owned.

He had made his fortune, and, while writing constantly, he invested his money in a typesetting machine and engaged in other speculative schemes, all of which failed. He became his own publisher by investing in the Charles Webster Publishing Company, and published General Grant's memoirs. These earned a fortune and made the company prosperous for a time. But the company failed, eventually, and was forced to go into bankruptcy.

In the decade of the "Gay Nineties," this failure began to wear out Twain's optimism. His earlier enthusiasms gradually faded away, and he became bitter and morose. Heavily in debt, he paid off every cent he owed by going on a world lecture tour. While he was away, his daughter Suzy died of typhoid, and he returned from his tour with an unspoken distaste for the human race.

By 1898, he settled all his debts, but his disillusionment with society in general manifested itself in a letter he wrote to William Dean Howells the following year.

"I have been reading the morning paper. I do it every morning—well knowing that I shall find in it the usual depravities and basenesses and hypocrisies and cruelties that make up civilization and cause me to put in the rest of the day pleading for the damnation of the human race."

His beloved wife, Olivia, had sometimes called him "Youth", and in a sense he represented "Youth" in his books for all time to come: in the persons of Becky Thatcher, Tom Sawyer, and Huckleberry Finn. In 1902, he recalled a last visit to his home in Hannibal, on Hill Street, where he had spent his youth. "It all seems so small to me," he remarked. "I suppose if I should come back here in ten years from now it would be the size of a bird house."

And so, Mark Twain, "the most conspicuous man on the planet"; the "rough Bohemian" from Sagebrush, who loved to play three-cushion billiards, "the best game in the world"; the frontiersman turned writer, who wanted nothing more than to please his hearers and amuse his readers, became a very embittered man.

The deaths of his wife Livie in 1904 and his daughter Jean in 1909 caused him untold grief, and he willingly backed out of the limelight. Of all his literary honors, he most cherished his Doctor of Literature degree from Oxford University in 1907.

Mark Twain died at his home, "Stormfield," in Redding, Connecticut, on April 21, 1910 and his death was regretted the world over.

Part III:
This Gloomy War

Of war I sing, war worse than civil, waged over the plains of Emathia, and of legality conferred on crime; I tell how an imperial people turned their right hands against their own vitals. How kindred fought against kindred . . . What madness was this, my countrymen . . . what fierce orgy of slaughter . . .

—Marcus Annaeus Lucanus, A.D. 62

On April 12, 1861, at 3:20 in the morning, a note demanding the surrender of Fort Sumter was handed to Major Robert Anderson, commander of the fort in Charleston Harbor, South Carolina.

Anderson refused, and Brigadier-General P.T.G. Beauregard, commanding the Provisional Forces of the Confederate States of America, gave the signal for the attack. Thirty-six hours later, with fires which were fast reaching the powder magazines raging in the barracks, and his men half-starved, Anderson surrendered. He marched out of the fort with flags flying and drums beating.

This open declaration of war on the Federal military garrison ended four months of waiting, and on April 15 President Abraham Lincoln called upon the loyal states to furnish seventy-five thousand men "to suppress combinations . . . too powerful to be suppressed by the ordinary course of judicial proceedings."

Abraham Lincoln's inauguration portrait, this is one of five pictures of the new president made by Brady in the Washington gallery in March 1861. The pictures were posed by an artist, George Story, who later became curator of the Metropolitan Museum of Art in New York. At the time, Story had a studio in the same building as Brady's gallery, on the floor above.

From a photograph by Mathew Brady. Author's collection.

Abraham Lincoln— president-elect

On Saturday afternoon, February 23, 1861, President-elect Abraham Lincoln walked into Mathew Brady's Washington Gallery to sit for his official inauguration photograph. He was accompanied by his close friend and body-guard, Colonel Ward Hill Lamon, city marshal of Washington, a giant of a man "who was a cavalier with the ladies," and who could drink his weight in whiskey without showing it.

The Presidential party had only arrived that morning from Springfield, Illinois, and had not yet fully recovered from their harrowing trip. It had been one of the strangest, most unpredictable train rides in the history of railroading. Enroute, on February 12, Lincoln had reached his fifty-second birthday. Indeed, he had no illusions about the difficulties he would face when he reached Washington. Intrigue and treason had taken over the nation's capital. On February 4, the Provisional Government of the Confederate States had established its authority at Montgomery, Alabama, with Jefferson Davis, a wild radical from Mississippi, as its President. Seven states had announced separation from the national Government; and in Charleston Harbor, South Carolina, Major Robert Anderson and a small garrison were besieged in Fort Sumter, cut off from all communication and supplies from the main-land, and surrounded by a ring of forts. It would only be a matter of time before Anderson would be forced to capitulate.

The twelve-day train ride had been a round of speeches, receptions, dinners, and parades. Mr. Lincoln had been under constant guard, and the watchful eyes of Colonel Lamon and Col-onel Ephraim Ellsworth, at every city stopover.

Things really began to happen, however, when Mr. Lincoln and his party reached Philadelphia. Allan Pinkerton, Chicago's first official detective, at present on temporary assignment to Mr. Samuel Felton, the president of the Philadelphia, Wilmington and Baltimore Railroad, to investigate secessionist sabotage,

had uncovered a plot in Baltimore to assassinate the President-elect when his train reached the city.

Contacting Norman P. Judd, a member of the Presidential party, Pinkerton was taken to Mr. Lincoln's suite in the St. Louis Hotel and introduced. "We have come to know, Mr. Lincoln, beyond the shadow of a doubt, that there exists a plot to assassinate you. The attempt will be made on your way through Baltimore, day after tomorrow. I am here to help in outwitting the assassins." The man Pinkerton overheard planning the plot was a Baltimore barber named Fernandia. In Washington, William E. Seward had also learned of the plot, and had sent his son Frederick to Philadelphia to warn Mr. Lincoln.

After the speech and flag-raising at Independence Hall, in Philadelphia, the train traveled to Harrisburg for Mr. Lincoln's last appearance in public before going to Washington. At Harrisburg, young Bob Lincoln, entrusted with the satchel containing Mr. Lincoln's inaugural speech, mislaid it, and a frantic, somewhat humorous, search was carried on.

During the search for the satchel, its "secret contents," and what Mr. Lincoln called "his certificate of moral character written by myself," another satchel similar to it was uncovered under a mountain of luggage. Colonel Lamon found that it contained a soiled shirt, a bottle of whiskey, a deck of cards, and some paper collars. "I never saw Mr. Lincoln more angry than upon this occasion," wrote Lamon, "but the liquor was of exceeding quality!"

The last leg of the trip, from Harrisburg to Baltimore, was made at night, the train again traveling in a blackout with cut telegraph lines. At three-thirty in the morning, the train pulled into Baltimore, where one of Pinkerton's operatives boarded the private car to report "that all was right." Mr. Lincoln rested quietly in his berth as the car was hauled over the spur line, moving slowly and quietly through the dark streets of Baltimore to the Pennsylvania Central depot for the final trip to Washington.

Before long, the train sped on to the capital city, running through the Baltimore suburbs without mishap, much to the relief of the apprehensive Pinkerton and Lamon, whose worries for the safety of the President-elect died away with every turn of the wheels.

At six o'clock on the morning of February 23, 1861, the "Presidential Special" rolled slowly into the Washington Union Station as the unfinished Capitol Dome appeared in sight, and came to a hissing, rattling stop.

Pinkerton leading the way, Lincoln and Lamon following, they stepped out of the car unobserved and walked toward the outer door of the depot. The President-elect wore a strange-looking hat pulled down over his eyes, and a cape-like cloak drawn closely about him, a disguise insisted upon by Allan Pinkerton and other members of the party.

Pinkerton then purposely fell behind Lamon and Lincoln as the crowd of men and women rushed toward them. Then Lamon saw a man in the crowd gazing intently at Lincoln, apparently trying to see through the disguise.

Standing to one side, the man looked at Mr. Lincoln sharply as he passed, then he suddenly reached out and seized Mr. Lincoln's hand, shouting, "Abe! You can't play that on me!"

Pinkerton and Lamon, instantly alarmed, were about to strike the stranger when Lincoln stopped them, saying, "Don't strike him! It is Washburne. Don't you know him?" The man was Elihu Washburne, a congressman whom Lincoln knew from Illinois.

William E. Seward, knowing of the danger Mr. Lincoln was in, had passed the information to Washburne, "who knew its value as well as Seward did." But this didn't stop Pinkerton from admonishing Washburne to keep his mouth shut until the party had left the station.

Climbing into a hack, they all drove to Willard's Hotel, where Mr. Lincoln and Pinkerton got out into the street and entered the ladies' entrance of the hotel. Meanwhile, Colonel Lamon drove around to the front, sending word in to the proprietor, who came out to the rear entrance to greet his distinguished guest.

Such was the humiliating arrival of the President-elect, Abraham Lincoln, into Washington City on the morning of the day he sat for his inaugural portrait to the New York and Washington society photographer, Mathew B. Brady. Washington, on that day, was a city seething with treason and danger.

Newspaper accounts of the night ride of the President-elect into Washington were, of course, played up. The Baltimore papers were the most vitriolic.

The *Baltimore Sun* editorialized:

> . . . had we any respect for Mr. Lincoln, official or personal, as a man, or as a President-elect of the United States, his career and speeches on his way to the seat of government might have cruelly been impaired; but the final escapade by which he reached the capital would have utterly demolished it, and overwhelmed us with mortification.
>
> As it is, no sentiment of respect of whatever sort, with regard to the man suffers violence on our part . . . we do not believe the Presidency can ever be more degraded by any of his successors than it was by him. . . .

When Mr. Lincoln had been safely delivered to his hotel, Pinkerton sent the following homemade cypher to his operatives: "Plums delivered nuts safely!" It was probably the most humiliating code message ever sent; it was ludicrous, despite the seriousness of the threat against Mr. Lincoln's life by Southern extremists of the lunacy fringe of that day.

Later developments, however, proved that from the day his train crossed into Maryland, "there was never a moment his life was not in danger, up to the time of his assassination in 1865." Nevertheless, Mr. Lincoln regretted his humiliating arrival into Washington, convinced that he had committed an unpardonable error "listening to the solicitations of a professional spy," and he "upbraided Lamon" for letting him degrade himself "when he should have exhibited the utmost dignity and composure."

And so it was probably with a feeling of mortification and disgust that he arrived at Brady's gallery that same afternoon, although he didn't display any of his emotion by word or expression.

George H. Story, an artist, who in later life became curator emeritus of the Metropolitan Museum of New York, had a studio in the same building on Pennsylvania Avenue, one floor above Brady's gallery. Brady and the artist had become good friends, and Brady had often asked him to assist in posing some of the "great and near-great" who came to the gallery for their "Imperials."

Nervous at the prospect of photographing the most important man in the nation, Brady had asked George Story to assist him in posing the President-elect. Story was delighted at the opportunity. "I was very pleased," he recalled, "at the prospect of meeting Mr. Lincoln, and I hurried down to Brady's."

When Story walked into the studio, Lincoln and Lamon had already arrived. The studio had already been set up, and the shades under the skylights drawn back. Mr. Lincoln had taken his seat at the table with the marble top, waiting to be posed. "His dress," the *Washington Evening Star* reported, "was his plain clothes, black whiskers,—and how well trimmed—a different man entirely from the hard-looking pictorial representations seen of him . . . some of the ladies say he is almost good-looking." The "hard pictorial representations" were the line-cut impressions taken from photographs, which were caricatured to the point of libel.

Mr. Lincoln's depressed mood was not lost on Story, who noticed that "he did not utter a word, and he seemed absolutely indifferent to all that was going on about him; and he gave the impression that he was a man overwhelmed with anxiety, fatigue and care."

While Brady and his photographic assistant, Alexander Gardner, prepared the coating of the glass plates and other details concerning the wet plate process then in vogue, the photographer took Story aside and asked him to pose Mr. Lincoln. The young artist, who had been studying Mr. Lincoln all the while and had caught the mood, recognized at once that a photograph "as he was" would make a great picture.

Surprising both Brady and Gardner, Story exclaimed, "Pose him? . . . No! . . . Bring the camera at once!" The camera was hurriedly placed in position and focused; and while Lincoln pondered, the plate was exposed.

In his later recollection of the incident, Story related: "As soon as I saw the man I trusted him. I had received private information that undoubtedly there would be a war, and I knew that Lincoln was the man to handle the situation. There was a solemnity and dignity, and a general air about him, that bespoke weight of character. Honesty was written in every line of his face. In dress and appearance, he was elegant, his clothes being made of the finest broadcloth. Nor was he awkward despite his height. His hands and feet were small and shapely."

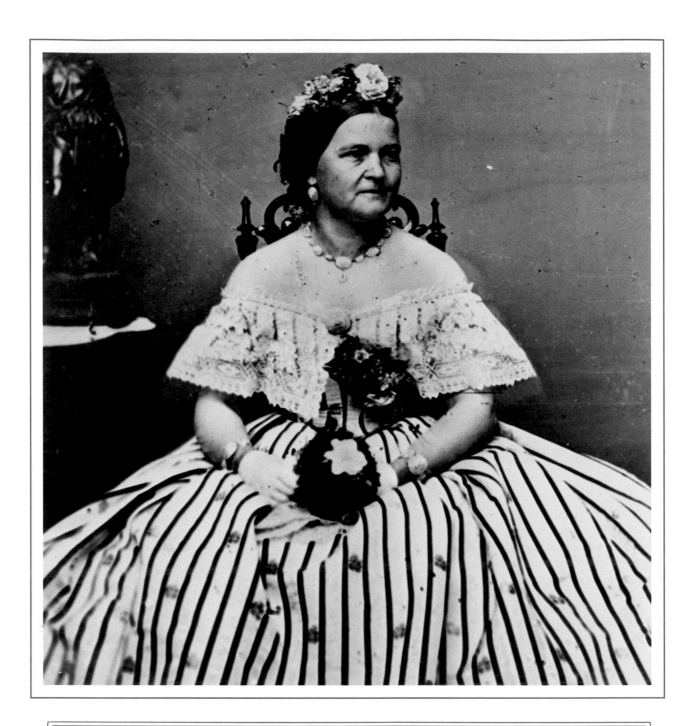

Mary Todd Lincoln, First Lady 1861-1865, is dressed in a Worth Inaugural Ball gown in this Brady photograph made in 1861. Lincoln and his wife were never photographed together.

From a photograph by Mathew Brady. Author's collection.

Unpaved and tree-lined, Washington, D.C.'s Pennsylvania Avenue, the main thoroughfare of the nation's capital, leads to the Capitol. At the outbreak of the war in 1861, the dome of the Capitol was still in an unfinished state.

From a photograph by Mathew Brady. Author's collection.

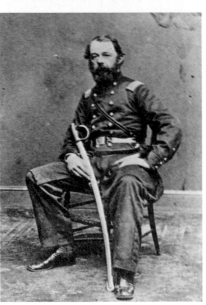

Brady's studio was a stopping-off place for many soldiers who wanted a record of themselves in uniform. Upper left: Col. William B. Hyde, commander of the Ninth New York Cavalry, wore a variation of the regulation uniform, a "Prince Albert"-type tunic, and a blue kepi at a rakish angle. The holster and cartridge-box are attached to the belt of black leather with a brass "U.S." buckle. Upper right: Col. George S. Nichols of the Ninth New York Cavalry was dressed in regulation blue uniform and sword-belt with a tasseled gold sash. Lower row: Col. John B. Swain, commander of the Eleventh New York Cavalry, was photographed in regulation blue, with gold belt and long tunic. The variation on the right, probably of his own design, was a short tunic bordered with caracul collar piping and cuffs. Trousers are regulation sky-blue. Brady used an "immobiliser," a large clamp that held the subject's head steady during the long, one-minute exposure.

Photographs by Mathew Brady. Author's collection.

Bull Run—
they marched wearing almost anything

The Civil War "G.I." had a large and varied wardrobe. Each regiment dictated its own styles until military "regulations" changed it all.

The untrained, youthful Union Army that marched to the Battle of First Manassas (Bull Run) in Virginia in 1861 wore every conceivable type of uniform. In short, their uniforms had everything except uniformity.

The date was July 14, 1861. The place, the Warrenton Turnpike into Virginia. The heat was oppressive; the sky like brass. Over the Warrenton Turnpike marched the Union Army, thirty-five thousand strong of all arms, under the leadership of Major General Irwin McDowell.

Ankle-deep in red dust but full of enthusiasm, the army marched in fairly good order; but before six miles had been covered, the monotonous exertion of marching at "route-step" began to tell in the ranks.

Knapsacks and blankets became grievous burdens to the raw recruits, and were carelessly tossed into thickets or left by the roadside.

Of the states that hurriedly mustered regiments to answer President Lincoln's call for seventy-five thousand volunteers "to put down the rebellion," each had its own conception as to what constituted professional military dress.

The Seventh Regiment of New York Infantry, for example, wore a uniform of "Confederate" grey with red piping, and white, pipeclay belts.

The Seventy-Ninth New York (Highlanders) marched to battle in kilts.

The Eleventh New York came dressed in the uniforms of French Colonial Zouaves with bright red, baggy pantaloons, short blue tunics, and white puttes, topped with a red and blue kepi.

Garibaldi Guards, representing New York's Italian contingents, marched in the uniforms of

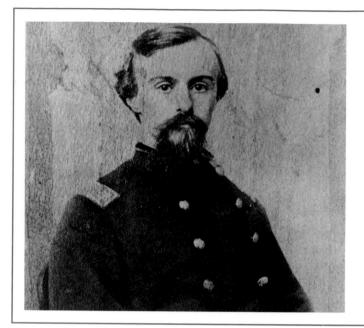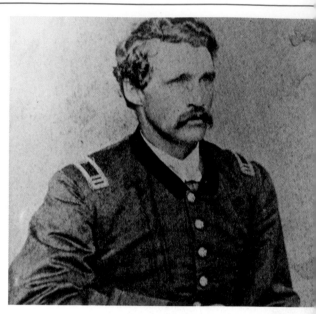

Left: Lt. Col. Samuel H. Wilkeson, Eleventh New York Cavalry, wore the regulation "Prince Albert" blue tunic and double-row brass buttons. Right: Capt. Elijah Hartwell, Tenth New York Cavalry, wore a variation of the regular cavalry uniform, with a low-cut collar of velvet and a single row of brass buttons. Facing page: Col. William H. Sackett, Ninth New York Cavalry, wore the regulation blue tunic with epaulettes and double-row brass buttons.

Photographs by Mathew Brady. Author's collection.

the Carabineri (police) of their native Italy.

Blenker's New York German Regiment marched in the forest green-colored uniforms of the German Army.

Regiments from Michigan dressed as lumberjacks, wearing checkered shirts, skull caps with tassels, and bowie knives stuck in their wide belts.

One New York regiment marched to battle in sports clothes: blue blazers, white duck trousers, white shoes, and straw hats with a bright red hat band.

"Light marching order" was not the rule. One private carried a trunk full of fine linen shirts; others carried cooking utensils, valises, camp chairs, pillows, skillets, and sundry camp articles.

"Soft tack" and "salt pork," tough as a "G.I." shoe, was the military ration; but the volunteers brought their own delicacies. Some carried ice cream freezers, "to be able," they said, "to make ices when the going got hot!"

But hidden under this pitiful masquerade lay the simple fact that many of these men had never fired a rifle. Some didn't even know how to load one.

A few regiments of regulars, dressed in regulation blue, were the only professional soldiers in the entire army.

"They had come to war with no other compulsion than love of country, and to restore the Union; but like the war itself, which was the result of political bombast and stupidity, so was this amateur invasion army sent into the field against the sound advice of professional military men."

Every schoolboy knows the outcome of the Battle of Bull Run—the rout of the Union army, the chaos that followed the defeat, the Union recovery, and the subsequent battles that followed.

The fancy-dress battle that was Bull Run was the first and the last time the U.S. Army wore individual uniforms. By the time the war was a

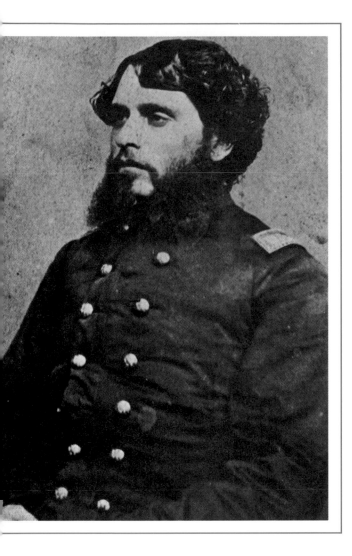

The artillery private and gunner wore the same uniform, except that his jacket had red piping on the collar and cuffs. His arms consisted of a short "artillery sword" and a Navy Colt 45-caliber revolver, of the cap and ball type.

The "horse soldier," or cavalryman, wore the best looking uniform of all: sky blue trousers with yellow piping on the trousers, and a navy-blue tunic with yellow piping, similar to the World War II "Eisenhower Jacket" used in the army and air force.

It is interesting to note that the U.S. Army dress uniform of today was modeled after the Union Cavalry officer's uniform, even to the rank shoulder strap insignia.

The cavalryman was armed with a 45-caliber Navy Colt revolver, worn with the butt and holster facing outward, and a short cavalry saber. His hat, as with the artillery kepi, was navy blue, with crossed brass sabers on the collar and top of the hat.

The officer's uniform was navy blue, with double rows of brass buttons running the length of the "Prince Albert"-type coat. When in dress, the officer wore a gold and red sash with tassels around the waist, supported by the leather sword belt. The trousers had a thin gold stripe on each side of the trouser leg.

The rank insignia was embroidered on wide shoulder straps in gold. The sky blue center carried the embroidered emblem of rank: a gold or silver bar denoted second and first lieutenants; two bars for a captain; a silver leaf for a lieutenant colonel; a gold leaf for a major; a single star for a brigadier-general; two stars for a major general; and three stars (the rank revived by Congress for General Grant) for lieutenant general.

At the close of the war, four stars denoted the General of the Armies of the United States.

Officers' headgear varied, but most line officers wore the wide-brimmed black Stetson with gold crown bands bearing an acorn on each end, and a brass wreath on the front of the hat with the insignia of rank.

The pictures of the officers accompanying this chapter depict some of the liberties they took with their uniforms. This is especially visible in the pictures of Colonel J.B. Swain of the Eleventh New York Cavalry.

year old, all wore regulation two-tone blue.

Among the officers and in the War Department, there was a laxity of regulations concerning uniforms. The officers were permitted to make moderate changes in style, so long as rank insignia and "U.S." identification were worn prominently.

The standard regulation uniform of the soldiers of the Armies of the Potomac, the Tennessee, and the Cumberland was two-tone blue.

A Union infantry private wore a single-breasted navy-blue tunic with a single row of brass buttons, and trousers of sky blue, topped by a navy-blue kepi with a black leather visor.

He carried a single-shot 45-caliber Enfield musket, powder, and a cartridge box of black leather fastened to a wide black leather belt with a brass buckle marked "U.S."

His other accoutrements consisted of a blanket roll; knapsack; tin, canvas-covered water canteen; folding cooking utensils; and a bayonet and scabbard.

After the disastrous defeat of the Union army at Bull's Run, Virginia, on July 21, 1861, Major General George McClellan was appointed commander-in-chief of the Federal armies.

McClellan had gained a creditable reputation in western Virginia and much was expected of him by President Lincoln and the country.

What McClellan lacked as a field commander, he made up for as "a fine organizer." Taking the demoralized troops of the Bull Run campaign, and the freshly recruited levies that were pouring into Washington, McClellan formed the Army of the Potomac. His goal was a trained combat force of a quarter of a million men organized into army corps, divisions, brigades, and regiments, with artillery, cavalry, engineers, a signal corps, and a transportation unit of wagon trains.

This army was to be commanded by trained combat and staff officers.

From the middle of July 1861 to March 1862, the men of the Federal army drilled, marched, and trained at its base in Washington, while an Intelligence Corps, headed by a Chicago detective, Allan Pinkerton, gathered information about the enemy's operations and intentions. Discipline was strict, and death by firing squad was the penalty for desertion.

McClellan's main failing as a field commander was that he determined to win his battles "by manoeuvering and marching rather than by fighting," and this fallacy became his ultimate downfall.

Early in 1862, after eighteen months of inaction, President Lincoln issued McClellan a direct order to attack the Confederate Army at Manassas. The order, dated March 8, relieved McClellan as commander-in-chief, giving him command of the Army of the Potomac, without authority anywhere else.

On April 2, the Army of the Potomac moved out of its camps and embarked on transports for the trip to the Yorktown Peninsula, a move McClellan had planned the year before.

With characteristic sloth, McClellan moved his force up the Peninsula, fought a minor action at Big Bethel, captured Yorktown only after General John B. Magruder allowed him to do so, and found himself embroiled in a series of sanguinary battles known as the Seven Days, in which the far superior Army of the Potomac was outfought at every turn.

Beginning at Beaver Dam Creek, June 25, 1862, Lee and the Army of Northern Virginia fought McClellan at Gaines' Mill, Mechanicsville, Savage's Station, Fair Oaks, Frayser's Farm, Malvern Hill, and Harrison's Landing, and in a week pushed the Army of the Potomac out of Virginia.

On the third day of the Seven Days' battles, McClellan, in a telegram to Secretary Stanton: "If I save the army now, I tell you plainly that I owe no thanks to you nor to any other persons in Washington. You have done your best to sacrifice this army."

McClellan, "the little Napoleon," was relieved by President Lincoln. Major General John Pope, placed in command of the Army of the Potomac, met Lee at Second Manassas, as the Confederates called it, on August 30, 1862, on the same battleground of Bull Run, was disastrously defeated in a sanguinary battle, and thereby paved the way for Lee's first invasion of the North.

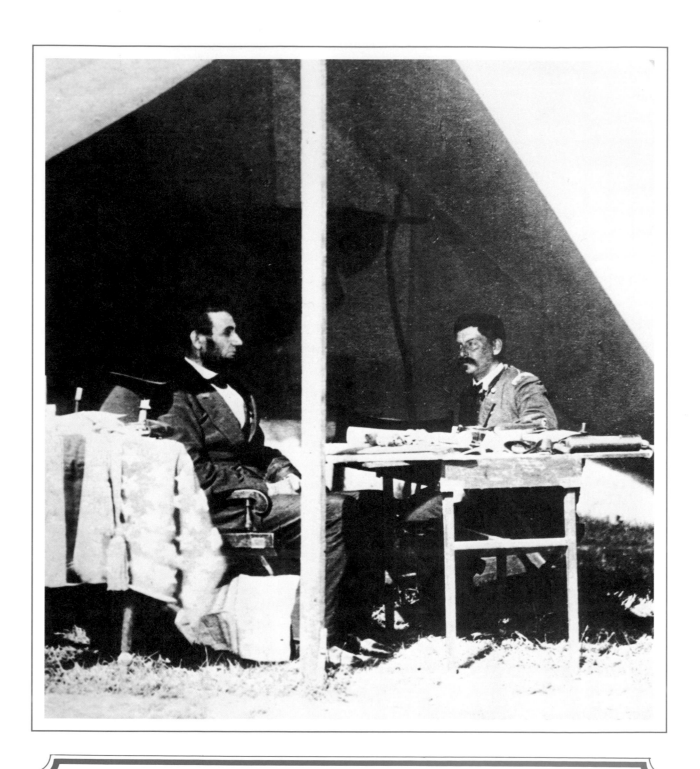

Two weeks after the Battle of Antietam on September 17, 1862, President Lincoln visited General George Brinton McClellan at his headquarters at Antietam, with the object of firing him for his failure to pursue Lee. This photograph was made by Brady on October 3, 1862.

From a photograph by Mathew Brady. Author's collection.

McClellan— a great engineer with a special talent for a "stationary engine"

In July of 1861, six months after the Union Army's defeat at Bull Run, a Government official came to see President Lincoln about getting a pass to visit the army's headquarters at Alexandria, Virginia, where the army was undergoing reorganization under its new commander, Major General George Brinton McClellan.

President Lincoln issued the pass and wished the man good luck. "I'll report when I come back, if I find the army," said the man. "Oh, you will," said the President laconically. "It's there. That's just the difficulty."

If Mr. Lincoln's remark seemed facetious, the barb was more than justified. It was indirectly aimed at his new supreme commander, Major General George Brinton McClellan.

One of the most controversial military figures of all time, General McClellan, nicknamed "the Little Napoleon," would have made a fascinating subject for a latter-day psychiatrist.

His background was indeed impressive. Born in Philadelphia on December 3, 1826, the third child and second son of Doctor George McClellan and Elizabeth Brinton McClellan, his family had come to New England from Scotland early in the eighteenth century. His great-grandfather, Samuel McClellan, had served as a brigadier-general with the Connecticut Militia throughout the Revolutionary War.

A student at the University of Pennsylvania in 1840, he left college in his second year to fill his appointment to the United States Military Academy at West Point in 1840. In 1846, he graduated second in his class as a second-lieutenant of engineers.

That same year, when the war with Mexico broke out, Lieutenant McClellan, with his engineer company, took part in the Matamoros campaign. In January 1847, as engineer officer, Lieutenant McClellan supervised the building of military roads and bridges for the army from

the Rio Grande to Tampico. Later, he joined General Winfield Scott's expedition to Vera Cruz.

For distinguished service in the bloody battles of Contreras, Churubusco, and Chapultepec, he received the brevet rank of first lieutenant; and with the close of the war in 1848, he returned to West Point as an instructor in practical military engineering. While at the academy, he translated the French regulations in bayonet exercises into English, adapting them for use in the American army.

During the next decade, McClellan engaged in various military engineering projects, among them the construction of Fort Delaware in New York State.

In March 1852, Lieutenant McClellan joined the expedition to explore the sources of the Red River in Arkansas, commanded by his future father-in-law, Captain R.B. Marcy. With the completion of this assignment, he became chief engineer for General Persifor F. Smith, who was engaged in harbor and river work in Texas.

But the most important of these engineering assignments came about during the following spring, when Lieutenant McClellan was given command of the expedition surveying a route for a transcontinental railroad across the Cascade Mountains. McClellan's route was subsequently rejected as being impractical; but Secretary of War Jefferson Davis, impressed with his work, directed him to continue to study the feasibility of a rail line over the same route which would be favorable to Southern commercial interests.

Following a trip to Samana Bay in Santo Domingo to investigate its possibilities as a naval station, and his resignation as lieutenant of engineers, in 1855 McClellan was appointed captain of one of the new cavalry regiments; but he never saw service with this regiment, for in April 1855 he was detailed to a board of officers sent to Europe to study foreign military systems. McClellan and the board spent a year in Europe, visiting the Crimea, and making a study of the siege of Sevastopol. His detailed reports of these operations and his recommendations for improving the American military system received great praise.

Resigning his army commission in 1857, McClellan accepted the position of chief engineer for the Illinois Central Railroad. Three years later, he became president of the Ohio and Mississippi Railroad.

With the firing on Fort Sumter, McClellan returned to the army, this time as a major general of Ohio volunteers, in command of the state's military forces; but on May 13, he was appointed a major general in the regular army and placed in command of the Department of the Ohio, which authority included the states of Indiana, Ohio, and Illinois.

Events now moved rapidly. After securing Kentucky for the Union, McClellan, acting with an alacrity far from his later wont, seized the initiative in western Virginia, drove out the Confederate forces near Grafton, and secured the main junction of the Baltimore and Ohio Railroad. He followed up these minor successes with the campaigns of Rich Mountain and Philippi, securing the western part of Virginia for the Union. And this is where McClellan's initiative ended.

McDowell's defeat at Bull Run in July 1861, and McClellan's successes in western Virginia, led to the latter's appointment as commander of the Army of the Potomac; and it was then that a metamorphosis took place in the McClellan character.

He became an enigma, enmeshed in a maze of sloth, indecision, pride, jealousy, and spite; and what he didn't reveal about himself in his dispatches, he more than uncovered in letters to his wife and rash utterances to his officers and friends.

When Lincoln gave him his commission, the President said, kindly, ". . . the supreme command of the army will entail a vast labor upon you." And McClellan replied, "I can do it all." At the same time, he wrote his wife that he didn't see how he could possibly handle the job, because it was too big.

At this time, the Army of the Potomac was in a state of utter confusion; and McClellan, in a burst of energy, reorganized, drilled, and trained it into an effective fighting force of about one hundred twenty thousand men between the ages of nineteen and twenty, many thousands of them under nineteen. But no sooner did he have the army in fighting trim than something happened to the McClellan confidence; and the army remained in its camps, the men themselves impatient at this inactivity, at Alexandria, Virginia.

"Why doesn't McClellan move with his army, and how can we get him to move?" Mr. Lincoln asked his advisors. But to give McClellan his due, the President went on to say that if McClellan ". . . can't fight himself, he can make others ready to fight."

President Lincoln realized all too well that the Confederate Army was fighting to win; but what he didn't realize was that his supreme commander had other ideas about conducting the war. McClellan intended "to win his battles by maneuver rather than by fighting."

During the long period of inactivity, McClellan put on showy parades, and on one occasion, while reviewing his troops with Judge Advocate General Erasmus D. Key, the men gave a rousing cheer. This prompted McClellan to say: "How these brave fellows love me! What a power that love places in my hands! What is there to prevent me from taking the government in my own hands?" Shocked by the treasonable tone of this remark, General Key replied: "General, don't mistake these men. So long as you lead them in battle against the enemy, they will adore you and die for you; but attempt to turn them against their government and you will be the first to suffer."

From July 1861 to January 1862, McClellan remained inactive, with a powerful army at his back. Meanwhile, the Confederate Army had fallen back to the line of the Rappahannock River unbeknown to McClellan, who had watched a line of empty field works at Manassas armed with "Quaker Guns"—logs on gun-carriages painted to look like guns.

This embarrassing intelligence, and the fact that the enormous amounts of military supplies furnished McClellan "had brought the exhausted condition of the Treasury" to the point of bankruptcy, compelled President Lincoln to issue "General War Order No. 1," which stung McClellan into action. The Peninsula Campaign was the result.

Moving his army by ship to Fortress Monroe in Virginia, McClellan started up the peninsula to Yorktown in a series of tedious siege operations—his objective, Richmond. His slowness, and the spectacle of five thousand Confederate troops under General Magruder holding one hundred twenty thousand at bay for a month, exasperated President Lincoln and brought comment from John Hay, the Presi-

dent's secretary. "The little Napoleon sits trembling before the handful of men at Yorktown, afraid either to fight or run!"

While McClellan stalled, he wrote to the President for a battery of heavy Parrott guns. Replied the President: "Your call for Parrott guns from Washington alarms me, chiefly because it argues definite procrastination."

On June 26, Lee opened the Battles of the Seven Days by launching a powerful attack on McClellan at Gaines's Mill, pursuing the Army of the Potomac all the way to Malvern Hill, where it made a stand in a furious battle and suffered heavy casualties and tremendous losses in equipment and supplies.

McClellan blamed his failure to take Richmond on President Lincoln and the Government, saying that the Government had not "sustained" him. His troops were turned over to General John Pope as fast as they could be gotten out, and McClellan was removed and ordered back to Alexandria to await further orders.

In a masterful move, Lee defeated Pope's army at the battle of Second Manassas in August, while Stonewall Jackson attacked Pope's supply depots at Manassas Junction, capturing enormous amounts of cannon, ammunition, clothing, and food. And what he couldn't carry away, he put to the torch, including a great number of railroad locomotives and cars.

President Lincoln, despairing at these defeats and having no other officer at hand to save the situation, restored McClellan to command. Shortly before his reinstatement, McClellan wrote his wife: "I fancy Pope is in retreat . . . I don't see how I can remain in the service if placed under Pope, it would be too much a disgrace . . . I shall keep as clear as possible of the President and Cabinet. . . ."

Elated by his victory over Pope, Lee marched into Maryland, his first invasion of Northern territory, in an attempt to secure the state for the Confederacy. Then, on the morning of September 13, McClellan was handed the key to a complete victory over Lee's army. An alert sentry found a copy of Lee's battle order, "General Orders No. 191," wrapped around a packet of cigars, which gave Lee's secret troop concentrations in detail. Armed with this important intelligence, McClellan could have had

the game, but he was too slow to act on it.

McClellan could have destroyed Lee in the battles of South Mountain and Antietam, the "bloodiest single day's action of the Civil War," but Lee skillfully withdrew his decimated army across the Potomac, and McClellan didn't pursue until late in October. Earlier in the month, Lincoln ordered him to bring Lee to battle, but McClellan complained about the jaded condition of his horses. "I have just read your dispatch about sore-tongued and fatigued horses, the President replied. "Will you pardon me for asking what the horses of your army have done that would fatigue anything?"

President Lincoln then paid McClellan a surprise visit at Antietam to find out for himself what plans, if any, McClellan had for pursuing Lee. And it was during this visit that Mathew B. Brady made several photographs of President Lincoln and his vacillating commander. Brady, with the army, had made several photographs of the Antietam campaign, along with one of his photographers, T.J. O'Sullivan.

President Lincoln returned to Washington, and McClellan marched into Virginia. At Warrenton, McClellan received an order to turn over the Army of the Potomac to General Ambrose Everett Burnside, "and to proceed to Trenton, New Jersey to await further orders." The orders never came, and McClellan's military career was ended.

McClellan, always the politician, was nominated for President by the Democratic Party in the election of 1864. He resigned his commission on election day. The returns gave him New Jersey, Kentucky, and Delaware, with twenty-one electoral votes against President Lincoln's two hundred twelve.

Disappointed in the election, General McClellan sailed for Europe, where he spent the next three years. Upon his return to the United States, he engaged in the construction of a new type of steam warship, but the project was abandoned for lack of funds in 1869.

He was offered the presidency of the University of California in 1868, but declined the offer. In 1870, he accepted the job as chief engineer of the New York Department of Docks, but only held it for two years.

In 1878, he was elected governor of New Jersey, serving until 1881. This ended his political career.

In appearance, McClellan was a fine-looking man who had red hair and mustache, was slightly under middle height, and had regular features and a stocky, powerful frame.

A studious man, "he knew and used all the principal languages of western Europe, ancient and modern." An omnivorous reader, he was interested in books on archaeology, exploration, and military literature. While in Europe, he spent much time mountain-climbing in Switzerland.

As a military organizer, strategist, and tactician he was an exceptionally good planner; but like many military men, he just didn't have the stomach for sending men into battle. General Robert E. Lee recognized McClellan's shortcomings as a combat officer, saying: "I regret parting with McClellan, for we always understood each other so well. I fear they may continue to make these changes until they find someone I don't understand."

Major General George Brinton McClellan died of a heart attack in Orange, New Jersey on October 29, 1885. He was survived by his wife, Ellen Mary Marcy, daughter of his old captain, Randolph B. Marcy, of the Red River expedition. He also left two children, a daughter and a son.

Innovations in Military Hardware and Operations

United States Military Railroad's locomotive No. 133, photographed at Nashville, Tennessee, 1863, an "American"-type 4-4-0. These balloon-stacked locomotives were handsome in appearance. Smokebox, balloon stack, pilot, and cowcatcher were carried on a four-wheel swivel truck. No. 133 was decorated with flower boxes on its pilot beam and running boards for the picture.

From a photograph by Mathew Brady. Author's collection.

The U.S. Military Railroads— one of the Union's most potent weapons

In David Selznick's motion picture masterpiece, "Gone with the Wind," there is an exchange of dialogue between Rhett Butler and a group of young Southern hotheads who, knowing that the war is imminent, boast of their military prowess.

The young Southerners brag that "one Southerner can lick five Yankees," and win the war in a week.

Rhett Butler's answer to this is "You can't win a war with words, gentlemen." He goes on to point out that the North has coal mines, railroads, shipyards, cannon factories, and a fleet to "bottle up" Southern harbors and starve them out; that all the South has is "cotton and arrogance."

"What does all this mean to a gentleman, sir?" asks one of the group more heatedly than the rest.

"I'm afraid it's going to mean a great deal to a great many gentlemen before long" is Butler's laconic reply.

No summation of the South's situation at the start of the war could have been more truthful or observant; and the railroads became one of the most vital military weapons of the entire war. Their accessibility determined, in large part, where the armies would fight their battles.

When the war began, the South controlled the important Mississippi, Tennessee and Cumberland rivers, which run through the central United States.

The Cumberland, for example, joins with the Ohio River on the Missouri-Kentucky border.

The Mississippi River runs through Arkansas, following this course to its own junction with the Ohio. The "Father of Waters" then sweeps southward through Vicksburg and on to New Orleans, where it empties into the Gulf of Mexico at Fort St. Philip.

On the other hand, the North controlled two-thirds of the nation's railroads, as well as controlling the vast industrial facilities for the

production of locomotives, cars, and rolling mills.

Moreover, the North had access to the coal mines, most of the country's iron ore, copper, and other industrial metals. In short, the North had the ability to sustain a long war, with industrial power ready to go on an immediate war footing.

The most important railroad, of immediate concern to both sides, was the Orange and Alexandria Railroad, which terminated at Alexandria, Virginia, across the Potomac River, near Washington.

Strategically, the railroad was a potential avenue of invasion, since it ran in an almost straight line through the Shenandoah Valley, parallel with the Blue Ridge Mountains, as far as Lynchburg, Virginia.

At Lynchburg, it connected with the Richmond and Danville, and Southside railroads, approximately sixty miles from Washington, where it joined the Manassas Gap Railroad.

At Gordonsville, Virginia, the line joined the Richmond, Fredericksburg and Potomac Railroad at Hanover Junction, terminating at Richmond, capital of the Confederacy, across the lines of the Virginia Central running east.

When the war began, the Confederates held Alexandria, Virginia, and it had been General Robert E. Lee's plan to construct a rail line connecting the Orange and Alexandria with the Loudon and Hampshire railroads, in order that the rolling stock of the O and A, as well as its motive power, could be transferred south before the Union forces could capture it.

But the Union Army was too quick; it seized the Orange and Alexandria terminal and the town itself before the Confederates could remove any more than two locomotives.

What rolling stock they couldn't move in time was put to the torch. All the Union Army could save were the large stocks of rails.

The captured locomotives, renamed General Beauregard and General Johnston, found their way to the tracks of the Richmond, Fredericksburg and Potomac, and Virginia Central railroads, where they were badly needed.

More disastrous to the Confederates, however, was the Union Army's capture of the Orange and Alexandria's large yards and shops for locomotive and car building and repair,

which Union Army engineers quickly put into operation.

After consolidating their capture, United States Military Railroad engineers and the Union Army extended their control of the line twenty-two miles into Virginia territory, westward to Manassas Junction, where they found that the retreating Confederates had destroyed the track and bridges east of Bull Run.

In 1861, Virginia's sixteen railroads were almost wholly inadequate to the military demands that the war placed upon them.

Indeed, the Southern railroads all conformed to a somewhat similar pattern. For one thing, for almost two years after the war started, they remained in civilian control, civilian demands on them taking precedence over military ones.

The Orange and Alexandria was the only railroad using standard gauge trackage, which enabled the Union forces to use their own locomotives and cars in the transport of troops and supplies. And as the Union armies moved southward, the lack of the uniformity of the Southern railroads' track gauges kept the United States Military Railroad Construction Corps busy changing them over to standard gauge.

Railroads operating south of the James River, running east to west, operated over a track gauge of five feet. Railroads operating above the James River, running from north to south, employed the standard gauge of four feet, eight and a half inches, making continuous rail operations over these lines impossible.

The roadbeds and track of the Civil War railroads, by today's standards, were anything but stable. More often than not, ties and rails were laid down on bare ground, without drainage ballast, and suffered accordingly in rainy weather.

A case in point was a heavy rainfall which accounted for an unusual accident on the poorly constructed roadbed of the Richmond and York River Railroad, when the spring rains of 1861 softened the dirt ballast.

An embankment gave way under the weight of a standing locomotive, which slid downhill for fifteen feet without the locomotive capsizing or leaving the track.

Railroad ties were usually cut in half from oak, locust, chestnut, and other hardwoods, with the round side of the tree placed on the

ground, and were laid without benefit of creosote or tar treatment to protect them from rot.

Rails, differing in size and weight, rolled from iron rather than steel, were of the "T" type, and varied in weight from fifty to sixty pounds to the yard.

Some of the South's railroads even employed ancient wooden "stringers," topped with a thin strip of "strap-iron," weighing only from sixteen to twenty pounds to the yard.

These "flat-bar" rails broke down very frequently under the weight of heavy traffic. More often than not, these rails would rot or splinter from exposure to weather.

Most of these rails were already oxidizing and crystalizing from over-age when the war began, and many of them collapsed under the weight of the trains.

Railroads using iron "T" rails were laid on ties without "tie-plates," and were spiked directly to the wooden ties. Switches and crossovers were of the "stub" type, in which the butt ends of the turnouts were bent to meet the stub ends of the crossovers.

Most of the South's rolling stock and locomotives were already over-age in 1861. The balloon-stacked locomotives were of the classic "American" type, or 4-4-0—four connected sixty-inch driving wheels, a four-wheel swivel, and a pony truck designed to guide the drivers around the sharp curves on most American railroads of the time.

Their boilers, wood-burning fireboxes, and cabs were carried on the driving wheels. The smoke-box, balloon-stack (designed to catch flying sparks), cowcatcher, steam chests, and cylinders were carried over the pony truck.

Most of these locomotives were handsome in appearance, with gaudy paint jobs and highly polished brass fittings and headlights.

In length, they measured about thirty-seven feet, without the tender, and weighed in at about twenty thousand pounds, with a tractive effort of about three hundred seventy-five thousand pounds.

For the most part, these locomotives were designed and built by the Baldwin Locomotive Works, Norris and Sons, Rogers, Boston Locomotive Works, and Hinkley.

Passenger equipment was generally of the same type: coaches had open-end platforms, uncomfortable seating, and a coal stove at each end, as well as four-wheel swivel trucks and hand brakes.

"Box"-type freight cars and flat cars averaged about twenty feet in length, and had hand brakes.

Way cars (cabooses) and cattle cars had open windows at each end, and were also mounted on four-wheel swivel trucks.

Early in the war, the North converted passenger coaches into hospital cars, with double-decked bunks running the length of the car on both sides of the center aisle.

Not until late in the war did the South employ hospital trains for moving the wounded, since the shortage of equipment precluded innovations of this kind.

With the great disadvantage of an almost nonexistent industrial capacity; with only two iron foundries and rolling mills in the entire South to manufacture military hardware and railroad equipment; with no shipyards to speak of, the Confederacy had to hit hard and fast to achieve her goal of independence.

Total victory had to be hers before the North could martial its military and industrial might to subdue her.

But this was a forlorn hope.

When President Lincoln signed the "Government Railways and Telegraphs Act," and put into existence the remarkable United States Military Railroads, it all but spelled doom for the Confederacy's chances of an early victory.

The Orange and Alexandria Railroad played out its important role of carrier for the Union armies operating in Virginia for the first two years of the war.

The Confederate cavalry tore up its trackage, wrecked its trains, and rendered destruction to its bridges and telegraph lines; but the United States Military Construction Corps, under the very capable direction of Colonel Herman Haupt, former engineer of the Pennsylvania Railroad, rebuilt the bridges and righted the derailed trains almost as fast as the Confederates could wreck them.

During the great Battles of Second Manassas, Antietam, and Fredericksburg, Colonel Haupt was at his best, especially with the direction and movement of military trains.

In 1862, after Lee's defeat at Antietam, the Orange and Alexandria Railroad was made

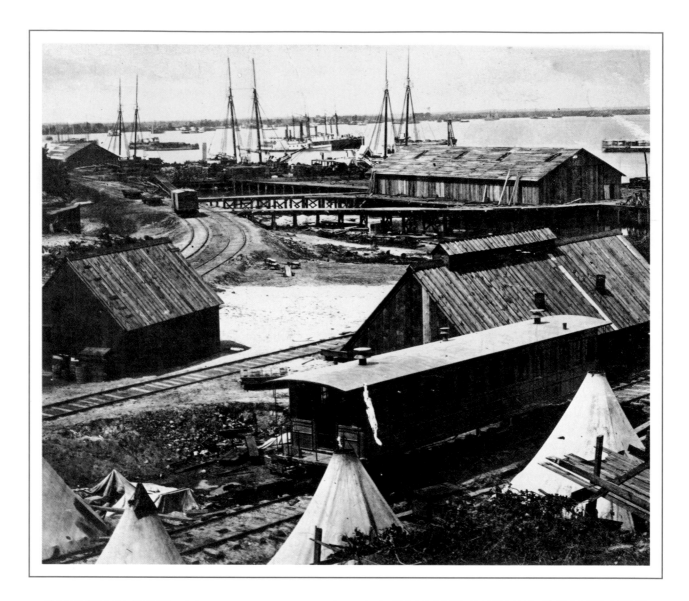

This 1864 photograph of the terminal and loading wharves of the City Point Military Railroad shows a passenger coach in the foreground with armored sides of lead. It was built to carry President Lincoln to Grant's headquarters but was never used.

From a photograph by Mathew Brady. Author's collection.

operative beyond the Rappahannock River, and served as the main supply line to the Union armies fighting the battles of Fredericksburg and Chancellorsville.

Without the rails and motive power it needed, and the organized military rail operation like the United States Military Railroads, the Southern rail lines—suffering from war damage and wear—gradually fell into disuse.

In the final year of the war, only the Southside, Virginia Central, and Weldon railroads were left open to Lee. Sheridan's capture of Lee's last supply train on the Weldon Railroad settled the matter.

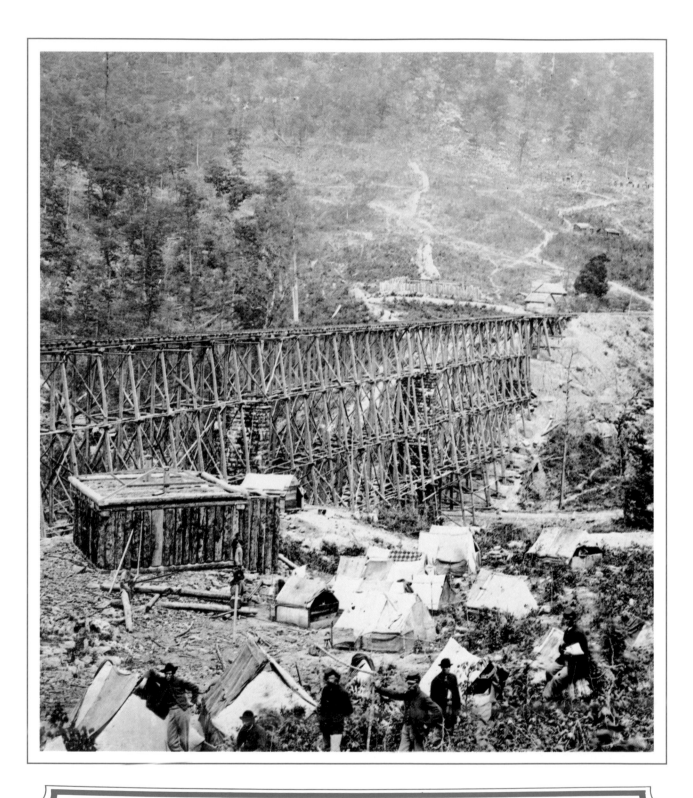

United States Military Railroad bridge near Nashville, Tennessee, in 1863-1864. The blockhouse in the foreground was built to guard the bridge from enemy cavalry raids.

From a photograph by Mathew Brady. Author's collection.

The Civil War— a railroad war

In the decades before the Civil War, America's railroads were anything but models of efficiency. Constituent railroads were short lines of forty or fifty miles in length, usually serving farming or manufacturing communities.

Most were the prey of speculators, and few, if any, operated on regular daily schedules. Moreover, their directors gave no thought whatsoever to the possibility that they might one day become a military necessity.

As the nineteenth century reached the halfway mark, rising commercialism demanded quick and inexpensive transportation, which the Government, at that time, was incapable of providing.

To add to this perplexing problem in transportation, the discovery of gold in California immediately changed the old order of practically everything. Nevertheless, these boom years became the heyday of magnificent opportunity, and a quick solution to the transportation problem was needed. The railroad was the obvious answer.

When the war came, the North had more than twenty thousand miles of operating lines, more than twice the mileage of all the Southern railroads combined, with access to the coal mines, gun factories, locomotive and car builders, and iron mines.

The idea that railway transportation would become an important military logistics weapon was completely overlooked by the Southern political leaders.

Thus, the ability to wage a prolonged war gave the North an enormous advantage—a factor which wasn't taken into account by the confederate Government until it was too late.

Almost from the beginning, the ghosts of military attrition began to account for everything the Union armies couldn't overcome by fighting.

And so the Civil War became a railroad war—the first modern war in which sophisti-

cated military hardware was brought into use.

President Lincoln immediately assumed authority to take control of all operating railroads in the United States, especially those with terminals at Washington, D.C., and put them under the control of the Government Railways and Telegraphs, directed by Thomas A. Scott of the Pennsylvania Railroad.

Andrew Carnegie, the steel man, was appointed Superintendent in Charge of Railways.

From the beginning, the military railroads began operating with a purpose. Admittedly, for the first few months of the war, operations were grossly inefficient simply because field officers and commanding generals didn't know how to employ the railroads as military logistics weapons.

But President Lincoln's appointment of two brilliant and experienced railroad men, General Daniel McCallum and Colonel Herman Haupt, changed all that; and with McCallum as director and Haupt as director of operations and construction, order was brought out of chaos, and the men of the Military Railroad Construction Corporation performed amazing feats of operating railroads and building bridges under fire.

In the South, the Confederate Government, with unbelievable lack of foresight, didn't recognize the importance of seizing military control of its railroads, and left them in the hands of their civilian directors, who gave precedence to their commercial car loadings rather than to the Confederate military forces.

But the saga of the military railroads is an amazing narrative of train operations, bridge construction, and reconstruction and restoration of rail lines damaged by shell fire and cavalry raids.

If the North had Daniel McCallum and Herman Haupt, however, the South had its brilliant commanders, Robert E. Lee and Thomas Jonathan Jackson, whose talent for railroad destruction was equalled only by that of General William Tecumseh Sherman, Jackson's Yankee counterpart.

The first hostile act of war against the Federal Government took place on the night of April 18, 1861, when a small body of Confederate troops attacked and burned the U.S. arsenal at Harpers Ferry, Virginia, and seized control of the all-important Baltimore and Ohio Railroad in order to halt troop trains bound for Washington, which almost totally isolated the North's capital city.

Colonel Thomas J. Jackson, now in command of Virginia troops, first saw to the sacking of the Harpers Ferry Arsenal, giving special attention to the removal of the gun-manufacturing machinery.

Then, Jackson had another idea: to procure rolling stock and locomotives badly needed by the Southern railroads. At the same time, Jackson's strategy included depriving the Federal Government of the use of the Baltimore and Ohio Railroad.

But Jackson had to take a political consideration into account before he could carry out his plans. The Maryland legislature had not yet decided whether to join the Confederacy, and Jackson could make no overt move lest he offend the Maryland government. Once he learned that Maryland had decided to remain neutral, Jackson acted at once, and with precision.

First, he noted that long, heavy coal trains from western Virginia, headed for Baltimore with coal for the U.S. Navy, passed through the fifty-mile sector assigned to him by Governor Letcher of Virginia. He also noted that long, empty trains moving up to the mines also passed through his military zone day and night.

Here, to the wily Jackson, was the perfect opportunity for collecting enough rolling stock to last the Confederacy for a long time.

On the trumped-up pretext that the coal trains were keeping his men from getting "their proper rest," Jackson ordered John W. Garrett, president of the Baltimore and Ohio, to see to it that after May 15, all coal trains operating over the double-tracked, twenty-seven-mile zone between Point of Rocks on the east and Martinsburg on the west, had to make their run between the hours of eleven a.m. and one p.m. each day.

Jackson then sent Captain John D. Imboden and a contingent of cavalry to intercept and halt all eastbound trains at Point of Rocks. Then he sent Colonel Kenton Harper to Martinsburg to halt all westbound trains at noon the next day.

Unaware of the trap Jackson had set for them, the trainmen moved their trains on schedule as ordered, moving freely into the

cul-de-sac for an hour after eleven a.m. Precisely at noon, Imboden and Harper halted all traffic, closing both ends of the trap.

To ensure against recapture, Jackson ordered all the bridges and track destroyed in his sector, further consolidating his catch by blasting rock onto the tracks at Point of Rocks.

The surprise was complete. The haul—fifty-six locomotives and three hundred fifty cars—constituted the largest capture of railroad equipment that would be taken by either side during the entire war.

Jackson and his men also destroyed seventeen railroad bridges in four weeks, including the eight hundred thirty-seven-foot Harpers Ferry Bridge. Then, on June 2, Jackson destroyed the important railroad bridge over the Opequon River, completing the destruction by running a train of fifty coal cars into a chasm of the Potomac River, where they burned with such intense heat that the car wheels and axles melted.

But Jackson's big capture at Point of Rocks in May was to prove no boon for the Confederacy. Returning to Martinsburg to continue his destruction of the Baltimore and Ohio's extensive car and locomotive shops, he discovered that his captured fifty-six locomotives and three hundred fifty cars were standing in the yards. These he promptly put to the torch.

As this valuable rolling stock burned, however, Jackson had some afterthoughts. Before the fire reached the standing locomotives, he had the fire put out, and sent for two of the South's top railroad engineers, Hugh Longust and Thomas R. Sharp, and a select crew of thirty-five mechanics, laborers, and teamsters. Upon arriving, they were put to work salvaging the locomotives.

After dismantling the balloon-stacked, blistered locomotives, Jackson had them hauled overland by forty horse teams to Strasburg, Virginia, the nearest station on the Manassas Gap Railroad, for shipment to Richmond.

Moving these locomotives over thirty-eight miles of mountainous terrain took three days of the worst kind of back-breaking labor; but not until all thirteen locomotives had reached the Confederate capital did the work end.

When the Baltimore and Ohio's harried officials tallied up Jackson's score, they found that sixty-seven locomotives had either been cap-

tured, burned, stripped of their running gear, or dumped into the Potomac River.

The men of the U.S. Military Railroads also performed some remarkable feats of rebuilding destroyed railroad bridges over otherwise impassable gorges, in the shortest space of time, and mostly under fire. No man was more deserving of receiving accolades for his engineering genius and ability than Herman Haupt, the colonel in command of the Construction Corps.

And no man was more appreciative of Haupt's talents than was Lincoln.

Outside Washington, the Confederates had destroyed the railroad bridge over Potomac Creek, which ran through a gorge one hundred feet high. Using fresh timber from the surrounding woods, Haupt built his bridge in record time.

President Lincoln had seen this bridge, and reported to the War Committee "that he had seen the most remarkable structure that human eyes ever rested upon."

"That man, Haupt," he said, "has built a bridge across Potomac Creek, about 400 feet long and nearly 100 feet high, over which loaded trains are running every hour, and upon my word, gentlemen, there is nothing in it but beanpoles and cornstalks." After that, timber railway trestles became known as "Beanpole and Cornstalk Bridges."

As the war went on, the Union generals learned to use the railroads to good advantage. Sherman not only knew how to use the railroads, but was a master at destroying them when necessity demanded it—and he also knew how to rebuild them.

When Hood's Confederate Army tried to stop Sherman's advance on Atlanta, the Confederates tore up miles of tracks and even blasted a tunnel near Dalton, Georgia, all of which delayed Sherman's food and forage supplies. When the men complained, Sherman told them: "The quicker you build the railroad, the quicker you'll get something to eat."

Sherman's ability to rebuild his supply railroad lines became the despair of the Confederates, since he rebuilt them faster than they could destroy them. "Oh, Hell!" a Rebel soldier remarked, "what's the use of destroying the tunnels, don't you know Sherman carries a duplicate tunnel?"

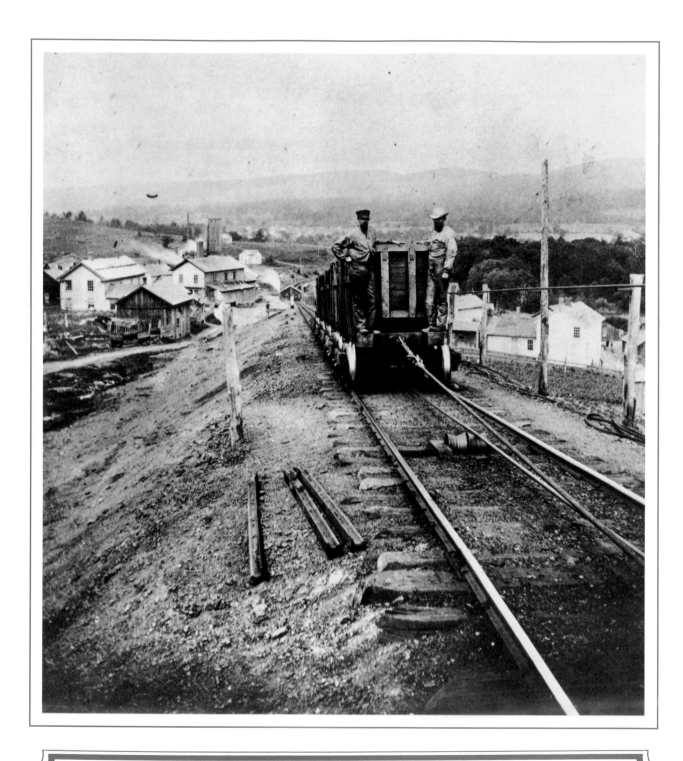

Portage system for hauling canal boats over the mountains of Pennsylvania. Photograph taken along the Lehigh Canal sometime in 1859-1860.

Author's collection.

During Grant's masterly move on Petersburg, Virginia, Major General James Harrison Wilson's cavalry struck at the railroads west of Petersburg and Richmond. But Wilson's attack was blunted by the very capable Generals Wade Hampton and Fitzhugh Lee, though not before Wilson's men destroyed sixty miles of track, presenting Lee with an enormous supply problem.

Grant's well-known City Point Railroad served the Union lines that were laying siege to Petersburg.

It was over this line that the huge Knox Mortar, "Dictator," was moved on a flat car to a "Y" section of track where it was used to shell Petersburg. The "Y" track made it possible to aim the huge gun in three directions.

This unique mortar weighed seventeen thousand pounds, and fired a three hundred-pound round shell five miles, which exploded with terrific force. It was supposed to "dictate" the peace, but its powerful recoil broke the axles of the flatcar it was mounted on. Later, a heavier car was built to support it.

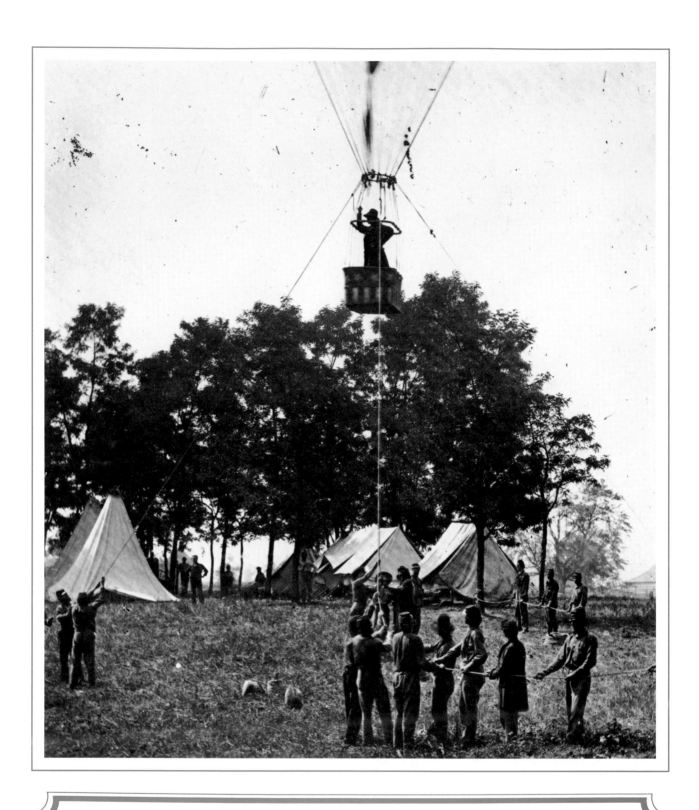

Professor T.S.C. Lowe, aeronaut of the Army of the Potomac, observing the progress of the Battle of Fair Oaks, July 1862, from the U.S. Military Balloon "Intrepid."

From a photograph by Mathew Brady. Author's collection.

Professor Thaddeus Sobieski Coulincourt Lowe— the most shot-at man in the war

On April 20, 1861, Professor Thaddeus Sobieski Coulincourt Lowe, an inventor, meteorologist, and aeronaut, climbed into the gondola of his balloon, cast off the lines, and ascended into the atmosphere over Cincinnati, Ohio. Nine hours and nine hundred miles later, he brought his free-flight balloon down at Pea Ridge, a small settlement on the borderline separating North and South Carolina, only to be immediately arrested as a spy.

The Civil War had started only six days before with the firing on Fort Sumter in Charleston Harbor, and all Northerners traveling in the South came under suspicion. An angry mob bent on violence suddenly appeared, and Professor Lowe was about to make a run for it, when a stranger stepped out of the crowd and identified Lowe as the scientist who, the year before, had made a balloon ascent at Charleston, South Carolina.

After assuring Lowe's captors that the balloonist "was not connected with military af-

fairs," Lowe was allowed to go free. The stranger who identified Lowe was truthful, for Lowe's flight from Cincinnati was entirely scientific in purpose. Lowe believed that, at certain high altitudes, high velocity winds blowing from west to east would carry a balloon from America to Europe. The flight just completed was designed to prove to Professor Joseph Henry of the Smithsonian Institution that a European flight was feasible in a larger balloon, using coal gas as an inflatant.

Lowe partially proved his point, for his record flight from Cincinnati to the Carolina border was made at altitudes ranging from seven thousand feet to twenty-three thousand feet, at an air speed of one hundred miles an hour.

Thaddeus Lowe was not unaware of the military possibilities of observing enemy movements from the air. Not long after the start of the war, following his flight from Cincinnati, Thaddeus Lowe came to Washing-

ton, D.C. on June 6, 1861, to see Secretary of War Simon Cameron to point out the military possibilities of the balloon in warfare.

Twelve days later, on June 18, to prove his point Lowe made an ascent near Washington, and scored an historical "first" by sending President Lincoln the first telegraphic message from an airborne balloon.

Convinced that the balloon had a place in warfare, President Lincoln appointed Lowe chief of the aeronautic section of the Army of the Potomac. From that moment on, Lowe and his balloons "Intrepid" and "America" made aeronautical history in the Battles of Bull Run, the Seven Days, Second Manassas, Antietam, and Gettysburg.

At the bloody Battles of Gaines Mill and Fair Oaks, Lowe went aloft and witnessed the battle in progress from the location pictured in the photograph accompanying this chapter.

On the second ascent, Major General Fitzjohn Porter, a member of Major General George B. McClellan's staff, wanted to see for himself the enemy's dispositions, and made the ascent alone. The balloon was "captive"—raised and lowered by a cable and winch. When General Porter reached the proper altitude and was scanning the battlefield with his glasses, the cable parted. The balloon broke free and floated over the Confederate lines. There was much shooting, but no shot reached the balloon. After half an hour, a change in the wind brought the balloon back over the Federal lines. Instructions were then signalled to Porter, who lowered the balloon by releasing the gas valve.

Whenever the opportunity afforded, reporters, sketch artists, and Brady's photographers made the "balloon camp" their "field headquarters." Military information transmitted by a telegraph key, located in the gondola of the balloon, was received by the "sounder" on the ground, where the information was recorded and sent on to General McClellan at headquarters.

Lowe himself always piloted all military flights and transmitted flag signals and telegraphic messages. Every flight was accompanied by a "steady fire from the ground." After the war, Lowe always said that "he was the most shot-at man in the war."

Surprisingly enough, the Confederates also had an observation balloon, a creation made from the cloth of hundreds of evening dresses and wedding gowns, which actually never got off the ground. Named the "Silk Dress Balloon," it was transported to Richmond, Virginia; but before it reached the Confederate capital, it was captured by the Federal forces after it had drifted onto a sandbar, "on the way to its first flight."

Yet, even with the extraordinary assistance of Lowe's amazing balloon observations, the Battles of the Seven Days had brought no action to McClellan. Lee had committed his entire army to the capture of the Army of the Potomac, and he came pretty close to accomplishing his aim. Lee struck McClellan's base at White House Landing on the Pamunkey River and captured an enormous amount of supplies—food, guns, horses, mules, wagons, and artillery.

At the finish, McClellan managed to hold Harrison's Landing and extricate his army. The Seven Days' battles, more a running fight than a sustained battle, took its toll of lives. Lee lost twenty thousand men in the savage fighting, and sixteen thousand of McClellan's men failed to answer roll call.

Thaddeus Sobieski Coulincourt Lowe was born at Jefferson Mills, New Hampshire on August 20, 1832, the only son of Clovis and Alpha (Green) Lowe. Following his education in New England, young Lowe became interested in aeronautics and ballooning as a means of exploring the outer reaches of the atmosphere, and in studying the upper air currents.

In 1858, Lowe had made his first balloon flight in Ottawa, Canada, in connection with the flying of a large balloon he named the "City of New York"; and in June 1860, he made an ascension over Philadelphia, which brought him to the attention of Professor Joseph Henry of the Smithsonian Institution.

Professor Henry, intrigued with Lowe's aerial experiments, gave him some instruments for aerial research. Lowe, himself, invented an instrument for aerial navigation, a device for quickly determining latitude and longitude without a horizon; but he miscalled his invention an "altimeter."

But the first man to introduce aerial military reconnaissance and aerial military photography in the war is perhaps entirely unknown for his other scientific achievements.

After the war, he was elected to the Military Order of the Loyal Legion, reserved only for soldiers of the Army of the Potomac and Army of the Tennessee. Relieved of his military duties, Lowe shifted his interest to commercial pursuits. In 1866, he discovered a way to make artificial ice, built a plant for its manufacture, and became the first man to employ this refrigeration material for commercial purposes in the United States.

In December of 1868, Lowe equipped the ocean-going steamer *Agnes* with a refrigerator, using his artificial ice for the transportation of perishable food products from Galveston, Texas to New York. He then transported a shipment of freshly slaughtered beef from Texas to New Orleans in the same type of refrigerator. "The shipment arrived at its destination," wrote the *New York Sun* reporter on December 10, 1868, "in good condition, looking a fresh as if it had been freshly slaughtered, although killed five days earlier."

This remarkable man moved to Pasadena, California in 1894, where he became widely known for his construction of the incline railway in Rubio Canyon on Echo Mountain, the nearest mountain peak to the well-known Mount Wilson, where he established and equipped an observatory on the summit. The mountain was later renamed Mount Lowe.

Thaddeus Sobieski Coulincourt Lowe, aeronaut, meteorologist, and inventor, the man who contributed so much to American technology and science, died at his home in Pasadena, California on January 16, 1913. He was survived by his wife, the former Leontine Gachon, whom he had married in Paris in 1855, and his three sons.

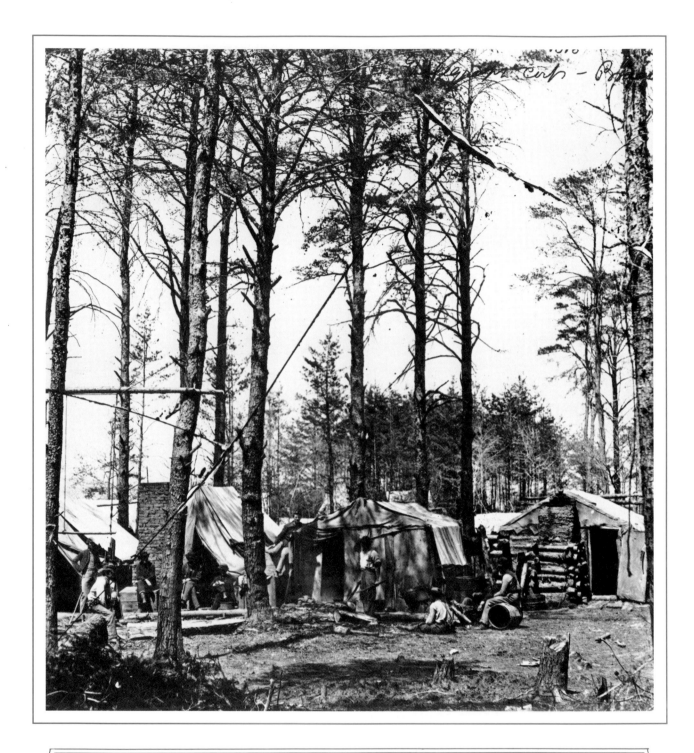

Log and tar-paper huts such as these, in the permanent camp of the United States Military Telegraph at Warrenton, Virginia, 1863, were used throughout the war when the army went into winter quarters. Telegraphic cables can be seen suspended from trees at the left.

From a photograph by Mathew Brady. Author's collection.

Secret Telegraph Codes

Apart from the fact that the American Civil War was a railroad war, the military hardware such as the heavy artillery, and types of weapons such as the Knox Mortar, called "The Dictator" (and which could be called the Civil War "H" bomb), were quite sophisticated for their time.

Added to this military equipment was military photography and the military telegraph, also quite sophisticated equipment despite their crude construction and methods of operation.

The War Department military telegraph system, directed by the Bureau of Railways and Telegraphs, was housed in the "telegraphic room" in the War Department Building, near the office of Secretary of War Edwin M. Stanton, who ruled it with an iron hand.

The system consisted of a "battery room," the source of the electrical power supply units which kept all lines operative. About twenty telegraphers, each seated at a desk with a key

and "sounder," sent and received coded messages, which, as soon as received, were handed to the "code clerks" for deciphering.

When a battle was in progress, President Lincoln, Secretary Stanton, and David Homer Bates, chief of the telegraph room, spent many hours waiting for news of the outcome of the engagement. The President sometimes stayed in the telegraph room all night.

In the field with the army units, covered army wagons specially equipped with batteries, sending keys, and "sounders," and usually manned by two operators, were placed behind the lines near the headquarters tents. These were moved when the army moved.

In permanent bases, in the rear areas, permanent telegraphic headquarters were set up in huts, like those pictured at Warrenton, Virginia.

Sometimes the lines were destroyed by roving calvary detachments. Other times, railroad telegraphers, soldiers with the Confederate

Henry Jarvis Raymond, founder (1851) and editor (1851-1859) of The New York Times. *He was also a founder of the Republican Party and attended its first national convention in 1856. Raymond held public office several times.*

From a Brady photograph made in his Washington studio in 1861

Army, would "tap on" to a Federal telegraph, "listen in" and copy the message, and then try to decode it, sometimes with success, for those codes were quite simple when compared with today's sophisticated methods.

The telegraphic lines in and out of Washington were always vulnerable to cavalry raids, and sometimes the damage was so extensive that it took several days to get the lines back in service.

Colonel Herman Haupt, superintendent in charge of the United States Military Railroads, probably used the military telegraph more frequently than many of the army's commanders in his operations of moving munitions and supplies, checking transport, "and telegraphing the President" at every opportunity.

Some famous telegraphic messages that reached President Lincoln during his nightly vigils at the War Department were transmitted by Colonel Haupt and Major General George Gordon Meade, the dyspeptic commander of the Army of the Potomac at Gettysburg.

During the night of the Battle of Second Manassas (or Bull Run), Lincoln wired Colonel Haupt from the War Department, anxious for news.

Lincoln: "WHAT NEWS, WHAT NEWS, IF ANY? IS THE RAILROAD BRIDGE OVER BULL RUN CREEK DESTROYED AS YET?"

Haupt: "IF IT ISN'T, IT PROBABLY WILL BE!"

Another incident that was dramatized on the army telegraph lines occurred several weeks after the Battle of Antietam.

Lincoln was anxious that McClellan pursue Lee's army, which had been badly handled. McClellan had found one excuse after another as to why he shouldn't pursue Lee.

McClellan telegraphed President Lincoln, saying that his horses were jaded and worn out.

President Lincoln, exasperated with McClellan for his dilatory tactics, wired back:

"WHAT HAVE YOUR HORSES DONE THAT WOULD TIRE ANYTHING?"

At the close of the Battle of Gettysburg, Major General George Gordon Meade telegraphed the President:

"WE HAVE SWEPT THE ENEMY FROM OUR SOIL!"

The angry President Lincoln wired back:

"WHEN WILL OUR GENERALS EVER GET IT THROUGH THEIR HEADS THAT THE WHOLE COUNTRY IS OUR SOIL."

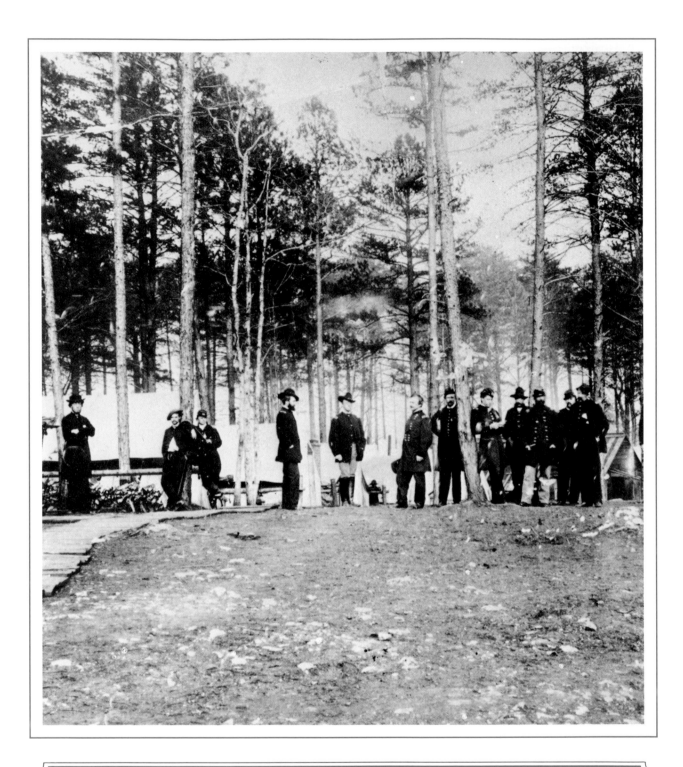

United States Sanitary Commission Field Camp. The Commission's activities ranged from ambulance service to rest lodges to propaganda, but its principal efforts were aimed at improving medical services in the field.

Author's Collection.

The Sanitary Commission— a strange set of purposes

One evening in the fall of 1861, two months following the Battle of Bull Run in July, Mrs. Julia Ward Howe and her husband were returning to Washington in their carriage.

They had both been working outside the city with the Army of the Potomac in connection with the newly formed United States Sanitary Commission, a relief organization founded to help wounded soldiers and their families left destitute by the war.

The night was "exceedingly dark," and enroute they were compelled to turn off the road and stop, to permit a regiment of troops to march past them. The troops were singing a cadence to "John Brown's Body," a popular song written by William Steffe in 1852, and now a war song.

It struck Mrs. Howe that the lyrics to the song were greatly inappropriate to the music, and she mentioned this to her husband, seated beside her on the carriage seat.

Her husband's answer was: "Julia, why do you not write better ones?" Mrs. Howe thought about it for a while. When they arrived home that night, she continued to turn the matter over in her mind and later fell asleep. Suddenly she wakened, and the words that open the song came to her.

"Mine eyes have seen the glory of the coming of the Lord."

That night, the "Battle Hymn of the Republic" was born, and Mrs. Howe's song became the most patriotic song in the nation. It was sung everywhere, especially in the churches. Mrs. Howe, a well-respected member of the U.S. Sanitary Commission, and her song were destined to go down in history.

The war progressed from there, and the casualty lists mounted accordingly. The astronomical losses in dead and wounded in the battles that followed were staggering beyond belief.

Even more so were the unsanitary conditions that prevailed in the camps behind the lines and in the field hospitals, which for the most part were old barns or wrecked houses.

The suddenness of the start of the conflict caught both sides ill-prepared for a prolonged war. Neither side had made any provisions for the care of the wounded; there were no military hospitals equipped to care for large numbers of wounded men, few medical supplies, and even fewer competent military surgeons.

Ambulances to remove the desperately wounded from the battlefields were no more than springless, two-wheeled wagons; and woe betide the unfortunate soldier who got himself wounded, or fell sick while in camp.

To meet this deplorable situation, the United States Sanitary Commission was created by the Federal Government in June 1861, shortly before the Battle of Bull Run in July. It was presided over by a Unitarian Divine, the Reverend Dr. H.W. Bellows, who had been active in war relief work from the start of the conflict.

A book entitled, *How a Free People Conduct a Long War*, written by a Yale graduate and professor of history at the University of Pennsylvania, came to the attention of President Lincoln. Its author, Charles Janeway Stille of Philadelphia, so impressed Lincoln that Stille was appointed a member of the commission's executive committee.

The passage in Stille's book that impressed Lincoln most summed up the pattern of sectional war as Lincoln, himself saw it.

Stille wrote:

War is always entered into upon a vast deal of popular enthusiasm, which is utterly unreasoning. It is the universal voice of history, that such enthusiasm is wholly unreliable in supporting the prolonged and manifold burdens inseparable from every war waged on an extensive scale, and for a long period.

The popular idea of war is a speedy and decisive victory and an immediate occupation of the enemy's capital, followed by a treaty of peace. Nothing is revealed to the excited passions of the multitude but dazzling visions of national glory, purchased by small privations, and the early subjugation of their enemies.

At the first reverses they yield to depression, blame the government, and the armies; the unreasoning abuse then matches the original enthusiasm; ... alterations of victory and disaster ... blunders so galling in policy adopted by

Government, or in the strategy of its generals, that the wonder is success was achieved at all.

During the kaleidoscope of the war, the Sanitary Commission fulfilled its function, and as the war progressed, the commission developed into a widespread war agency employing as many as five hundred agents.

Its work covered all types of aid, such as field and hospital medical inspection and field and ambulance service. It provided railroad hospital cars, conventional railway passenger coaches which had been converted to accommodate thirty-three beds in double tiers running along each side of the car, and hospital steamers.

The commission also maintained and operated feeding stations and soldiers' lodges, similar to our present-day U.S.O., and furnished financial assistance to the families of deceased or wounded soldiers by raising funds by private contributions from churches and charity organizations.

Although the U.S. Sanitary Commission was founded and financed by the Federal Government, its financing was inadequate to meet its needs, and the deficit was made up by private contributions, mainly from local charities which later affiliated themsleves with the parent organization.

But a goodly part of the funds were raised at "Sanitary Fairs," staged across the North in various cities to raise money. On several occasions, President Lincoln was called to speak at these war rallies, and these patriotic gatherings gave him the sounding-board he needed to express and reiterate the nation's war aims.

There was another side to the U.S. Sanitary Commission's operations, however, and that was the "unofficial" service it performed as a war propaganda office—not unlike our World War II Office of War Information.

Every government at war needs a propaganda service to keep the public's interest in the fracas at fever pitch and to provide counter-propaganda to refute that of the enemy.

The Sanitary Commission was no exception to this rule of thumb.

To counteract Southern propaganda generated against the North by disseminating stories about the North's "invasion of Southern terri-

tory" and the "atrocious treatment" of Southern prisoners of war, the Sanitary Commission's propaganda service, acting with the radical Committee on the Conduct of the War as well as the Union League, tried to outdo each other in the spreading of "atrocity stories."

And these atrocity stories professed to reveal rebel depravity, and to show the felonious and savage nature of the Southerners.

Nor was the Lincoln Administration lax in its efforts to "create a favorable atmosphere" in European circles toward its war aims.

Journalists and churchmen were sent to France and England to promote sympathetic attitudes toward the Union cause; but this propaganda, for the most part, fell on deaf ears. Many people were convinced that neither side was in the right.

The Fort Pillow Massacre in April 1864 gave the Sanitary Commission's propaganda sideline, as well as the Committee on the Conduct of the War, the propaganda ammunition they needed to support the Union's war aims in the abolishment of slavery.

On April 12, 1864, six thousand cavalry men, under the command of the Confederate General Nathan Bedford Forrest, approached Fort Pillow, a military redoubt located on the Mississippi River at the Tennessee border.

The garrison of the Federal fort, commanded by Major Booth, included two hundred sixty-two Negro soldiers led by white officers.

General Forrest, a brilliant officer and the central figure in the desperate affair, had a battle record that stretched from Shiloh to Murfreesborough and Chickamauga, names with blood on them.

Known for his fearlessness in battle, Forrest had fifteen horses shot under him, and his strategy and tactics were classic military maneuvers.

"War means fighting and fighting means killing," he had said; and he lived up to every word of his statement.

Forrest, under a flag of truce, it was later learned, served notice on the Federal officers in the fort that he would storm the place unless they surrendered.

While the truce was in effect, Forrest violated the rules of war by attacking the fort. In the violent action, more than half the garrison was killed or buried alive, including two hundred

sixty-two Negro troops massacred with "no quarter" shown.

When word of the Fort Pillow massacre reached the North, Senator Ben Wade, and Congressman Daniel W. Gooch of Massachusetts, investigated the affair, interviewed the Union survivors and eyewitnesses, and came up with a report.

It read:

> ... at least three hundred were murdered in cold blood after the post was in possession of the rebels and our men had thrown down their arms and ceased resistance.
>
> Men, women and children, were shot down, beaten and hacked with sabres; children not more than ten years old were forced to stand up and meet their murderers while being shot; the sick and wounded were butchered without mercy, the rebels even entering the hospital buildings and dragging them out to be shot.
>
> Some were shot in the river; others on the bank were shot and their bodies kicked into the water, many of them still living, but drowning amid cries of "No Quarter!" "Kill the damn niggers!"

Forrest, who was undoubtedly to blame for the massacre, reported to Richmond that "after the surrender demand was refused [he] stormed the fort, and after a contest of thirty minutes captured the entire garrison, killing five hundred and taking one hundred prisoners, and a large amount of quartermaster stores. The officers of the fort were killed including Major Booth, commanding. I sustained a loss of twenty killed and sixty wounded."

What had begun as a battle ended as mass murder, and some of Forrest's men, horrified at what they were seeing, were powerless in trying to stop it; but they did try, although to no avail.

When news of the massacre reached the ears of President Lincoln, he realized, as horrible as the massacre was, that the unprecedented incident in the war, propaganda or no propaganda, truthful or not, came as a boon to the Federal cause.

It was a fact that the South could not deny. In the eyes of the Northern Abolitionists, it called for retribution, and they clamored for it. If the Wade-Gooch report had been "embroidered," there was at the same time a great deal of truth in it.

A towering figure in nineteenth-century American letters, Walt Whitman served during the Civil War as an aide in camp hospitals. The experience is reflected in his maturer poetry.

From a photograph in the author's collection.

In a speech delivered at a Sanitary Fair in Baltimore, President Lincoln said:

A painful rumor, true I fear, has reached us of the massacre by the rebel forces at Fort Pillow, in the west end of Tennessee, on the Mississippi River, of some three hundred colored soldiers and white officers.

There seems to be some anxiety in the public mind whether the government is doing its duty to the colored soldier, and to the service, at this point ... it is a mistake to suppose the government is indifferent to this matter, or is not doing the best it can in regard to it ... we are having the Fort Pillow affair thoroughly investigated; and such investigation will probably show conclusively how the truth is.

If there has been a massacre of three hundred there, or even a tenth part of three hundred, it will be conclusively proved, the retribution shall as surely come. It will be a matter of grave consideration in what exact course to apply the retribution; but in the supposed case it must come.

Lincoln was speaking as a lawyer and, as it turned out, the story was truthful. Talk about it lasted a long time, but the Fort Pillow affair was swallowed up in the noise and clamor of bloodier battles yet to come.

The United States Sanitary Commission, while operating as a propaganda service, went on to function in a more important field—the care of the wounded soldier and his family.

In its ranks was Clara Barton, who later founded the American Red Cross, and who worked at her desk in the Patent Office dispensing and dispersing medical supplies and medicines to the various field hospitals.

Other Sanitary Commission volunteers worked unceasingly, helping to raise hygienic standards in the camps, military bases, and military hospitals which, at best, were places of fearful incompetence. In those days, despite the efforts of the Sanitary Commission, there were many soldiers who did not survive the crude surgery of inexperienced doctors. If a wounded soldier survived an amputation, he wasn't only lucky. He was an iron man.

One Union soldier, ordered to a hospital, refused to go, on the grounds that he would rather take his chances on the battlefield than come under the incompetent hands of the army surgeon.

"I insisted on taking the field," wrote the soldier from Ohio, "thinking that I had better die by rebel bullets than Union quackery."

But the Sanitary Commission served its dual purpose; and it was no secret at the time that, while millions of dollars went into the pockets of the war profiteers, many of those millions found their way into the U.S. Sanitary Commission's and Christian Commission's accounts for the care of the wounded soldiers and their families.

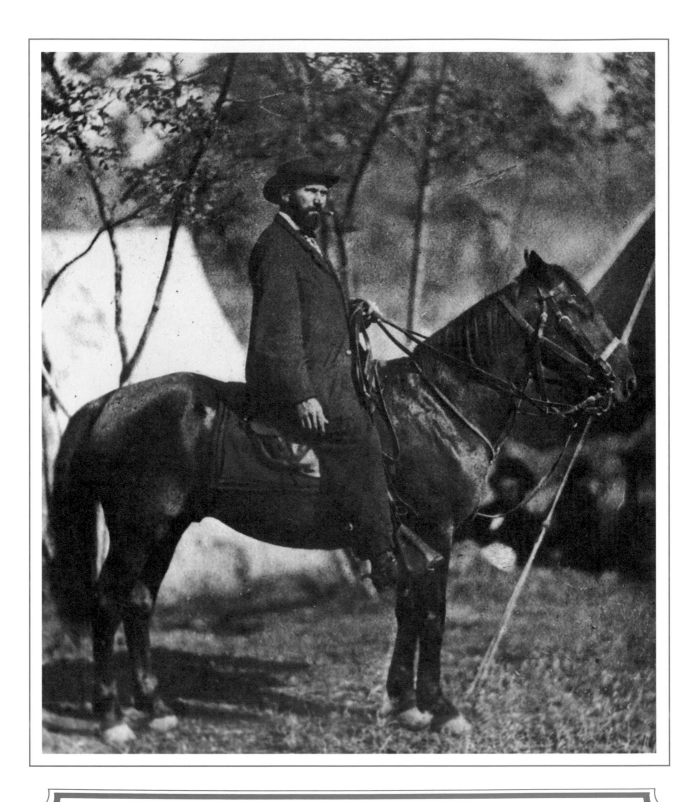

Allan Pinkerton, "Major Allan," was photographed by Brady on the battlefield of Antietam, Maryland, in October 1862.

From a photograph by Mathew Brady. Author's collection.

Allan Pinkerton—
master detective and Union spy

On a freezing cold, rainy night in Glasgow, Scotland in November 1839, Allan Pinkerton, age twenty, was about to take part in a secret Chartist military raid on Monmouth Castle.

The main object of the raid was to force the release of another Chartist, Henry Vincent, who had been jailed there.

The Chartists, made up of a large segment of Great Britain's starving millions of factory and mill workers, had formed "a revolutionary democratic agitation" movement, designed to relieve their grinding poverty and abolish their deplorable working conditions.

The demands of the Chartists were simple and reasonable. The "Heart of the Movement," the "People's Charter," covered six points: "equal electoral areas, universal suffrage, no property qualifications, vote by ballot and annual parliament."

Led by John Frost, Glasgow's former mayor and justice of the peace, this ragged, poverty-stricken "army" of wretched mill workers marched on Newport in a pouring rain, Allan Pinkerton in the forefront.

Crudely armed with picks, shovels, sledges, axes, and antique guns, they formed in a field outside the castle to await two other contingents that were to also take part in the raid.

Unknown to Frost and Pinkerton, the shuttered windows of the Westgate Hotel, facing the town square, concealed a company of the King's Forty-seventh Foot Regiment, ready to bushwack them.

When the marching ragamuffins got well within the square, the soldiers opened fire. The result was mass execution. The bodies of the dead and dying Chartists lay scattered all over the pavement.

Frost and other Chartist leaders were arrested and condemned to death; but before sentence could be carried out, public pressure forced their release. But Allan Pinkerton, "a most ardent Chartist," had a price on his head.

The Chartists and the "moral-face" groups

battled well into 1842, during which time Pinkerton's friends had kept him well-hidden.

Some weeks before, Pinkerton had met and fallen in love with Joan Carfae, a pretty bookbinder's apprentice and Unitarian choir singer "with whom I got to sort of hanging around with . . . and knew I couldn't live without. . . ."

When Joan learned that he was wanted by the police, she went looking for him, having learned of his hiding place from his friends in the cooper's union.

He told her he "was all set to make American barrels," and that it was going to be lonesome "without his bonnie singing bird around the shop."

They were secretly married in Glasgow on March 1, 1842; and after tearful goodbyes to his mother, "with whom he was very close," and his brothers Robert and William, the couple were smuggled aboard ship by a former employer, Neill Murphy.

They sailed for America the next morning. The ship's captain gave them "a snug apartment as man and wife," and Allan paid for their passage by working as a deck hand.

Four weeks later, after a stormy passage, the ship arrived off Nova Scotia and became icebound, "slipping her cable, and striking a rock." Taken ashore in lifeboats with the rest of the passengers, the couple booked passage for Quebec on a coaster "with only their health and a few pennies."

A year later, the young couple came to the United States, where they settled in Dundee, a small Scottish village fifty miles from Chicago. Here, "in this fair and lovely spot," Allan Pinkerton built a one-story log cabin, after the fashion of the time, for himself and his bride, amid " . . . noble hills, sunlit valleys and opulent herds of the district."

In the shed behind the cabin he set up his shop for making barrels and casks, and hung out his sign: "ALLAN PINKERTON, COOPERAGE." He worked hard, "up at 4:30 A.M., 7 days a week, bed at 8:30 P.M.," and in time he "built up a comfortable business."

His first introduction to what would become his chosen life's work seems to have been destined, and came about inadvertently.

One day, while cutting wood on a small island in the Fox River, he stumbled upon the remains of a campfire. His curiosity aroused,

"since no one picnicked in those days," he decided to investigate. One night he heard a boat approaching, and in the moonlight he saw several men jump ashore.

He notified the Kane County sheriff, and together they watched the strange men, who turned out to be a gang of horse thieves and counterfeiters, all of whom they arrested.

The attendant publicity brought two storekeepers to see him, "with a little job in the detective line." The storekeepers, I.C. Bosworth and H.E. Hunt, were certain that counterfeiters were passing "wildcat" money in their stores, but they had no proof, only suspicion.

"But what do I know about that sort of thing?" was Pinkerton's answer to their offer of a job.

"You helped to break up the coney gang and horse thieves on Bogus Island, didn't you? We're sure you can do this sort of work, if you only will."

That conversation was the beginning of one of the greatest police-detective careers in the annals of law enforcement.

Not long afterward, Hunt came to see Pinkerton to inform him that two counterfeit ten-dollar bills had been passed in his store. The bills, easy to copy, had been issued by the Wisconsin Marine and Fire Insurance Company, and personally backed by George Smith, a wealthy and highly respected frontier banker.

Meanwhile, a stranger, who later turned out to be John Craig, a counterfeiter, arrived in Dundee and began asking the whereabouts of Old Man Crane, also suspected of flooding the town with "wildcat money." Pinkerton knew Crane by reputation; and gaining Craig's confidence, he bought $125 worth of counterfeit bills from him with marked bills.

Days later, Craig was arrested by Pinkerton and a Cook County deputy sheriff, and found to have the marked bills in his pocket. But Craig's arrest taught him a lesson in human nature.

A corrupt police officer allowed Craig to escape for a price, "and a certain law officer was much richer than he had been."

Craig's arrest in Chicago brought vast changes in the lives of the Pinkertons. When William L. Church, sheriff of Cook County, offered the budding detective a deputy's appointment, Pinkerton accepted immediately.

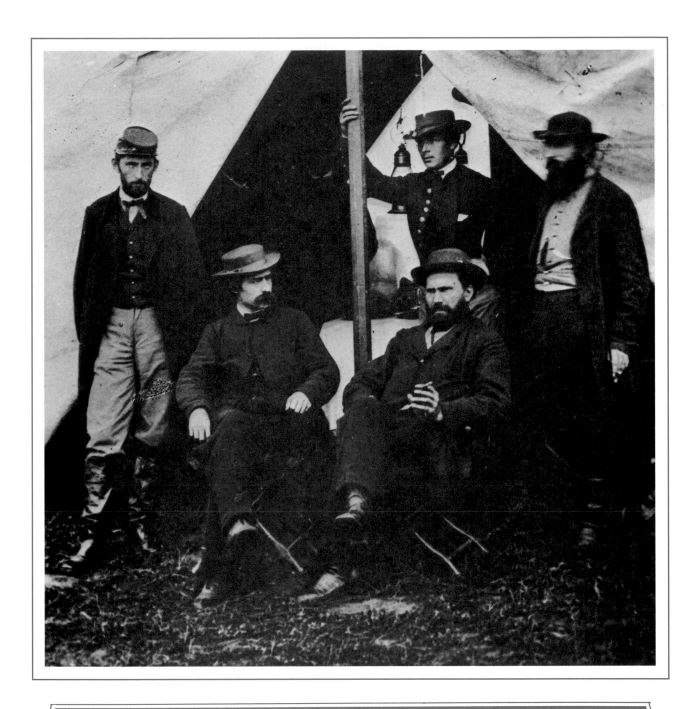

"Major E.J. Allan" and his men were photographed in camp at Antietam in 1862. Left to right: probably Lieutenant George Bangs, standing; E.B. Bradbury and Allan Pinkerton, seated. Standing behind Pinkerton is Timothy Webster, next to an unknown Union Army scout.

From a photograph by Mathew Brady. Author's collection.

The Pinkertons went to Chicago, where they took up residence in a white frame house—a far cry from the homes they had known in the Glasgow slum, known as Gorbals, where Allan was born on August 29, 1819.

Allan was the son of a police sergeant. When Allan was ten years of age, his father was severely injured during the Chartist riots and never walked again. He died four years later, when Allan was fourteen.

Allan was a husky youth who could take care of himself, and the slum environment didn't break down his confidence in himself, though it easily might have. Gorbals, known for the number of brothels (or she-bangs), robberies, and murders, was a district of dirty, ramshackle buildings dating from the Reformation.

Sudden death walked the dark streets and alleys like a stalking tiger, where the body-snatchers, lurking in doorways, armed with pads soaked with chloroform, attacked and quickly dispatched their victims, whose corpses ended up on the medical school's dissecting table, still warm.

But poverty never defeated the Pinkertons, for there were close family ties between his brother Robert, himself, and his mother. To help support the family, Allan became a cooper, joined the union, became an "ardent" Chartist, and took an active part in their demonstrations.

In appearance, Allan Pinkerton was of medium height, and powerfully built, with a round, pleasant face, and brown hair. "His searching blue-gray eyes never left your face when he spoke to you." With intense drive, this taciturn man could swing a ten-pound hammer for hours without tiring.

And it was this stamina that came to his rescue on many occasions when dealing with thugs and criminals.

The Pinkertons liked Chicago. The bustling prairie city and meat-packing center boasted a population of sixteen thousand persons, with theaters, new stores, and churches ready to provide sources of diversion.

On the ominous side, "outlaws of every description, white, black and red," raised the crime rate daily.

His reputation as deputy sheriff and his integrity prompted Mayor Boone to appoint him as Chicago's only detective, and Allan's first case in this capacity was an unarmed encounter with armed thugs, whom he subdued with his bare fists.

His reputation and integrity as a police officer were not lost on Chicago's underworld, and there were many attempts on his life.

At one time, he was shot at by a gunman from ambush, "the two slugs shattering the wrist bone . . . passing along the bone to the elbow, where they were cut out by the surgeon, together with a piece of coat."

Crime continued to mount across the nation during this period. Organized gangs were in full control of sections of cities like New York, Chicago, and San Francisco. And it was unsafe to walk the streets of New York, especially in the ghettos, where victims disappeared without a trace.

In 1850, Allan Pinkerton opened his own detective agency, which prospered almost at once and still bears his name today. Among his clients were several large railroads, among them the Illinois Central, Michigan Central, and the Burlington railroads. And he gained a national reputation for apprehending the criminals involved in the Adams Express Company robberies.

In January 1861, prior to the outbreak of the Civil War, Pinkerton's operatives, working on a case in Baltimore involving Confederate sympathizers sabotaging the Philadelphia, Wilmington and Baltimore Railroad, uncovered a plot to assassinate President-elect Abraham Lincoln while enroute to Washington for his inauguration.

For the first two years of the Civil War, Allan Pinkerton and his operatives worked as army secret service agents behind the lines in Georgia, Tennessee, and Mississippi—a dangerous activity, at best.

Timothy Webster, one of his best operatives, was caught and hanged in Richmond as a spy; and Pinkerton, himself, was almost caught when a barber he knew perceived the detective's disguise and almost gave him away.

Pinkerton's first encounter with a female Confederate spy in Washington had all the makings of a musical comedy, which disquieted him, "and made his blood boil."

Mrs. Rose O'Neill Greenhow, "a tall, striking brunette, with flashing black eyes, and a patrician manner of a woman born of royal blood,"

used her wiles and sexual attractiveness on young Union Army officers. Rose "got around," so to speak, and it was a matter of common knowledge in some quarters that she "traded her favors for important military information."

One stormy night in August 1861, Pinkerton and three operatives—John Scully, Pryce Lewis, and Sam Bridgeman—were watching Rose's house on Sixteenth Street from a small park across the street, "hiding under the dripping trees." A young Union officer ducked into the house, and was seen to enter the living room with Rose.

Through the living room window, they saw the officer give Rose a map, and overheard him describe to her the strength of the fortifications around Washington.

Moments later, the officer and Rose "went upstairs arm in arm," returning an hour later. After a goodnight kiss, the officer left.

Leaving his men to watch the house, Pinkerton followed the officer, "in his stocking feet," the rain coming down in sheets. Realizing he was being followed, when the officer reached his barracks he called the provost guard, reported that he was being followed, and went inside.

Pinkerton, much to his embarrassment, was arrested. Refusing to reveal his identity, he was placed in the brig. Next morning he managed to get a message out to General Winfield Scott, who had him released. Not long after, Rose was arrested and placed in Old Capitol Prison, "where she held court like a queen."

At the close of the war, he re-opened his agency, establishing branch offices in Philadelphia and New York. His activities read like a "Penny-Dreadful."

In 1877, he and his agency apprehended the ghouls who tried to steal the body of Abraham Lincoln from its tomb in Springfield.

The criminal who conceived the scheme, Big Jim Kenealy, was arrested on information dropped inadvertently by a woman of "dubious character" who had overhead a member of the gang boast "that he was going to steal Lincoln's bones!"

The body was to be held for ransom, hidden in the Indiana Dunes.

Curiously enough, since there was no statute dealing with graverobbing, Robert Lincoln, the late President's son, could only charge the criminals with stealing a $75 coffin, for which crime they drew a year each.

Sadly, in the spring of 1880, Allan Pinkerton, aged sixty, suffered a massive stroke which all but paralyzed him completely.

But being the man he was, he refused to retire, and conducted business at his office each morning from a wheelchair, "checking reports, dictating for hours," while the office was managed by his son William.

About a year later, exciting newspaper headlines announced that Frank and Jesse James and their gang had robbed a Chicago and Alton express train at Buel Cut in Jackson County.

While Pinkerton operatives searched for these desperadoes, Allan Pinkerton received word at home that Jesse James had been shot and killed in his own home by Bob Ford, one of the gang.

Fred and his brother Charlie were caught and indicted for murder, and in October Frank James gave himself up to Governor Crittenden, in the governor's office. Frank was also indicted for murder, and literally got away with it. He was pardoned by one of Missouri's soft-headed supreme court judges, John W. Henry, and subsequently acquitted.

On the afternoon of July 1, 1882, Allan Pinkerton, one of the nation's greatest detectives, died quietly in his home. His wife, his daughter Joan, and his beloved sons Robert and William were at his bedside.

Thus came to a quiet end the fabulous career of one of the nation's greatest detectives, the founder of the oldest, most respected detective agency, which London's newspapers once referred to as "The American Scotland Yard."

It was his credo "that a detective of considerable intellectual power, and knowledge of human nature, as will give him insight into character, could break any criminal." Pinkerton was the "right man at the right time."

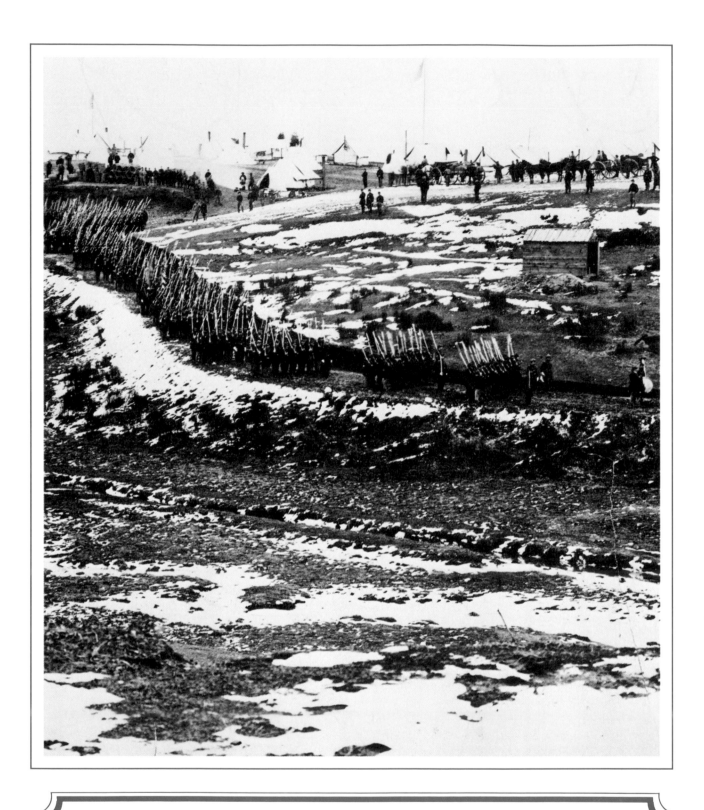

The Army of the Potomac in winter quarters near Alexandria, Virginia. Snow partially covers the ground as the troops move out of camp.

From a photograph by Brady

Civil War Spies

Norman Judd, a member of the Lincoln inauguration party traveling from Springfield, Illinois to Washington, D.C., and who was instrumental in frustrating the plot to assassinate President-elect Lincoln when he reached Baltimore, was the first man to see the necessity of establishing a military secret service.

In a letter to President Lincoln on April 21, 1861, Judd suggested that Allan Pinkerton, the famous Chicago detective, be appointed to head the organization. Wrote Judd:

"Dear Lincoln:

"Pinkerton's men can live in Richmond and elsewhere in perfect safety. Of course, secrecy is the keynote to success. I believe that no force can be used to so good advantage in obtaining information.

"If you approve," he wrote, "Pinkerton can come to Washington and arrange details. I have no doubt of the importance of this, surrounded as you are by traitors. . . . Our people expect you will call out immediately 300,000 men, and

that they will not remain cooped up in Washington waiting for events; but that your active military will be in Virginia, with Richmond for its seat. Aggression is the only policy now . . . our people are crazy with excitement and furor."

On that same day, Allan Pinkerton offered his services to President Lincoln, and the U.S. Secret Service was born.

Allan Pinkerton became "Major E.J. Allan" (his cover name); and his top agents, carefully chosen from his staff in Chicago, became military operatives, personally assigned to work behind the lines of the Confederacy.

Although highly trained in civilian detection procedures and in the apprehending of criminals, at the same time they were completely untrained in the evaluation of military information, such as troop movements and the use of secret military codes which came into use later in the war.

Nevertheless, they were brave men, willing

to risk their lives in gathering this military information; and before the war was over, many did lose their lives, hanged as spies.

Among the Pinkerton operatives active as spies were young Timothy Webster; Sam Bridgeman; and Pryce Lewis, a true Londoner whose cover name was "Lord Tracy." Lewis posed as a British peer, with Sam Bridgeman acting as his footman and body servant.

Handsome, debonair, the "James Bond" of the Civil War, Pryce Lewis was a natty dresser, with English-cut clothes, red, Russian leather boots, and a stovepipe hat which topped a head of brown curly hair and long sideburns.

Sam Bridgeman, his footman, was the direct opposite: rotund, with pale blue eyes, a flat, florid face, and a short, wiry build.

They moved freely about Richmond, and successfully passed themselves off as an English baronet and footman.

In 1861, Washington, D.C. was a hotbed of secessionists, most of whom worked for the Government, and they freely passed military and Governmental information through the lines with impunity.

There were even active spies wearing U.S. Army uniforms, among them Colonel Thomas Jordan, an officer on General Winfield Scott's staff.

Jordan passed on his information to his paramour, Mrs. Rose O'Neal Greenhow, the wife of a prominent medical doctor and artist, Dr. Charles Robert Greenhow. She, in turn, sent the information south by courier on horseback.

Dr. Greenhow, from all accounts, didn't seem to mind the fact that his wife was the lover of this officer and obtained information from him in return for her "favors."

Nevertheless, Rose O'Neal Greenhow was the first self-appointed female Confederate spy. She extracted military information from Colonel Jordan that spelled defeat for the Union Army at the Battle of the First Bull Run.

Her message to General Pierre Toutant Gustave Beauregard, commander of the Confederate Army at Manassas Junction, Virginia, that "McDowell [plans] to move on Manassas tonight," gave him the time he needed to gather his forces into battle formation behind Bull Run Creek.

Rose O'Neal Greenhow, at first regarded as a neurotic nuisance, was watched and caught passing and receiving military information by Allan Pinkerton. For a while, she eluded the Federal agents, but a search of her home revealed a mass of military information which was surprisingly detailed and accurate for such an inexperienced spy.

Rose was arrested and placed in Old Capitol Prison, where she promptly turned her cell into an information center—all under the noses of the guards "whom she captivated" by her good looks.

Rose even had her society lady friends working in her behalf. They were prepared to cut the telegraph lines in and out of Washington, and almost did before the plot was discovered.

But Timothy Webster, one of the brightest of Federal secret agents working in Richmond, didn't fare as well as Rose Greenhow did.

Webster made his way to Richmond without mishap and began his spy activities in hotel lobbies and bars where Confederate officers and agents congregated, posing as a sympathizer. But Webster was caught, arrested, given a quick trial, and sentenced to hang.

The Federal Government tried to intercede in Webster's behalf, but President Jefferson Davis refused to acknowledge the request for clemency, a decision he would live to regret.

Allan Pinkerton, worried about his operative, went to see Secretary of War Edwin M. Stanton. Stanton promised to help save Webster's life, but Stanton "was little disposed to assist the others" who sold out Webster to save their own lives.

Stanton never forgave Davis for not commuting Webster's death sentence—and later in the war, when two Confederate spies were caught in New York City, Stanton refused to acknowledge Davis' plea for clemency.

John Y. Beall and Captain Robert Cobb Kennedy, the spies, died on the scaffold on Governor's Island, their pleadings to be shot ignored by their captors. Stanton had a long memory.

Timothy Webster's hanging as a Federal spy was turned into a public spectacle in Richmond. Webster, too, had pleaded to be shot, but his plea was also refused.

He was taken from his cell in Castle Thunder Prison, and brought to Camp Lee, located on Richmond's fairgrounds. Weak and ill, unable to walk, he was taken to the scaffold in a carriage before sunrise, accompanied by Hattie

Lawton, another Federal spy who attended him as a nurse.

Since the Confederate Government had no official executioner, the jailer of Castle Thunder was given the job of hanging Webster.

According to one Richmond reporter, "Webster treated his approaching death with scorn and derision" and his hanging was nothing short of pathetic, frightening in all aspects.

The provost guards dragged him up to the scaffold platform and placed the noose around his neck. The trap was sprung prematurely, and the noose slipped down around Webster's waist. Webster fell to the ground with a bump, was again picked up by the guards, and dragged to the platform.

This time, the hangman slipped the noose around his neck and held it there; but the rope was tied so tightly that Webster's face turned a bright red. "I suffer a double death" were Webster's last words.

Military espionage in the Civil War was just as dangerous an occupation as it is today. During the Civil War, military rules were strict, and execution was swift.

The Union spies were dedicated men and women, and a few lived to tell about their experiences. Among them, Allan Pinkerton himself had had a few narrow escapes, twice nearly losing his life.

For the most part, spies in the Civil War were unsung heroes.

The famed locomotive, "General," of the Western and Atlanta Railroad, was principal fugitive of the Great Locomotive Chase. After its capture by Andrews' Union raiders at Big Shanty, Georgia, the "General" sometimes developed speeds of close to ninety miles per hour. Despite the uncertain roadbed, the "General" managed to remain on the tracks, a testimonial to its builders.

Courtesy, Louisville and Nashville R.R., Chattanooga, Tenn.

The Andrews Raid, or "The Great Locomotive Chase"

The place was Atlanta, Georgia. The date was June 7, 1862. In the courtyard of the Atlanta jail, seven Union soldiers, including their captain, James J. Andrews, were about to be hanged as spies for stealing a locomotive and train in one of the most daring military raids in railroad annals.

As the men were brought out into the courtyard and onto the scaffold, nooses were placed around their necks. In a few moments, the trap was sprung and it was all over. The remaining twelve Union soldiers who had also taken part in the raid, including two who had later joined the raiding party but had not been able to board the train at Marietta, Georgia, had their courtmartial suspended temporarily, and were returned to prison.

Not long afterward, with the same amount of courage and daring, the twelve prisoners attacked their guards and made their escape in broad daylight; but six were recaptured and returned to prison, where they languished until their exchange in March 1865, a month before the end of the war. The remaining eight succeeded in making their way to the Union lines, with a wild tale to tell.

It all began with the Federal occupation of Nashville, Tennessee by the Army of the Ohio, under Major General Don Carlos Buell. Shortly before the Battle of Shiloh, Buell and his Army of the Ohio were ordered west to join General Ulysses S. Grant's forces. Buell had left a small garrison at Nashville, and another small force at Cumberland Gap.

Buell left a third force of about eight thousand men, under Major General Ormsby McKnight Mitchell, to guard the region south of Nashville against any surprise moves the Confederates might make from that quarter.

Major General Henry Wager Halleck, the self-styled master of military strategy and Chief of Staff in Washington, probably the most inept, unimaginative general officer in the Union Army, left Mitchell with discretionary

orders which had been born of a confused mind and an ignorance of the true state of the military situation.

Halleck had advised Mitchell to occupy Fayettesville, twenty-eight miles from Huntsville, Alabama, a Confederate stronghold, with special orders to occupy, if possible, the Memphis and Charleston Railroad there, or at Decatur, Georgia if the situation allowed it. Otherwise, he was to "act according to circumstances."

General Ormsby McKnight Mitchell, the officer who received these instructions, was a vainglorious character. A former college professor with little or no military experience or training, he had an overpowering ambition for public recognition as a great soldier-hero. Guarding a railroad and waiting for something to happen in a back area presented little opportunity for the making of war heroes; nevertheless, Mitchell was "on his own," and he intended to "provide himself" with the opportunity for glory, if none presented itself in the natural course of events.

Mitchell's "opportunity" arrived in the person of James J. Andrews, a former quinine salesman turned spy and soldier for General Buell, who used his former occupation as a "cover" for his spying activities. Andrews was a brave man who wasn't afraid to take chances, even though General Buell had serious doubts as to his spying abilities. And if Mitchell needed a man to help him in his quest for military glory, Andrews was that man.

General Mitchell realized that the relief of east Tennessee, "with its loyal population," was a matter close to the hearts of both President Lincoln and Secretary of War Edwin M. Stanton. Moreover, both Mitchell and Andrews were under the shadows of mightier military soldiers and spies; and so it was only natural that they collaborated in their bid for fame.

They both knew that Chattanooga, an important railroad terminal, was lightly garrisoned, and that capturing it would glorify them for a long time.

Andrews' plan was audacity itself. He would take twenty trained men through enemy lines to Marietta, Georgia, two hundred miles away, on the line of the important Western and Atlantic Railroad. They would then steal a train, cut the telegraph lines, and run the stolen train northward to Chattanooga, burning the bridges behind them! At the precise time the train was stolen, Mitchell would attack and occupy the Memphis and Charleston Railroad at Huntsville, Alabama, cutting communications both west and south. This done, Chattanooga would be open to capture and occupation, without interference.

Precise timing and coordination were the keys to the success of the wild scheme, and Mitchell and Andrews agreed on Friday, April 11, 1862, as the zero hour for the joint capture of the Memphis and Charleston Railroad, and the theft of the train.

Exchanging their uniforms for civilian clothes, Andrews and his raiders left on their mission separately, working their way south in small groups to various stations along the way, taking different trains to their agreed meeting places, telling inquisitive strangers that they were Kentuckians on their way to join the Confederate Army.

On April 11, Mitchell, right on schedule, attacked Huntsville, Alabama at six a.m., routing the small garrison, and capturing a number of freight cars and fifteen locomotives. He then placed his force across the rail line. Act one of the drama went off without incident.

But the vain Mitchell wasn't content to let matters stand as planned and agreed with his cohort, Andrews. Instead, he sent a detachment along the tracks eastward, destroyed several bridges, and captured five more locomotives.

He made an attempt to destroy an important bridge at Bridgeport, and others at Decatur, Georgia; but at Bridgeport, the Confederates beat him to the punch, wrecked the east span, and withdrew. So engrossed had he become in his personal campaign for War Department recognition that Mitchell completely forgot about Andrews and his raiders, and the fact that he had placed them in great danger.

The ambitious Mitchell then telegraphed Stanton at the War Department: "This campaign is ended and I can now occupy Huntsville in perfect security, while all Alabama north of the Tennessee flies no flag but that of the Union."

In his haste to gain fame, Mitchell had ruined his own communication lines, and wrecked the

railroads that could have been put to his own use.

In Atlanta, precisely at six a.m. on the morning of April 12, a day later than agreed upon, Conductor W.A. Fuller "highballed" his engineer, Jeff Cain, at the throttle of the General, hauling the northbound passenger train. Rain was falling as the train pulled out of the station, and in addition to the passenger coaches, three empty boxcars were "dead-heading" to Chattanooga.

While Fuller's train moved toward Marietta, Andrews and his men purchased tickets, boarded another train without undue notice, and rode to Big Shanty, the station selected for the theft of the train.

Aboard the train, Andrews noticed that many trains were running or standing on sidings, a portentous note to his plans. Here it must be noted that most railroads of the period were of the single-track variety, with turnouts every ten miles or so to allow trains coming from both directions to pass each other at given places and times.

As the General pulled into Big Shanty, Andrews and his men scattered throughout the cars, where they heard Conductor Fuller announce: "Twenty minutes for breakfast." And while the passengers and train crew rushed for the restaurant, Andrews and his men dropped off on the opposite side of the train. Andrews himself moved toward the boxcars, while his engineer slipped forward and climbed into the General's cab.

When his men were safely on board the boxcars, Andrews uncoupled the passenger coaches and climbed into the cab. And the train pulled slowly out of the station.

A camp of Confederate soldiers, on the opposite side of the track, took no notice of the departing General and its train; but Conductor Fuller, at breakfast, was startled to hear the sound of the locomotive pulling out of the station.

Quickly followed by his engineer, Cain, Fuller started in pursuit on foot, but Andrews had them quickly outdistanced. Up to this time, Fuller had no way of knowing that the men who stole his train were Federal soldiers, out of uniform. He thought that they were Confederate deserters who would abandon the train as soon as they made their escape.

Andrews, who had obtained copies of train schedules, had familiarized himself with the track he would have to cover. He also knew where he would meet the three trains coming from the opposite direction—two regularly scheduled, and the third, an unscheduled freight. So far, although Andrews had planned carefully, he had made the fatal mistake of waiting a day before he made his move. Nevertheless, by pulling out of Big Shanty, he had gained twenty minutes, and for the moment would have no collisions with unscheduled trains.

Reaching Etowah Station, Andrews saw an old locomotive, the Yonah, standing on a siding with steam up; but seeing that she was slow and old, he didn't stop to disable her—another mistake that would count later.

At Kingston, thirty miles from Big Shanty, Andrews found the train for Rome, Georgia, waiting to transfer passengers from Fuller's train, which Andrews had stolen. But when the General was recognized hauling three boxcars instead of the passenger train, explanations were demanded of Andrews.

Andrews coolly told his inquisitors that he was running a "special," carrying three cars of gunpowder for General Beauregard at Corinth. When Andrews asked about the local freight, he was informed that it was expected at any moment. Andrews then backed his train into a siding and waited. Moments later, the expected freight arrived, its locomotive carrying a red flag, indicating another train following behind.

Andrews kept his head, bellowing at the freight conductor: "What does it mean that the road is blocked in this manner, when I have orders to get this powder to Beauregard?"

The trainman's answer was a shock to Andrews, who suddenly realized his own mistake in delaying his mission by a day. Mitchell had attacked and cut the Memphis and Charleston Railroad, and the trains that escaped were now heading in his direction, southward.

Andrews immediately changed his attitude and became apologetic. His imposing appearance bore validity when he asked if the conductor of the local train would please back his train to a safe distance from the "powder cars." The perplexed conductor complied, and Andrews put on a good act, moving among his questioners while he kept an eye on the telegraph office,

pretending exasperation that there was no train order for him to clear the track ahead of him.

After an interminable wait, the second train arrived; but suspicion was still apparent among his questioners, who little guessed that Andrews' main reason for pretending to wait for a message was to prevent any messages of inquiry going out about him.

Another train now arrived, also carrying a red flag, and Andrews could do nothing but "sweat it out." An hour and a half passed, while Andrews' men in the boxcars waited in breathless silence, expecting to find themselves trapped at any moment.

Finally, the last of the local freights passed into the sidings, and Andrews' "powder train" again headed for Chattanooga. At Kingston, four miles beyond, Andrews stopped to cut the telegraph lines and pry up some rails and was startled to hear a train whistle coming up behind him from the south! He and his men made a run for the train, and started for Adairsville where, according to his schedule, he expected to find the southbound express on a siding waiting for him to pass. Instead, Andrews found the siding occupied by a mixed train, which meant that the express was obviously running late and was somewhere between Adairsville and Chattanooga.

Andrews then decided to chance it and make a run for Calhoun, nine miles away, and get there before the southbound express did. The General was a fast locomotive and could possibly make it, and Andrews "opened her up" to a speed of a mile a minute. Again, Andrews' luck was with him, and he reached Calhoun to find the express train already there. Using his story of carrying powder to Beauregard, he was allowed to pass.

As far as Andrews knew, the express was the last of the southbound trains, and the track was now opened to Chattanooga and safety. Off they went again, ripping up track and cutting telegraph lines. Destroying track was a problem, since they did not have the proper tools for such work. All they had to do now was burn the Oostenaula Bridge, and the rest of the way could be made in safety. While they were ripping up the rails, a locomotive whistle was heard behind them, and they were compelled to abandon the work.

On came Fuller at full throttle. Andrews could only reason that his pursuers could make quick repairs; and unless Fuller's locomotive could be derailed by one of the breaks, burning the Oostenaula Bridge would be impossible.

To make matters worse, rain began to come down, which would soak the timbers.

Fuller, a remarkable, tenacious man, kept up the chase at full throttle. He and his engineer, Jeff Cain, had first started after Andrews in a handcar taken from a track crew. Coming to Andrews' break in the track, the handcar derailed and went into the ditch. It took only a few minutes to get the handcar back on the rails.

At Etowah, Fuller found the Yonah. Commandeering the old engine, Fuller pressed her for all she was worth, and reached Kingston five minutes after Andrews had left! What Andrews never realized was that the three freight trains he had back on a siding were below the "Y" which connected the Rome line with the main line, further slowing up Fuller.

Dropping the Yonah for the engine belonging to the Rome train waiting on the siding, Fuller uncoupled the engine Texas, the same type as the General, and again took up the chase.

Reaching the broken rails at Adairsville, Fuller's train was almost derailed, but the engineer saw them in time and reversed his engine. Near Calhoun, the Texas struck the third break in the track at full speed, but miraculously ran over it without derailing.

Fuller was now only minutes away from his quarry, and Andrews now uncoupled one of his boxcars and let it roll backward, hoping for a collision; but Fuller slowed his engine down until the rolling boxcar met his front coupler. He then pushed the car ahead of him.

As Fuller began to draw closer, Andrews uncoupled his other car. Fuller handled it the same way, but the Texas was slowed down. The two racing locomotives now reached the Oostenaula Bridge, but Andrews couldn't stop to burn it. Meanwhile, the General's water and fuel were running low, and at Resaca, Fuller paused in his pursuit to push the two boxcars into a siding, which again gave Andrews time to cut the telegraph lines.

It now became apparent to Andrews that unless he reached the bridges at Chickamauga and destroyed them, his mission would end in

total failure and capture. The General was pushed to the limit, while the rear end of the boxcar was pushed out onto the track behind him. And the "stringers" Andrews had intended using as fuel to burn the bridges were now dropped onto the track in the hopes of derailing the speeding Texas; but this, too, failed. Andrews then dropped a rail onto the track, on a blind curve. The Texas struck it head-on, with a terrific shock, but it didn't derail, and now matters became desperate.

Running into Dalton, Andrews again cut the telegraph line. Fuel and water were fast being used up, and burning the Chickamauga bridges was a forlorn hope. Now the Texas could be seen, her pilot and tender swarming with soldiers.

Some distance beyond Dalton, Andrews and his men built a barrier across the track to gain time to reach a covered bridge, while they piled wood in the middle of their last car and set fire to it with brands from the engine, now running on her last head of steam.

Despite the rain, the fire caught, and the burning car was hauled onto the bridge and uncoupled on the center span. The bridge roof caught fire, but the Texas caught up, entered the burning bridge and slowly pushed the burning car out into the open and onto a siding.

The end of the chase was now only minutes away, and Andrews, seeing the hopelessness of the situation, ordered his men to jump and make a run for the woods. But Andrews had delayed too long. The woods were full of Confederate soldiers, and one by one, Andrews and his men were picked up.

The daring Andrews and eight of his men received the death sentence by court-martial, and they were executed in Atlanta, Georgia on June 7, 1862.

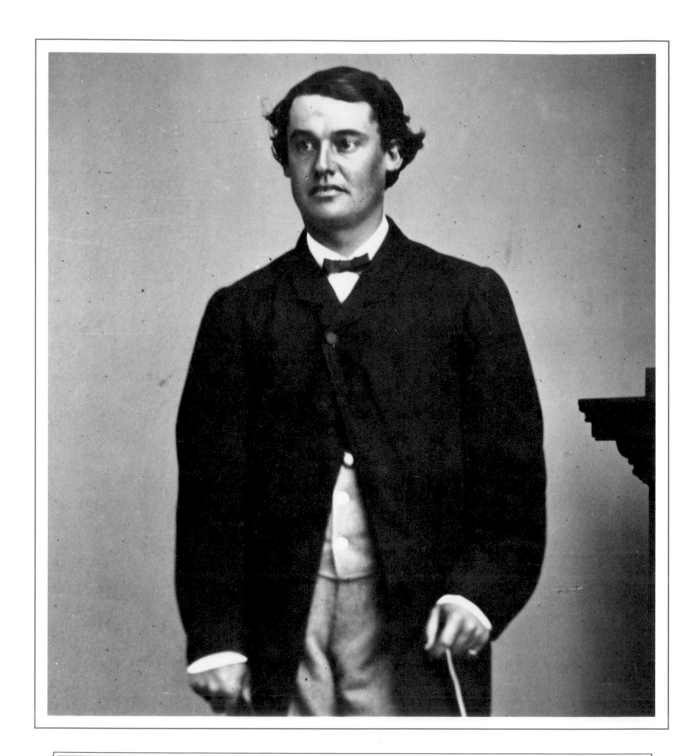

This gun, a Napoleon gun of Cushing's Battery at Antietam, fired a six-pound shot about two miles effectively. A smooth-bore, brass barrel, this gun was used extensively in the field. Sometimes as many as forty of these field pieces were assembled in battery, hub to hub.

Photographed by Brady on the battlefield of Antietam, September 20, 1862. Author's collection.

Abram Stevens Hewitt— Union gunmaker and foe of corruption

On Saturday, August 30, 1830, a railway locomotive, somewhat similar to England's Stevenson's Rocket, stood on the rails of the Baltimore and Ohio Railroad outside Baltimore.

Named the Tom Thumb by its builder, Peter Cooper, and weighing six tons, with thirty-inch driving wheels, the little steam engine had been designed and constructed by its builder in answer to a challenge.

Two years before, the Baltimore and Ohio Railroad, on the verge of bankruptcy because of the inadequacy of its motive power in negotiating the heavy grades and sharp curves of the road's right-of-way, needed a locomotive capable of hauling a string of carriages over the formidable Allegheny Mountains.

Peter Cooper, not believing that this was "impossible," had accepted the challenge to build one that could climb hills.

"I'll knock an engine together in six weeks," he had said, "that will pull carriages at ten miles an hour!" Cooper had made good his boast, and even bettered the speed at more than twelve miles an hour.

John Hewitt, a native of Staffordshire, England, had assisted Peter Cooper in the construction of the Tom Thumb, and was present at this demonstration with his eight-year-old son, Abram Stevens Hewitt. Born on a farm in Rockland County, the boy spent his summers working on the farm, attending elementary schools during the winters in New York City, where his father operated his business.

A month later, on September 18, 1830, in answer to skeptics who challenged the capabilities of the Tom Thumb, the little steam engine entered into a race with a well-known race horse from Riley's Tavern to Baltimore.

The little engine could have easily won the race had it not been for a boiler leak which had developed because of excessive steam pressure.

Young Abram Hewitt and his father had also been present at the race.

In 1841, young Abram Hewitt won a scholarship in a competitive examination, and entered Columbia University in New York City, graduating with first honors in 1845. After graduation, he elected to remain at the university to teach mathematics, at the same time studying for a law degree. He was admitted to the New York State Bar in 1849.

Before starting his second year at Columbia, an incident occurred which changed the entire course of his life. He became friends with Edward Cooper, the son of Peter Cooper and a student at the college, and that summer the two young men sailed for a vacation in Europe to tour the old countries.

On their return trip, the ship they were on foundered in a severe storm in the Atlantic. The boys managed to save themselves, drifting around in an open boat for twelve hours before they were picked up by a passing vessel.

The terrifying experience they shared together cemented their friendship, and upon their graduation, Edward's father, Peter Cooper, presented them with his Trenton Iron Works, and set them up in the foundry business.

The young men formed a partnership under the company name of Cooper and Hewitt, and began the manufacture of iron girders and "I" beams.

A year after the outbreak of the Civil War, Abram Hewitt traveled to England to study the making of gunbarrel iron. When he returned in 1862, he constructed an iron foundry at Weston, New Jersey and introduced the first open-hearth furnace in America, which provided the United States Government with all the gunbarrel production it needed to prosecute the war.

With the close of hostilities, the Cooper-Hewitt Company prospered, and more than kept pace with the growing iron and steel industry. By 1870, the firm produced the first steel of commercial value in the nation; and shortly thereafter, under the expert guidance of the two young industrialists, the company expanded its operations by merging the Ringwood, Pequest, and Durham Iron Works.

In the natural course of events that followed, Abram Stevens Hewitt found himself a force in industry and finance, becoming president of the United States Smelting Company and of the New York and Greenwood Railroad Company, and vice-president of both the New Jersey Steel and Iron Company and the Alabama Coal and Iron Company.

A short time later, he became a director of the Erie Railroad Company, and also of the Lehigh Coal and Navigation Company, one of the oldest companies in America, whose barge canals and picturesque locks are today part of the quaint Pennsylvania countryside around Easton and New Hope.

With the success of his various business enterprises, in 1855 Abram Stevens Hewitt married Sarah Cooper, the only daughter of Peter Cooper, thereby uniting two of the nation's most illustrious families. Theirs was a happy union lasting to the end of their days.

Hewitt's first brush with politics came in 1867, when President Andrew Johnson appointed him commissioner to the Paris Exposition, and his subsequent report on the European steel industry was so well-written that it was translated into several languages.

His close association with Samuel Tilden led him deeper into politics, and, together with his partner Edward Cooper, and Samuel Tilden, Hewitt joined in a campaign to rid New York City and the Democratic Party of "Boss" Tweed, mayor of New York and head of the "Tweed Ring" and Tammany Hall.

William Marcy Tweed, probably the most ingenious political thief in the history of party politics, had an iron grip on New York City, and was bleeding the city treasury white by his fraudulent dealings and thievery.

Tweed was in his element in New York City. If he was controlled politically by Tammany Hall, the city in turn was controlled by "Boss" Tweed. The Civil War, and the two years of peace that followed, had transformed New York into "a city of extremes and contradictions."

Within its boundaries lived the worst and the best. Extreme poverty rubbed dirty elbows with the newly affluent. Incredible slum areas competed for attention with the magnificent mansions of the new millionaires.

One marble palace, in particular, belonged to A.T. Stewart, the multi-millionaire merchant, founder of the famous A.T. Stewart Department Store.

In 1844, it was A.T. Stewart who financed Mathew B. Brady's first Fulton Street gallery, and made it possible for the master photographer to gain an international reputation in

the field of portrait photography.

New York and Tammany Hall spawned "Boss" Tweed, and it was the political cartoons of Thomas Nast that wrecked him. Tweed, strangely enough, had a hero, Samuel Swartout, another political grafter and thief who, in 1837, had stolen a million dollars in Government funds, and literally got away with it by running off to Europe. He was never prosecuted, and it was Tweed's avowed ambition to go Swartout one better.

In that era, Samuel Swartout's name was used as a verb, which meant that to defraud on the grand scale was "to Swartout." As New York's political "Boss," Tweed, a genius at fraud and grand larceny, in the course of three years took the city for $200,000,000.

One of his typical gambits was to pay a carpenter to work at City Hall for a month for $360,747.61. Another time, Tweed paid a plasterer $2,870,464.06 for nine months' work. To this day, no one has figured out what the six cents were for.

Hewitt, Tilden, and Cooper set their sights on Tweed, and while they were successful in reforming the Democratic Party and Tammany Hall, it was left to the cartoonist, Thomas Nast, to bring Tweed and his cohorts to book.

The Nast cartoon that aroused and outraged New York citizens against Mayor Tweed showed the Roman Coliseum, with Tweed and the Tammany Tiger chewing up the citizens and gouging them out of their money.

Nast's amazing cartoon eventually destroyed Tweed, who surreptitiously offered Nast $300,000 and a trip to Europe if he would only stop attacking him in his cartoons.

Tweed ran off to Europe with his spoils, but he was found and extradited to New York for trial. He died in prison.

Abram Stevens Hewitt's reputation for personal integrity and his inherent political ability got him elected to Congress on the Democratic ticket in 1874, after he cleaned out the riffraff of the Democratic Party in New York.

He continued to serve New York in Congress until 1886, holding positions of authority on committees dealing with labor, finance, and national resources.

In 1876, he served as chairman of the Democratic National Committee in the Rutherford B. Hayes-Samuel J. Tilden Presidential campaign of that year.

The crisis that developed during the election, caused by a tie between the candidates, called for drastic action, and Hewitt's proclamation urged the party to take it; but Tilden urged a compromise. Hewitt, acceding to Tilden's wishes, became a member of the committee which drew up the Electoral Count Act, which eventually gave birth to the Electoral Commission, which gave the election to Hayes.

Ten years later, Abram Stevens Hewitt became the Democratic Party's choice for mayor of New York, to run against Henry George, who ran on the United Labor Ticket, and Theodore Roosevelt, who ran on the Republican ticket.

In one of the most exciting elections in the history of New York City, Hewitt won, gathering a plurality of 22,500 votes over Henry George, and 30,000 votes over Roosevelt. His victory was a personal triumph.

Characteristically, Abram Stevens Hewitt's administration was a model of efficiency and excellent city government. The new mayor could not be bought or manipulated by politicians, and his reforms and city improvements were the best the city had ever known.

New York's dire need for public transportation for its teeming population was answered by Hewitt's proposal for the New York Rapid Transit Railroad, an improvement which won him the Chamber of Commerce Gold Medal.

As a philanthropist, Abram Stevens Hewitt was generous, and when his father-in-law, Peter Cooper, founded Cooper Union, today one of the finest schools of university grade for the arts and engineering in the nation, he and his wife donated $600,000.

He was subsequently elected chairman of the board of trustees, a post he held for forty years, and his inspired direction in all its educational and financial affairs made the school what it is today.

His other collegiate appointments included service as chairman of the board of Barnard College; trustee of Columbia University; and trustee of the Carnegie Institution.

Abram Stevens Hewitt, the brilliant son of John Hewitt and Ann Garniers (Gurnee), a member of an old and respected Huguenot family, had made his mark as "a good citizen." Born at Haverstraw, New York on July 31, 1822, he died at the age of eighty-one, at Ringwood, New Jersey, full of years and honors. Peter Cooper Hewitt was his only son.

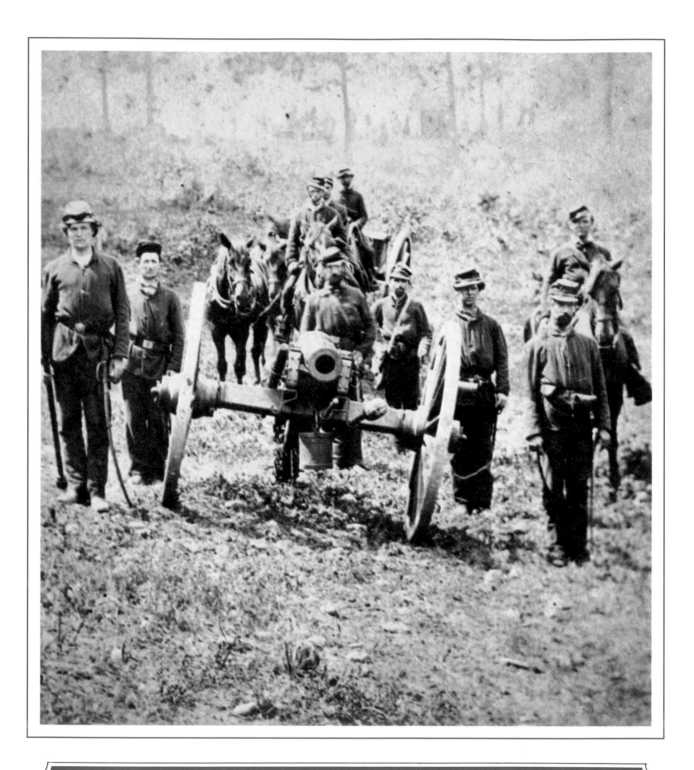

Brilliant industrialist, financier, and philanthropist, Abram Stevens Hewitt helped break the Tweed Ring which was strangling the New York City treasury. Hewitt constructed the first open-hearth furnace for the production of steel in the United States.

From a photograph by Mathew Brady, 1859. Author's collection.

The Battle of Antietam

George H. Putnam, an American student attending the German University of Bremen, walked down the gangplank of the German ocean steamer *Hansa*, which had just ended her maiden voyage at her pier at the foot of the Battery, in New York Harbor.

Putnam had left his studies at the university to return home and enlist in the Union Army. Walking up Broadway, he reached the corner of Ann Street, location of *The New York Herald* offices. Seeing an anxious crowd looking intently at the *Herald*'s bulletin board, impressed by the crowd's silence, he joined the crowd out of curiosity to see what the commotion was all about. The *Herald*'s announcement read:

"A BATTLE IS NOW GOING ON IN MARYLAND, SCARCELY 140 MILES AWAY: AND IT IS HOPED THAT GENERAL McCLELLAN WILL DRIVE LEE'S ARMY BACK INTO THE POTOMAC."

The battle in progress was the Battle of Antietam Creek, near the town of Sharpsburg, Maryland; and the South's first invasion of the North was pronounced by the *New York Herald*'s editor, Horace Greeley, as "the bloodiest day in American history."

Indeed, the battle was unprecedented, due both to its fateful outcome and to its importance to President Lincoln's political fortunes.

On the beautiful fall morning of September 17, 1862, two great armies, totaling more than a hundred and thirty-five thousand men, confronted each other in a magnificent double line more than three miles in length. In fact, at one point in the line, the Union right flank and the Confederate left were so close to each other that the footfalls and subdued voices of the pickets of both sides could be heard.

It was said at the time "that it required no prophet to foretell what would happen in the morning."

As the night stars flickered their last and the morning broke, clear and beautiful, a roar of artillery suddenly rolled over the Maryland countryside on that fearsome day. And the battle opened when Major General Joseph Hooker hurled his eighteen thousand infantry against the thin lines of General T.J. "Stonewall" Jackson and encountered Jackson's men in an open field, pushing them back across the Hagerstown Pike to a line of woods, where they made a stand.

The furious battle raged for fourteen hours—struggles fought in desperation, as only more than a hundred thousand men and five hundred pieces of artillery could make it in close combat.

At the end of the battle at Burnside's Bridge, after the pall of smoke that covered the field had cleared away, one observer noted that "the scene that presented itself made the stoutest heart shudder."

"There lay upon the ground, scattered for more than three miles over valleys and hills, or in the improvised field hospitals, more than twenty thousand men bearing terrible wounds."

Thus it was that George H. Putnam, later Brevet Major, 176th New York Infantry, read the telegraphic reports of the holocaust at Antietam on Mr. Greeley's bulletin board, one hundred and forty miles away.

The Battle of Antietam ended in a draw; but the moral effect of the battle was immeasurable, as it reawakened the confidence of the Northern people, and emboldened President Lincoln to issue his proclamation ending Southern slavery.

The close of the battle also had its side effects, not the least of them being an irresponsible, slanderous story concerning Mr. Lincoln, himself, accusing him of impropriety and questionable conduct when he visited the Antietam battlefield two weeks after the engagement.

It came about this way. Realizing that Lee's army had been badly mauled in the battle but had managed to extricate itself, break off the battle, and re-cross the Potomac River, Lincoln knew that a prompt pursuit of Lee would, in all probability, finish the battle for all time. To President Lincoln's way of thinking, Lee could have been destroyed and the war ended, had McClellan acted with alacrity and brought him to battle again. Since all his pleadings and entreaties with McClellan to act had fallen on deaf ears, Mr. Lincoln decided to pay a surprise visit to his wavering field commander and find out why McClellan did nothing but sit in his camp.

Mr. Lincoln paid his "surprise" visit to Antietam on October 3, 1862. Two weeks after the battle, he suddenly made his appearance in the Union Army's camps. After a long conference, dissatisfied with McClellan's lame excuses for not having pursued Lee, before returning to Washington Mr. Lincoln was escorted over the battlefield by General McClellan, a party of officers, and the President's friend Ward Hill Lamon, marshall of Washington. They rode over the places of interest in an army ambulance.

During the ride, Lamon was asked to "sing a sad little song" at the request of the President. Lamon sang the song, and then one of the party asked Lamon to sing one of his Negro comic songs, among which was "Picayune Butler," and again Lamon complied.

The story of the singing on the battlefield reached the ears of a reporter of the *New York World*, a violently anti-Lincoln newspaper, and this irresponsible reporter decided to make political capital out of it.

The story appeared in the *New York World* and *Essex Statesman*, and was also picked up by the *Chicago Times*, exaggerated out of all proportion to its importance in the retelling. The story was headlined:

LINCOLN UPON THE BATTLEFIELD.

We see that the papers are referring to the fact that Lincoln ordered a comic song to be sung upon the battlefield. We have known the facts about this transaction for some time, but have refrained from speaking of them.

As the newspapers are now stating the facts, we will give the whole. Soon after one of the most desperate, sanguinary battles, Mr. Lincoln visited the commanding general, with his staff, took him over the field in a carriage, and explained to him the plan of battle, and the particular places where the fight was most fierce.

At one point, the commanding general said: "Here on this side of the road, 500 of our brave fellows were killed, and just on the other side of the road, 400 more were slain, and right on the wall 500 rebels were destroyed. We have buried them where they fell."

"I declare," said the President, "this is getting gloomy. Let us drive away." After driving a few roads, the President said: "Jack" (to a companion), "this makes a fellow gloomy. Can't you give us something to cheer us up? Give us a song, and give us a lively one."

Thereupon, Jack struck up, as loudly as he could bawl, a comic Negro song, which he continued to sing while they were riding off from the battle-ground, and they approached a regiment drawn up, when the commanding general said: "Mr. President, wouldn't it be well for your friend to cease his song 'til we have passed this regiment? The poor fellows have lost more than half their numbers. They are feeling very badly, and I should be afraid of the effect that it might have on them."

The President then asked his friend to stop his singing until they got by that regiment. We know that the story is incredible, that it is impossible that a man who could be elected President of the United States could so conduct himself over the fresh-made graves of the heroic dead.

When this story was told us, we said that it is incredible, impossible, but the story is told on much authority, and we know that it is true. We tell the story that the people may have some idea of this four years more of such rule.

If any Republican holds up his hands in horror, and says that this story CAN'T BE TRUE, we say we sympathize with him from the bottom of our soul; the story can't be true of any man fit for any office of trust, or even for decent society, but the story is every whit true of Abraham Lincoln, incredible, and impossible though it may seem.

Ward Lamon, incensed at this outright, slanderous lie, told his friend Lincoln that he should refute the story personally; but Mr. Lincoln refused, saying: "No, Hill; there has already been too much said about this falsehood. Let the thing alone. If I have not established character enough to give the lie to this charge, I can only say that I am mistaken in my own estimate of myself. In politics, every man must skin his own skunk. These fellows are welcome to the hide of this one. Its body has already given forth its unsavory odor."

Lamon, insistent on answering the scurrilous charge, wrote a vitriolic reply, which President Lincoln, when he read it, refused to let Lamon release. Lincoln did sanction Lamon's later, revised reply, which ended in a complete denial of the charge, and admitted that he did do some singing, but not at the request of the President.

"Neither General McClellan, nor anyone else, made any objections to the singing," wrote Lamon. "The place was not the battlefield; the time was 16 days after the battle; no dead body was seen during the whole time the President was absent from Washington, nor even a grave that had not been rained on since it was made."

But Lamon's paper was never made public until long after the incident. Mr. Lincoln had determined to remain silent about the entire distressing affair.

"You know, Hill," he said to his friend, speaking of Lamon's paper, "that this is the truth and the whole truth about that affair; but I dislike to appear as an apologist for an act of my own which I know was right. Keep this paper, and we will see about it."

There ended the matter. In the election of 1864, the country gave Mr. Lincoln another four years in the White House, and the malicious article died of its own lie.

The reporter who wrote the article went into deserved oblivion, and he later turned out to be the same reporter who planted the equally unsavory story, in 1861, that President Lincoln had arrived in Washington for his inauguration, concealed in a Scottish cap and cape to hide from a would-be assassin.

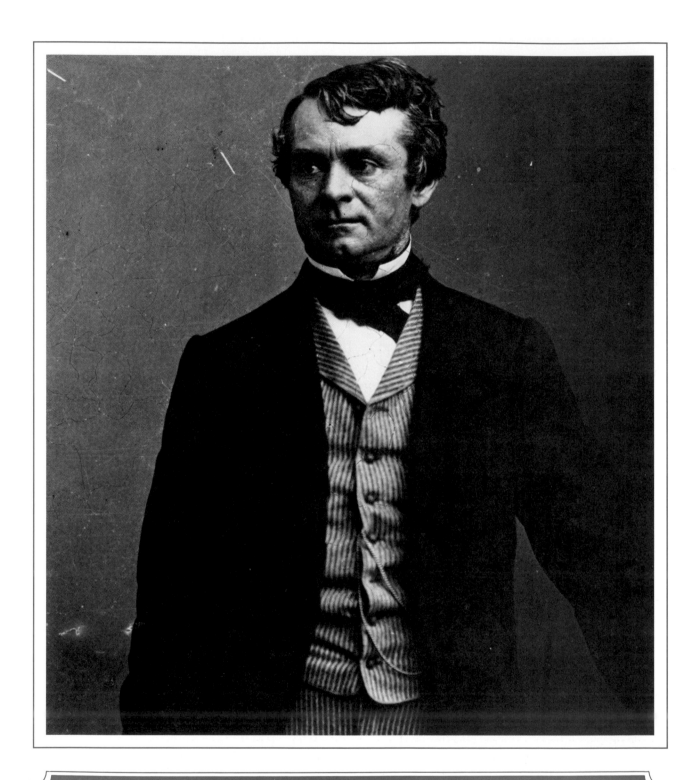

A staunch supporter of the policies of President Lincoln, Governor Andrew Gregg Curtin of Pennsylvania was among the first of the Northern governors to recruit regiments to fight the Civil War.

From a photograph by Mathew Brady, 1861. Author's collection.

Andrew Gregg Curtin— the "soldier's friend"

On September 24, 1862, a week following the bloody Battle of the Antietam, one of the most critical of the Civil War, the governors of the Northern states gathered at Altoona, Pennsylvania for a meeting of great importance.

They met in response to an invitation extended by Andrew Gregg Curtin, governor of Pennsylvania, to discuss ways and means "of taking measures for the more active support of the Government."

Earlier in the month, Governor Curtin, in a letter to Count Adam Gurowski, a State Department translator, political gadfly, malcontent, and meddler, wrote that " . . . besides doing my own proper work, I am sadly but firmly trying to help organize some movement, if possible, to save the President from the infamy ruining his country."

Count Gurowski, a self-appointed critic of President Lincoln and the war policies of his Administration, had been vociferous in his calamity-howlings. As a pseudo-intellectual, nursing an overblown ego, Gurowski had taken it upon himself to publish a diary in which he severely criticized members of the Cabinet, the President, and the Government itself, which had paid him a salary as a State Department translator.

Wrote Gurowski: "Lincoln is a simple man of the prairies, and his eyes penetrate not the fog, the tempest. He begins now already to believe that he is infallible; that he is ahead of the people, and frets that the people remain behind. Oh simplicity or conceit! Oh God, Oh God! to witness how by the hands of Lincoln-Seward-McClellan, this noblest human structure [the American nation] is crumbled. . . ."

In his literary tirades, Gurowski was consistent. He called Secretary Seward "an intriguer" and "a snake," and went on to say that Seward "had an unhappy passion for generalization. He goes off like a rocket. Most people

hearing him become confused, understand nothing, are unable to follow him in his soarings, and believe him to be intoxicated."

"The more I scrutinize the President's thus so-called emancipation proclamation, the more cunning and the less good-will and sincerity I find therein. . . ."

Coming at a time when President Lincoln was about to announce his Emancipation Proclamation, which would eliminate slavery in any form in the United States, Gurowski's writings were especially damaging.

Being a member of the Russian aristocracy and the Czar's regime, Count Gurowski could not condone the freedom of any people; world publication of Lincoln's proclamation, freeing the American Negro from slavery, could possibly trigger similar revolutions in other countries as well as his own, where the Russian people lived under the grinding rule of a powerful monarchy.

Official Washington was shocked by these irresponsible writings, and Gurowski was fired from his job at the State Department.

On the other side of the coin, anti-slavery groups had a few things to say, among them that President Lincoln did not have the courage to issue his Emancipation Proclamation; that President Lincoln was under the dominating influence of Secretary Seward, whom Lydia Maria Child, another busybody, had classified as "a snake" and "a crooked, selfish hypocrite."

What these noisy, self-appointed critics failed to realize was that President Lincoln needed a clean-cut military victory before he could announce his proclamation officially; that military power to enforce it was vitally necessary; that it would mean nothing if, by some mischance, the North lost the war.

Major General George Brinton McClellan, the North's prime military vacillator, who never wanted to fight a battle if he could "maneuver" himself out of one, had victory within his grasp at Antietam; but he failed to pursue Lee's worn-out army and let Lee get away to fight another day, much to the disgust of the President.

As it turned out, the battle was a draw, but McClellan, in his monumental egotism, had called his failure "a masterpiece of art!" Lincoln had removed McClellan from command after his disaster of the Seven Days earlier that year, but had reinstated him following Major General John Pope's equally shocking defeat at Second Manassas in August. Pope, a braggart and blowhard whose "headquarters were in the saddle," had proven himself even more incompetent than McClellan; and, having no one else to handle the emergency, Lincoln had reinstated McClellan, "the little Napoleon."

Governor Curtin, well aware of these simple facts and of the mountainous problems confronting President Lincoln, had called the meeting at Altoona to circumvent the machinations of the Lincoln detractors, and, if possible, to curb them by a show of unity of purpose among the Northern states and their total support of the President.

An active, dedicated man "of commanding presence and genial manner," Andrew Gregg Curtin had the gift of intelligence, wit, and the ability to use words in a most effective manner, especially in a court of law in arguments before judges and juries.

The son of Roland and Jean Gregg Curtin, Andrew was born on April 23, 1815(?), at Bellefonte, Pennsylvania, a town in Centre County. Descended from sturdy Scottish-Irish stock, his father, Roland, had settled in Bellefonte from Dysert, County Clare, in 1800. In 1807, Roland became an iron-monger, and erected a forge on Bald Eagle Creek, four miles from Bellefonte, where he manufactured iron until his death in 1850.

Andrew's mother, Jean Gregg, his father's second wife, was the daughter of Andrew Gregg, a congressman and later senator, and Assistant Secretary of State under Joseph Heister. It was only natural that Andrew would one day enter the field of the law and politics.

Andrew Gregg Curtin's elementary education had its beginning in his home town of Bellefonte, under the tutelage of William Brown, a schoolmaster who operated a private school of about a dozen students. Completing his grade school education, Andrew entered the Harrisburg Academy for two years, completing his college education at the Pennsylvania Military Academy, where he majored in mathematics and the classics under the able instruction of the Reverend David Kirkpatrick.

Upon his graduation from the military academy, Andrew Gregg Curtin turned to the study of law, receiving his preliminary law

Abraham Lincoln, sixteenth president of the United States, 1861-1865. Contrary to some opinion, the author believes this photograph was made in the Washington Gallery on April 10, 1865, a few days before his death.

Author's collection

studies under W.W. Potter, of Bellefonte, an eminent attorney.

To prepare for his bar examinations, he entered Dickinson Law School at Dickinson College, receiving instruction from Judge John Reed. A brilliant student, his aptitude for the law manifested itself, and in 1839 he passed his bar examinations and went into a law partnership with John Blanchard, another excellent lawyer, who was later elected to Congress. Andrew Gregg Curtin was then twenty-four years of age; his future seemingly was assured.

His first adventure into the game of politics came in 1840, when he stumped for General William Henry Harrison's candidacy for the Presidency. A remarkable speaker, he had made his presence felt, and Harrison was elected.

Curtin, as the young political entrepreneur, followed up this initial success by joining the supporters of Henry Clay in 1844; and four years later, he again took to the stump in support of General Zachary Taylor, hero of the Mexican War and Whig candidate for the Presidency in 1848. His candidate again won.

Although his support of General Winfield Scott failed in the election of 1852, Andrew Curtin's name was entered in the nomination for governor of Pennsylvania. He refused the nomination, and threw his welcomed support behind the nomination of James Pollock, and got him the election.

Governor Pollock immediately appointed him to fill two important posts: secretary of the Commonwealth of Pennsylvania, and ex-officio superintendent of common schools, both of which offices he conducted brilliantly. By applying for a large appropriation to further the public school system, and pushing a bill through the legislature which authorized the establishment of state normal schools throughout the state, he increased his own public popularity and gave Pennsylvania a fine school system.

In the stormy election of 1860, one of the most critical political confrontations in the nation's history because of its sectional issues, it naturally followed that Andrew Gregg Curtin would become the logical nominee for governor of Pennsylvania on the Republican ballot. It also naturally followed that since Pennsylvania was a pivotal state in the election of Abraham Lincoln to the Presidency, if Andrew Gregg Curtin were governor, the state would follow his lead.

Abraham Lincoln, the newly formed Republican Party's candidate, looked to Andrew Curtin for his state's support, as did Henry S. Lane of Indiana, to swing the balance of these pivotal states over to Lincoln's side. Lane won in Indiana, and Andrew Curtin, firmly backed by A.K. McClure, chairman of the state committee, won in Pennsylvania by a majority of 32,000 votes. These victories were interpreted as securing Lincoln's election.

"The people mean to preserve the integrity of the National Union at every hazard," Governor Curtin told his audience in his inaugural speech on January 15, 1861. He further proclaimed "the unswerving loyalty of Pennsylvania to the Union."

With the outbreak of war imminent, Governor Curtin was the first of the Northern governors to be called to Washington by President Lincoln. After lengthy consultations with the President on April 8, 1861, Governor Curtin returned to Harrisburg, appeared before the state legislature, and won its overwhelming support for President Lincoln and the war effort.

First of the public men to realize the import and magnitude that the coming conflict could reach, Governor Curtin invoked such a powerful spirit of loyalty among the people of his state that they doubled the quota of fourteen thousand troops. Again going before the state legislature, Governor Curtin obtained authority "to equip and maintain" an additional force at state expense, thereby fathering the Pennsylvania Reserve Corps, which, in July 1863, would enable Pennsylvania to meet Lee's invasion head-on.

But unwilling to let matters rest there, Governor Curtin, "to inspire patriotic feeling," obtained funds from the Society of the Cincinnati of Pennsylvania to buy regimental flags for the state's regiments to carry throughout the war. Moreover, his compassion for the soldiers of his state earned him the sobriquet of the "Soldier's Friend," and his efforts to make certain that they received the best of medical care in the military hospitals became known across the state.

The volunteer soldiers of his state were his foremost concern, and this extended to their

dependents as well. In 1863, he appealed to the state legislature for money to establish a fund for the support and schooling of children orphaned by the war. Another fund was also set up to bring the bodies of Pennsylvania soldiers, killed in battle, back to their home state for burial.

The sum total of his concern and devotion to the soldiers manifested itself in the election of 1863, when the votes of the soldiers, and their friends, elected him to a second term by an overwhelming majority.

On January 1, 1863, amid rumors, a storm of slurs, and voiced misgivings as to whether or not the President would sign and issue the Emancipation Proclamation, Secretary of State William E. Seward and his son Fred came to President Lincoln's office at the White House. It was New Year's Day, and they found Mr. Lincoln alone. Secretary Seward carried the original draft of the proclamation, and all that was needed was his signature. With little or no ceremony, and a "slightly tremulous" hand, the President signed the document, after which the Secretary added his signature and affixed the great seal. The proclamation was now law.

In formal legal language, it read, in part:

> That on the first day of January first, in the year of our Lord, one thousand eight hundred and sixty-three, all persons held as slaves within any state or designated part of a state, the people whereof shall then be in rebellion against the United States, shall be then, thenceforward, and forever, free; and the executive government of the United States, including the military and naval authority thereof, will recognize and maintain the freedom of such persons, and will do no act or acts to repress such persons, or any of them, in any efforts they may make for their actual freedom.

1863 was to be a momentous year for Pennsylvania and for Governor Curtin. When it was learned in June that Lee's army was advancing to threaten Harrisburg, the state capital, in a second invasion, President Lincoln sent out an urgent call for fifty thousand additional troops to support the Army of the Potomac, fixing the term of military service at six months. It was not intended that they should serve longer than the immediate emergency.

As Lee's army approached Chambersburg, Pennsylvania, the debate in the legislature about the length of service for volunteers was still underway. Governor Curtin, with his usual alacrity, "urged that with the enemy six miles from Chambersburg . . . men should not quibble," and quickly mobilized thirty regiments of Pennsylvania militia at Harrisburg, in addition to artillery and cavalry, which he turned over to Major General Darius Couch of the Army of the Potomac.

From July 1 to July 3, 1863, a page of history waited while the Army of the Potomac and the Army of Northern Virginia fought themselves to a standstill at Gettysburg. When it was over, more than thirty-seven thousand men were dead, wounded, or missing.

In 1864, for his masterful management of his state's wartime affairs, Governor Curtin was re-elected by a majority of 41,000 votes; and upon the completion of his term, his name was placed second on the ticket to General Grant's candidacy for the Presidency, but the election of 1868 went to Schuyler Colfax.

A year later, President Grant appointed him Minister to Russia, a diplomatic post he filled with honor. Upon his return to the United States in 1872, he was selected as delegate-at-large to the Constitutional Convention.

The reasons behind his next political move are unknown, but in the Presidental campaign of 1872, Governor Curtin placed his full support behind Horace Greeley, which alienated his Republican friends. He joined the Democratic Party, and in 1878 he ran for Congress and was defeated.

In 1880, Governor Curtin ran again and won, serving three consecutive terms until his retirement in 1887. The remaining years of his active life were spent in retirement from politics, living quietly in his home, surrounded by members of his family. He died in his home on October 7, 1894, following a severe attack of illness.

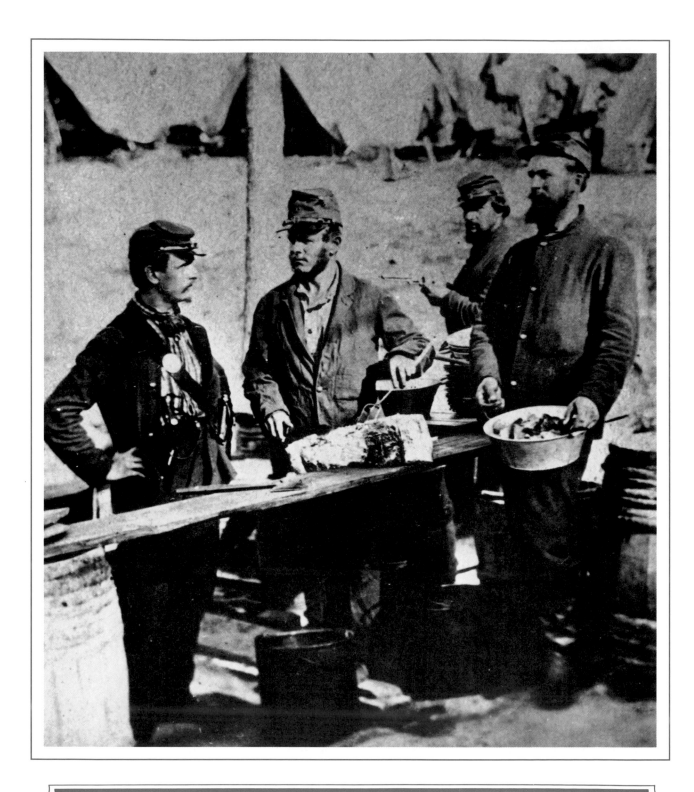

Company cooks of the Army of the Potomac at Antietam, Maryland, September 1862, are shown preparing freshly killed beef for the company mess.

From a photograph by Mathew Brady. Author's collection.

How the Armies Ate— or how they didn't

The soldiers of the Army of the Potomac had something in common with the soldiers of every army America has put in the field since the Revolution of 1776: "chow"—or the lack of it—and the company cook.

In the Civil War, when the Union Army was on the march, the men carried their own rations, usually hard-tack (a dry pilot cracker); a small bag of coffee; and the "staple," salt pork—meat as tough as the shoes they wore.

Utensils were carried, along with the rations, in their knapsacks.

During a campaign, the soldiers built their own campfires—when permitted—and boiled their coffee, made with water from a nearby stream. K-rations were unheard of in 1861.

In camp, between battles, when the camp kitchens and supply trains caught up with them, the men were given regular meals, including freshly killed beef which was apportioned and cooked while the meat still quivered.

And what the army didn't supply, the men could buy—providing they had the money—from the sutler, who followed the army with his wagon: peaches, candy, whiskey.

In the Union Army, one thing was certain. The men in the ranks could always count on eating—that is, if their supply wagons weren't captured by an alert Confederate patrol.

But matters of food were far different in the Confederate Army.

The long-suffering "Johnny Reb" could always be certain of one thing—the lack of food, except when a Federal supply train was captured; then matters in camp assumed the equivalent of a banquet.

The Confederate soldier, for the most part, lived on a diet of "goober peas," fresh, green corn cooked on a stick over a fire, all the apples and chickens he could steal, and chicory coffee.

In the Antietam Campaign, he caught robins and cooked them over his fire, and roasted apples along with the green corn.

During the campaign, Lee gave strict orders that there would be no "foraging liberally on the country"; that anyone caught stealing chickens or pigs would be shot.

At the battle of Fredericksburg, during the truce, the men of both sides exchanged tobacco for coffee.

The Yankees had plenty of coffee and the Johnny Rebs had plenty of Virginia tobacco.

They would place their various exchange "goodies" on little wooden rafts, pushing them across the Rappahannock River with a little help from the current.

This practice, and the lack of animosity between the soldiers of both sides in the winter of 1862, was a grave concern to the officers.

The Battle of Fredericksburg, on the Rappahannock River in Virginia, fought on December 13, 1862, was by any stretch of the military imagination the worst Federal military blunder of the entire war. The engagement was directed by the most incompetent officer in the U.S. military establishment, Major General Ambrose Everett Burnside.

Burnside lost his head and ordered charge after charge against Lee, solidly entrenched behind a stone wall on Marye's Heights. Even Burnside's officers, sickened by the wanton, senseless slaughter, balked at carrying out Burnside's orders, but not until almost 20,000 men were dead or wounded.

The battle raged all day, in the winter mist rising from the river, and the sloping field was littered with the broken bodies of men and horses, the dead "rolled out for shelter for the living, dead artillery horses breast-works for little groups of blue-coated men."

Darkness brought an end to the battle, but Stonewall Jackson opened a cannonade, the muzzle flashes of his guns scorching the cold night sky. Later that night, the spectacle of the northern lights illuminated the carnage, flickering over the wounded and dead.

Burnside's disaster at Fredericksburg appalled President Lincoln and the nation. Burnside followed with an utterly senseless expedition, called "Burnside's Mud March," designed to turn Lee's flank and executed in a pouring rain that made the roads virtually impossible to travel. It took five days to extricate the army, which reached its camps at White Oak Church "more dead than alive."

The Mud March ended the campaigns for the winter, and in May 1863 the new commander of the Army of the Potomac, Major General Joseph Hooker, began his bid in a new campaign for Richmond, precipitating Stonewall Jackson's classic battle at Chancellorsville.

Jackson, leaving Lee with half the army, made an end-run of the Army of the Potomac's exposed flank, held by Major General Oliver Otis Howard's 11th Corps, attacked in a surprise move, "crossed the T" of the Federal Army, and drove Hooker's force from the field—and its commander into oblivion. Jackson's inspired move opened the way for Lee to make a strike north through the Shenandoah Valley.

President Lincoln removed Hooker, replacing him with Major General George Gordon Meade. But the victory at Chancellorsville cost Lee his best lieutenant, for Stonewall Jackson died, shot accidentally by his own men while reconnoitering his lines in the darkness.

This boy, an unidentified Michigan volunteer, had only an army belt buckle and a hunting knife to show that he was a soldier. But he adopted a brave look and the Napoleon pose for Brady's camera on the battlefield.

From a photograph by Mathew Brady. Author's collection.

The Soldiers of the Civil War, North and South—all Americans

Stephen Crane, the newspaper writer and novelist who was named for a New Jersey signer of the Declaration of Independence, had no actual military experience. Yet, his novel *The Red Badge of Courage*, in the words of William Dean Howells, "sprung to life fully armed," so vivid and lifelike were Crane's descriptions of a young Civil War soldier under fire.

Of the young soldier hero in his novel, Crane wrote:

"There was a consciousness always of the presence of his comrades about him. He felt a subtle battle brotherhood more potent even than the cause for which they were fighting. It was the mysterious fraternity born of the smoke and danger of death. The rifles, once loaded, were jerked to the shoulder and fired without aim into the smoke, or at one of the blurred and shifting forms which, upon the field before the regiment, had been growing larger and larger like puppets under a magician's hand...."

Such was the fictional and legendary version of a moment in the life of a Civil War soldier, when battle was upon him. In contrast with the real, on-the-scene description of what General Thomas Perley saw and described in his official report of the aftermath of the battle of Fredericksburg on December 14, 1862, Stephen Crane's picture of battle reads like something out of a bad musical comedy.

For some unknown reason, the American Civil War has always been regarded erroneously as a "romantic" war, and many writers and historians have played up this peculiar notion of it. Actually, it was one of the bloodiest wars in our history; it was fought with a vengeance during its course and afterward. Witness, for example the Battle of Fredericksburg, and General Perley's report.

After the Battle of Antietam, "the bloodiest single-day's action" of the war, General Lee and his Army of Northern Virginia withdrew from Maryland into Virginia, and took up a powerful position on the south bank of the

Rappahannock River, above the town of Fredericksburg, on a steep slope behind the town.

The Confederate line of battle, about five miles long, ran along the crest of the hill, called Marye's Heights, on a dirt road the entire length of the line, buttressed by a stone wall parallel to it which formed an almost impregnable position against a frontal attack. Here, Lee's army waited for Burnside and the Army of the Potomac's advance.

Every officer on Major General Ambrose E. Burnside's staff was well aware of the strength of Lee's position and had strongly advised against it; but Burnside, the newly appointed commander-in-chief, disregarded their counsels. General A.E. Burnside, noted for nothing except the initiation of a male fad called "side-burns" and a couple of early military victories, had been appointed by President Lincoln to command the Union Army as its supreme commander. Burnside informed Mr. Lincoln, before accepting the command, that he was unqualified to command such a large army, and then set out to prove that he wasn't.

The Army of the Potomac to open its attack, had to first throw a pontoon bridge across the river approach to the town, which was constantly under the fire of Barkesdale's sharpshooters, who were firing from the window of every house on the river side. Once across the river, the troops had to reform their regiments and ascend the heights under the concentrated fire of massed artillery and rifles, which swept the field for more than a half mile in every direction. The snow on the ground and the wintry cold added to the Union soldier's ordeal.

Despite the advice of his officers, Burnside ordered frontal attacks in wave after wave, decimating entire regiments until his officers, appalled at the slaughter, refused to commit their men to any further assaults.

When it was over that day, more than twelve thousand eight hundred men, dead and wounded, lay on the snow-covered slope. Burnside then asked for a temporary truce to collect his wounded and bury his dead.

General Perley had a close, personal view of the carnage, as the wounded, who survived two days and nights of exposure in the snow without water or medicine, were collected by the medics.

"The dead were swollen to twice their natural size, black as Negroes in most cases. They sprawled in every conceivable position, some on their backs with gaping jaws, some with eyes as large as walnuts, protruding from glassy stares; some doubled up like a contortionist . . . here lay one without a head, there's one without legs, yonder a head and legs, without a trunk; everywhere horrible expressions, fear, rage, agony, madness, torture; lying in pools of blood, lying with heads half-buried in mud, with fragments of shell sticking in oozing brain, with bullet holes all over puffed limbs."

During the course of the holocaust, General Lee said to General Longstreet as they watched Burnside's lines advancing in parade order toward them, flags flying in the winter sunlight: "It is well that war is so terrible, otherwise we should grow too fond of it." Another incident on the field took place during Burnside's truce. One of Lee's men, reprimanded by a Union officer for picking up a fine Belgian rifle, in violation of the truce, stared at that officer's polished boots for a long moment, and then said: "Never mind, I'll shoot you tomorrow and get them boots."

But it was left for General "Stonewall" Jackson to voice the main objective to Lee: "We must do more than defeat them. We must destroy them!"

Such were the feelings of the times, and the ordeals of the Union soldiers who fought the great battles and died.

What were these soldiers like, these Civil War "G.I.s" who had answered Mr. Lincoln's call for volunteers in 1861, and had put their lives on the line for the cause they believed in?

For the most part, they were non-professionals, enlistees who had answered the calls from their various states, without any military training whatever. The greater number had come from the rural areas of their states, with little more schooling than that found in the elementary schools of that day.

In the early part of the war, many regiments in the Southern armies from Virginia, comprised the highly educated young men of the "F.F.V.s" (First Families of Virginia), who were killed off or permanently incapacitated by wounds in the first big battles. For the most part, the South's armies consisted of men and

boys from the farms and villages who had little or no schooling.

But the soldiers of the North and South had one thing in common: they were Americans. Surprisingly, many Union regiments comprised large numbers of immigrants from Sweden, Germany, Italy, France, and Ireland. At the outset, to show their loyalty to their adopted country, they joined up the moment they got off the boat. In the last months of the war, many Negro slaves were formed into regiments; but in the beginning, they were called "contraband" and employed as army teamsters, camp cooks, and orderlies.

Typical of the U.S. volunteer's experiences in the war are the recollections of Private Warren Lee Goss of the Pennsylvania volunteers, "who had eagerly enlisted" along with "hundreds of others." Before enlisting, Private Goss "lay awake all night, thinking the matter over," and thinking also of the $11.00 a month "and promised glory" he would receive.

He especially gave thought to Governor Andrew Curtin's pronouncement "that the bodies of men killed in action would be preserved in ice and sent tenderly forward!" Morticians followed the armies to perform this service.

And so it was "with nervous tremors and cold chills running up and down his back" that Warren Goss stood before the door of the enlistment office, reading the poster that promised the new recruit "chances of promotion and travel." Goss was twenty-two years old when he signed up. His uniform was a bad fit. The trousers were too long "by three or four inches"; the flannel shirt was coarse and unpleasant, "too long at the neck and too small elsewhere." His forage cap (kepi) "was an ungainly bag" with a paste-board top and a leather visor. All this has a familiar ring.

The soldiers of the North and South suffered immeasurable hardships. Criticizing Government officials conducting the war, Henry Adams, the writer and astute observer, wrote: "Not a man in Washington knew what his task would be, or what he was fitted for; everyone, without exception, Northern and Southern, was to learn his business at the cost of the public, and the education was to cost [the North] a million lives and $10,000 million dollars."

After the Union disaster at Bull Run in 1861,

George William Curtis, editor of the *New York Tribune*, wrote: "As for causes, they are in our condition and character. We have attempted to wage war without in the least knowing how."

At the start of the war, there was no organization; there were no hospitals capable of handling the enormous casualties; no methods of supply; and no facilities for housing large numbers of troops.

The wounded suffered the most, surgery being so crude; and the soldier who survived an amputation or the removal of a bullet, either in the field or in the rear area hospitals, was indeed an iron man. Laudanum and morphia were the pain killers, and if these drugs were unavailable, whiskey took their place. Even simple surgical hygiene was conspicuous by its absence. Wrote one Union medical officer:

"We operated in old, blood-soaked, and often pus-stained, coats ... with ... undisinfected hands. We used undisinfected instruments from undisinfected instrument cases ... and sponges ... only washed in tap water and used as if it were clean. If there was any difficulty in threading the needle, we moistened it with bacteria-laden saliva, and rolled it between bacteria-laden fingers. We dressed the wounds with clean but undisinfected sheets, shirts, tablecloths, or other old linen rescued from the family bag."

Any soldier who survived that could console himself in the belief, and rightly, that he led a charmed life. But the soldier in the Southern armies suffered even worse tortures, if that was possible. Most of the time there were no drugs or medicines or pain killers, since supplies were cut off by the Federal naval blockade of the Southern ports. Operations and amputations were performed in the field and in the hospitals by overworked doctors, whose techniques in military medicine left a lot to be desired.

But the soldiers of both sides had their lighter side and bore their hardships with remarkable courage and esprit de corps. The Southern armies were always short of food and clothing for the troops, "and foraged liberally on the country."

Before invading Maryland in 1862, Lee gave strict orders that looters would be shot for stealing food from the Maryland farmers on the line of march; but he admitted to his officers privately, and jocularly, "that the chickens had

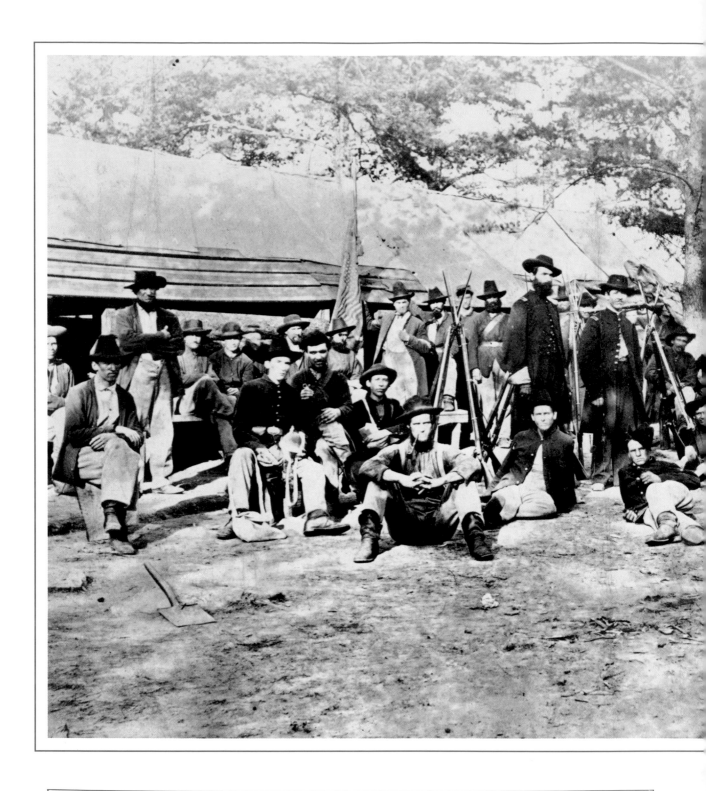

Company "D," 21st Michigan Infantry, was photographed during the Murfreesboro campaign, in Tennessee, 1864.

Photographer believed to be George N. Barnard. Author's collection.

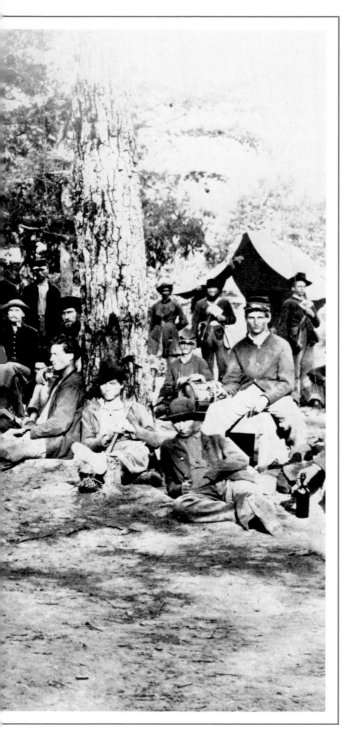

last one; but its done the business pretty thoroughly for me, I should say. Lord! What a scramble there'll be for arms and legs, when we old boys come out of our graves on Judgement Day."

Of the United States regular officers' corps, most field officers and engineer officers were highly competent, well-educated, and experienced soldiers. Fortunately, the incompetent officers, those with no appreciable experience in directing large armies in combat, were removed after their failures early in the war; such as Major Generals John Pope, A.E. Burnside, George Brinton McClellan, Nathaniel Prentiss Banks, and others like them.

The officers of the Southern armies for the most part were West Pointers who had resigned their commissions to join the Confederacy. The most outstanding of these officers were Lee; Longstreet; A.P. Hill; D.H. Hill; T.J. Jackson; J.E.B. Stuart of the cavalry; and E.P. Alexander, Chief of Artillery. There were, of course, many other West Pointers in the Confederate services.

The volunteer officers, such as the officers shown in the Brady photographs accompanying this chapter, representing various Northern states, came from all walks of life. They received their rank by vote, as all volunteer officers were elected by the men who enlisted under them, usually from their own districts. Their grades ran from second lieutenant to colonel. When these volunteer regiments were assimilated into the regular army for the duration of the war, their officers, when promoted to higher grade, were brevetted. This meant that, although they were promoted from colonel to brevet brigadier-general, they still received the pay of their former rank. When "mustered out," they retained their original rank, and mustering-out pay.

The Army of the Potomac and Army of Northern Virginia, in the East, and the Army of the Cumberland and Army of Tennessee, in the West, U.S. and C.S.A., respectively, were splendid armies. The men who remained with them for the duration, despite their enlistment terms, had come forward without question, to serve the "causes" they believed in. They had marched, fought, and suffered untold hardships under the stars and stripes and the stars and bars, following the footsteps of Grant, Lee, Sherman, Johnston, et al., into the history books, proud of the service they rendered. We will never see their like again.

to roost mighty high when Hood's Texicans were about."

In the hospitals, too, there was grim humor and a feeling of resignation toward serious hurts. One amputee, bedridden but light-hearted, was asked by Louisa May Alcott, a volunteer nurse who tended him, "Is this your first battle, Sergeant?"

"No, miss," replied the soldier. "I've been in six scrimmages, and never got a scratch till this

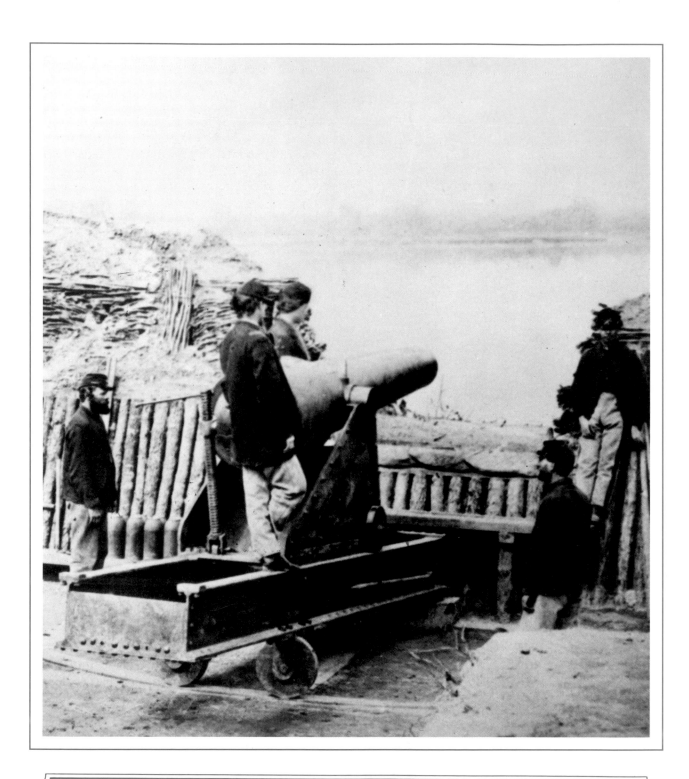

Guarding the approaches to Richmond, a number of Confederate batteries were mounted on both banks of the James River. This one, captured early in 1864, shows a Parrott rifle mounted on a siege carriage.

The Long Arm—
the artillery of the Civil War

At the Battle of Antietam on September 17, 1862, the Army of Northern Virginia's lines ran through the town of Sharpsburg, Maryland. Lee's headquarters were located in a house near the center of town.

The Army of the Potomac's lines, outside the town, ran from Antietam Creek on the left, to the Potomac River on the right.

Near General McClellan's headquarters at the rear was a reserve artillery park which held a large number of "Napoleon" guns, horse-drawn brass cannon, the most versatile field piece of the Union Army.

One of the Confederate prisoners, just taken and held with a group near these guns, was seen studying them with great interest by a Union officer. The officer walked over to the Rebel soldier and said, with a friendly smile: "What now, Johnny Reb. Just what do you see in that gun?"

The Rebel soldier, with a wave of his hand across the artillery park, replied: "Why you 'uns have almost as many of them thar 'US' guns, as we 'uns have!"

What that Rebel soldier implied was that the Confederate Army, in the victories prior to Antietam, had captured large numbers of these fine guns and had turned them against their Union antagonists.

The fact was that these field pieces were prized by both sides until the famous Parrott Field Rifle—a "rifled" gun with longer range —superseded it.

Named after Napoleon Bonaparte, himself an artillerist, and France's greatest military hero, the Napoleon gun was the best all-around field piece of the Civil War. A heavy gun with a brass barrel of four- to five-inch bore, it fired a ten-pound shot for an effective range of two thousand yards.

A "smooth-bore," it had no "rifling" in the barrel and was loaded through the muzzle, firing solid shot or shell.

It had a gun crew of ten men, including an officer and the men who handled the horses that hauled it. Mounted on a field carriage, it had a "trail" that attached to a limber, or caisson (ammunition carrier), which could be

uncoupled quickly when the gun was in position for firing.

During the loading, the gunner "thumbed the vent," after the inside of the barrel was sponged, to clear it of any live sparks that might be inside while the powder bag was being inserted.

Unless this was done, sparks on the inside could ignite the powder, fire the gun, and kill the rammer loading the shell. There were several incidents of premature firings due to not "thumbing the vent" when the powder charge was being inserted; but the men learned fast, and accidents of this nature rarely occurred when the war got underway.

A round shell, carrying an explosive charge, had a fuse inserted in the shell case. The fuse was cut to length and timed to burn down while the shell was in flight, and to ignite the explosive charge when the shell reached its target. The range determined the length of the fuse, which was ignited by the propelling charge, usually about ten pounds of black powder packed in a silk bag.

As the shell flew through the air, the fuse burned down inside the shell, causing it to burst into fragments which flew in all directions.

The Napoleon gun was used in batteries of from four to six guns, each with a crew of ten. In the big battles, as many as forty or fifty guns would be used in battery, hub-to-hub, firing on command or "at will"—loading and firing as fast as the crews could load them, usually about a minute between rounds.

Lieutenant General Thomas Jonathan "Stonewall" Jackson, who had taught mathematics and artillery tactics at the Virginia Military Institute at Lexington, Virginia, "loved a well-fought gun," and never ceased to admire his youngest artillery officer, Major John Pelham, who was probably one of the best artillery officers in the Confederate Army.

Artillery played an important role in the Civil War. This was especially true of the Napoleon gun because of its mobility and versatility in the field. And the greatest massed artillery action, in which the Napoleon gun played an important role, took place at Gettysburg on the Third Day, when Lee's artillery began a "softening-up" of the Union line, just before the eighteen thousand-man force of Major General

George E. Pickett made its famous charge against the Union center.

First Lieutenant Frank Aretas Haskell, U.S.A., of Major General John Gibbon's staff, wrote of this artillery duel and bombardment, in a letter to his brother shortly after the battle. He wrote:

Eleven o'clock came. Not a sound of a gun or musket can be heard on the field; the sky is bright, with only the white, fleecy clouds floating over from the West. The July sun streams down its fire upon the bright iron of the muskets in stacks upon the crest, and the dazzling brass of the Napoleons. The army lolls and longs for the shade, of which some get a hand's breadth, from a sheltertent struck upon a ramrod.

The silence and sultriness of a July noon are supreme. We dozed in the heat, and lolled on the ground, with half-opened eyes. Time was heavy and for want of something to do, I yawned, and looked at my watch. It was five minutes before one o'clock.

I returned my watch to my pocket and thought I might possibly go to sleep, and stretched myself on the ground accordingly. My attitude and purpose were those of the General and the rest of the staff.

What sound was that? There was no mistaking it. The distinct sharp sound of one of the enemy's guns, square over to the front, caused us to open our eyes and turn them in that direction, when we saw directly above the crest the smoke of a bursting shell, and heard its noise.

In an instant, before a word was spoken, as if that was the signal for general work, loud, startling, booming, the report of gun after gun in rapid succession smote our ears, and their shells plunged down and exploded all around us.

We sprang to our feet. In the briefest time the whole Rebel line to the west was pouring out its thunder and its iron upon our devoted crest. The wildest confusion for a few moments obtained sway among us. The shells came bursting all about. The horses, hitched to the trees, or held by the slack hands of orderlies, neighed out in fright, and broke away and plunged riderless through the fields.

The general at the first had snatched his sword, and started on foot for the front. I called for my horse; nobody responded. I found him tied to a tree, nearby, eating oats, with an air of the greatest composure, which under the circumstances, even then struck me as exceedingly ridiculous. He alone, of all beasts and men near was cool. I am not sure but that I learned a lesson then from a horse. . . .

No more than a minute since the first shot was fired, and I am mounted and riding after the General. The mighty din that now rises to Heaven

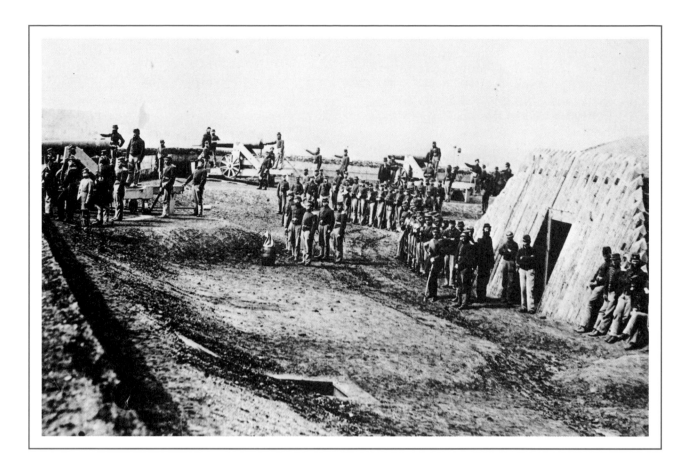

and shakes the earth, is not all of it the voice of the rebellion; for our guns, the guardian lions of the crest, quick to awake when danger comes, have opened their fiery jaws and begun to roar. . . .

The men of the infantry have seized their arms, and behind their works, behind every rock, in every ditch, wherever there is shelter, they hug the ground, silent, quiet, unterrified, little harmed.

Thus began the Civil War's greatest artillery bombardment and duel. Lee's "softening up" had begun. The noise was terrific, and the Union artillery, comprised of the new Parrott rifled field pieces firing ten- and twelve-pound shot and shell in rapid succession, and the Napoleon smooth-bores firing "at will," plastered Lee's lines with shrapnel and canister.

Union gunners later reported that the noise was so loud and the firing so intense that they couldn't hear their own guns!

And well they couldn't, for Lee had one hundred twenty-five guns in battery, hub-to-hub, divided between two locations, throwing a devastating enfilading fire upon the Union Army's center on the crest of the ridge.

The odd fact is that, for some reason never explained, had the Confederate gunners aimed their pieces lower, they could have probably wiped out the Union center. As it was, the Union line, formed into a "fish-hook," received most of the shell-fire at the curve of the hook at Cemetery Ridge.

Lieutenant Haskell wrote:

The enemy's guns, now in action, are in position at their front of the woods. A hundred and twenty-five Rebel guns, we estimate, are now active, firing twenty-four pound, twenty, twelve and ten-pound projectiles, solid shot and shells, spherical, conical, spiral. The enemy's fire is chiefly concentrated upon the position of the Second Corps. From the Cemetery to Round Top, with over a hundred guns, and to all parts of the enemy line, our batteries reply.

Who can describe such a conflict as is raging around us? To say that it was like a summer storm, with the crash of thunder, the glare of lightning, the shrieking of the wind, and the clatter of hailstones, would be weak. The thunder and lightning of these two-hundred and fifty guns and their shells, whose smoke darkens the sky, are incessant, all pervading, in the air above our heads.

These guns are great infuriate demons not of earth, whose mouths blaze with smoky tongues of living fire, and whose murky breath, sulphur-laden, rolls around them and along the ground, the smoke of Hades. These grimy men, rushing, shouting, their souls in a frenzy, plying the dusky gloves, and igniting the spark, are in their league, and but their willing ministers. . . .

Compared to the Gettysburg artillery duel, Haskell considered the great battles of Second Manassas, Antietam, and Fredericksburg as "no more than holiday salutes."

The projectiles shriek long and sharp, they hiss, they scream, they growl, they sputter; all sounds of life and rage; and each has its different note, and all are discordant. We see the solid shot strike axle, or pole, or wheel, and the tough iron and heart of oak snap and fly like straws.

We see the poor fellows hobbling back from the crest, or, unable to do so, pale and weak, lying on the ground with a mangled stump of an arm or leg, dripping their lifeblood away; or with a cheek torn open or a shoulder smashed. And many, alas, hear not the roar as they stretch upon the ground with upturned faces and open eyes, though a shell should burst at their very ears. Their ears and their bodies this instant are only mud.

We watched the shells bursting in the air, as they came hissing in all directions. Their flashes a bright gleam of lightning radiating from a point, giving place in the thousandth part of a second to a small, white puffy cloud, like fleece of the lightest, whitest wool.

These clouds were very numerous. We could not often see the shell before it burst; but sometimes, when we faced toward the enemy, and looked above our heads, the approach would be heralded by a prolonged hiss, which always seemed to me to be a line of something tangible, terminating in a black globe, distinct to the eye, as the sound had been to the ear.

The shell would seem to stop, and hang suspended in the air an instant, and then vanish in fire and smoke and noise.

The great artillery duel at Gettysburg, on the Third Day, ended as abruptly as it had started. It had begun precisely at one o'clock, and had ended as precisely at three o'clock. Two hundred guns had participated, while the men of both armies watched the heaviest artillery duel that has ever taken place on the American continent.

Then, almost immediately, "Pickett's Charge" followed; eighteen thousand men, stretched across a front of half a mile, advanced steadily toward the Union center, guiding on "the clump of trees," and the front of the Second Corps a mile away.

It was then that the Union artillery really went to work. Into action at once came all one hundred guns, Parrott rifles, and the Napoleons loaded with canister (anti-personnel tin cans loaded with round lead pellets, like enlarged buckshot, which had the devastating effect of giant, sawed-off shotguns fired at close range).

As Pickett's men got within range, the Union guns opened fire, the canister (anti-personnel shells) tearing great gaps in their advancing lines.

"All our available guns are now active," wrote Lieutenant Haskell, "and from the fire of shells, as the range grows shorter, and shorter, they change to shrapnel, and from shrapnel to canister; but in spite of the shells, and shrapnel and canister, without wavering or halt, the hardy lines of the enemy continue to move on."

Pickett's charge broke the Union line, and General Lewis A. Armistead, commanding a brigade in Pickett's Division, reached the Union General Cushing's guns in battery, and died there. Thus ended the Battle of Gettysburg, in which the "Long Arm" played its most important role.

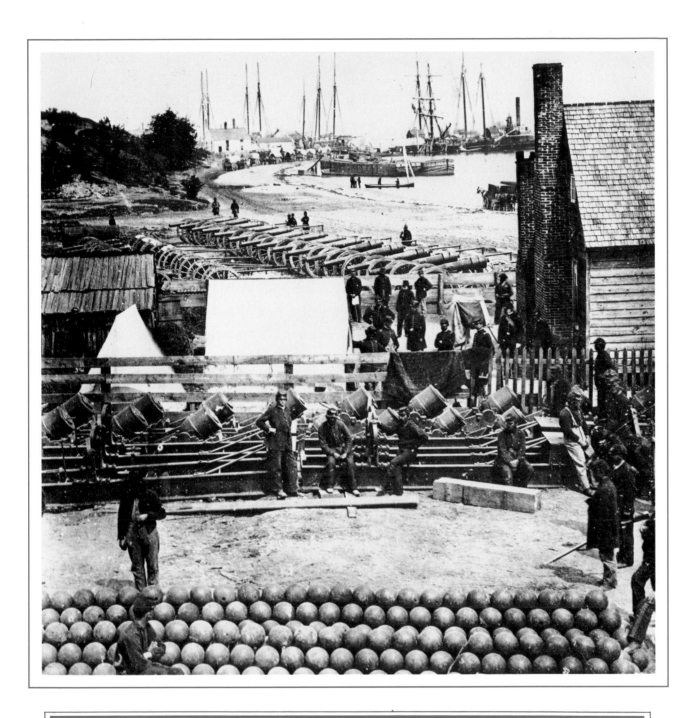

McClellan's supply base at City Point, Virginia, during the Peninsula Campaign in 1862.

From a Brady photograph

Major General Daniel Edgar Sickles disobeyed orders at the Battle of Gettysburg and more than half his men were either killed or wounded in the second day's action. He held various political offices, and scandal and controversy followed him wherever he went. He was a man of incredible energy, the disposition of a loan shark, and the morals of an alley cat.

From an india ink photographic portrait by Mathew Brady. Author's collection.

Dan Sickles— the insatiable bon-vivant

He disobeyed field orders at Gettysburg, and more than half of his men were killed or wounded. He had an affair with a Spanish queen and tried to become "king-maker" in Europe—with some success. His mistresses were numerous, but he killed his wife's lover. A man of incredible energy, he held various political offices—and scandal and controversy followed him wherever he went. Major General Daniel Edgar Sickles had the disposition of a loan shark, the morals of an alley cat, the energy of a Tyrannosaurus rex, and a propensity for raffishness Nero would have envied.

A ruthless political opportunist, "Dashing Dan" Sickles, a master of political intrigue, exemplified the New York political manipulators and operators who swarmed into Washington in 1861, bent on making "a good thing" out of the misery of the Civil War.

The single-minded Sickles, with his enormous drive, fast-talked his way into—and out of—a myriad sensational scrapes and intrigues that checkered his amazing career. In short, Dan Sickles was a heel.

Descended from Zachariah Sickles of Vienna, Austria, a member of the Dutch West India Company who settled in America in 1656, Daniel Edgar Sickles was born in New York City on October 20, 1825, the son of George Garrett and Susan Marsh Sickles. After the usual course through the elementary schools of the city, young Sickles attended the College of the City of New York (or the academy that was to become C.C.N.Y.) for an indeterminate period, after which he went into the printing business. He began the study of law under the tutelage of Benjamin Franklin Butler and was admitted to the New York Bar in 1846, at the age of twenty-one. A year later he was elected to the New York State Legislature, proof on the face of it that he was precocious in the ways of the unscrupulous New York politics of the mid-century.

Some time in 1850, Sickles met and married

Theresa Bagioli, the pretty seventeen-year-old daughter of an Italian music teacher. Sickles was eleven years her senior.

Married life started out well for the couple. That same year Sickles was appointed corporation counsel for the City of New York: a Tammany Hall appointment, Sickles being a confirmed Democrat and a member of that political fraternity that perpetuated itself by giving away small turkeys to its constituents at Christmastime in exchange for votes. After all, it was in this period of the 1850s that the strange metamorphosis of Election Eve took place: a resurrection occurred and names carved on tombstones made their ghostly appearance on ballots—in very considerable numbers.

Always seeking something more glamorous, Sickles resigned his legal post after a few months and became Secretary of the United States Legation in London, where he and his wife resided for the next two years. When this assignment terminated, the Sickleses returned to New York and the astute young politician picked up various threads where he had left them.

In a short time, he managed to get himself elected to the New York State Senate, where he served four turbulent years, in the midst of a sea of personal financial problems and that notoriety that always seemed about to engulf him.

In 1856, at the end of his term, Sickles ran for Congress on the Democratic ticket. He was elected and took up residence in Washington, D.C., with his wife and their daughter. For the first two years of his Congressional service his home life remained serene, but then he discovered that his wife was having a love affair with Philip Barton Key, the son of Francis Scott Key, author of "The Star-Spangled Banner." In a huge rage at his wife's indiscretions and apparently without any reflection that he himself made a steady practice of marital infidelity, Sickles first made his wife sign a confession of guilt and then armed himself, sought Key out, and shot him to death.

In that not-very-permissive age, the Key murder trial, with its sensational overtones, was subjected to all that what would later be known as the "yellow press" could give it. Sickles had his wife's forced confession intro-

duced as evidence and got himself acquitted on the grounds of "temporary insanity." The insanity defense, introduced for the first time in the Sickles trial, would thereafter become a principal defense in similar trials.

Typically, "Justice" having been more or less served, Sickles forgave his wife and they resumed domestic life in Washington to the end of his Congressional service in 1861. But though he had forgiven his wife with characteristic ostentatious magnanimity, Sickles could not obtain hers. Within a few years she was dead, probably of the mixture of personal shame and public disgrace she had suffered at his indelicate and soiled hands.

To give the devil his due, when the Civil War began in 1861, Sickles, throwing partisan politics aside, offered his services to President Lincoln, who accepted and authorized him to raise troops for the Federal service. With his usual energy, Sickles recruited and organized the Excelsior Brigade in New York, becoming its colonel. With the opening of Major General G.B. McClellan's first Peninsula Campaign against Richmond in 1862, Sickles was promoted to brigadier general. He led his brigade through the sanguinary battles of the Seven Days, in which Lee and Jackson defeated the Army of the Potomac with great loss of life and military equipment for the Federal forces.

Remarkably enough, Sickles gave a good account of himself on the field, considering his complete lack of military training. Especially noteworthy was his handling of the Third Corps at Chancellorsville, where Lee again defeated the Army of the Potomac, this time under Major General "Fightin' Joe" Hooker, who was outmarched, outwitted, and outfought by Stonewall Jackson. At a crucial moment in the battle, Sickles attacked Jackson in a bloody engagement and stopped the Confederate advance. It was later that evening that Jackson was fatally wounded by his own men while reconnoitering his lines in the dark.

In the ensuing campaign, his last military adventure, the now Major General Sickles arrived on the field of Gettysburg with his Third Corps on July 2, 1863, the second day of the great battle. Major General George Gordon Meade, who had superseded the hapless Hooker, posted the Third Corps on the Federal left, covering two important hills, Big Round

Top and Little Round Top. With General Henry Hunt, chief of artillery, Sickles reconnoitered the position assigned to him by his commander, watching Lee's forces move into position on Seminary Ridge a mile away.

"Shouldn't I move my line forward?" Sickles queried Hunt.

"Not on my authority," Hunt replied. "I will report to General Meade for his instructions." Hunt then suggested to Sickles that he scout out the woods to find out whether they harbored enemy troops. Sickles sent in a detachment of Berdan's First U.S. Sharpshooters to feel out the enemy.

Suddenly a small boy came running out of the patch of woods, yelling at the top of his voice: "There's Rebels in them woods!" he shouted. "Whole rows of them!"

Berdan's men, moving forward in skirmish line, were immediately met by a burst of rapid fire coming from behind the trees.

At about 4 p.m., word of Sickles' change of position reached the ears of General Meade and, angry as a hornet, Meade galloped over to Sickles' position, his staff riding close behind him.

Sickles' troops were much too forward, he told the brash political general emphatically, and they must be withdrawn.

"Very well," replied Sickles. "I'll withdraw them, sir." But as he spoke, a shell from a Rebel battery whistled over and exploded a short distance away. Meade said grimly:

"I wish to God you could withdraw, sir! But you see those people don't intend to let you!"

Longstreet opened a furious attack on the unlucky Third Corps, the men taking cover behind patches of trees, rocks, anything that would provide protection from the intense enemy fire. The situation became desperate as Longstreet's massed artillery fired into the ranks of the Third Corps, and he subsequently knocked it out of action.

When this second day's fighting ended, more than half of the men of the Third Corps were either dead or wounded, victims of military incompetence.

Late in the day Sickles was struck by a shell, with the result that a field amputation of his right leg was necessary. The whole incident—his blunder, his disobedience of the orders of his commanding officer—gave rise to bitter controversy in the years that followed the war.

In fairness to Sickles, had the Union's battle been an offensive one rather than defensive, the position he chose would have been advantageous. But Meade had early recognized that the field of Gettysburg dictated a defensive action to force Lee to attack a strongly held position. But this rationale does not alter the fact that Sickles disobeyed orders, and that the result of his brashness was an enormous loss of life.

Sickles' wound ended his military career, and when he recovered he was sent on a confidential mission to South America in 1865 at the close of the war. When he returned to the United States later that year, he was appointed military governor of the Carolinas, but his "over-strenuous" efforts and excessive zeal in discharging his duties compelled President Andrew Johnson to relieve him in 1867.

In 1869 Sickles was appointed American Minister to Spain, and with his appointment American-European diplomacy took a definite turn for the worse. The complications of the *Virginius* affair (53 of the passengers and crew of a ship flying—fraudulently—the American flag had been executed summarily for filibustering) and the Cuban problem, questions that came to the fore, proved that Sickles was thoroughly incapable of coping with his job. But his incompetence in handling delicate matters of state seem to have been of little moment in view of his budding romance with Isabella II, Queen of Spain!

Resigning his post as Minister in 1873, and with nothing to occupy his time, Dan Sickles turned to Love as a diversion. Isabella responded with enthusiasm, and the peg-legged soldier and the Spanish queen, both of them in their late forties and living in Paris, proceeded with their affair in the open, oblivious of public reaction. Strangely enough, their romance never carried a breath of scandal in either Spain or France, since they made no attempt to conceal the feelings they had for each other; but that didn't prevent Parisians from referring to the American as "Yankee King of Spain."

If this weren't enough to curl the hair of those members of the State Department responsible for America's "image" abroad, Sickles, the experienced politician and behind-the-scenes manipulator, whose methods would have received the approbation of Machiavelli himself,

Clara Barton. After working with the International Red Cross in Europe during and after the Franco-Prussian War, she returned to the United States and worked to found the American Red Cross, becoming its first president in 1882.

From a photograph by Mathew Brady. Author's collection.

decided to become a "king-maker." The candidate was Isabella's son, Alfonso. The period of the 1870s saw many "pretenders" to the Spanish throne, and Alfonso was perhaps the most legitimate.

General Sickles, using all his political wiles and Spanish influences, which were considerable, and falling back on his Tammany Hall astuteness, did manage to place his man on the throne of Spain as Alfonso XII. Sickles' political victory, however, turned out to be a personal setback for the ambitious American. Isabella's "political considerations" for her son compelled her to return to Spain from Paris, where she had been living. Her departure ended the blazing romance she had had with "Dashing Dan."

But that didn't end his involvement with the court affairs of Europe by any means. During his efforts to place Alfonso on the Spanish throne, Sickles had taken up the cause of another royal aspirant, Louis Philippe Albert, Comte de Paris, grandson of Louis Philippe of the House of Orleans. Sickles and the young nobleman had become friends when the youth had been a military observer, and aide-de-camp to General McClellan during the Peninsula Campaign. Employing the same tactics he would have used in directing a campaign of his own for office in New York, Sickles became the young man's "campaign manager" in his attempt to gain the throne vacated by Napoleon III after the Franco-Prussian War. Sickles' efforts were to no avail. France was done with monarchy and remained a republic.

While in Spain, his romance with Isabella hardly cold, Sickles married Senorita Carmina Creagh, who became his second wife at a ceremony at the American Legation in Madrid, where the couple lived for the next seven years.

When Sickles returned to the United States for the last time, his wife refused to come with him, not wishing to leave her home in Madrid. To add to Sickles' mounting distress, his daughter died.

Back in New York, he became chairman of the New York State Monument Commission in 1880, but his administration was clouded by what was then called politely "a misappropriation of funds." The stigma had little effect on Sickles' political posture, for he ran for Congress on the Democratic ticket—and won. He served as a Representative in Washington from 1893 to 1895, to the accompaniment of the usual Sickles' fireworks. At sixty-eight, Sickles was still the "old, cantankerous, irresponsible gentleman, continually involved in financial and personal altercations" which never seemed to leave him.

Alone, separated by distance and death from his family, the veteran of Gettysburg finally returned to the place where he had lost his leg. His last years were devoted to preserving the battlefield as a National Monument, a fight he won, which was reminiscent of his earlier successful fight to secure Central Park for the City of New York.

The hot summer of 1913 saw the last reunion of the Blue and Gray at Gettysburg, and Major General Daniel Edgar Sickles, "grand old man of the occasion," was present at the age of eighty-eight. Among all the negatives that marked his long career of public service and personal ambition, two positive achievements stand in his favor: his acquisition of Central Park and the preservation of the Gettysburg battlefield.

The rest is something else, but no one can say that a dull life ended when General Sickles died in New York on May 3, 1914.

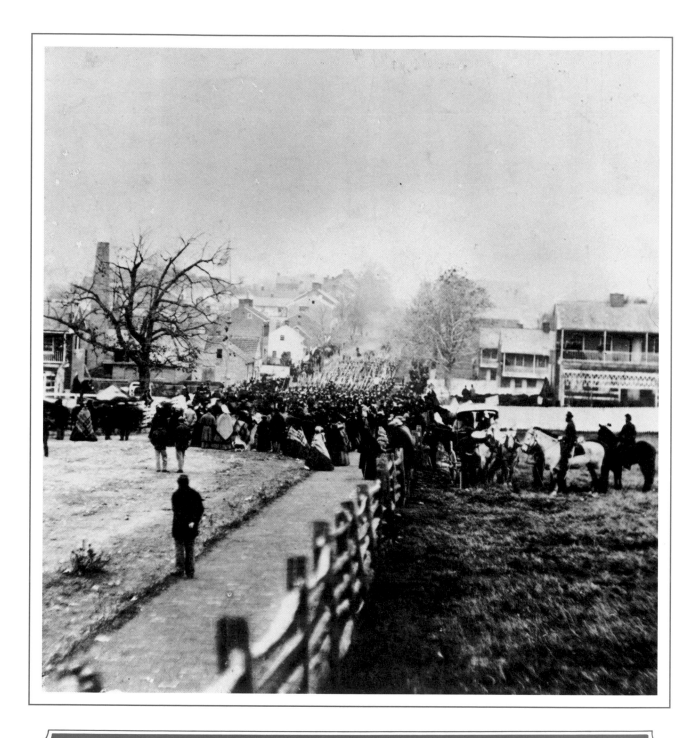

The parade to the battlefield of Gettysburg passes through town on November 19, 1863. In a short time the President was to make his famous dedicatory address at the cemetery. Edward Everett, whose speech preceded Lincoln's, wrote to him the next day: "I should be glad if . . . I came as near the central idea of the occasion in two hours as you did in two minutes."

From a photograph by Mathew Brady. Author's collection.

Mr. Lincoln at Gettysburg

Late in the hot, sultry afternoon of July 3, 1863, the final day of the raging Battle of Gettysburg, a young Federal officer, aware that history had been made that day, left the dressing station, mounted his horse, and went searching for his commanding officer, Major General John Gibbon.

The young officer's name was Frank Aretas Haskell, First Lieutenant, Company I, Sixth Wisconsin Volunteer Infantry, aide-de-camp to General Gibbon.

"Feeling like a boiled man," Lieutenant Haskell, his own wound giving him a lot of pain, slowly guided his horse among the broken, separated units of the various Union regiments. The unprecedented battle of the Civil War had ended only an hour or so before, and the field on which the holocaust had just taken place was now deserted, except for the scattered bodies of the soldiers yet to be recovered by the burial parties.

Passing a field hospital, he was appalled at what he saw. "The surgeons," he wrote, "with coats off and sleeves rolled up . . . are about their work . . . their faces and clothes spattered with blood . . . how long they have worked, the piles of legs, arms, hands and fingers about partially tell. . . ."

A battlefield always looks far different after than during the battle, and Lieutenant Haskell, a sensitive man, awed by the silence about him, guided his horse along the crest of Cemetery Ridge, which he had helped to defend. Gazing long and thoughtfully across the five-mile stretch of landscape, he recalled that, not two hours before, more than a hundred and seventy thousand men had been engaged in a frenzy of fury, bent on killing each other. The great armies were now gone from the field.

Now only the human wreckage of battle remained, scattered across the field, oblivious forever to the causes that brought it about; mute testimony to the relentless power of man-made violence.

Three days later, on July 6, Lieutenant Haskell, again mysteriously drawn to the

battlefield, "could not repress the desire or omit the opportunity to see again where the battle had been." His division had been withdrawn and halted for the day about four miles from the field. What he experienced in the battle, and what he saw afterward, he recorded in a letter to his brother.

It seemed very strange upon approaching the horseshoe crest again, not to see it covered with thousands of troops, horses and guns; but they were all gone—the armies, to my seeming—had vanished—and on that lovely summer morning the stillness and silence of death pervaded the locality where so recently the shouts and cannon thundered.

The recent rains had washed away many an unsightly spot, and smoothed many a harrowed trace of the conflict; but one still needed no guide to follow the track of the storm. . . .

The spade and shovel, so far as a little earth for the human bodies would render their tasks done, had completed their work—a great labor, that.

But still one might see under some concealing bush or sheltering rock, what had once been a man, and the thousands of stricken horses still lay scattered where they died.

The scattered, small arms and the accoutrements had been collected, almost all that were of any value; but the great numbers of bent and splintered muskets, rent knapsacks, bruised canteens, shreds of caps, coats and trousers, of blue or grey cloth, worthless belts and cartridge boxes, torn blankets, ammunition boxes, broken wheels, smashed limbers, shattered gun carriages, parts of harnesses, of all that men or horses wear or carry in battle, were scattered broadcast over miles of the field. From these one could tell where the fight had been the hottest. . . .

No soldier was to be seen, but the numbers of civilians and boys, and some girls, even, were curiously loitering about the field, and their faces showed not sadness or horror, but only staring wonder or smirking curiosity. . . .

Summer went into fall, and four months and sixteen days after the Battle of Gettysburg, a *New York Herald* reporter, himself a sensitive man, had come to Gettysburg to attend the ceremonies dedicating the battlefield as a national military cemetery. As he wandered over the field, his steps brought him among the newly made graves of the soldiers, which were arranged in neat rows across the gentle, sloping hillside. The crowds attending the ceremonies had all gone. The gray, wintry sky overhead contributed to the somber reality of the moment; and the somewhat awesome silence surrounding his lonely walk did not intrude upon his thoughts.

Later, the *Herald* correspondent wrote: "The air, the trees, the graves are silent. Even the relic-hunters are gone now. And the soldiers here never wake to the sound of reveille."

In July, the Fates, controllers of human destiny, had predetermined the intricate gambits on the military chessboard that had brought about the titanic collision of the Union and Confederate armies on the farmlands of Pennsylvania. Neither Lee nor Meade had planned to fight a battle at Gettysburg.

Nor, in November, had Mr. Lincoln planned to deliver a speech there. His presence had been an involuntary afterthought on the part of those responsible for arranging the dedication ceremonies.

Together, these elements, the tragedy of the battle itself, and Mr. Lincoln's "few appropriate remarks"—even though months apart—made Gettysburg "the true grand epic" that would stand forever in the annals of the American tradition.

Somehow, the *Herald* correspondent and the young Federal officer, Lieutenant Haskell, had felt the awesome fatalism of Gettysburg's haunting moment in time.

Shortly after the battle in July, the Honorable David Wills of Gettysburg suggested to Governor Andrew Gregg Curtin of Pennsylvania that "a plot of ground in the midst of the battlefield be at once purchased and set apart as a soldier's national cemetery, and that the remains of the dead be exhumed and placed in this cemetery," with plots of ground allotted to each state for its graves.

Governor Curtin heartily approved of the plan, and ordered that seventeen acres of ground on Cemetery Hill, fighting center of the Union line that had broken the spearhead of the Confederate attack, be set aside for the purpose.

The plan was outlined in a letter to President Lincoln, that the designated acreage ". . . will be consecrated and set apart to this sacred purpose by appropriate ceremonies of Thursday, November 19, instant. I am authorized by the Governors of the various States to invite you to be present and participate in these ceremonies, which will doubtless be very imposing and solemnly impressive. It is the desire that, after the oration, you, as Chief Executive

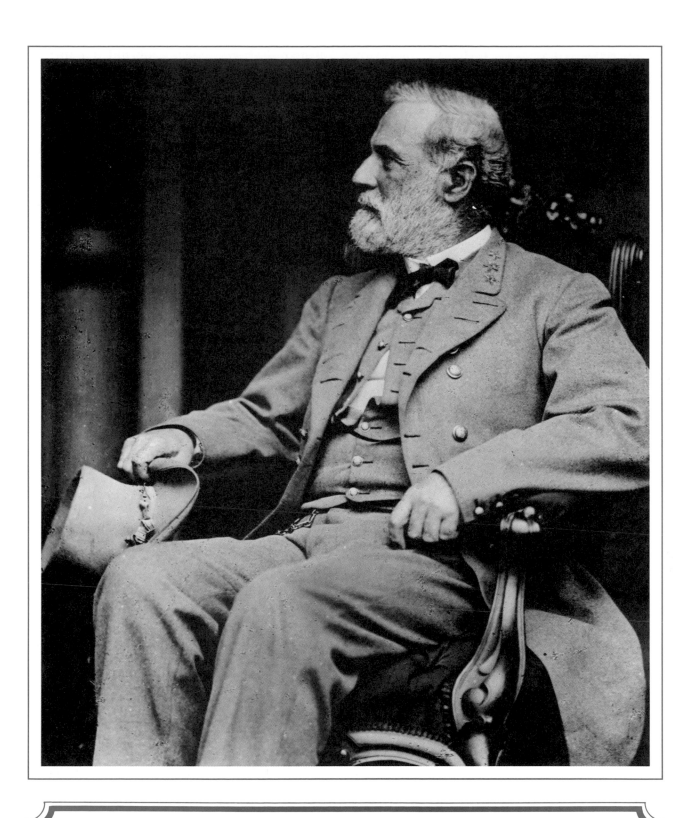

Robert E. Lee of Virginia, general in command of the Confederate forces at Gettysburg.
Author's collection.

of the Nation, formally set apart these grounds to their sacred use by a few appropriate remarks."

A printed invitation, sent with the letter, was mailed to President Lincoln by David Wills, special representative of Governor Curtin and president of the Commission for the National Soldiers Cemetery at Gettysburg.

The man chosen by the commission to dedicate the cemetery and deliver the principle address was the Honorable Edward Everett, the distinguished American orator. Former governor of Massachusetts, a member of Congress, and Secretary of State under President Millard Fillmore, Everett had been a professor of Greek, a Phi Beta Kappa poet at Harvard, and one time the college's president.

In addition to these scholarly accomplishments, Everett enjoyed the distinction of being an accomplished speaker, with a record of eighty-one addresses and one hundred and twenty-five speeches. He was also the author of two volumes of orations. As president of Harvard, Everett refused to be pressured into discriminating against colored students. "If this boy passes, he will be admitted, and if the white students choose to withdraw, all the income of the College will be devoted to his education."

In 1861, Mr. Everett was not as charitable in his outspoken pre-judgment of the newly inaugurated President Lincoln, who he said was "evidently a person of very inferior cast of character, wholly unequal to the crisis" facing the nation. Everett undoubtedly had a high opinion of himself, and had probably based this opinion on irresponsible hearsay circulated by Mr. Lincoln's political detractors. But intellectual snobbery was also a factor.

Mr. Clark E. Carr, a representative of the Board of Commissioners of Galesburg, Illinois, even had the presumption to question the decision to invite Mr. Lincoln to speak at all, on the grounds that he "gravely" doubted the President's "ability to speak upon such a grave and solemn occasion"! This, too, carried all the earmarks of snobbery and discourtesy toward the self-taught man who had the genius to write the first Inaugural Address.

Moreover, the members of the board disclosed their pettiness by delaying Mr. Lincoln's invitation to speak. According to Carr, "the proposition to ask Mr. Lincoln to speak at Gettysburg ceremonies was an afterthought." The invitation had included members of the Cabinet and Major General George Gordon Meade, who had commanded the army at Gettysburg.

Mr. Lincoln had received his invitation to speak on November 2, more than six weeks after Edward Everett had received his. In fact, the board had originally planned to conduct the exercises on October 23, 1863, in deference to Mr. Everett's "convenience" in preparing his address.

Nevertheless, on Sunday, November 2, Ward Hill Lamon, marshall of Washington City and the President's closest friend, with Noah Brooks accompanied the President to Mathew Brady's gallery for a portrait photograph. Mr. Lincoln carried a draft of his address in an envelope, together with a memorandum of it in his hat.

During the sitting, the President had mentioned his address to Ward Lamon, saying in "an offhand" manner that he felt that it was unsatisfactory and that he had some misgivings about reading it publicly, since it did not, in his opinion, "come up to public expectation."

The pressure of work and of conducting the affairs of the war had not allowed him much time in which to improve it. Moreover, he had been compelled to spend three weeks on his Annual Message to Congress—"and the actual commencement of the work on the Pacific Railroad" had been another matter that had needed his attention.

And so it came about that on the morning of November 18, 1863, President Lincoln boarded the special train for Gettysburg. The trip was pleasant; the train stopped long enough in Baltimore for him to greet about two hundred spectators who were on hand to see him.

Enroute, he joined General Schenck and members of his staff in their car, along with Mayor Frederick Lincoln of Boston (no relation). Their conversation was informal and lively, and after a time Mr. Lincoln excused himself, saying: "Gentlemen, this is all very pleasant, but the people will expect me to say something to them tomorrow, and I must give the matter some thought."

At Hanover Junction, Pennsylvania, the train stopped long enough for Brady to take a picture

showing the President and some members of his party standing on the platform. Mr. Lincoln posed on the left of the picture, wearing his high silk hat.

The special train pulled into Gettysburg at sundown, and the President was driven to the home of David Wills, where he was to stay the night.

Gettysburg, normally a town of 3,500 residents, once again overflowed with soldiers and civilians, government officials and guests. Many, unable to get accommodations, slept in private residences or spent the night sleeping on the floors of hotel lobbies.

As was the custom of the times, military bands serenaded the various officials, the musicians moving from one political celebrity to another, followed by crowds eager to see the President and Secretary of State firsthand.

John Hay, Mr. Lincoln's personal secretary, kept a diary of these momentous years, and added a page on that particular night. He had met Colonel John W. Forney, editor of the *Intelligencer and Journal*, and in his diary he recalled:

> We found Forney, and drank a little whiskey with him. He had been drinking a good deal during the day and was getting to feel a little ugly and dangerous. He was particularly bitter on Montgomery Blair [Postmaster General] ... he talked very strangely, referring to the affectionate and loyal support which he [Forney] and Curtin had given to the President in Pennsylvania, with references shown the Cameron Party, whom they regard as their natural enemies. We met Nicolay [Lincoln's other secretary] and went back to Forney's room ... and drank more whiskey. Nicolay sung his little song of the "Three Thieves" and we sung "John Brown." At last we proposed that Forney make a speech....

To the crowd that gathered outside the hotel, Forney said: "... in a eulogy of the President, that great, wonderful, mysterious inexplicable man who holds in his hands the reins of the Republic; who keeps his own counsels; who does his own purpose in his own way, no matter what temporizing minister in his Cabinet sets himself up in opposition...."

That night there was a dinner in the Wills's home, where Mr. Lincoln met Edward Everett and Governor Curtin, excusing himself at ten o'clock to work on his address in his room. Later, he spent a half hour with Secretary

Seward, staying at the Harper house next door, taking his work sheets with him. Sometime around midnight, President Lincoln went to bed.

The next morning, November 19, 1863, a crowd of about fifty thousand persons gathered on Cemetery Hill for the ceremonies scheduled to start promptly at ten o'clock. The President, dressed in a black suit, high silk hat, and carrying white gloves, left the Wills's home and mounted a horse. He had received some encouraging news from Secretary Stanton to the effect that Grant had successfully attacked Chattanooga, and that Lincoln's son, who had been seriously ill, was on the way to recovery.

A Lieutenant Cochrane, riding in the parade of dignitaries, later wrote: "Mr. Lincoln was mounted upon a young, and beautiful, chestnut horse, the largest in the Cumberland Valley. His towering figure surmounted by a high silk hat made the rest of us look small."

The parade to the battlefield lasted about fifteen minutes. The orator of the day, Mr. Everett, was late, and to fill the time the band played until noon.

Among the dignitaries who had taken their places on the platform were Governors Curtin of Pennsylvania, Bradford of Maryland, and Seymour of New York. The military was represented by General Abner Doubleday (reputed inventor of baseball); Generals Schenck, Stael, and Couch; Provost Marshal General Fry; foreign ministers; some members of Congress; and Ward Hill Lamon.

The Reverend Thomas H. Stockton opened the ceremony with a prayer, over a sea of uncovered heads, closing with "... bless the efforts to suppress this rebellion ... as the trees are not dead, though the foliage is gone, so our heroes are not dead, though the foliage have fallen...."

Benjamin French, architect in charge of Washington Government buildings, then arose and introduced the Honorable Edward Everett. In a speech lasting two hours, Everett touched on how the Greeks cared for their dead in battle, the fields and the Allegheny Mountains, saying, "as my eye ranges over the fields whose sods were so lately moistened by the blood of gallant and loyal men, I feel, as never before, how truly it was said of old that it is sweet and becoming to die for one's country."

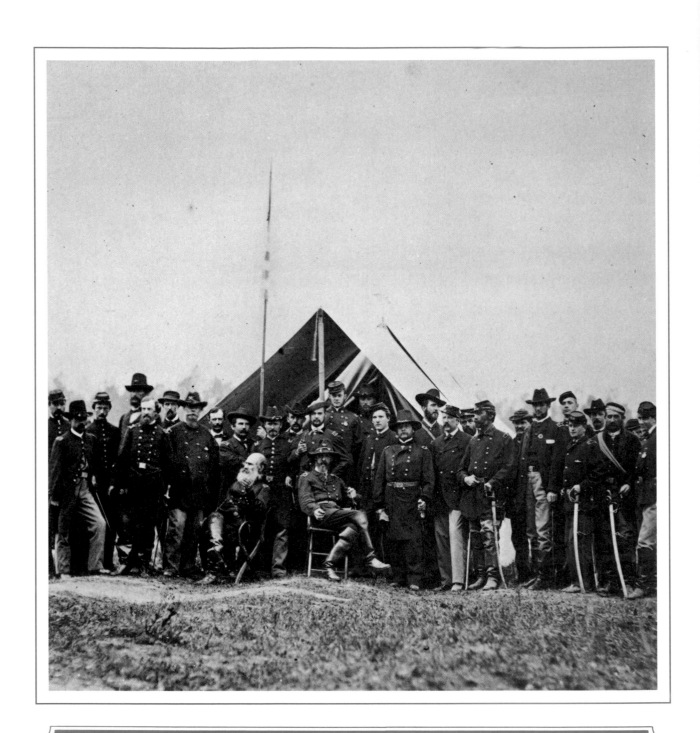

General George Gordon Meade and his staff, July 5, 1863, at Gettysburg. On the 4th Meade wired Lincoln: "We have swept the enemy from our soil." Lincoln replied: "Will our generals ever get that idea out of their heads. The whole country is our soil."

Author's collection.

The Baltimore Glee Club then sang an ode, after which Ward Hill Lamon arose, walked to the podium, and said: "The President of the United States."

At this, President Lincoln adjusted his steel-rimmed eyeglasses. "The President rises slowly," observed the reporter for the *Cincinnati Commercial*, "draws from his pocket a paper, and, when the commotion subsides, in a sharp, unmusical treble voice, reads the brief, pithy remarks."

Four score and seven years ago, our fathers brought forth upon this continent a new nation, conceived in liberty and dedicated to the proposition that all men are created equal.

Now we are engaged in a great civil war, testing whether that—or any nation, so conceived and so dedicated—can long endure.

We are met on a great battlefield of that war. We have come to dedicate a portion of it as the final resting place for those who here gave their lives that the nation might live.

It is altogether fitting and proper that we should do this.

But, in a larger sense, we cannot dedicate, we cannot consecrate, we cannot hallow, this ground. The brave men, living and dead, who struggled here, have consecrated it far above our poor power to add or detract.

The world will little note nor long remember what we say here; but it can never forget what they did here.

It is for us, the living, rather, to be here dedicated to the unfinished work that they have thus far so nobly advanced. It is rather for us to be here dedicated to the great task remaining before us, that from these honored dead we take increased devotion to that cause for which they here gave the last full measure of devotion; that we here highly resolve that these dead shall not have died in vain; that the nation shall, under God, have a new birth of freedom, and that government of the people, by the people, for the people, shall not perish from the earth.

It was over almost as soon as it had begun, with applause "at five places in the address, and long continued applause at the end of it."

And of course, later there were the critical comments, professional and otherwise, that followed in the press and elsewhere, all varying according to the temperament of the writer.

John Russell Young, correspondent for the *Philadelphia Press*, commented on Mr. Everett's address, writing, "that it was a splendid oration . . . beautiful, but as cold as ice," and further observed that "in wandering around these fields, one is astonished and indignant to find at almost every step of his progress the carcasses of dead horses which breed pestilence in the atmosphere . . . a score of deaths have resulted from this neglect in the village of Gettysburg."

The reporter for the *Harrisburg Patriot and Union* wrote: "The President succeeded on this occasion because he acted without sense and without restraint in a panorama that was gotten up for the benefit of his party than for the glory OF THE NATION AND THE HONOR OF THE DEAD. We pass over the silly remarks of the President . . . we are willing that the veil of oblivion shall be dropped over them. . . ."

The *Chicago Tribune* reporter recognized a literary masterpiece: "The dedicatory remarks of President Lincoln," he telegraphed, "will live among the annals of men."

But the final tribute came from the Honorable Edward Everett, himself. In a note to the President, he wrote: "I should be glad if I could flatter myself that I came as near to the central idea of the occasion in two hours as you did in two minutes."

To which Mr. Lincoln graciously replied: "In our respective parts yesterday, you could not have been excused to make a short address, nor I a long one. I am pleased to know, that, in your judgement, the little I did say was not entirely a failure."

"Tradition, story, history—all will not efface the true, grand epic of Gettysburg," wrote Lieutenant Frank Aretas Haskell, the soldier. "The air, the trees, the graves are silent . . . and the soldiers here never wake to the sound of reveille," wrote the civilian. Both had recognized Gettysburg as being what Mr. Lincoln had put into words.

The Generals

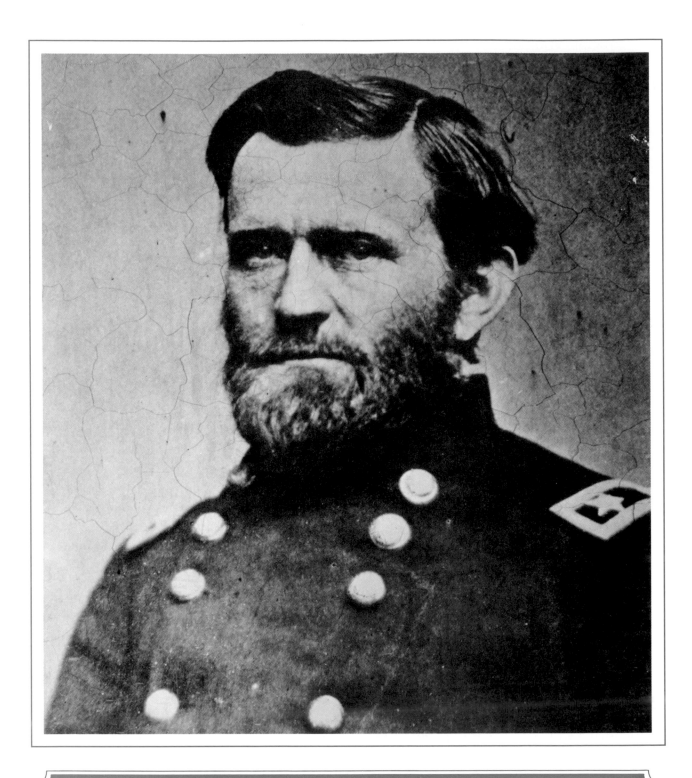

This photograph of General U.S. Grant, in the uniform of a major general, was made by an unknown photographer in the West, and shows him as he looked about the time of his military victories at Fort Donelson and Vicksburg.

From a photograph in the author's collection.

Lt. Gen. Ulysses S. Grant

"War," said General U.S. Grant to his friend John Russell Young, "is progressive, because all the instruments and elements of war are progressive. I do not believe in luck in war any more than luck in business. Luck is a small matter, and may affect a battle or a movement, but not a campaign or a career . . . there is nothing ideal in war."

Grant said that during one of many conversations the former commander of the Union forces had with John Russell Young, the correspondent, who accompanied the Grant family on their world tour after the alarms of war and politics had long since died away.

In 1861, Grant, "who disliked both war and the boredom of military life during peacetime," had accepted the colonelcy of an Illinois regiment because he didn't believe in secession or division of the country. "When I was in St. Louis the year before Lincoln's election," he said to Young, "it made my blood run cold to hear friends of mine, Southern

men—as many of my friends were—deliberately discuss the dissolution of the Union as though it were a tariff bill. I could not endure it. The very thought of it was pain . . . it was this feeling that impelled me to volunteer . . ."

A graduate of West Point with combat experience acquired in the war with Mexico in 1846, Grant had sought nothing but to serve his country in any capacity in which he could be helpful. "I only wanted to fight for the Union," he said.

To Ulysses Grant, soldiering was a noble and demanding profession that belonged to the young, especially when combat officers were involved. Youth was of paramount importance to the success of any campaign. "A successful general needs health, youth and energy," he said. "I should not like to put a general in the field over fifty. When I was in the army I had a physique that could stand anything. Whether I slept on the ground or in a tent; whether I slept one hour or ten in twenty-four; whether

I had one meal or three, or none, made no difference. I could lie down and sleep in the rain without caring . . . the power to endure is an immense power, and naturally belongs to youth."

The most formidable of the Southern generals who were his opponents, Robert E. Lee, in 1864, in a tribute to Grant's military ability and tenacity, told his officers that they must "make up [their] minds to get into line of battle and stay there, for that man [Grant] will fight us every day and every hour till the end of the war."

After his successful campaign against Confederate partisans in Missouri in 1861, Grant was promoted to brigadier general. It was his strategic concept of the Mississippi Valley theater of the war that brought the only military victories of which the Union could boast in light of the military disasters in the East.

The Tennessee and Cumberland rivers were highroads to the heart of the Confederacy, he believed, and their economic dependencies, "broad areas untouched by war"; if these routes were cut, that would stop the flow of military supplies and arms to the Confederate armies in the field in the East. Acquiring reluctant permission to reduce the forts protecting these waterways from his superior at Washington, General Henry W. Halleck (probably the most incompetent of all the incompetent officers in the Federal forces), Grant began his campaign against them.

With the assistance of the Navy's gunboats, which proceeded up the Tennessee ahead of Grant's strike force of 17,000 men, the campaign opened, and by February 6, 1862, Fort Henry was attacked successfully by Commodore A.H. Foote's gunboat flotilla. Believing his position untenable, Confederate General Lloyd Tilghman sent his garrison across country to Fort Donelson on the Cumberland and surrendered Fort Henry.

Grant kept moving ("war is progressive") and—while Foote's gunboats went back down the Tennessee to the Ohio, swung into the Cumberland, and then steamed up to Fort Donelson—part of Grant's army went round by water transport. His other units marched across country, following Tilghman's garrison. Grant then invested Fort Donelson and, after a

short decisive engagement, the work fell. Within the fort, General John B. Floyd, former Secretary of War of the United States, who had plotted and planned defection and who had made off with $750,000 dollars in Indian Trust Bonds, true to character ran away, leaving General Simon Bolivar Buckner to accept Grant's "unconditional surrender" demand. It is said that Grant decided to attack at once when he discovered from a prisoner that the fort's garrison had been provided with a week's rations. There would be no necessity for this issue, he reasoned, if the Confederates intended to hold out and not retreat.

Grant moved on; his next target was Pittsburg Landing on the Tennessee River. He landed there and encamped. General Halleck, aware of the acclaim Grant was unwittingly getting, decided to interfere with an alternative plan, which left Grant wide open to a sudden attack in force. The attack came and developed into the great battle of Shiloh. At six o'clock in the morning of April 6, 1862, near a little church called Shiloh, Confederate forces under the able General Albert Sidney Johnston mounted a surprise attack which dispersed the advance units of Grant's army, overrunning and forcing Prentiss's division to fall back on Grant's second line. For two days the battle raged, "a confused and terrible thing." The first day's fighting involved the troops of General William Tecumseh Sherman and General Prentiss, which held the forward positions. The furious struggle lasted several hours, and Grant's army was forced back to within a half mile of Pittsburg Landing at the river's edge, where massed artillery stopped the Confederate advance. Nightfall ended the immediate fighting. During the night, the forces of General Don Carlos Buell's army, 25,000 strong, crossed the river on pontoon bridges under torchlight, and Grant ordered a counterattack for 5 a.m., to be supported by the gunboats in the river. But the Confederate army withdrew, and neither force, weakened by terrible losses, was up to renewing the pursuit. General Albert Sidney Johnston was killed early in the contest, the command going to General P.T.G. Beauregard.

"Shiloh was one of the most important battles of the war," commented General Grant to correspondent Young. "It was there that our

Western soldiers first met the enemy in a pitched battle. From that day they never feared to fight the enemy, and never went into action without feeling sure they would win. . . . Sherman was the hero of Shiloh."

By July 3, 1863, the battle of Gettysburg had been fought and won on the farmlands of Pennsylvania. The next day, Grant captured Vicksburg, Mississippi, a powerful position held by General John Pemberton's forces, after a siege of forty-seven days. Since May, Grant had been tightening a ring of iron around the "Gibraltar of the West," the "City of a Hundred Hills." Its people, living in bombproofs and underground shelters, starved, eating rats and dead army mules when such fare was available. For more than a month, the pounding of the big naval guns at the rear, the mortar shells on the land side, and the terrifying explosions of the land mines and flying saps moved closer and closer. Finally, on the Fourth of July Pememberton surrendered the city and his entire command, giving Grant full control of the Mississippi River.

The Vicksburg campaign was a masterpiece of military planning and operation, entirely conceived and executed by Grant, and was so acknowledged.

Coming on the heels of Vicksburg, a battle at Chickamauga, Tennessee, as bloody as either Antietam and Gettysburg, left General William Starke Rosecrans and the Army of the Cumberland bottled up in a siege at Chattanooga. To make certain his victory at Vicksburg and its effects were not nullified, Grant himself rushed to Chattanooga to take over. As supreme commander of the western armies, Grant regrouped the forces, restored communications, and fought his way through the Confederate encirclement in November 1863, when Braxton Bragg's army was defeated at the battle of Missionary Ridge.

At President Lincoln's request, Congress restored the rank of Lieutenant General (full rank) of the army; the bill became law on February 26, 1864. The Senate confirmed Grant's nomination to that rank, and Grant was called to Washington to receive his commission, delivered by President Lincoln himself at the Executive Mansion. Present were Grant's eldest son, members of the Cabinet,

and a few soldiers of Grant's staff. The ceremony was short, President Lincoln and his new commanding general exchanging short speeches of conferment and acceptance, both of which were written by Mr. Lincoln, who knew Grant's "disinclination to speak in public." "Assuring him [the President] that I would do the best I could with the means at hand, and avoid as far as possible annoying him or the War Department, our first interview ended."

Assuming personal command of the Army of the Potomac, Grant made his temporary headquarters at Culpeper, Virginia. He appointed Major General Philip H. Sheridan chief of cavalry and gave the overall command of the Western armies to his friend, that very capable officer, Major General W.T. Sherman. Then, with the confidence born of President Lincoln's assurance that he had the full support of the administration, Grant opened his 1864 campaign.

For the first time since the war began, there was to be a concerted movement of all the Union armies, a plan devised by Grant to end the war as quickly as possible. Grant, leading the Army of the Potomac, would engage Lee and hammer his army until it disintegrated; the Western armies, under Sherman, would attack the Confederate units in the northwest Georgia region, and drive them southward—into the sea, if possible. So, by May 1864, *all* the Union armies were in motion.

What followed that year shocked the North, but the South was crushed by it. "My general plan now," wrote Grant, "was to concentrate all the force possible against the Confederate armies in the field. . . . accordingly, I arranged for a simultaneous movement all along the line."

On May 4-5, 1864, with ten days' rations and a supply of ammunition in its wagon train, trailed by a large contingent of beef cattle driven with the trains to be butchered as needed, Grant's army headed for Virginia, his men each carrying three days' rations and fifty rounds of cartridges in their haversacks.

Crossing the Rapidan River at Germanna Ford without mishap, the Army of the Potomac, 120,000 strong, entered "The Wilderness," an almost impenetrable, fifty-square-mile forest of dense trees, underbrush,

abandoned mines, and swamps, and fought one of the most furious battles of the war. Preliminary action was followed by a skillful series of military maneuvers, which precipitated the sanguinary battles of Spottsylvania Courthouse, the North Anna, and Cold Harbor, which brought Grant's armies to the south bank of the James River, the casualties suffered on both sides astounding.

By July 30, 1864, Grant had invested Petersburg, Virginia, and opened a siege that lasted almost a year. There would be no turning back, Grant informed President Lincoln. The siege wore on, with boredom, heavy casualties, and distinct indications that Lee's army could not withstand the daily attrition exacted from it. On March 29, 1865, it became apparent that Lee was evacuating Petersburg and Richmond, the decimated remnants of his loyal army moving south and west in the general direction of Five Forks. But at Five Forks, after a sharp action, Lee realized that his position was hopeless.

Encircled by Grant's forces, his supply lines cut, without food or shoes or forage, his escape routes cut off by the cavalry of General Philip Sheridan, Lee surrendered at 1 p.m. on the afternoon of April 9, 1865, at the McLean House at Appomattox Court House, Virginia. The war was over.

There are, however, one or two incidents worth telling to complete the sketch of General Grant during the last year of the war. One day, near the war's close, at the City Point headquarters on the James River, one of Grant's officers asked: "Why don't you ask the President to come down and visit you?" To which Grant replied that Mr. Lincoln was the commander-in-chief and could come whenever he wished. Someone then brought to Grant's attention that the main reason Lincoln had not come was because of the talk about his interference with his generals in the field, that he was reluctant to impose himself on them. Grant at once telegraphed to Washington and invited Mr. Lincoln to visit the army at City Point.

"He came at once," wrote Grant. "He was really most anxious to see the army, and be with it in its final struggle. It was an immense relief to him to be away from Washington. He remained at my headquarters until Richmond

was taken. He entered Richmond, and I went after Lee."

General Grant was pleased and happy that President Lincoln had spent most of his last days at City Point. "Lincoln . . . spent the last days of his life with me," wrote General Grant. "I often recall those days," he continued. "He lived on a dispatch boat in the river, but he was always around headquarters. He was a fine horseman, and rode my horse, 'Cincinnati.' We visited the different camps, and I did all that I could to interest him. He was very anxious about the war closing; was afraid we could not stand a new campaign, and wanted to be around when the crash came. I have no doubt that Lincoln will be a conspicuous figure of the war; one of the great figures of history. He was a great man, a very great man. The more I saw of him, the more this impressed me. He was incontestably the greatest man I ever knew."

General Grant's last years, following his two terms in the presidency from 1869 to 1877, were years of painful illness. Cancer had attacked his throat, and the medical science of the time was unable to relieve his suffering. Though frequently urged by his friends to write his memoirs, Grant had never until just before his illness seriously thought of writing anything for publication, but then the editor of the *Century Magazine* asked him to write a few articles on the war.

Grant was sixty-two, and an injury he received from a fall had confined him to his home. So, grasping this opportunity as a pleasant pastime of study, to which was added the need for money, Grant agreed to do the articles, the work being "congenial."

These articles and a visit from Mark Twain convinced him that he should write his memoirs. The first volume of the *Memoirs* and a portion of the second were already written before he realized that his illness was terribly serious. At the time, he was living in a small cottage on Mount MacGregor, New York, north of Saratoga Springs. The disease, taking its irresistible course, kept him in constant pain; but even in those terrible moments of great suffering, he never spoke unkindly to anyone. To his faithful servant, Harrison, he talked about his book; his greatest fear, that he would die before it was completed.

"I have been awake nearly all night," he would say, "thinking about my book. If that were only finished I should be content." At this stage of his illness, his voice was scarcely a whisper, almost inaudible. More concerned about his family than for himself and unwilling to cause anxiety, he feigned sleep when members of the family entered his bedroom.

During the months of July and August 1884, he sat on the porch of his house, his throat bandaged, completely absorbed in his work, writing, writing, writing. Nothing touched him more deeply than the spectacle of the crowds of well-wishers who gathered affectionately about his door to inquire after his health. They came by train, by carriage, and on foot from the railway station, some walking silently past the house—some waved, others raised their hats in salutation. Letters and telegrams from Schofield, his Secretary of War, Sheridan, his great cavalry commander, former Confederate opponents like Joe Johnston and James Longstreet—and he was gratified that "people, both North and South," were "equally kind in their expressions of sympathy." General Simon Buckner, a member of his West Point graduating class, and the officer who surrendered Fort Donelson to him, spent an hour talking with him, Grant writing his replies with a pencil, his speech having failed. During that interview with General Buckner, Grant wrote: "I have seen, since my sickness, just what I have wished to see ever since the war—harmony and good feeling among the sections."

Grant's last days are grievously sad. On July 2, 1885, while seated on the porch of his house, Grant handed his physician, Dr. J.H. Douglas, a note he had penciled. It read:

"I ask you not to show this to anyone, unless it be the physicians you consult with, until the end. Particularly, I want it kept from my family. If it is known to one man, the papers will get it, and they [his family] will get it. It would only distress them beyond endurance to know it—I would say, therefore, to you and your colleagues, to make me as comfortable as you can. If it is within God's Providence that I should go now, I am ready to obey his call without a murmur."

Dr. Douglas tried to encourage the General, but a few days later the dying soldier handed him another note. It read: "After all, however, the disease is still there, and must be fatal in the end. My life is precious, of course, to my family, and would be to me if I could recover entirely. I first wanted so many days to work on my book, so that the authorship would be clearly mine. My work has been done so hastily that much was left out, and I did it all over again, from the crossing of the James River, in June, 1864, to Appomattox, in 1865. Since that time, I have added some fifty pages to the book; there is nothing more that I should do to it now, and therefore I am not likely to be more ready to go than at this moment."

General Grant's prayer that the end would soon relieve him of his agonizing pain was answered; but not before his most fervent wish, that he should live to finish his book, was gratified. "Of course I am sorry to leave my family and friends," he noted sadly, "but I shall be glad to go." A short while later he remarked; "Yes, I have many friends here, and I also have many friends on the other side of the river who have crossed before me"; adding after a brief pause, "It is my wish that they may not have long to wait for me, but that the end will come soon."

The former president rallied several times in the few days that followed, and there was much physical suffering borne in silence and patience. Finally, on Thursday, July 23, 1885, General Ulysses S. Grant, "man of iron," American soldier and ex-president, surrounded by his family, passed away peacefully. His last distinct words were: "I hope no one will feel distressed on my account . . ."

Grant's race with time had been won, and the success of his book was pre-ordained. The advance sale exceeded a quarter of a million copies. His friend, Mark Twain, sounded the eulogy:

"There is that about the Sun which makes us forget his spots; and when we think of Grant our pulses quicken . . . we only remember that this, a simple soldier, all untaught of the silken phrasemakers, linked words together with an art surpassing the art of the schools, and put them into something which will bring to every American ear, as long as America shall last, the roll of his vanished drums and the tread of his marching hosts."

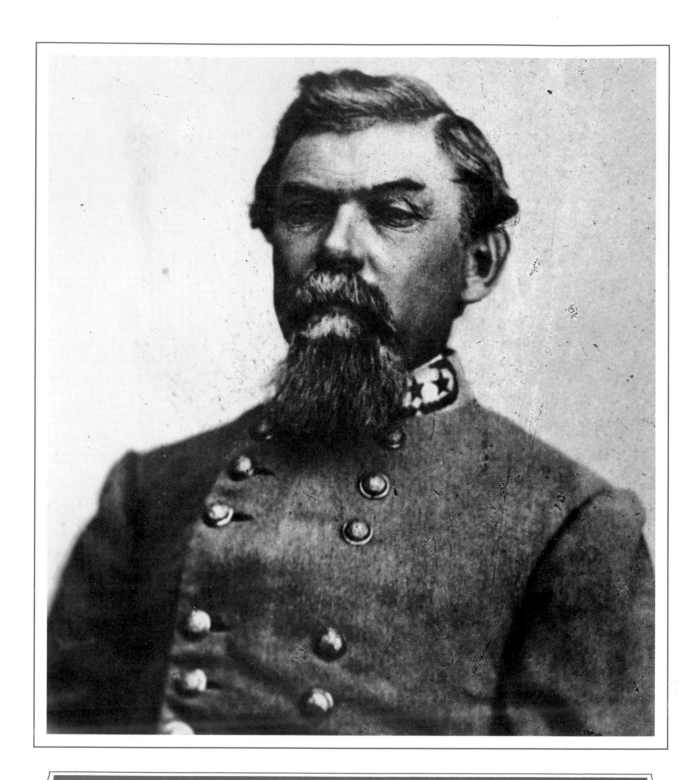

This photograph of Confederate Lt. Gen. William Joseph Hardee was probably made by either Vannerson of Richmond, Virginia, in 1864, or Mathew Brady at the end of the war when Brady was trying to complete his picture collection of Confederate officers.

From a photograph in the author's collection.

Gen. Joseph Hardee— trying to stop Sherman

On November 16, 1864, General William Tecumseh Sherman sat his horse atop a ridge outside Atlanta, the city he had fought for in a bloody campaign lasting six months, and which he had finally taken after a seventy-five-day series of battles and siege.

Now, from this ridge, he watched his devoted army of sixty thousand strong begin their march toward the Eastern coast; his objective, Savannah—two hundred and fifty miles away through hostile country.

His veteran army, probably comprising the best soldiers in the United States service, was now divided into two wings of thirty thousand men each, with two brigades of cavalry, the youthful Major General Judson Kilpatrick commanding and leading the vanguard of each wing.

Sherman's "March to the Sea" was unique in military annals.

It was estimated by Sherman at the outset that even though his troops had enough food

and ammunition to last for twenty days, at the marching rate of fifteen miles a day these supplies would be inadequate.

So it was necessary to organize a "foraging party" of forty men for each regiment, armed with Springfield rifles. Their job was to "forage liberally on the country," each forty-man unit spreading outside the line of march, raiding barns, smoke-houses, chicken coops, and granaries, with strict orders "not to enter private dwellings."

After they collected their loads of hams, chickens, turkeys, sorghum molasses, bread, and fodder for the cavalry and artillery horses, they joined the army or let it catch up with them.

To General Sherman, marching through Georgia was a lark for his men, and in his report of the campaign, Sherman wrote:

> The condition of the army was all that could be desired. As to rank and file, they seem so full of

confidence in themselves that I doubt if they want a compliment from me; but I must do them justice to say that whether called on to fight, to march, to wade streams, to make roads, clear out obstructions, build bridges, make corduroy, or tear up railroads, they have done it with alacrity and a degree of cheerfulness unsurpassed.

A little loose in foraging, they "did some things they ought not to have done," yet on the whole they have supplied the army with as little violence as could be expected, and as little loss as I calculated.

As Sherman's men marched and fought in the campaign designed to "make Georgia howl," Lieutenant General William Joseph Hardee of the Confederate States of America, recently given the command to defend Savannah at all costs and to stop Sherman if possible, prepared to meet Sherman's onslaught, his defending force a pitiful eighteen thousand men against Sherman's sixty thousand.

General Hardee, a Confederate officer of the highest caliber, whose star was overshadowed by the names of Lee, Jackson, Johnston, and Hood, was born on October 12, 1815 at "Rural Felicity," the Hardee estate in Camden County, Georgia.

He was the son of John and Sarah Ellis Hardee. His grandfather Anthony Hardy, of Pembroke, Wales, had settled in North Carolina, had fought in the American Revolution, and had once been a continental galley officer patrolling the Eastern coast of Georgia.

Young Hardee's father, a former major of cavalry in the War of 1812, had enrolled young William in West Point. William graduated in 1838 with the rank of second lieutenant, and was assigned to the United States Second Dragoons.

A year later, Hardee was promoted to first lieutenant and given a commission to go to Europe and study the cavalry tactics and organization of the European armies.

Upon his return to the United States, Hardee was assigned to duty at Fort Jessup, Louisiana, the jumping-off place of American troops being readied for the Mexican War. Later, he took part in the bloody actions of Vera Cruz, Contreras, and Monterey. He joined General Winfield Scott's forces in the capture of Mexico City, which ended the war.

Hardee's "devotion to duty and meritorious service" in the War with Mexico was rewarded with two promotions, which gave him the rank of brevet lieutenant colonel.

A student of warfare as well as a combat officer, Colonel Hardee wrote and published his *Rifle and Light Infantry Tactics*, which later became known simply as "Hardee's Tactics" and was adopted by West Point as a textbook.

That same year of 1855, Colonel Hardee was attached to the U.S. Second Cavalry, commanded by Colonel Albert Sidney Johnston, Lieutenant Colonel Robert E. Lee, and a junior major, George H. Thomas, who would become famous in 1864 as "The Rock of Chickamauga" for his stand and victory in that battle in Tennessee.

In 1856, Hardee received the permanent rank of lieutenant colonel and was assigned to West Point as commandant of cadets, the same post held by Robert E. Lee at the academy.

Hardee was on leave at his home when, on January 19, 1861, Georgia seceded from the Union, and two days later he resigned his commission in the United States Army and accepted a commission in the Confederate States Provisional Army as colonel assigned to a command in Arkansas.

After a year in this relatively inactive post, in June 1862 Hardee received promotion to major-general, organized the original Arkansas Brigade (known as "Hardee's Brigade"), and was transferred with his unit to Kentucky, where he became permanently attached to the Army of Tennessee.

As a divisional commander, General Hardee took an active part in the bloody battles of Shiloh Church and Perryville, all the way to Missionary Ridge—actions fought in a frenzy, ending with staggering casualties.

Now, with Sherman's relentless advance toward Atlanta, the Confederacy's rail center, General Hardee was called upon to command his division in a series of actions designed to stall Sherman between Dalton and Atlanta; but although his defensive actions were flawless, the Confederate Army of Tennessee was no match for Sherman's overpowering force.

In September, Atlanta fell to Sherman after a series of battles, and General John Bell Hood, who had superseded General Joseph E. Johnston, retreated toward Nashville, hoping to decoy Sherman away from Atlanta.

But Sherman had a few ideas of his own,

and the march to the sea was one of them.

As Sherman's army ground its way toward Savannah, creating havoc in his wake, General Hardee made his preparations for the defense of Savannah. A lieutenant-general as of October, he was given command of the military department of South Carolina, Georgia, and Florida; but it was a title on paper, without military forces strong enough to control and defend it.

Meanwhile, as Sherman's army approached the city, he fixed an appointed line on which his army, now in four corps, would assemble at the appointed time, a line running from Ogeechee Church on the river of that name to Halley's Ferry on the Savannah.

From this point, Sherman's advance, forty miles above the invested city, met and assembled at the appointed time, after which the advance against Savannah would continue along several roads.

Shotwell, the military writer, says:

> General Hardee had assumed to defend the city with about 18,000 troops. Trees had been felled where Sherman's road crossed creeks, swamps, or narrow causeways. But his pioneer companies were well organized and removed the obstructions quickly.
>
> So, no opposition from Hardee worth mentioning was encountered till the heads of the columns were within fifteen miles of the city.
>
> Here the roads were systematically obstructed by felled trees, earthworks and artillery. These obstructions however were easily turned. And Hardee was driven within his line.
>
> This followed first a swampy creek that emptied into the Savannah River about three miles above the city, and thence across the divide to the head of a corresponding stream which emptied into the Little Ogeechee.
>
> These streams were generally favorable to Hardee as a cover, because very marshy ground, bordered by rice fields, were flooded either by tide water or inland ponds.

In short, Savannah was admirably suited for a defensive battle. Fort McAllister was the real obstacle in Sherman's path, but this didn't prove too much of a deterrent to the redoubtable Sherman. On the morning of December 13, Sherman decided to carry the fort by storm.

Although Fort McAllister was a strong redoubt, which had twenty-three heavy guns and was manned with two companies of artillery and three companies of infantry—in all, two hundred men—it was no contest in an attack by a division.

General Sherman witnessed the assault from the roof of a rice mill on the other side of the river.

Sherman had been expecting the Federal fleet to support him, and, while watching Hazen's attack, he saw the smokestack of a warship.

A signal from the ship's captain read, "Has Fort McAllister been taken?"

"Not yet," signalled Sherman, "but it will be in a minute." The short engagement had lasted exactly fifteen minutes, with a loss of 134 of Hazen's men and 48 of the defenders.

General Hardee, now realizing his position, withdrew that night. The following morning, Sherman took possession of Savannah. The date was December 21, 1864. General Sherman, in a telegram to President Lincoln, at Washington, presented him with the city as a Christmas present, and General Hardee withdrew his army to Charleston to make another stand.

It was noted that "the behavior of Sherman's troops was good. Never was a hostile city occupied by a large army with less disorder."

General Sherman moved into Savannah and remained there a month, and then moved his army over the river and moved on Charleston. General Hardee, receiving no reinforcements, evacuated Charleston and moved his depleted army into North Carolina, where he made junction with the Army of Tennessee, once again commanded by General Joe Johnston. But before any further military action could take place, word was received that Lee had surrendered in Virginia.

A last battle at Bentonville settled the matter of the Army of Tennessee, and the war was over for General Hardee.

With the close of the war, General Hardee retired to Alabama, where he settled down on a farm, a legacy of his wife Mary T. Lewis, whom he had married in January 1863 in Greensboro, Alabama. The couple had one daughter.

General Hardee died on November 6, 1873, at Wytheville, Virginia, and was buried at Selma, Alabama.

As an epitaph, E.A. Pollard said of him: "An accomplished horseman, of commanding stature, and striking martial mien, his bearing in action was impressive and inspiring. To this was added, coolness that never failed; presence of mind never disturbed; and an intellect that rose, like his heart, in the tumult and dangers of battle."

The first "modern" war, the Civil War saw the emergence of many sophisticated weapons and much new military hardware, for use on both land and sea. Not the least of these were the United States Navy's river gunboats which formed the James River flotillas.

The rivers leading to Richmond being the narrow and shallow James and Pamunkey, the need for ships of heavy firepower and shallow draft produced the U.S.S. monitor "Onondaga" and U.S.S. "Sassacus."

The "Onondaga" from bow to stern measured 226 feet, with a beam of 49 feet 3 inches. This unique warship, an improved and enlarged version of John Ericsson's original "Monitor," which had fought the C.S.A. Virginia (or Merrimac) two years before at Hampton Roads, had a crew of 150 men and officers and carried an armament of two 15-inch 200-pound Dahlgren rifles and two 150-pound Parrott rifles. The "Onondaga" weighed in at 1,250 tons and had a remarkable speed of nine knots.

The "Onondaga" was built by the Continental Iron Works at Greenpoint, New York, launched on July 2, 1864, and commissioned the same day. She joined the James River flotilla, under Captain Melancton Smith, and saw action in the James against the river batteries lining both banks of the river to deny naval access to Richmond. The Confederacy, however, had nothing afloat that could compete with these monsters.

The "Sassacus," a unique "double-ended" side-wheeler gunboat of wood-and-iron construction, measured 205 feet bow to stern, between perpendiculars, with a beam of 35 feet. Her unusual ability to sail forward or backward without turning around, a maneuver usually impossible in the James and Pamunkey rivers for standard gunboats, made her a very useful vessel indeed. She drew eight feet of water, had a speed of from seven to nine knots, and carried two 100-pound Parrott rifles and eleven 9-pound Dahlgrens. With a complement of one hundred fifty men and officers, the unique double-end feature made "Sassacus" a formidable fighting machine.

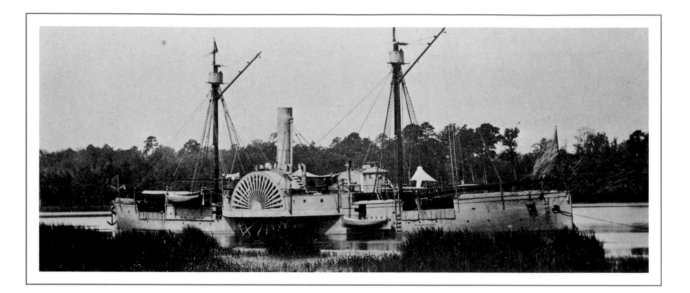

"Sassacus" was built for river fighting. Anchored in the James River, this heavily armed vessel saw action in the last year of the war. The third of her class, she had rudders at bow and stern.

Author's collection.

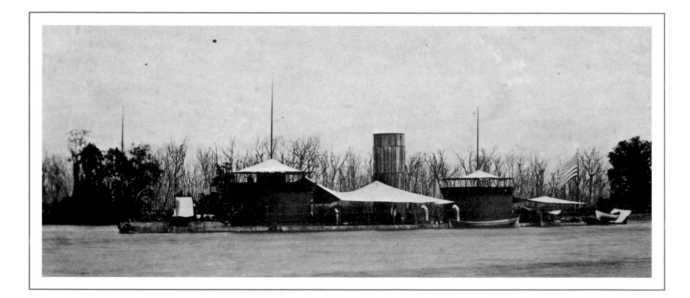

Seen in 1864 at her station in the James River flotilla, near Haxall's Landing, is the U.S.S. monitor "Onondaga." This improved version of the earlier "Monitor" of 1862 had no counterpart in the Confederate Navy.

Author's Collection.

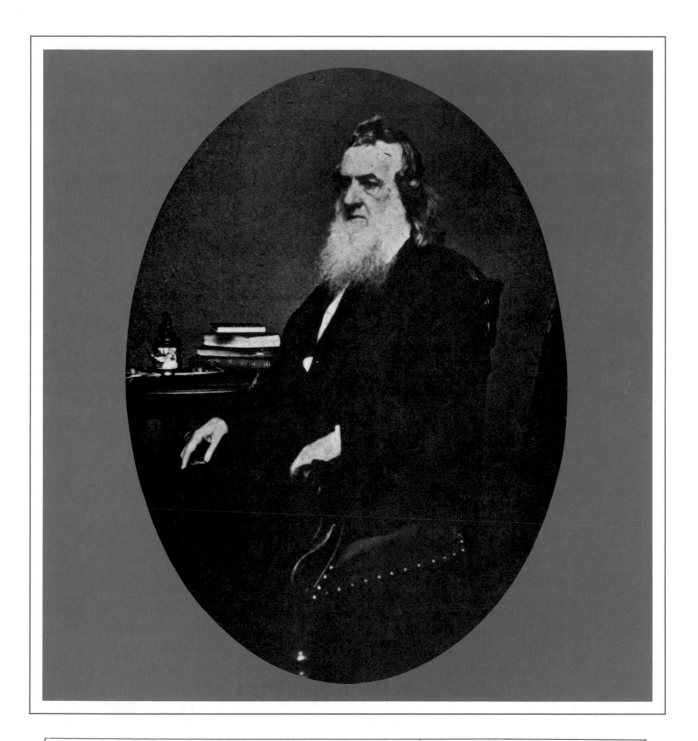

A "Nervous Nellie" type of man, bearded Gideon Welles was an efficient Secretary of the Navy even though he didn't know one end of a ship from the other. He kept a day-to-day diary of his term of office, which probably made a number of his less efficient colleagues nervous, too.

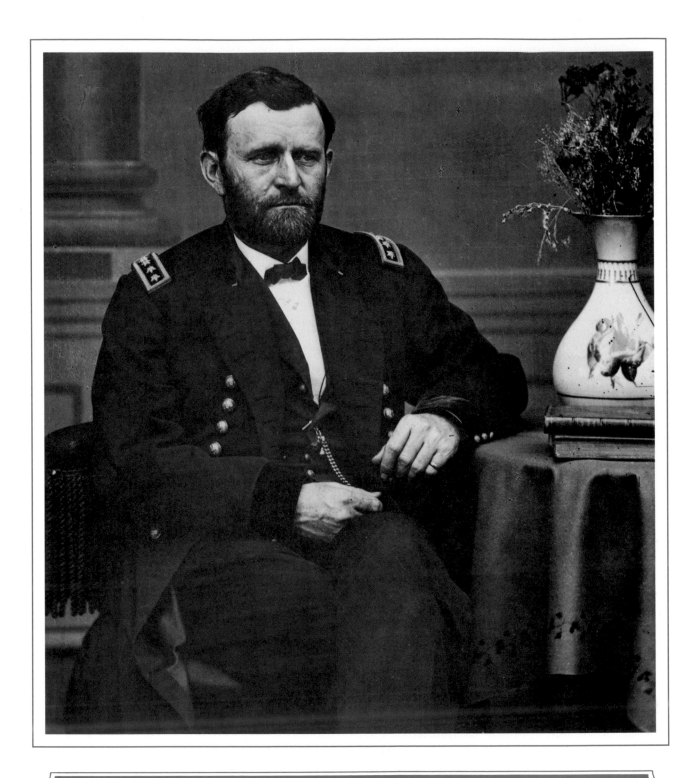

One of the finest pictures of the soldier-president, Ulysses Simpson Grant, this portrait was made by Brady some time in 1868 in the Washington gallery. It is a brilliant study, showing the general's full panoply of stars.

From a photograph by Mathew Brady. Author's collection.

Grant— using the railroads to stop Lee

On May 4, 1864, General Ulysses S. Grant, with the Army of the Potomac, one hundred twenty thousand-strong, crossed the Rapidan River into the wilderness of Spotsylvania, and by midnight, to all intents and purposes, had vanished into the air.

The region Grant and his army had apparently disappeared into was a forbidding area about thirty miles long and twelve miles wide, covered with dense undergrowth, swamps, large trees and jack pine.

The region was not exactly the kind of place that would encourage Grant's foot-soldiers, for the ground had been fought over by Lee and General Joseph "Fighting Joe" Hooker the year before, and the debris of the Battle of Chancellorsville was still very much in evidence.

Skeletons of men and horses, broken and rusty canteens, artillery axes, wrecked artillery limbers, and rusted rifles foretold of what was to come. At one place where the fighting had been severe, the skulls of men covered the ground.

While Grant's army fought its way through the underbrush, thickets, and swamps, by May 6, having received no word from Grant, President Lincoln and members of the War Department had grave concern for the nation's new commander and his army.

The only word they had received as to Grant's progress and condition came from Henry Wing, a *New York Tribune* reporter who had reached Union Mills on the Orange and Alexandria Railroad. He told an army telegrapher that "everything is pushing along favorably." Otherwise, all was silence.

Eager for news and angry, Secretary of War Edwin M. Stanton telegraphed the newspaperman that unless he released his information to the War Department at once he would be subject to arrest as a spy. Another, more temperate, wire was then sent to the reporter asking him if he would be willing to tell the

President in person where Grant's army was.

The reporter's reply was conditional. He would tell the President everything he knew if he would be permitted to transmit a one hundred-word dispatch to his paper, the *New York Tribune*.

President Lincoln accepted Henry Wing's offer and also agreed that Wing's dispatch could run over a hundred words, if necessary. The President then made arrangements with the *New York Tribune* to share its reporter's story with the Associated Press for distribution to other papers.

President Lincoln placed a military locomotive at Wing's disposal, and the reporter traveled to Washington for his meeting with Lincoln that morning at two a.m.

His interview was short. He informed Lincoln that Grant had given the order for an all-out dawn offensive against the enemy, and said that General Grant had told him, "If you see the President, see him alone and tell him that General Grant says there will be no turning back."

Grant's Battle of the Wilderness was a blazing holocaust of forty-eight hours of some of the most sanguinary fighting of the entire war. Fourteen thousand men were listed as killed, wounded, or missing in action when it was over.

Then Grant made another vital decision to advance toward Richmond by extending his left flank toward Spotsylvania Court House, "using the greatest numbers of troops possible," and at the same time informing President Lincoln that they intended to continue the bloody contest "until, by mere attrition, if in no other way, there should be nothing left to him."

Such was Grant's determination "not to turn back" across the Rapidan, as other less determined Federal generals had done before him.

But Lee guessed Grant's intentions, and a race between the two armies developed, with only a few miles between them. Both armies traveled on parallel routes. Lee won the race to Spotsylvania and was there to meet Grant; entrenched and ready, his army straddled across Grant's path.

The battle that took place was even bloodier than the one that had preceded it. Grant's men attacked the entrenched Confederates, who had built up parapets of hastily cut logs.

During the terrible conflict, the woods caught fire, and only the rain that followed prevented many wounded men from being burned alive. At a salient in the Confederate line, called the "Bloody Angle," hand-to-hand fighting became the rule, many of the blue soldiers being pulled over the log-parapets to be taken prisoner.

Others used their rifles as spears, thrusting their bayonets through chinks in the logs, or lunging their rifles into the bodies of the Union soldiers who charged the entrenchments wave after wave.

Before long, the trenches became filled with the dead and dying; blood was everywhere, mixed with the mud of the hastily built trenches. So intense was the rifle fire that trees were cut down as if by a giant scythe. One tree, twenty-three inches in diameter, was completely cut apart by bullets.

The furious battle developed into a ghastly spectacle of charge and counter-charge, with thousands of men dying on both sides of the waving lines. The battle that had started on the morning of May 8 and went on until the evening of May 18 ended in a draw. And the result of this battle made the stubborn Grant determined that he "would fight it out on this line if it takes all summer."

Lee's beloved cavalry chief, General J.E.B. (Jeb) Stuart, who had been harassing Grant's flanks, ran into General Phil Sheridan's cavalry at Yellow Tavern. In a furious battle on horseback, Stuart died with a bullet in his abdomen, and Lee's army lost its eyes.

Grant tried unsuccessfully to get his army between Lee and his home base at Richmond, but the wily Lee each time avoided the trap. During Grant's third try on the North Anna River, he was again checkmated by Lee, who was maneuvering; and the bloody chess game went on until Grant again met Lee, this time at Cold Harbor, where another full-scale battle took place. Twenty-two hundred men died in the first twenty minutes of the action.

After the battle, Grant wrote to Major General Henry Wager Halleck, at Washington. "I now find, after over thirty days of battle, the enemy deems it of first importance to run no risks with the armies they now have."

One thing was evident to Lee: that Grant was no Hooker, Meade, Burnside, or McClellan, "that he had at last met with a foeman who matches his steel, although he may not be worthy of it," as John Tyler, a Confederate War Department official, wrote.

"Each guards himself perfectly and gives his blow with a precise eye and a cool sanguinary nerve."

Grant now set his sights on Petersburg, and with equal tenacity Lee determined to defend it, knowing full well that if Petersburg, twenty miles away, fell, Richmond would fall too.

Grant's base was now City Point on the James River, the eastern terminal for the South Side Railroad—the Confederate railroad which Grant was now using to the point where it reached his army, and where the City Point Military Railroad was constructed to meet it.

It was an unusual, hastily constructed military railroad which ran parallel with Grant's lines entrenched before Petersburg, from one end of the line to the other. Supplies could be distributed to any point along the line.

Sometime late in October, a Union commando unit attempted to wreck the South Side Railroad west of Petersburg, but the attack proved a failure, and the units were returned to their places in the line. Thus ended all operations on the Richmond-Petersburg front for the winter.

And with the arrival of Christmas, the contesting armies spent the holidays in their trenches watching each other warily, the men of both sides suffering the cold and hunger of a barren Virginia winter.

Grant's City Point Railroad kept his army amply supplied throughout the winter of 1864.

On the other side of the lines, Lee's men starved and went cold and ragged, many without shoes, while Richmond's army warehouses bulged with ample food supplies. The South's commissary general, Major General Northrop, President Jefferson Davis's favorite friend and commissary officer, resisted all of Lee's requisitions for food for his army.

Public outrage finally forced Davis to relieve his recalcitrant commissary general; but it was too late. For a short while afterward, there was food available for his men in the trenches; but the damage had been done.

Grant, meanwhile, extended his lines of en-

circlement. In Lee's army there were many deserters. Some made their way to the Union lines and gave themselves up for a square meal and warm clothes.

For Lee, the main defense was the protection of the western end of the South Side Railroad; for when that went, defense of the Richmond-Danville line would be impossible. All it would take now for an enforced surrender was the Union capture or destruction of this single railroad line.

On or about March 4, 1865, Grant ordered his lines extended to cut the South Side Railroad into Petersburg, to deprive Lee of his supplies and to close his last escape route.

On March 29, Phil Sheridan, Grant's cavalry commander, started out to finish the job, riding around Petersburg to his objective. Lee now had to stop Sheridan before he and his six thousand troopers could reach the railroad at Five Forks. Lee struck Sheridan with everything he had; but after two hours of fighting, he had to give it up after Grant's infantry moved in support of Sheridan.

Notifying President Davis of his intentions, Lee now evacuated his men from the trenches around Richmond and Petersburg, moving them out under cover of night. Gaining a full day on Meade, who was in pursuit, Lee moved on toward Amelia Court House to meet a supply train there.

By April 4, Lee's main van reached Amelia to find that the train had not arrived, nor would there be one. Union cavalry had already cut the rail line at Petersville. And due to the Union capture of the rail junction at Burkeville, all trains from Lynchburg, carrying eighty thousand rations for Lee, had been cut off and the trains had been backed out of danger.

Lee's attempt to reach Farmville, twenty miles away, in an effort to get out of the trap Grant had set for him was futile. The retreating Confederate army was intercepted at Sayler's Creek, and the remnants crossed the Appomattox River and came to the vicinity of Appomattox Station on the railroad.

Lee's race had been lost.

Unknown to Lee, his supply train was now in the hands of Sheridan's cavalry, only three miles away. The end for Lee, his men and the Confederacy, was only one day away.

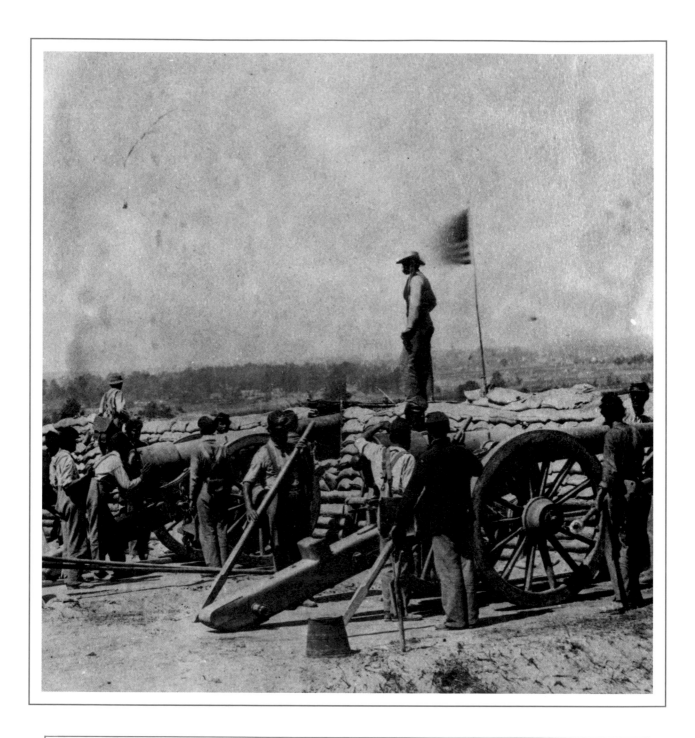

Fort Sedgewick, a salient in the lines before Petersburg, Virginia, June 3, 1864 – April 3, 1865. Named after Major General John Sedgewick, Fort Sedgewick was typical of the forts in the Union lines before Petersburg during the great siege. The guns are 12-pounder Parrotts with reinforced breeches, mounted on siege carriages. The gun at the left has its trail dug into the ground for greater trajectory.

From a photograph by Mathew Brady. Author's collection.

Petersburg— siege warfare

The date was June 16, 1864. Lieutenant General Ulysses S. Grant and the revitalized Army of the Potomac, having fought the bloody actions of the North Anna River and Cold Harbor on June 3, crossed the James River and advanced on Petersburg, Virginia— the strategic junction of the South's most important railroads, the Weldon and Petersburg, Norfolk and Petersburg, and Richmond and Petersburg.

Lee, realizing that Petersburg was seriously threatened, sent General P. T. G. Beauregard with reinforcements to try and halt Grant's relentless advance.

Grant's first move was now to make his hurriedly dug trenches so strong that they could be held by a moderately sized force, which would enable a much larger, mobile force free to move against Lee's rear.

And so the war settled down to a long siege, and Grant concentrated his entire strategic plan on two places—Georgia and Virginia.

With his most competent field commander, Major General William T. Sherman, leading a sixty-thousand-man force against Atlanta, while Grant and the Army of the Potomac held Lee hamstrung protecting Petersburg, neither Confederate Army could reinforce each other as in the past.

The agreement between Grant and his most trusted commander, Sherman, was that Grant would keep Lee fighting so hard and fast that he couldn't reinforce Johnston.

Sherman, meanwhile was to move south, take Atlanta, march to the sea, and advance on Columbia, North Carolina. Eventually, they were to move into Virginia and catch the Confederate Army between them.

On June 23, Grant wrote to Major General Henry Wager Halleck, the Chief of Staff at Washington:

> The siege of Richmond bids fair to be tedious, and in consequence, of the very extended lines we must have, a much larger force will be necessary

than would be required in ordinary sieges against the same force that opposes us.

With my present force, I feel perfectly safe against Lee's army, and, acting defensively, would feel so against Lee and Johnston combined; but we want to act offensively, we should concentrate our whole energy against the two principal armies of the enemy.

The lines around Petersburg now began to spread out as both armies deployed into their fixed positions; and before long, the lines would maintain a length of thirty-five miles, from White Oak Swamp, east of Richmond, across the James River to Bermuda Hundred, crossing the Appomattox River, then following a long arc east of Petersburg, the lower end of the line stretching westward.

The line of fortifications and trenches was interspersed with a string of strong gun emplacements and salients containing heavy rifled artillery—huge, seventeen-thousand-pound Knox mortars, capable of hurling a two-hundred-pound explosive shell five miles in a high trajectory, and smaller Coehorn mortars for close work.

Lee's trenches facing the Union line were equally strong, and were designed along the same pattern. Most of the sharp actions were fought east of Petersburg, where the lines of both armies were close together. At some places in the lines, the distance between them amounted to less than half a mile.

As with all sieges, the men built bombproof shelters, places to huddle in when bombardments became too dangerous and too close for comfort.

But where the lines came close together, during periods of inactivity, the pickets warily fraternized with each other, talking, swapping Virginia tobacco for Yankee coffee, exchanging newspapers and other articles that made life in the trenches bearable.

When this fraternizing of the pickets became known to General George Meade, in a letter to his wife he wrote: "I believe these two armies would fraternize and make peace in an hour, if the matter rested with them."

With the arrival of September, and into the month of October, operations all but ceased, except for sporadic sniping and an occasional round of shellfire. Boredom set in, as there was little to do except watch the enemy.

The preceding June, work had begun on a mine under the Confederate trenches, an enterprise conceived by a Union soldier and exploited by Major General Ambrose E. Burnside, perhaps the army's most incompetent officer.

Among Burnside's troops was the Forty-Eighth Pennsylvania, a regiment made up, in large part, of coal miners. Its regimental commander, Lieutenant Colonel Henry Peasants, was a mining engineer.

The idea of breaching the Confederate trenches by exploding a mine under a part of it intrigued Burnside, and if the project had been handled properly, in all likelihood the war would have ended a year or more before it did.

At any rate, Colonel Pleasants was given charge of operations. A six-hundred-foot tunnel approach was dug between the lines, with a long gallery running right and left under the Confederate salient.

The mine, started on June 25, was completed four weeks later and charged with several tons of high explosives.

The Army of the Potomac's First Division was given the dubious honor of making the attack to widen the breach once the mine was exploded. Fifteen thousand men under the leadership of one Brigadier General James H. Ledlie, who, according to one of his staff officers, was "a drunkard and an arrant coward"; the officer further said that it "was wicked to risk the lives of men in such a man's hands."

At precisely twenty minutes before five a.m. on the morning of July 30, the Petersburg Mine exploded with a cataclysmic roar as tons of black powder, below the earth's surface, ignited and erupted skyward.

A Confederate gunner who witnessed the spectacle wrote: "A slight tremor of the earth for a second, then the rocking as of an earthquake, and with a tremendous blast which rent the sleeping hills beyond, then a vast column of earth and smoke shoots upward to a great height, its dark sides flashing out sparks of fire, hangs poised for a moment in mid-air, and then hurtling downward with a roaring sound, showers of stones, broken timbers, and blackened human limbs, subsides—the gloomy pall of smoke flushing to an angry crimson as it floats away to meet the morning sun."

The Confederate soldiers who manned the demolished salient were no more. A crater, measuring a hundred seventy feet in diameter and thirty feet deep, was left smoking; and for several hundred yards on either side, the broken Confederate trenches were left unmanned, as the soldiers, dazed, sought safety. Not a Rebel battery fired a shot; and there was a deep silence; for how long, no one remembered.

Then, according to plan, the Federal artillery opened with everything it had, plastering the Confederate line unmercifully, in preparation for Ledlie's assault. Ledlie's assault took place, but without Ledlie; for this intrepid commander was hidden in a bombproof, drinking himself into insensibility.

Ledlie's men straggled to the site, stumbling aimlessly toward the deep crater, without an officer to lead them. So badly planned was the assault, that the men, instead of running around the edge of the crater to widen the breach, ran into it.

The assault was a total failure. The Confederates reformed, put up a spirited defense, and restored their line and halted the Federal advance.

The abortive affair cost Grant four thousand casualties, and he wrote General Halleck at Washington that "it was the saddest affair I have ever witnessed in this war . . . such an opportunity for carrying fortifications I have never seen and do not expect again to have."

Compared with casualties sustained by the Army of the Potomac since the start of the Petersburg campaign (sixty-four thousand), the loss was regarded as trifling; but it was the price Grant paid for incompetence on his staff. Burnside was relieved, and Ledlie was permitted to leave the service. And matters of the siege of Petersburg returned to normal until the following spring.

Boredom with the siege once more settled over the lines, and there were many Federal desertions. By fall, they were occurring with alarming frequency. Some of the Union men went over to the enemy, hoping to be able to reach their homes when prisoners were exchanged.

There was disobedience of orders and outright insubordination. On one occasion, there were three desertions, but the men were caught, court-martialed, and executed in the presence of troops, "as many as could be assembled conveniently to witness it," as a disciplinary measure.

But witnessing this execution had little effect on the men, for seven more desertions occurred the following night. All had witnessed their comrades standing before a firing squad the day before for the same offense. But there were no more military executions for desertion.

On April 3, 1865, the men of the Army of the Potomac received orders that Lee's lines before Petersburg would be carried by storm; and they pinned slips of paper to their uniforms with their names written on them for identification, in event of death.

During the night, the Federal artillery pounded the Confederate lines in the "softening-up" process, before launching the main advance. At dawn, the cannon fire stopped suddenly, and Grant's infantry moved out of their trenches and plunged headlong toward the Confederate line.

At battlesite, the fighting was furious, General Wright's corps sustaining a loss of one thousand one hundred men in less then twenty minutes; but the great frontal assault broke the Confederate line—and Lee's army. Grant's captures amounted to twelve thousand prisoners and fifty pieces of artillery.

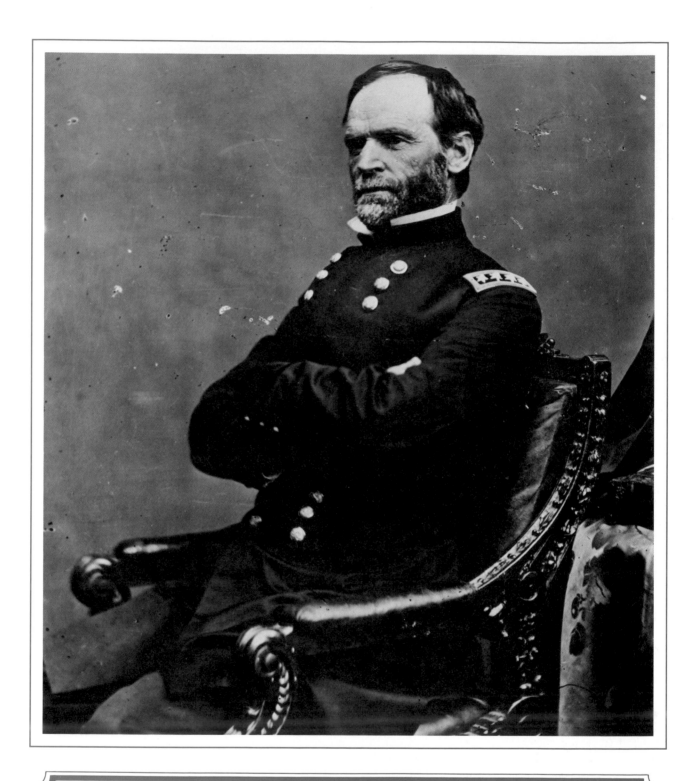

General William Tecumseh Sherman, U.S.A., was photographed in Brady's Washington gallery some time in 1866. General Sherman wears the stars of a full general. Sherman served as chief of staff after the war.

From a photograph by Mathew Brady. Author's collection.

William Tecumseh Sherman— the "war is hell" soldier

"On to Richmond!" was the cry of the would-be volunteer soldiers of the hastily organized Union Army of three-month enlistees who marched down the dusty Warrenton Turnpike in July 1861 to Bull Run, reported position of the equally raw and untried Confederate Army.

To Colonel William Tecumseh Sherman, professional soldier and commander of the Thirteenth United States Infantry, the recruits were as undisciplined and unruly as "the motley horde of correspondents, sightseers and junketing congressmen, and their wives, who followed it to see the fun."

That the impending great battle on the plains of Manassas, Virginia would end the rebellion was the fervent hope of General Irwin McDowell, who commanded the thirty thousand raw and untried troops.

But it was not to be. The Union Army suffered a disastrous defeat. Driven in disorder across Bull Run, the Union Army fled in panic back to Washington, along the road choked with camp followers and frightened politicians.

The military disaster drew the laconic comment from Colonel Sherman, that Bull Run ". . . was one of the best-planned . . . but one of the worst fought" battles of the war.

A month later, Sherman was promoted to brigadier-general and was posted to Kentucky as second in command to General Robert Anderson, who had surrendered Fort Sumter to Beauregard in April.

In poor health and aging, Anderson relinquished the command to Sherman, giving him the thankless job of trying to keep the state in the Union, "with no more than a group of home guards" to back him.

A responsible man and a talented soldier, Sherman, of a nervous temperament, held on as best he could under the circumstances. One of his problems was the irresponsible newspaper reporters who were lavish with their

information concerning his position. In his anxiety and stress, believing that the enemy learned about army movements through the newspapers (which happened to be true), Sherman barred reporters from his lines.

To retaliate, the reporters circulated a rumor that Sherman "was losing his mind." The rumor spread quickly and reached Washington, and Major General Don Carlos Buell was sent to relieve him of command.

Sherman was ordered to report to Major General Henry Wager Halleck, Chief of Staff, probably the most unimaginative, ineffectual and incompetent officer ever to wear an American uniform. Halleck, whom President Lincoln regarded as "a first rate clerk," "viewed Sherman with coldness and suspicion." At the time, Sherman became so depressed with his lot that "he had even contemplated suicide."

Returning from sick leave, Sherman was assigned the command of the District of Cairo, Illinois, General U.S. Grant's former command. After the fall of Fort Henry and Grant's spectacular capture of Fort Donelson, Sherman joined Grant, and the two soldiers conducted the bloody Battle of Shiloh (or Pittsburg Landing), thus beginning a friendship which lasted to the end of their days.

Actually, Sherman's removal and assignment to the Western army was as fortuitous for the country as it was for Sherman. Both men were realists, highly competent, who saw the war for what it was, as did President Lincoln.

The newspapers played up the frightful carnage at Shiloh, stating that the Union Army had been surprised in their camps by the Confederates; but Sherman more than redeemed himself at Shiloh, having had four horses shot from under him.

By July 1862, while the build-up of the Second Manassas and Antietam campaigns was getting underway in the East, providence, and President Lincoln, decreed that Henry Wager Halleck be superseded by U.S. Grant as commander of all the Western armies. Grant immediately placed Sherman in command at Memphis, Tennessee.

Sherman, with his usual alacrity and drive, stamped out the guerrilla warfare there, reestablished a strong civil authority, and attempted to bring the illicit cotton trade between the lines to a halt; but the Federal authorities, caught up "in the reign of the shoddy" at Washington, refused to support him. There was too much profit in buying cotton for Confederate paper money and selling it for Yankee dollars.

Grant's campaigns opened the Mississippi River between Memphis and Port Hudson, and in a masterful move they advanced on Vicksburg, the strongest Confederate fortification on the river, and captured it after a series of bloody battles and a siege that lasted until the city and stronghold were starved out. Vicksburg surrendered on July 4, 1863.

For his distinguished service in this campaign, Sherman was promoted to brigadier-general in the regular army.

In September, Grant sent Sherman to relieve Chattanooga, Tennessee, where he raised the siege on November 24, and went on to Ringgold, when he was recalled to relieve Knoxville. Without waiting for his supply trains, Sherman reached Knoxville on December 6 to find that the Confederates had already left. He then put his army into winter quarters on the Tennessee River.

The thanks of Congress for this campaign was little compensation to Sherman, however, for his young son and namesake, who had joined him during the Vicksburg campaign, died at Memphis of typhoid fever.

Grant's appointment in the spring of 1864 as lieutenant-general of all United States forces gave Grant's command to Sherman, and command of the Army of the Tennessee to General John McPherson, "the men to whom above all others" Grant was indebted for his successes.

From the beginning, Sherman had contended that the Confederacy was built on sand. "Pierce the shell of the C.S.A.," he had said, "and it's all hollow inside."

As supreme commander, Grant's new plan called for a combined and coordinated advance of all the Union armies for 1864. The Army of the Potomac, under Meade, was to attack Lee and Richmond, while Sherman advanced against General Joseph E. Johnston and Atlanta, the rail center and arsenal of the Confederacy.

Sherman concentrated his forces at Chat-

tanooga, which consisted of the Armies of the Cumberland, under Thomas; of the Tennessee, under McPherson; and of the Ohio, under Schofield, totaling one hundred thousand men. Opposing him was Johnston, with sixty thousand.

Capturing Atlanta after a fast-moving campaign, Sherman began his ruthless march through Georgia "to some point on the seacoast." His purpose was to break the resistance of the South by cutting off the supply of her armies.

Dividing his army into three units of twenty thousand men each, Sherman laid waste a sixty-mile-wide swath of countryside all the way to Savannah on the Eastern coast, destroying public buildings, railroads, and military supplies.

His army, "in the pink of condition," reached Savannah on Christmas Day, and he sent a telegram to President Lincoln presenting him with the city of Savannah "as a Christmas gift."

On February 1, 1865, Sherman moved on Columbia, South Carolina, a march that made the march through Georgia "child's play." Columbia was burned to the ground and Sherman was charged with the burning. Evidence shows, however, that stored cotton was set afire by the evacuating army, "fanned by a high wind" and assisted by "citizens who distributed liquor too liberally to the released Union prisoners," and Negroes "itching for revenge."

On April 9, 1865, General Lee surrendered at Appomattox Court House, and on April 17, General Johnston surrendered to Sherman, who granted liberal terms, more political than military in character, which again brought controversy down on Sherman's head. With the assassination of President Lincoln, Sherman's surrender terms to Johnston were repudiated "with a vigor and discourtesy" that offended Sherman.

When the war was over, a grand review of all the troops who had taken part in it marched down Pennsylvania Avenue in Washington. In the grandstand, Sherman publicly refused to shake the hand of Secretary of War Edwin M. Stanton. Years later, the two men were reconciled.

The last years of the soldier who made the famed comment that "war . . . is all hell" were filled with some bitterness and disappointment. He retired from active service on November 1, 1883, with the rank of major general and commander-in-chief, a post which began with Grant's inauguration as President on March 4, 1869.

Born in Lancaster, Ohio, on February 8, 1820, the third son and sixth child of Charles Robert and Mary Hoyt Sherman, he came from a family which had its roots in America since 1634. With the death of his father in 1829, "Tecumseh" or "Cump" was taken into the family of Thomas Ewing, a famous attorney. He graduated from West Point in 1840, sixth in his class; served in Florida, and in the Mexican War; and resigned his commission in 1853 to become a partner in a branch bank of a St. Louis firm in San Francisco.

The severe depression caused the bank to close its doors four years later, and Sherman, a man of integrity, personally assumed the responsibility of repaying the losses to his friends who had given him money to invest for them.

He studied law, opened a practice, and lost the only case he ever tried. In 1859, he applied for, and received, the post of superintendent of the Louisiana State Military College at Alexandria, Louisiana, where he became eminently successful. The coming of the war brought about his resignation.

On May 1, he married Ellen Ewing in Washington. The couple had eight children.

His last years were spent quietly at his home in New York City. Several attempts were made by both the Republicans and Democrats to nominate him for the Presidency, which he vigorously resisted. His only recreation was attending military reunions and private social functions.

At his death from pneumonia, at the age of seventy-one, on February 14, 1891, he was given the last rites of the Catholic Church, of which he was never a member. He was survived by six of his eight children.

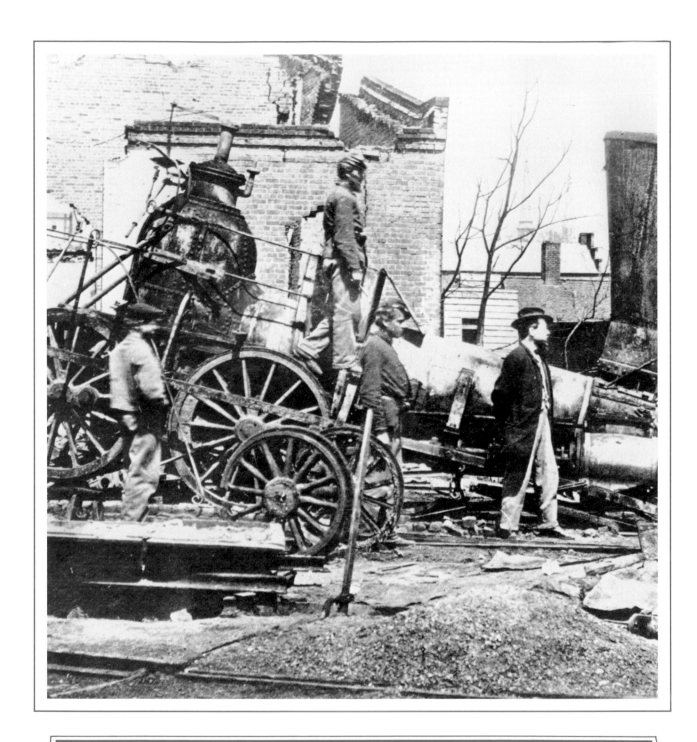

Grant's capture of Petersburg, Virginia, settled the fate of Richmond. All railroads leading into Richmond suffered a like fate from the heavy bombardment. The man in the long, black coat and felt hat standing next to this wrecked locomotive of the Richmond, Fredericksburg and Potomac Railroad, is believed to be David Woodbury, one of Brady's photographers.

From a photograph by Brady (or Woodbury), April 1865. Author's collection.

The Day Richmond Fell

It was Sunday, April 2, 1865. In Richmond, Virginia, the Confederacy's capital, President Jefferson Davis, grim and taciturn, was attending St. Paul's Episcopal Church, seated in the Davis family pew, quietly listening to the sermon being preached from the pulpit.

That morning, the congregation, comprised mainly of mourning women dressed in dusty black, listened to the Reverend Mr. Minnegerode, as he intoned: "The Lord is in His holy temple; let all the earth keep silence before Him." Although the congregation seemed to listen with quiet attention, the minds of most were preoccupied with what was happening outside the city, in the lines before Richmond and Petersburg.

In the church, as within the city, there was an expectant awareness of danger, and this danger suddenly made itself apparent with the hurried arrival of a mud-spattered officer, who walked quickly up the aisle, holding his saber-tache to keep it from clanking, and handed President Davis a dispatch from General Lee.

The urgent message was: "I advise that all preparations be made for leaving Richmond tonight. I will advise you later according to circumstances."

Picking up his hat, President Davis arose from his seat, the expression on his face cold and grim, left the church, amid the congregation's discreet silence, and hurried to the War Department. Once there, he telegraphed General Lee to the effect that it was impossible to evacuate the Confederate Government, as it would "involve the loss of many valuables, both for want of time to pack and of transportation."

When Lee, at Petersburg, received Davis's message, he angrily tore it into small pieces, saying to his officers: "I am sure I gave him sufficient notice." Lee then telegraphed Davis that leaving Richmond that night was imperative; that it "was absolutely necessary" that

the Confederate Army move out of their positions that night; that he would inform Davis of the army's escape route in order that he could move with it; and that he would furnish Davis with a guide.

But the irritable Mr. Davis had other ideas. After leaving instructions with his subordinates for the removal of Confederate funds and archives, Davis, at eleven o'clock that night, boarded a train on the Richmond and Danville Railroad, and with his cabinet members, "started for Danville," North Carolina, arriving there safely at noon the next day.

In Richmond, that Sunday, when the news spread that Lee's army had evacuated Petersburg and that the fall of Richmond was imminent, pandemonium broke loose. "Dismay reigned supreme," wrote Captain Clement Sulivane, the officer in charge of Richmond's evacuation. "Battalions melted away as fast as they were formed . . . partly, no doubt, from desertions."

The day before, on April 1, 1865, behind the Union lines investing Richmond and Petersburg, President Lincoln, visiting General Grant at his headquarters at City Point, had telegraphed Secretary of War Edwin M. Stanton that Grant's dispatches announced that

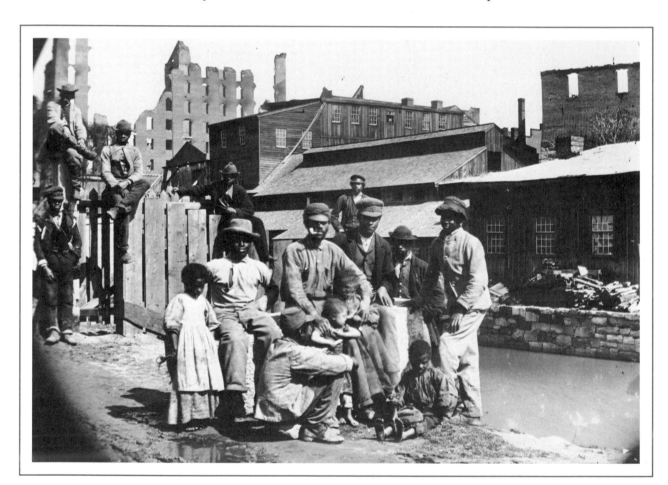

Framed against the background of the ruins of Richmond, Virginia, which symbolize the fall of the Southern Confederacy, after the great fire in April 1865 at the end of the war, freed Negro slaves await whatever is next along the Richmond Canal.

From a photograph by Mathew Brady, April 1865. Author's collection.

"... Sheridan ... had pretty hot work yesterday [at Five Forks] that infantry was sent to his support during the night," and that Grant had not had any further news from his chief cavalry officer, General Philip Henry Sheridan.

Indeed, Sheridan, following a concerted attack by General Lee's nephew, Major General Fitzhugh Lee, and Major General George E. Pickett, the officer who had led the Confederacy's great charge on the Third Day at Gettysburg, "had withdrawn in good order," and expected to renew the contest at almost any moment.

Sheridan had been at his best at Five Forks. Incongruous as it was, his battle had been fought to marching music, played by the regimental band mounted on gray horses. The music was loud, inspiring, and enthusiastic— until a hail of bullets pierced a trombone and smashed a snare drum. After that, the musicians dropped their instruments, picked up rifles, and joined in the fight.

Except for this seemingly ridiculous highlight, the fighting was furious, and the Confederate veterans fought with a desperation they had never known before a man named Grant led the Army of the Potomac against them.

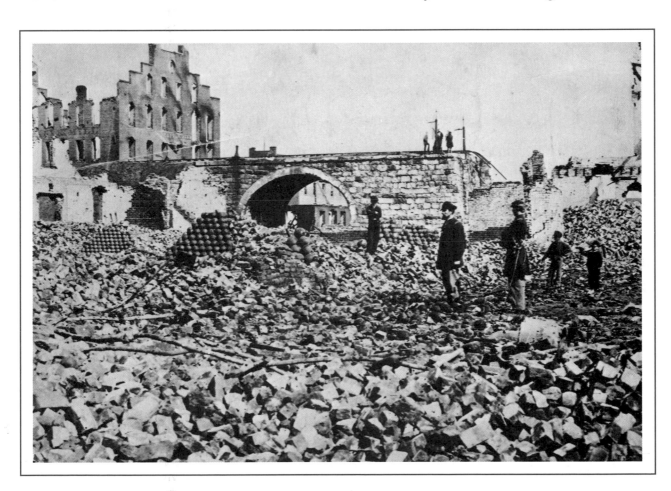

Ruins of the Franklyn Paper Mill, the Fredericksburg and Potomac Railroad's viaduct, and the Richmond Arsenal after bombardment and fire have accomplished their destruction.

From a photograph by Mathew Brady, 1865. Author's collection.

Sheridan had led his men into the most sanguinary of the fire-fights; a flag in one hand, his black horse, Rienzi, carrying him into the hottest of the fight, Sheridan shook his fist, shouted threats and encouragement one moment, and cursed his men the next.

Finally, in support, the Union regiments, under General Romeyn B. Ayres, charged the Confederate earthworks and drove everything before them, breaking through the thin Rebel lines, killing or capturing every man who didn't surrender.

At one point, Sheridan found himself in the midst of a large group of prisoners. His battle rage turned into humor, and he replied to a question one of the prisoners had asked him. "Whar do you want us-all to go?" asked a Rebel soldier. "Go right over there," shouted Sheridan, laughing, and pointing to the rear. "Get right along, now. Oh, drop your guns: you'll never need them anymore. You'll all be safe over there. Are there any more of you? We want everyone of you fellows."

At City Point, having received a dispatch from General Grant, President Lincoln, in turn, had telegraphed Secretary Stanton at Washington and Secretary Seward at Fortress Monroe. "Sheridan, aided by Warren, had at 2 p.m., pushed the enemy back so as to retake Five Forks, and bring his own headquarters up to I. Boisseau's. The Five Forks were barricaded by the enemy, and carried by Diven's Division of Cavalry. This part of the enemy seem now to be trying to work along White Oak Road to join the main force in front of Grant, while Sheridan and Warren are pressing them as closely as possible."

Sheridan's cavalry and the Fifth Corps of the Army of the Potomac had attacked all along the entire line, and had captured three infantry brigades, a wagon train, and a number of field pieces. Meanwhile, the Union General Horatio G. Wright attacked and destroyed the track of the Southside Railroad. At another part of the line, General John G. Parke's troops broke through the Confederate line, capturing forts, guns, and supplies. The Sixth Corps alone captured more than three thousand prisoners, as Grant's forces slowly encircled Petersburg and strangled the last of the Confederate Army's resistance.

At four-thirty p.m., Grant telegraphed President Lincoln: "The whole captures since the army started out will not amount to less than 12,000 men, and probably fifty pieces of artillery. All seems well with us, and everything seems quiet now."

The disastrous results of this battle caused General Lee to evacuate Petersburg; and when this city fell, so would Richmond. President Lincoln telegraphed his commander-in-chief: "Allow me to tender to you, and all with you, the nation's grateful thanks for this additional, and magnificent success—at your kind suggestion, I think I will visit you tomorrow."

On that same day, April 2, 1865, General Lee, saddened by his defeat and the inevitable results that were certain to follow, rode out of Petersburg, attended by his staff. And then came one of the imponderables of war that sometimes attend the soldier. Lieutenant General Ambrose Powell Hill, a fine young officer, and Lee's reliable friend, while riding through the Virginia morning mist inspecting his lines, was suddenly challenged by two Union sentries. It happened swiftly and drastically. Hill called upon them to surrender, and his demand was answered with a burst of rifle fire. Hill fell out of his saddle, dead; a misfortune of a war that had almost ended.

When Lee was told of Hill's death, he wept. "He is at rest now," murmured Lee, "and we who are left are the ones to suffer."

In Richmond, "under the quiet night with its million stars," panic had taken hold of the populace, breaking out in bloody riots—crazed men with guns on a rampage, carrying torches, and running amok through the dark streets.

During this Walpurgis Night of the Confederacy, the remaining railroad bridges entering Richmond were dynamited. Arsenals were put to the torch, with great flashes of flame and roars of exploding shells, their fragments spreading into the night sky. Across the stricken city, gangs of hoodlums, murderers, thieves, and deserters roamed through the darkened streets which were lighted only by the flames from burning warehouses and buildings.

Every so often, powder magazines near the Tredegar Iron Works, Richmond's only cannon and munitions factory, exploded with deafening roars, flames and white smoke from the explosions spreading across the sky; while

seconds later, an ammunition magazine exploded, sending hundreds of bursting shells into the air, whose fragments rained a shower of iron on the streets and burning buildings.

Rifle cartridges, catching fire, rattled off like strings of loud Chinese firecrackers—cartridges much needed by the troops fighting off the relentless advance of the Union forces.

"Either incendaries, or (more probably) fragments from the arsenals had fired various buildings," wrote Captain Sulivane, "and the two cities, Richmond and Manchester, were like a blaze of day amid the surrounding darkness."

Explosions from the vicinity of the James River told of the sinking of the last of the Confederacy's gunboats, and before break of day, thousands of starving citizens—men, women and children—rushed the doors of the army's last supply depot. Breaking it open, they ransacked its contents of sugar, molasses, hams, bacon, barrels of whiskey, and coffee, while fights broke out among the raging individuals struggling to see who would get the best of the spoils.

While the army's storage depots were being raided, the Richmond city government, helpless to restore order, ordered all the saloons and liquor stores wrecked, and their contents emptied into the streets. This gave rise to hundreds of looters, men and women who knelt in the gutters lapping up the whiskey, while others, black and white alike, filled pitchers and bottles of every description with the best products of the distilleries which had made the South famous.

The three high-arched bridges leading into Richmond were on fire and blazing fiercely. Only the last bridge between Richmond and Manchester remained intact; but not for long. While the looters cleaned out the warehouses and military supply depots, Captain Sulivane and two officers watched the last contingent of Confederate cavalry, led by General Gary, gallop over; and as the last gray horseman crossed the bridge, General Gary saluted Captain Sulivane, and ordered: "All over! Goodbye, blow her to Hell!"

Captain Sulivane and an engineer crossed the bridge and touched off the prepared explosives.

Moments later, as he and his officers watched the blue cavalry entering the city, the bridge went down with a great, grinding crash of thunder.

In Richmond, on the other side of the wrecked bridge, the troops of General Godfrey Weitzel's division took over the stricken city. On the morning of April 3, General Weitzel received the surrender of Richmond on the steps of City Hall. And by mid-afternoon, his soldiers restored order and put a stop to the looting and rioting. In the process, they blew up several blocks of flaming dwellings to stop the spread of the fires.

General Weitzel then set about issuing food and provisions to those who needed it, many of whom hadn't tasted a square meal in many weeks.

In Washington, David Homer Bates, the War Department telegraph and code clerk, wrote: "Lincoln's dispatch from City Point gave us in the War Department the first news of the capture of Petersburg and Richmond." And then came the first telegraphic message from Richmond in four years, sent by General Weitzel. "We took Richmond at 8:15 this morning. The city is on fire in two places. Richmond has fallen!"

On April 4, the *Malvern*, a steamer of the United States Navy, carried President Lincoln toward Richmond. The river channel had been cleared of battle debris, dead horses, crates, and boxes, which floated by as the ship slowly steamed up river.

As the President's ship neared the smoldering city, it ran aground, and Mr. Lincoln was rowed to Rockett's wharf in a twelve-oared barge.

At the wharf, Mr. Lincoln was greeted by a group of Negroes. According to General Horace Porter, General Grant's aide: "An old Negro of sixty or more years stepped out of the crowd, and spoke to the man whose Proclamation, two years before, had released him from bondage. 'Bless de Lawd, dere is the great Messiah! I knowed him as soon as I seed him. He's been in mah heart fo' foah long years. Glory, Hallelujah!' "

The old man fell to his knees. "Don't kneel to me," said Mr. Lincoln. "You must kneel only to God and thank Him for your freedom."

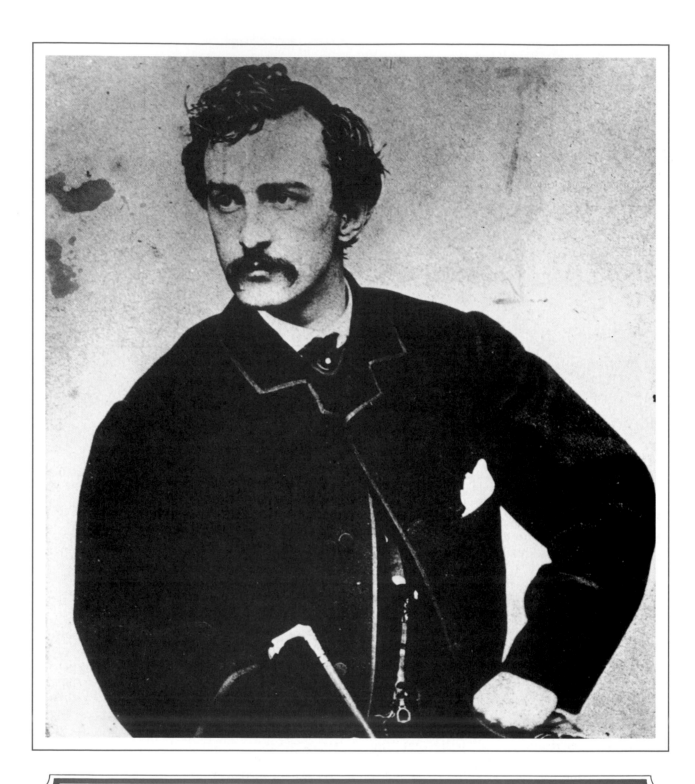

One of the most popular actors of his time, John Wilkes Booth epitomized the observation of actor Edwin Forrest that "all the damn Booths are crazy!" Wilkes Booth proved it by his murder of President Abraham Lincoln.

From a photograph by Mathew Brady, 1859. Author's collection.

John Wilkes Booth— the fatal plot

"That he was insane on the subject of the Civil War being a struggle between freedom and tyranny . . . no one who knew him well can doubt," remarked Edwin Booth the night he was informed his brother, John Wilkes, had murdered President Lincoln.

When the same news of the assassination reached the ears of Edwin Forrest, another celebrated actor, Forrest exploded angrily, "All those goddamned Booths are crazy!"

Forrest's outburst was not without foundation, for the early, bizarre beginnings of John Wilkes Booth seemed but to stress the observation of the Greek dramatist Euripides that "the sins of the fathers are visited upon the children." In no one was this more apparent than in the personality and character of the actor who was heard to say, "What a glorious opportunity there is for a man to immortalize himself by killing Lincoln!"

His father, Junius Brutus Booth, enjoyed two merited reputations, both equally large: the first as an internationally celebrated Shakespearian tragedian, the second as a hopeless drunk subject to "fits of singular phase . . . who made a fool of himself generally."

Rufus Choate saw Junius Booth, ". . . as a man filled with tender and sublime compassion for human and all other forms of life;—a compassion that often shook his controls and ran over into the pathetic, the ridiculous and even the comic," Choate adding that "Junius was the greatest actor who ever lived," even though he was given to "fits of wild flights of oratory and generally strange behaviour and fits of insanity."

The sins of the fathers were indeed well planted in Wilkes. Born April 28, 1838, on the family farm at Bel Air, Maryland, twenty-five miles from Washington, John Wilkes Booth, tenth child in the family, was nevertheless the illegitimate son of Junius and Mary Holmes, whom he "had tricked into a false marriage," since Booth was already married.

Wilkes, his brothers Junius and Edwin, and his retiring sister, Asia, were the only children of the Booth clan who received even cloudy recognition. Later, Asia, who loved her brother Wilkes, received some attention from the press, in an effort to link her to the assassination plot, but this was easily proven false.

As a youth, John Wilkes Booth, in modern parlance, would have been regarded as an oddball, with a wild streak in his nature. Named after the famous English agitator John Wilkes, a distant relative of his grandfather, young Booth mingled with the oystermen of Chesapeake Bay. At one time, to win a bet, he drove a sleigh across the dirt roads to Bel Air and back in the middle of July. On occasion he would "bait" his father who, being a vegetarian, prohibited the killing of any of the farm animals, even when needed for the table. When this happened, which was often when Wilkes was around, the elder Booth would "hold lengthy funerals for some of his dumb friends." Wilkes detested cats and would never miss a chance to kill them when he found them on the farm, despite his father's orders to the contrary.

Wilkes received his education "from nearby academies," and it was probably spotty and irregular at best. Nevertheless, as with most "Southern gentlemen" of the period, he was an excellent horseman, a skillful fencer, and a crack shot with a pistol.

In appearance, he seems to have resembled Edgar Allan Poe, the writer. Handsome, short of stature, with black hair and eyes, Booth recognized a physical defect in his bow legs, which he tried to conceal by wearing a long cape. But it was said "women spoiled him." Clara Morris, a young actress who had "fallen under the Booth spell," described him as having "an ivory pallor that contrasted with his raven hair; and his eyes had heavy lids which gave him an oriental look of mystery."

The War Department put it more directly: "Height, 5-feet, 8-inches; weight, 160-pounds; compactly-built; fair, jet-black hair, inclined to curl, medium length, parted behind; eyes, black and heavy dark eyebrows; wears a large seal ring on the little finger; when talking, inclines his head forward, looks down." To which could have been added: twenty-six years of age, with a mind diabolically deranged by the gaudy spectres of vanity, ego, and an insane desire for lasting fame.

His hatred for his father, because of his own illegitimate birth, was exceeded only by his hatred for President Lincoln; and he saw himself as the South's avenger. Such was John Wilkes Booth.

Early attracted to the stage, at the age of seventeen Wilkes Booth made his debut in the role of Richard III at the St. Charles Theatre in Baltimore, Maryland, with some success. But his approach to the theatrical season of 1857 and 1858 was apparently cavalier, for while playing subordinate roles at the Arch Street Theatre, in Philadelphia, he was frequently hissed for not knowing his lines.

Yet he subsequently rose to stardom, playing leading Shakespearian roles in touring stock companies. In 1863 bronchial troubles brought about a temporary retirement, but the following year he appeared at the New York Winter Garden in *Julius Caesar*, playing Mark Antony to his brother Edwin's Brutus. Their brother, Junius Brutus, Jr., played the role of Cassius. The forerunner of his last and fatal appearance at Ford's Theatre in Washington was in the role of Pescara in *The Apostate* on March 18, 1865. What he considered his greatest role was to come a month later.

On April 14, 1865, fateful day in the history of the Republic, the people of the North and South rejoiced. The great Civil War was over. The guns were silent; the battlefields, quiet places; although it would be another month before Kirby Smith surrendered in far-away Texas. Lee had surrendered only five days before, and the North celebrated the end of the war with a ceremony at Fort Sumter commemorating the raising of the flag, a tribute to Major Robert Anderson who had surrendered the fort on the same day four years before.

In Washington, the President had been busy all day with cabinet meetings and personal interviews with old friends. Later in the afternoon, there would be a short carriage drive with Mrs. Lincoln . . . and that evening there would be a theater party which the First Lady had arranged for General and Mrs. Grant and a few friends.

It was Good Friday. Washington City was gay. The war was over, and peace reigned over the nation.

Later, the president and his lady got into their barouche for their afternoon drive and

220 • *John Wilkes Booth*

headed in the direction of the Navy Yard.

"I never felt so happy in my life," he said. But Mrs. Lincoln had misgivings. "Don't you remember," she said, "feeling just so before our little boy died?" At the Navy Yard, Mr. Lincoln stepped aboard the monitor *Montauk*, walked the deck to stretch his legs, returned to his carriage, and drove back to the White House.

Since 9:30 that morning, John Wilkes Booth had been making his plans. Following his morning shave, he attended the rehearsal for the evening's performance at Ford's Theatre, timed the performance, engaged horses for his escape, and joined a group of hangers-on at Taltavul's Tavern for brandy and soda. Booth planned well, having timed things so that there would be only one actor on the stage who could possibly bar his escape. Then he called on his accomplices, George Atzerodt, a stagehand, drunkard, and coward; John Surratt, son of Mary E. Surratt, a successful blockade runner and Confederate courier; Michael O'Laughlin, a boyhood friend who gave a lift to the actor's ego; Edward Spangler, another stagehand at Ford's Theatre, vicious, unkempt, easily handled, who could be relied upon to perform his function at the theater; David Herold, a drug clerk who idolized Booth; Lewis Payne, alias Powell, a giant of a man, weak-minded and a Confederate deserter, and Mary E. Surratt, a religious widow whose undying belief in the Confederate cause—and her association with Booth—brought her the distinction of being the first woman to receive capital punishment in the United States. Such was the collection of gallows bait who blindly followed the master-schemer.

Until the morning of April 14, the plans of the assassins could have been thwarted. President Lincoln had earlier reserved a box at Grover's Theatre to attend the performance of Miss Effie Germon in *Aladdin, or The Wonderful Lamp*.

But Mrs. Lincoln had heard that Laura Keene was giving a benefit last performance of *Our American Cousin*, and asked the president to change his plans.

Earlier, General Grant had declined the invitation to join them, and had left for Burlington, New Jersey, with Mrs. Grant for a reunion with their children. The Lincolns invited Major Henry R. Rathbone and his fiancée, Miss Harris, to come to the theater with them in place of the Grants.

When Secretary of War Stanton learned that General Grant was not going to attend, he warned both the president and the Chief of Staff, General Henry W. Halleck, that he had heard of threats and conspiracies by "evil-disposed persons."

John Wilkes Booth, his plan complete, now set the stage for the crime. After buying drinks for Edward Spangler and Jacob Ritterspaugh at Taltavul's Tavern, he slipped away from his companions, picked his way through an underground passage to the theater, and up onto the stage. He carried a small pine board.

The theatre was dark. There was no one to watch his movements. Booth made his way to the State Box and opened the door. With his pocket knife he dug a hole in the plaster of the wall, large enough to receive the end of a board which he planned to jam against the door. Next, he cut a hole in the door panel large enough to see the president's head and shoulders. Cleaning up the fragments of plaster and the wood cuttings, Booth took one more look around and, leaving the way he came, went back to the National Hotel. When he had finished his dinner, he went to his room and loaded his pistol. All he had to do now was wait.

Ford's Theatre opened at the usual time. The weather remained as it had been all day, cold, gusty, and raw. Inside the theater, the curtain went up and the play began. Laura Keene, as Florence Trenchard, was in a scene with Lord Dundreary. His lines mentioned a window draft, a draft of medicine, and a draft on a bank.

Miss Trenchard: "Good gracious! You have almost a game of drafts."
Lord Dundreary (laughing hysterically): "That wath a joke, that wath!"

Laughter.

At that moment, in the midst of the laughter, President Lincoln and his party arrived. Miss Keene stopped the action, and the band swung into "Hail to the Chief."

Outside the State Box, the drunken John F. Parker, who was supposed to guard the Presidential party, sat outside the box, getting up every now and then to watch the play. A short while later, he deserted his post and went for a drink, leaving the president unguarded.

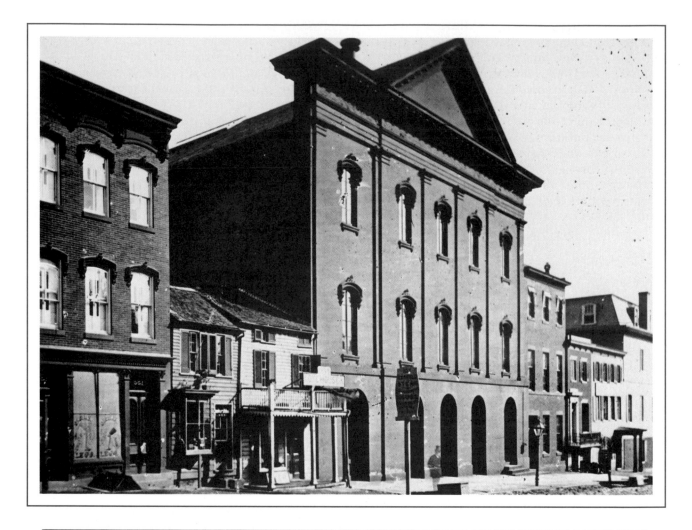

Ford's Theatre as it looked in April 1865, shortly after President Lincoln's assassination. The street sign alongside the theater's entrance announces "Kidder's Steam, Dye, and Scouring House — Clothes Cleaned and Pressed." On the left is a shop selling artificial arms and legs. On the right is Taltavul's Tavern, where John Wilkes Booth fortified himself drinking before committing his crime.

Author's Collection.

Meanwhile, John Wilkes Booth, standing at the head of the dress-circle steps, listened for the crucial lines on the stage. He had two minutes to carry out his crime. Mrs. Mountchessington, who had just learned that Asa Trenchard is not a millionaire, walks onto the stage and speaks:

"No heir to a fortune, Mr. Trenchard?"

Trenchard: "Oh, no! Nary a red. It all comes from barking up the wrong tree about the old man's property."

Laughter.

Booth peered through the hole he had cut in the door of the box. The derringer was in his hand. On the stage, the play continued. Mrs.

Mountchessington exited, leaving Harry Hawk, the actor playing Trenchard, alone on the stage. Hawk spoke his lines: "Don't know the manners of good Yankees. Wal, I guess I know enough to turn you inside out, old gal—you sockdologizing old man-trap!"

Booth aimed his weapon at the president's head and pulled the trigger. The shot rang throughout the theater, and the president's head fell forward.

Booth forced his way between the dying president and Mrs. Lincoln and rushed to the edge of the box. Major Rathbone, the president's guest, tried to stop him, but Booth slashed at him with a knife and cut his arm to the bone. Booth then jumped to the stage, breaking his leg in the fall when his spur caught on the flag draped over the box.

Booth picked himself up, was supposed to have shouted "Sic semper tyrannis" (Thus always to tyrants: the motto of the state of Virginia), and rushed, as best he could, across the stage, reached the stage door, mounted his horse, and raced out of the alley.

Left: Born in New York City in 1831, Mary Mitchell made her first stage appearance in Newark, New Jersey, in the spring of 1855 as Topsy in "Uncle Tom's Cabin." Elder sister of Maggie Mitchell, celebrated for forty years in the American theater as Fanchon the Cricket, Mary played engagements wherever city theaters or town "Opry Houses" could gather an audience.

Author's collection.

Right: Star of the play "Our American Cousin," Laura Keene was one of the witnesses to the assassination of President Lincoln at Ford's Theater in Washington, D.C.

Author's collection.

Pandemonium reigned inside the theater after Mrs. Lincoln's scream. Dr. Charles Leale, assistant surgeon of United States volunteers, twenty-three years old, entered the box. "I will do what I can," he said.

After examining the president, he said quietly, "His wound is mortal. It is impossible for him to recover."

Four men from Thompson's Battery of Pennsylvania Artillery carried Mr. Lincoln from the box to the Petersen House, 453 Tenth Street, directly opposite the theater, where they placed him on a bed in a small bedroom.

Members of the family, the Cabinet, army officers, the physicians, and clergymen sat through the night. Mrs. Lincoln, in an adjoining room, sobbing hysterically, had not been permitted into the room in which Lincoln was dying.

Finally, at 7:22 on the morning of April 15, 1865, Abraham Lincoln, sixteenth president of the United States, breathed his last.

Mr. Stanton, Secretary of War, the man who had served the president faithfully throughout the war, rose to the occasion. Closing the president's eyes, he said quietly, "Now he belongs to the ages."

On this night of planned wholesale murder, Booth's accomplice Thomas Paine attacked Secretary of State Seward with a dagger and left him for dead. But Seward survived his wounds.

Vice President Andrew Johnson narrowly missed death at the hands of George Atzerodt when the assassin, stupefied by drink, lacked the courage to carry out his murderous assignment.

John Surratt, assigned to kill General Grant, actually boarded the general's train. But Grant, having received word of the shooting of Lincoln, left the train at Baltimore to return to Washington. His sudden change of plans probably saved his life.

Washington was alive with crowds bordering on hysteria. $50,000 rewards were offered for the capture of Booth, dead or alive.

On the afternoon of April 25, a Federal cavalry detachment, under Colonel E.J. Conger, Lt. Col. Lafayette Baker, and Lt. Doughtery, reached Port Conway, and from there galloped to Bowling Green, where they found Booth and his accomplice Herold hidden in a tobacco barn belonging to a Mr. Garrett. The soldiers immediately surrounded the barn and ordered the fugitives to come out. Herold was captured alive.

Booth, it has been said, rushed from the barn, his carbine raised, when Sergeant Boston Corbett raised his own carbine and shot the actor. When asked why he fired against orders, Corbett replied, "God Almighty directed me!"

With all the conspirators finally captured, it only remained to hold trial by a military commission, presided over by Judge Rush Holt, which was held in July.

Part IV: Aftermath

Let the ghost of Pompey, who but lately was alive, foretell all the future to Pompey's son, if ye owe gratitude to the civil war.

—*Marcus Annaeus Lucanus, A.D. 62*

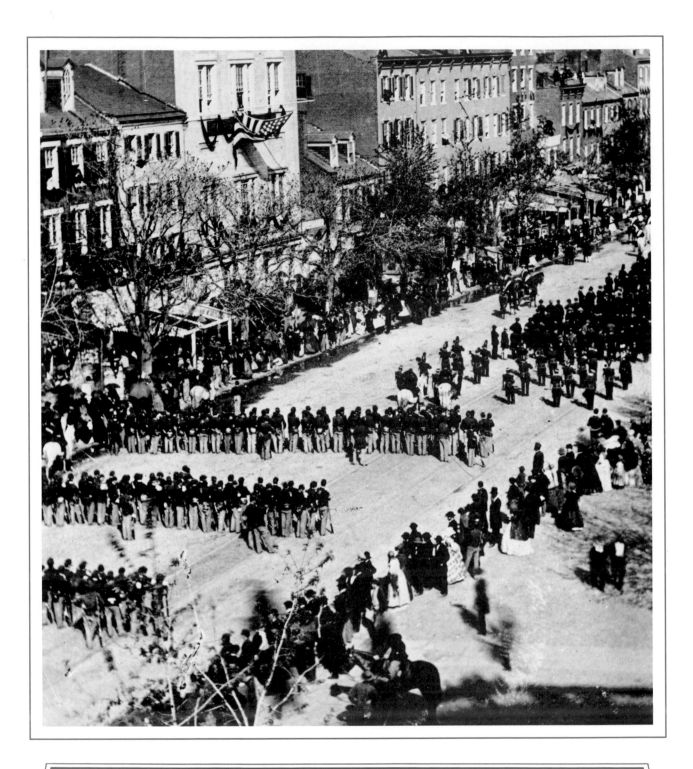

The funeral procession of the murdered President moves slowly up Pennsylvania Avenue, pausing momentarily in the line of march. The catafalque with the body of President Lincoln is at the head of the cortege and out of the frame to the right.

From a photograph by Mathew Brady. Author's collection.

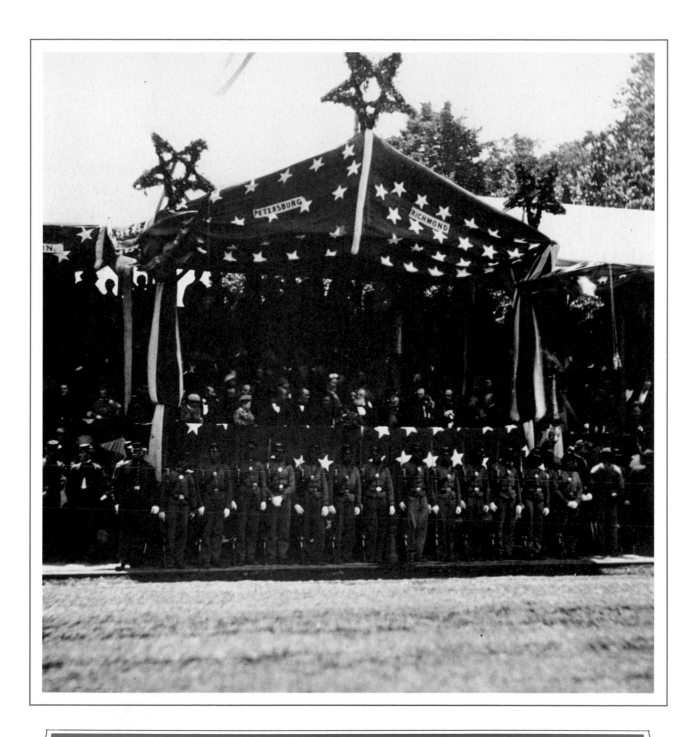

View of the Presidential grandstand and honor guard on Pennsylvania Avenue, April 26, 1865, watching Sherman's "Bummers" march past. This photograph was made during a gap between contingents. In the front row, starting fifth from the left, are seated Secretary of War Stanton, President Andrew Johnson, Lieutenant-General Ulysses S. Grant, and the white-bearded Gideon Welles, Secretary of the Navy.

From a photograph by Mathew Brady, April 1865. Author's collection.

Special prosecutor at the trial of the Lincoln conspirators, John Armor Bingham also became one of the seven men appointed to impeach President Andrew Johnson.

From a photograph by Mathew Brady. Author's collection.

John Armor Bingham— judge advocate for the conspiracy trial

"The common law is not a brooding omnipresence in the sky, but the articulate voice of some sovereign or quasi-sovereign that can be identified." O.W. Holmes, 189 U.S. 158 (1916)

The murder of President Lincoln carried all the dramatic elements of a Shakespearian tragedy. The first part of this murder plot, hatched by this madman against the President, Vice-President, and Secretary of State, unfolded according to plan, at ten thirty p.m. Two hours later, the rest of the plot, like an exploding shell, burst in bits in all directions.

The angry hysteria and expressions of public outrage that followed Mr. Lincoln's death in Washington and across the nation manifested itself in a terrifying panorama of newspaper headlines, which almost lent continuity to the wild events of the night.

PRESIDENT LINCOLN ASSASSINATED!

ESCAPE OF THE ASSASSINS!

INTENSE EXCITEMENT IN WASHINGTON!

SECRETARY SEWARD DAGGERED IN HIS BED, BUT NOT MORTALLY WOUNDED!

What followed is a familiar, century-old story: the relentless manhunt of Colonel L.C. Baker and the Washington Cavalry over the Maryland and Virginia countrysides; the capture of Booth and his accomplice, David Herold; the shooting of Booth, against strict War Department orders, by Sergeant Boston Corbett, a former New York bowery drunk and a religious fanatic who said that "God told me to do it"; the dramatic roundup of the rest of the conspirators, and their unprecedented trial by a special military court.

Vice-President Andrew Johnson, who assumed the Presidency upon the death of President Lincoln on April 15, angered and grieved by the enormity of the senseless crime and apparently influenced by "the outcry in every house in the land yesterday," ordered a military commission set up to try the conspirators, overriding those officials who questioned the propriety of a military trial.

President Johnson believed, as did many others, that the murder of Abraham Lincoln was only a part of a "gigantic plot"; and he stated very plainly that the assassins' *reward should be the halter or the gallows.*

Strangely enough, the temper of the times precluded any public outcry against this prejudicial, pre-trial statement. And his special prosecutor, John Armor Bingham, minced no words in support of Johnson's authority. "The Executive," he said, "has the power to exercise all sorts of extra-constitutional powers," including the power *to string up the culprits without any trial!*

No man was better fitted for his job of special prosecutor than Assistant Judge Advocate John Armor Bingham. Lawyer, and former stump speaker for William Henry Harrison's "log cabin and cider" Presidential campaign, Bingham was a forceful speaker who never hesitated to use invective, insolence, and arrogance in his speeches when the need arose.

In most of his legal and political arguments, he made short work of his detractors and political foes; but in the months that followed, his defense of Johnson's executive authority in the Lincoln Conspiracy Trial would come back to haunt him.

Indeed, the entire trial, coming as it did on the heels of the South's military collapse, was conducted in an irrational climate of national hysteria, rage, and helpless grief.

John Bingham helped to prosecute a memorable trial, with plenty of legal fireworks. During the stormy course of the trial, there were accusations of "gross perjury" on the part of the Government's witnesses, John Lloyd and Louis Weichman. Weichman was the prosecution's "star" witness against Mary G. Suratt. Indeed, under the defense's cross-examination, Weichman claimed that Secretary of War Stanton had promised him a job for testifying in the Government's behalf.

Judge Advocate General Joseph Rush Holt was accused of suppressing important evidence contained in Booth's Diary; and he was also blamed for withholding the military commission's recommendation of clemency for Mrs. Suratt, which President Johnson claimed had never reached his desk.

But John Armor Bingham "stole the show," for his job as the prosecuting attorney was to intimidate and bully defense witnesses. In his final summary of the evidence before the court, he stated categorically "that the entire rebellion was simply a criminal conspiracy, and a gigantic assassination in which Jefferson Davis is clearly proven guilty ... as John Wilkes Booth, whose hand inflicted the mortal wound upon Abraham Lincoln."

The findings of the military commission were final, and allowed no appeal for clemency. The conspirators were found guilty on all counts and convicted. Four were sentenced to hang: David Herold; George Atzerodt; Thomas Paine; and Mrs. Mary G. Suratt, in whose home Booth had hatched his plot. The other five— Samuel Arnold, Dr. Samuel A. Mudd, Edward Spangler, Michael O'Laughlin, and John Suratt, a former Confederate spy—received long-term sentences at hard labor in the military prison at Fort Jefferson, in the Dry Tortugas, off Key West, Florida.

The various sentences meted out to these pathetic wretches makes a fascinating study, though one which is too lengthy for this chapter. However, it is interesting to note that, of the four defendants sentenced to hang, only one wielded a weapon. Thomas Paine forced his way into Secretary Seward's house and knifed him badly. Atzerodt, a hopeless drunk who was assigned by Booth to kill Vice-President Johnson, got his "wind up," threw his gun away, and spent the night begging drinks in several barrooms. Nevertheless, Atzerodt, Mrs. Suratt, and David Herold—who committed no bodily harm to anyone but who were in on the plot—died on the scaffold. John Armor Bingham and the prosecution got their convictions.

John Armor Bingham was born on January 21, 1815, the son of Hugh Bingham, a carpenter, at Mercer, Pennsylvania. As a boy, he received his early education in the elementary schools of the region, and spent his off-school

The world's foremost portrait photographer, Brady had a host of friends. Some are pictured in this rare photograph. From left to right, seated, Henry Kirk Brown, sculptor, and Mathew B. Brady; standing, (probably) Constantino Brumidi, painter and designer of the interior of the United States Capitol; the next man is unknown; but Earl De Gray is believed to be the figure on the far right.

Author's collection.

hours working in a printing office, a job lasting two years.

He entered Franklin College, studied law, and was admitted to the bar. In 1840, he moved to Cadiz, Ohio, where he opened a law office and became prominent in Ohio politics.

Elected to Congress in 1854, he served continuously, except for an interim when he failed to gain re-election to the 38th Congress until 1873.

Appointed judge advocate in January 1864 by President Lincoln, he was made solicitor of the court of claims, handling war damage claims.

But John Armor Bingham's second and most dramatic role of his political career came with his appointment as one of the seven impeachment managers selected by the House of Representatives to conduct impeachment proceedings against President Johnson.

At first, he voted against the House's initial attempt at impeachment, and, in his argument on the floor against the second attempt, he said that "President Johnson was not guilty of any impeachable offense," all of which didn't sit very well with the Republican radicals who wanted Johnson out of the Presidency.

The attempt to impeach President Johnson was purely political, a maneuver on the part of Senate radicals Benjamin Wade, Charles Sumner, and Thaddeus Stevens, who wanted to remove the one man who stood in the way of their plans for the South.

President Johnson had believed in Lincoln's "General Amnesty" to the South, and had planned to carry out Lincoln's avowed policy "of curbing post-war profiteering, exploitation and vengeance" planned for the South by Northern radicals in Congress.

In a weak moment of political expediency, John Bingham yielded to the political pressures of Wade, Sumner, and Stevens, and voted for impeachment.

Johnson's defense in the Senate came to the front and flung Bingham's words back at him, quoting the statement he had made during the conspiracy trial to the effect that "the President might suspend the laws and test them in the courts," which embarrassed Bingham in his final plea for impeachment.

In his closing speech in the Senate, which lasted three days, he ignored the implication of the defense, refuted his own earlier statement,

and called the defense plea "the monstrous plea interposed for the first time in our history." Bingham's clack in the Senate galleries applauded "his confident manner," and pronounced his speech, "one of his greatest. . . ."

An interesting sidelight on the impeachment, which triggered the entire proceedings, came about when President Johnson asked Secretary Stanton to resign. Stanton refused, and Johnson suspended him, making General Grant Secretary of War pro-tem on August 12, 1867. Johnson promptly submitted his reasons for removing Stanton, but the Senate refused to concur, and Stanton was reinstated, much to the disgust of General Grant.

On February 21, 1869, Johnson formally removed Stanton, instructing him to turn over the office to General Lorenzo Thomas, ad interim. Stanton again refused, supported by the radicals Sumner, Wade, and Stevens. The impeachment proceedings followed, the Senate calling Stanton's removal "illegal."

According to the Tenure of Office Act, President Johnson could have removed any and all of the former Cabinet members if he had so wished; but, "with unfortunate tolerance," he had permitted Stanton to remain in his Cabinet, accepting his "cordial assent to his views." Stanton, meanwhile, in a masterpiece of duplicity, was an informer for radicals Wade, Sumner, and Stevens, reporting everything Johnson did or said.

This disclosure of incredible disloyalty and duplicity remains forever a black mark on the political escutcheon of Edwin McMasters Stanton. Curiously enough, shortly before his death, Stanton admitted that "he had never doubted the constitutional right of the President to remove members of the Cabinet without question from any quarter."

Perhaps John Armor Bingham's greatest contribution to the post-war Reconstruction period was the framing of the first section of the Fourteenth Amendment to the Constitution, which forbade "any state by law to abridge the privileges or immunities of citizens of the United States, or to deprive any person of life, liberty or property without due process of law, or to deny the equal protection of the laws."

John Bingham managed to survive the political maelstrom that swirled about him for many years, simply because he was an adroit politi-

cian who could think and act the same way his confreres did—without impunity, right or wrong, self-service always in mind. And the political acts, tricks, duplicities, and loud talk that surrounded him serve today as an object lesson in how to frustrate legislation—good, bad, or indifferent—to gain political ends.

In 1873, John Armor Bingham's political star failed to shine on him, but his friends managed to get him an appointment as Minister to Japan, a job he held for twelve years.

He died in March 1900, in his home in Cadiz, Ohio. He was married to Amanda Bingham, by whom he had three children.

Nellie Grant Sartoris, daughter of General Ulysses S. Grant, photographed in the Brady Washington gallery.

Author's collection.

Nellie Grant—
the darling of Washington Society

In 1873, in his annual message to the Congress, President Ulysses S. Grant said: "Washington is rapidly assuming the appearance of a capital of which the nation may well be proud. It is now one of the most sightly cities in the country, and can boast of being the best paved."

President Grant could have added with pleasure and pride, that his beautiful nineteen-year-old daughter—Nellie, as she was known to her friends—was "the darling of Washington Society," who dressed in the latest Paris creations, and who drove about the capital city in a black phaeton drawn by two matched black horses.

No young lady in Washington could match her natural beauty and bright, happy personality; and, as the President's daughter, she was the subject and main topic of the society columns.

Ellen "Nellie" Grant was indeed a beautiful girl, with a "piquant" face and well-proportioned figure which, in today's scheme of things, would have rated enthusiastic wolf-whistles wherever she went.

Vivacious, with a lively personality, Nellie was idolized by her father, mother, and brothers; but it was her father who had more than a little to do with her education and upbringing.

Nellie was a great credit to him. As a young lady above reproach, with fine, cultivated manners, Nellie also had inherited her father's level head and native intelligence, which was more than could be said for many of Washington's society belles.

She had also inherited her father's calm, searching outlook, and during Congressional sessions not a day passed that some item of news didn't appear in the newspapers about her social activities as the President's daughter, "she of the beautiful face who was . . . almost daily seen on the prominent thoroughfares in a light phaeton behind a span of matched black

ponies, usually accompanied by her most intimate friend, Miss Anna Barnes, daughter of the Surgeon General of the Army."

And the columnists wrote of the White House evening soirees when "Miss Grant and Miss Barnes were of the receiving party, while General Orville Babock, in his usual courteous manner, presented the visitors."

Nor did they overlook what she wore, for Nellie set the pace for fashionable dress in Washington. "Miss Grant, over a rose-colored silk, wore a Paris muslin and Valenciennes lace overskirt, gracefully looped. Miss Barnes wore black silk and Roman sash," ran one of the items.

Even before the nation's greatest soldier was elected to the Presidency by a grateful people wearied of war, Nellie Grant's beauty, vivacity, and perfect, lady-like manners captivated her family's circle of friends. Indeed, Nellie's popularity reached its zenith when she was invited to go abroad, chaperoned by Secretary of the Navy Adolph E. Borie and Mrs. Borie, longstanding friends of her parents before they had come to Washington.

In London, the United States Minister to England, Robert C. Schenk, who is credited with introducing the game of poker into staid English society, and Colonel Adam Badeau, General Grant's biographer and consul-general to the English Court, were Nellie's escorts at all British Society's lavish gatherings.

Mrs. Borie, Nellie's chaperon, apparently found it difficult to keep up with her vivacious charge. And it was only natural that Nellie created a sensation at the English Court, when she was presented to Queen Victoria, who "was captivated by her youthful exuberance."

But events in Nellie's life were changed abruptly when, on the trip home, aboard ship, she was introduced to Algernon Charles Frederick Sartoris, the blond, handsome nephew of Fanny Kemble, the famous American actress. It was a case of love at first sight; a year later, they would be married.

Indeed, Nellie Grant had come a long way since she was a little girl of eight, when her father, the Commanding General of the Armies of the United States, was in the process of preparing his next campaign against the Confederacy's stronghold at Chattanooga.

The general himself was a devoted family man, and his wife and children were always in his thoughts. It had always been that way, and their welfare was his main concern.

Nothing was too good for them, especially when it came to the education of his children, which he considered of paramount importance.

To his wife, Julia, he wrote, from his headquarters at Petersburg: "I want the children to prosecute their studies, and especially in languages. Speaking languages is a much greater accomplishment than the little paraphernalias of society, such as music, dancing, etc. I would have no objection to music being added to Nellie's studies, but with the boys, [Frederick and Ulysses, Jr.] I would never have it occupy one day of their time or thought."

Music, to the tone-deaf soldier who couldn't carry a tune if his life depended upon it, wasn't for men.

Grant also wondered if the schools in St. Louis were good enough for his children, who were staying in that city with their cousins Harry and Louisa. At one point, the general thought of moving to Princeton, New Jersey, where he had found ". . . that they have as fine schools as there are to be found in the country."

Nellie's father wanted, above all else, for ". . . the children to be at good schools and without loss of time. . . . If you cannot make good suitable arrangements in St. Louis," he wrote his wife, Julia, "you may go where you think best, East or West."

He closed his letter, saying, "I want the children to be at a good school." To the end of their lives, General Grant's three children reflected the education and upbringing he insisted they avail themselves of.

The Grants were model parents, and their own beginnings had been humble. The soldier who broke all the accepted rules of war, and who had won his battles by careful decision and dogged determination, carried the unusual stamp of an original thinker, a characteristic all his children acquired.

A great horseman, when he was at West Point, Grant jumped a horse over a six-foot, six-inch hurdle, to the acclaim of his classmates and the faculty. He loved horses and dogs, and wouldn't have thought of shooting a wild animal any more than he would have thought of shooting himself.

When Grant was stationed at Fort Vancouver

on the West Coast in 1854, he suffered long periods of despondency because he was away from his family.

He hated garrison duty and its boredom, and spent much of his time reading and re-reading the much-handled packet of letters from his wife, especially the letter from his wife which bore the inked imprint of his second boy's foot.

Before he had married his beloved Julia, there had been no extended courtship. The couple were out buggy riding one day, and came to a bridge over a flooded stream.

"I'm going to cling to you no matter what happens," Julia cried as they crossed over the flooded bridge. And he had replied quietly: "How would you like to cling to me for the rest of your life?"

They married, and went to live on a farm property he had rented from his father. He had cleared the property and had built a two-story log cabin, "a masterpiece of simple design and craftsmanship," named it "Hardscrabble," and hauled cord wood ten miles into St. Louis at $10 a cord.

Later, he traded "Hardscrabble" for a house in St. Louis. After a long struggle at various, uninteresting jobs, he sold the house and moved to Galena, Illinois, where he went to work for his father, selling hides to shoemakers and harness makers for the pitiful salary of $800 a year.

With the outbreak of the Civil War, Grant offered his services to the Government, which chose not to reply to his offer. Later, he was appointed a colonel of Illinois volunteers and took his regiment to Missouri.

In the opening Western battles of Belmont, Shiloh Church, Fort Donelson, and Vicksburg, he distinguished himself and became a war hero, much to the chagrin and jealousy of the Eastern generals McClellan and Halleck, whose vitals were eaten away by jealousy at the thought of being superseded by the undisputed superior military abilities of the quiet man from Galena.

In the East, there followed the flaming Battles of the Wilderness, Cold Harbor, Spotsylvania, the North Anna, Petersburg, Richmond, and Five Forks, and the end of the war at Appomattox Court House.

These military achievements had been won despite the morass of intrigue, personal jealousy, slander, and obstructionism which had enveloped him.

On June 4, after the battle of Cold Harbor, he wrote to Nellie, now age eight, who had made an appearance with her brothers at a big Sanitary Commission Fair in St. Louis. Shortly before, Nellie had written to him at his field headquarters in Virginia, telling him about her Shetland pony, "Little Rebel," "a member of the family."

His order that ended the battle of Cold Harbor, in which he later admitted that he had lost his temper, ordering attack after attack against Lee's almost impregnable position, was preceded by his reply to her letter.

He wrote:

My dear little Nellie:

I received your pretty well-written letter more than a week ago. You do not know how happy it made me feel to see how my little girl, not yet nine years old, could write. I expect by the end of the year you and "Buck" [Ulysses Jr., age twelve] will be able to speak German, and then I will have to buy you those nice gold watches I promised.

I see in the papers, and also from Mama's letters, that you have been representing "the Old Woman Who Lived in the Shoe" at the fair. I know you must have enjoyed it very much. You must send me one of your photographs taken at the fair.

And then he went on to tell her of his own trials and tribulations.

We have been fighting now for 30 days and have every prospect of still more fighting to do before we get to Richmond. . . . When we do get there I shall go home to see you and Ma, Fred, Buck and Jess. I expect Jess rides Little Rebel every day. I think when I get home I will get a little buggy to work Rebel, so that you and Jess can ride about the country during vacation. Tell Ma to let Fred learn French as soon as she thinks he is able to study it. It will be a great help to him when he goes to West Point. Be a good girl, as you have always been, study your lessons, and you will be contented and happy.

Following the end of the war and family reunion, there came the election to the Presidency, and the Grant family moved to Washington.

On May 21, 1874, Washington society was treated to the sumptuous wedding of Ellen "Nellie" Grant and Algernon Charles Frederick

Sartoris, one of the most lavish society affairs the capital city had ever beheld.

Invitations to Nellie's wedding at the White House were printed on white satin ribbon, upon which was also printed the dinner menu. The invitation list was limited to one hundred fifty of Washington's highest-ranking officials, and personal friends of the Grant family.

The most spectacular event of Washington's social season featured a display of the couple's wedding presents in the Oval Room of the White House. The gifts were valued at from $60,000 to $75,000. The Brussels point lace on Nellie's wedding dress of white satin alone was reputed to have cost $5,000.

The wedding ceremony itself was held in the East Room of the White House, under a floral wedding bell hung in the center of the room, decorated with intricate floral monograms of the bride and groom.

A small, silk-covered table on one side of the room held the ceremonial pens with which the ceremony was witnessed by Secretary of State Hamilton Fish, and Sir Edward Thornton, the British ambassador.

Nellie's bridesmaids were dressed alike in rich gowns of white silk, and the bride's mother was dressed "in a stunning black silk dress with ruffles and puffs of black illusion. The groom was dressed in full evening clothes, and the bride's brother, Colonel Frederick Dent Grant, the groom's best man, was dressed in full uniform. The President wore evening clothes."

Following the wedding ceremony, under the great floral bell, the bridal party retired to the State Dining Room, "wherein was spread a table that has probably never been excelled in this country for richness, artistic skill or systematic arrangement."

From the pyramid of the pearly white, flower-crowned bridal cake extended a decoration of natural flowers. Around the room were emblazoned miniature flags announcing, "Success to the President," "Success to the Supreme Court," "Success to the Army," "Success to the Navy," and "Hail Columbia."

Following the wedding, the couple left for New York on their honeymoon in a Pullman Palace Car accompanied by the Grant relatives and Nellie's bridesmaid, Anna Barnes.

The couple's farewell to New York, before sailing for Europe, competed in lavishness with their wedding in Washington.

Wrote a *New York Graphic* reporter upon the couple's departure for Europe: "America keeps a fragrant memory of the maiden whom England gains as a matron."

But it remained for Walt Whitman, the poet, to put the literary finishing touches on Nellie's departure for England. Entitled "A Kiss to the Bride," Whitman wrote:

O youth and health! O sweet Missouri Rose! O Bonny bride!
Yield thy red cheeks today unto a Nation's loving kiss.

Nellie Grant Sartoris lived with her husband in London for two years, and returned to Washington for a visit with her family, bringing her first baby with her. On this occasion, she was photographed by Mathew B. Brady, "the Washington society photographer," in his National Gallery.

At this sitting, Brady made three pictures of Nellie Grant Sartoris against the studio's finest backdrop: a standing pose, one in which Nellie was seated, and one with her firstborn.

Nellie returned to her home in England. Apparently her marriage ran into troubled waters, for shortly after the birth of her third child, Nellie separated from her husband and returned to America with her three children.

Much later in her life, after her divorce from her husband, Nellie married a man who had been her childhood sweetheart. This time, her marriage was a happy one and lasted to the end of her days.

Epilogue: Mathew Brady

With the close of the war, Brady's fortunes went into a steady decline. His picture files contained many hundreds of plates that told an almost complete pictorial story of the bloody conflict, but the sale of war pictures stopped almost at once.

After Appomattox, happy that the war was over, Americans turned busily to solving their personal and living problems. Peace was an actuality, and few cared about looking at war pictures.

Moreover, the government was in the throes of Reconstruction and, preoccupied with that enormous undertaking and its attendant alarms, had neither the time nor the inclination to give much thought to anything else, not to mention the pressing postwar political problems rebuilding the country had spawned.

Brady and his work were soon forgotten in the rush of events, and several years later George Alfred Townsend, the war correspondent and writer, when he paid a visit to the Washington Gallery, was pleasantly surprised to discover that Mathew Brady, the photographer with whom he rode to the first Battle of Bull Run, was still alive.

"Brady the photographer still alive?" he wrote. "Thought he was dead for many a year. No, like a ray of light travelling toward the vision from some past world or star, Mathew Brady is at the camera still, and if he lives eight years longer he will reach the age of 75. I felt as he turned my head, a few weeks ago, between his fingers and thumb, still intent upon that which gave him his greatest credit—finding the expression of the inner spirit of a man—that those same three digits had lifted the chins and smoothed the hairs of virgin sitters, now grandmothers, the elite beauties of their time."

Townsend's prediction that Brady would live to seventy-five, oddly enough, proved to be correct. But the last few years of Brady's life were filled with bitterness and disappointment. He had come far and accomplished much, but

his country remained unmindful of his achievement. He had tried assiduously to interest the government in purchasing his war picture collection to illustrate the momumental *Official Records of the War of the Rebellion,* but the offer made by Brady was turned down. During his last years he worked at his profession, tried to reinstate the Washington Gallery, had a few law suits brought on by bad debts, and encountered many other vicissitudes. Finally, through the help of some of his influential friends, his collection was acquired (a small part of it) by the War Department at an auction of articles in a warehouse, which he had owed some $2,000. Finally, Congress awarded Brady $25,000 for right and title to the pictures the War Department had acquired.

This financial relief, however, was short-lived, since most of the money went to his creditors. The man who had prosecuted and financed the enterprise upon which he had set his heart, being the nation's "pictorial war correspondent," preserving his country's history with his camera, and who believed in it enough to risk his own private capital, became ill and despondent.

He probably realized that he had outlived his fame. The small amount of money he had received from a recalcitrant Congress for his achievement having gone in good part to settle debts, he was left all but penniless. Misfortune, encouraged by destitution, again dogged his footsteps. Of late, some of his detractors have said that he took to drinking. Maybe he had.

But there is no concrete evidence to substantiate this—and if he did, in the writer's opinion, no one had a better right. At any rate, his inebriation, occasional or not, is presumed to be the cause of his being struck down by a horse-drawn streetcar while crossing Pennsylvania Avenue at 14th Street. Unconscious and bleeding from cuts and bruises, he was rushed to the hospital.

For many months he was confined to bed, unable to walk well; and when he recovered sufficiently to leave his bed, it was only with the aid of crutches that he was able to get around at all. The accident put an end to his photographic career.

The last few years of Brady's life were marked by crushing disappointment, poverty, and illness. Brady was heavily in debt, his studio and equipment forfeited to pay the last claims and legal judgments against him. His friends rallied to help him.

Brady, on April 8, 1895, was to receive a Grand Testimonial Benefit from his comrades of the Seventh Regiment of New York, to be held at Carnegie Hall. It was to be his farewell. But there ensued a year of frustrating delays— the impossibility of obtaining a slide projector being among other ridiculous problems that cropped up—yet the event to raise money for Brady's relief was about to take place.

But the man who was to receive the honor was dead, in an alms ward in the Presbyterian Hospital of New York, on January 16, 1896.

Mathew Brady is buried in the Congressional Cemetery in Washington, D.C., alongside his wife, Julia Handy Brady.